ORGANON
OF THE
MEDICAL ART

ORGANON

of the

MEDICAL ART

∎

SAMUEL HAHNEMANN, M.D.

Edited and annotated by

WENDA BREWSTER O'REILLY, PH.D.

The sixth edition of
Dr. Samuel Hahnemann's work of genius
based on a translation by
Steven Decker

PALO ALTO, CALIFORNIA

Adapted from the sixth edition of the
Organon der Heilkunst
completed by Samuel Hahnemann in 1842.

Book jacket and endpaper reproductions of Samuel Hahnemann's original
sixth edition manuscript are taken from §52, §53 and §148.

Library of Congress Cataloging in Publication Data

Hahnemann, Samuel, 1755-1843.
[Organon der rationellen Heilkunde. English]
Organon of the medical art / Samuel Hahnemann ; edited and
annotated by Wenda Brewster O'Reilly ; the sixth edition of
Dr. Samuel Hahnemann's work of genius based on a translation
by Steven Decker.
xxi, 407 p. ; 25 cm.
Includes bibliographical references (p. 367) and indexes.
ISBN 1-889613-00-2
1. Homeopathy I. O'Reilly, Wenda Brewster II. Title

RX68 .0513 1996
615.5'32—dc21 96-086095

2 4 6 8 10 9 7 5 3

Book design by Diana Howard
Printed in the United States of America

Birdcage Books
853 Alma Street
Palo Alto, California 94301
USA

TEL: (650) 462-6300
FAX: (650) 462-6305
www.BirdcageBooks.com

Distributed by Publishers Group West
1700 Fourth Street, Berkeley, CA 94710 USA • (800) 788-3123

■ ACKNOWLEDGEMENTS ■

My deepest thanks to:

Jeremy Sherr, whose teaching first inspired me to take on this project and provided the firm foundation upon which my understanding of the *Organon* grew.

Steven Decker, whose insight and understanding of Hahnemann's philosophy is reflected in every paragraph of this adaptation. In addition, he brought grace and wit to each phase of the journey we undertook in bringing this work to light.

Anna Quinn, who journeyed with us, participating in every aspect of the process of translating and adapting Hahnemann's text. Anna compiled the interlinear translation, making thousands of revisions as Steven's translation took shape, and she reviewed draft after draft of my text, comparing it to Steven's translation. At every step, she contributed to the clarity and accuracy of this work.

John Melnychuk, who worked many long hours to review numerous drafts. His attention to the biggest questions and smallest details was invaluable.

Richard Pitcairn, whose expertise and willingness to work late into the night greatly improved the quality and completeness of the Glossary.

Melanie Kornfeld Grimes, for her historical research, willingness to help in any way, and her moral support.

Simon Taffler, for sharing his clinical and teaching experience, scholastic research, and enthusiasm.

Julian Winston, who cheerfully produced even the most deeply buried historical information on a moment's notice.

Stephen Tabor, for his help with the Latin and Greek, and also to Kevin O'Brien for his contribution to the Latin translation.

All those who contributed their time and expertise at various stages of the manuscript's preparation, with special thanks to: Robert Bannan, Andrea Bartig, Greg Bedayn, Steve Blendell, Margaret O'Reilly Ciskanik, Greg Cooper, Alfred Frei, Annette Gamblin,

Diane Goodwin, Diana Howard, Anne and George Ivison, Cynthia Lamb, Felicity Lee, Louisa Lera, Christine Millum, John Morgan, Maggie Moss, Elizabeth Oakley, Kathi Parker, Michael Quinn, Gay Slater, Gordon Summers, Francis Treuherz, and the many others who lent their assistance and encouragement.

Past translators of the *Organon,* Robert Ellis Dudgeon and William Boericke; Jost Künzli, Alain Naudé and Peter Pendleton; and Conrad Wesselhoeft. Their translations of the *Organon* were like old friends throughout the process of translation and adaptation of Hahnemann's text, often helping to clarify Hahnemann's meaning.

Kerry and Maureen Kravitz, John and Judy Mayfield, Curtis and Neise Turchin, and John McLean, for their enduring friendship and support.

William R. Brewster, M.D. and Sean O'Reilly, M.D., who understood in their hearts and demonstrated in their work what it is to be a medical-art practitioner.

Of course, I could never have taken on this work without the daily support and encouragement of my husband, James O'Reilly and our daughters, Anna, Noelle and Mariele. James turned his own work life inside out to allow me to follow the path that led to, and then through, this project. He understood before I did what I was doing and why, he provided valuable assistance in editing the manuscript, and he smiled each of the five hundred or more times that I said I was almost done.

And finally, my enduring admiration and appreciation to:

Samuel Hahnemann

whose calling to cure lives on in all who venture into the
Organon of the Medical Art.

Aude sapere
DARE TO KNOW

CONTENTS

Organon contains the word 'or,' which in Hebrew means 'light.' In the beginning God made light which, endowed with love and truth, fertilized life with the seeds of source. In the medical world, Hahnemann's *Organon* represents this light. Here lies the organic origin, the creative core of true healing. Like rays of sunlight traveling to earth, Hahnemann's wisdom shines through the mists of time to illume our way, brighten our thoughts, warm our hearts. It would not suffice to say that Hahnemann was ahead of his time for that would imply that one day he may be behind it. Like the true simillimum, Hahnemann's genius is timeless and his work is as relevant to all medical practices today as it was two hundred years ago. Homeopathy stands firmly on his pillars of truth, which have been confirmed and potentized by daily experience. Universal law forms the basis of homeopathy. Becoming a homeopath does not depend on the study of materia medica. It is not defined by prescribing potentized remedies, nor is it reliant on remembering the repertory. It is the living and understanding of these laws which endows our medical practice with true healing.

On first reading the *Organon*, I shared the initial frustration of many homeopaths. It seemed at once too simple, too complex, difficult to understand, or stating the obvious. Yet, as with a chest of treasures buried in the deep, careful investigation and diligent study expose jewels of wisdom. Each reading reveals new gems, pearls of truth on which we may base our art of arts. Like good wine, Hahnemann's teachings improve with time. It was recommended by the old homeopaths that the *Organon* be read twice yearly for the first fifty years of practice, and thenceforth once a year. As a teacher of homeopathy, I am regularly faced with many questions, most of which can be answered directly from the *Organon*. It seems as if Hahnemann experienced, analyzed and solved most issues facing the contemporary homeopath — from case-taking to epidemics, diet to second prescription, one-sided

cases to obstacles. Provings and placebo, antipathy and antidote, mental illness and miasm — all are thoroughly discussed. This diversity has not led to complexity. The *Organon* is arranged in clear and well defined paragraphs, each linked to the next in a magnificent chain of logic. From the physician's calling in the first paragraph, and the highest ideal of cure in the second, the path of reason spirals to the final discussions on alternative therapeutic approaches. This arrangement is not a linear one, but rather a wonderfully woven web of intricate meanings that encompasses the whole of medicine.

Furthermore, this monumental work is not a tome of somber seriousness. Sprinkled with wit and passion, graced by metaphor, augmented by anecdote, it is a joy to behold. Hahnemann does not allow the *Organon* to descend into a restricting doctrine; rather, he has created a flexible vessel into which we may expand our growing consciousness. To illustrate this we need only meditate on his principal prerequisite for successful case-taking: freedom from bias. Nonetheless, the *Organon* is not an easy book to grasp. Complex structure, long sentences, condensed concepts and the problems inherent in any translation have obscured the totality. This edition brings new clarity to Hahnemann's classic and timeless work.

When Wenda O'Reilly first discussed the project with me, I thought her keen mind and analytical thinking would be ideally suited for examining the structure of the *Organon*. I could not have foreseen how extensive and valuable the result would be. She has based her adaptation of the *Organon* upon the sound foundation of Steven Decker's definitive new translation. As in homeopathy, a translation should encompass both science and art — precise linguistics softened by the implication of meaning. Steven Decker has adhered closely to the source, finding words in English to capture the literal meaning of the German original as well as its larger meanings. In his precise rendering of Hahnemann's terminology, Decker has unveiled what was previously obscure.

Wenda O'Reilly's adaptation of Decker's translation brings further clarity to the text. Her division of the text into chapters and sections helps to delineate the inherent organization of Hahnemann's

text, and her side-headings and editorial notes provide focus for our thoughts. The addition of a comprehensive index and multilingual glossary provide the previously unavailable map and key, necessary for treasure hunting. Armed with insight, determination and enthusiasm, Wenda O'Reilly has produced the treatise that we have been waiting for since Hahnemann finished the final edition of his *Organon*. This new translation and adaptation of the *Organon* has been prepared with all the care and precision that it deserves, and it sheds new light on our high mission of restoring the sick to health.

INTRODUCTION

■ ■

by Wenda Brewster O'Reilly, Ph.D.

Samuel Hahnemann was a physician, chemist, linguist, historian of medicine, and scientific revolutionary. Early in his career, he became so disillusioned with the state of medical practice that he stopped practicing medicine in the firm belief that the methods he was taught would do more harm than good. Instead, he made his living translating medical and other texts. While Hahnemann was translating the Scottish physician William Cullen's *Materia Medica*, specifically the section on the toxicology of Peruvian bark, he was struck by the similarity between the symptoms of poisoning from Peruvian bark (also known as cinchona, from which quinine is derived) and the symptoms of malaria against which it was used as a medicine. It occurred to him that this similarity might not be coincidental, but rather it might be the very basis of the medicine's curative power.

Through numerous experiments conducted over several years, Hahnemann established that any medicine will cure a particular disease if it is capable of producing symptoms in healthy individuals which are similar to the totality of disease symptoms in the sick. These experiments also led to Hahnemann's development of guidelines for medicinal experimentation, which include testing medicines only upon healthy individuals (to avoid confounding the action of the medicine with the symptoms of the disease), the use of small doses, and the testing of any medicine on both men and women and on people with various bodily constitutions in order to determine a medicine's full range of action.

Hahnemann's use of minute, potentized medicinal doses originally arose from his interest in reducing the adverse affects of medicines. He then discovered that by successively diluting and succussing a medicinal substance, not only were the adverse effects of the medicine diminished, but the inherent curative power of the

substance was dramatically increased. This led to his discovery that medicines and diseases act dynamically, not materially.

Samuel Hahnemann was a linguist of phenomenal ability. He spoke German, Latin, Greek and French fluently. At the age of twelve, he was given the responsibility of teaching other children Greek and Latin. As an adult, he translated complex medical texts from English, French, Greek and Latin, and quoted from Hebrew and Aramaic texts in his teaching. In all, he was conversant in at least eleven languages. His multi-lingual ability was integrated with his equally complex and multi-faceted way of viewing the world.

While Hahnemann's view of health and disease was accessible to the most intuitive minds of his generation, they had little scientific basis for understanding why things worked as Hahnemann indicated. Hahnemann himself attached little importance to understanding the 'why' of his discoveries, focusing instead on the 'what' and the 'how.' He constructed his philosophy and practice of medicine upon unbiased observation, pure experience, and unfettered deliberation. It is only recently that we are beginning to formulate theoretical constructs that address the 'why.' Hahnemann's approach to medicine had little to do with the world view described by the Newtonian physics of his day; it is much more closely aligned with modern post-quantum physics. Hahnemann envisioned a holistic world in which the foot is not the man himself. He saw that individuals were neither jigsaw puzzles nor pieces in a larger puzzle, where the sum of all parts equals a whole. Rather, he saw that parts of a larger whole holographically represent that whole; the whole and its parts form an indivisible unity.

Over the course of a sixty-year career, from 1783 when he stopped practicing the medicine of his day, until he died in 1843, Samuel Hahnemann developed the homeopathic mode of medical treatment, which was as different from the prevailing medical practice as day is to night. Its basic premises were the use of similar medicines whose actions were fully known to the medical-art practitioner, the individualized treatment of a person's disease, the use of one single, simple medicine at a time to avoid the unpredictable effects of combining two or more drugs, and the use of potentized medicines whose ability to act dynamically upon the patient's life

force was thereby greatly increased. Another major achievement was Hahnemann's identification of miasms and his differentiation between the essential nature of a disease (its 'wesen') and the forms in which it manifests.

During his long professional career, Hahnemann condensed his precepts on the philosophy and practice of medicine and the maintenance of health into successive editions of the *Organon of the Medical Art.* The first edition was published in 1810, and the sixth and final edition was completed in 1842, the year before he died (see Comments on the Text, p. 275). Hahnemann did not write the *Organon* only for medical pracitioners, in fact, he prescribed the book itself to patients. The *Organon* is a remedy of the highest potency. Like other great works of art, it constantly reveals new marvels and mysteries, acting dynamically in relation to each reader, and acting differently with each reading.

THIS TRANSLATION AND ADAPTATION OF THE *ORGANON*

Over the past few years, Steven Decker and I have worked closely together to bring Hahnemann's work of genius to light for modern readers. His goal has been to provide the most accurate translation of Hahnemann's language and thought. Mine has been to adapt the translation in such a way as to make it as comprehensible and as accessible as possible. Steven Decker's new translation of the *Organon* conveys more of Hahnemann's meaning than ever before, preserving the primary sense of his words as well as their imagery, color and texture. He has brought to the translation not only his keen understanding of the German language of Hahnemann's time, but also of Hahnemann's underlying philosophy, which was shared to some extent by a few other writers and philosophers of his time. This small group (including his contemporaries, Johann Goethe and Samuel Taylor Coleridge) comprise the beginning of what may be referred to as a dynamic school of thought.

Steven Decker's translation (which is available in computer format) includes three parts: a modern German version of the *Organon* in which obsolete spellings are replaced by current German spellings, an interlinear translation in which an English word appears

below each word of the original Old German text, and a literal English translation of each sentence of the *Organon* which follows as much as possible Hahnemann's original periodic sentence structure. I have further adapted each sentence by placing Hahnemann's translated words into a modern English grammatical structure, often expanding his very condensed style of writing. In addition, I have delineated the structure of the *Organon* by dividing it into chapters and sections, and interpreted the text in side-headings and editorial footnotes (indicated with an asterisk). I have also added a glossary and an index.

The Glossary includes definitions of medical terms used in the *Organon*, as well as translation notes on specific words. Readers can now understand terms as Hahnemann meant them instead of having to guess which of an English word's several meanings was meant to apply. Also found in the Glossary are definitions of concepts that are helpful in understanding Hahnemann's mode of thought.

The Index allows readers to use the *Organon* as a reference work. It also organizes information on certain topics. For example, listed under 'Homeopathic treatment' readers will find every homeopathic use of a medicine or treatment discussed by Hahnemann in the *Organon*; under 'Definition of' readers will find Hahnemann's own definitions of terms in the text.

Steven Decker and I worked together to solve one of the prime difficulties in translating and adapting a text of such complexity as the *Organon*: the problem of consistency versus context. At every turn, translators must choose between translating a particular word consistently throughout a text or translating it according to context. Previous translators have opted primarily for translation according to context. However, one way in which readers come to understand Hahnemann's precise meaning is by seeing how he uses certain key words in various contexts. Steven and I approached this problem from different directions. Steven drew on a wide selection of English words to find the particular one that could span the various meanings of a given German word. We then worked together to define key terms in the Glossary so that readers can fully under-

stand the nuances to be associated with particular terms. In other words, through the Glossary definitions, we are giving readers the opportunity to assign the full meaning of a given German word to the English word being used to translate it. One example is the use of 'malady' throughout the text. 'Malady' is being used to translate the word *Uebel,* which has two meanings in German; it means both illness and evil. There is no word in English that immediately conveys both of these meanings to the reader. 'Malady' has been assigned the task of conveying both of these meanings and has been defined as such in the Glossary. Another example is the word 'impinge,' translated from the German *einwirken.* Of its various possible definitions, 'impinge' has been assigned the particular definition: to have initial superficial contact with something, followed by a thrusting, driving or penetration into it.

Another frequently encountered problem in moving from one language to another is that different languages carry different ways of looking at something, conceptually dividing things into smaller or larger units. Where one language may use several words, another may use only one. For example, English has the terms 'curing' and 'healing,' which originally had different meanings. 'Cure' referred to medical intervention while 'healing' referred to the human organism's own efforts to recover from disease or injury. German, however, has only one term (*Heil-*) that covers both healing and cure, and which can refer to anything that is remedial or therapeutic. Any such differences between Hahnemann's original terminology and the translation are presented in the Glossary. As a result, readers will be able to better know and understand what Hahnemann wrote and what he meant.

In some cases, linguistic differences between Hahnemann's German and modern English describe profound differences between his philosophy or world view and that of most modern English-speaking readers. The structure of Hahnemann's thought and writing in the *Organon* is functional, not linear. If one reads Hahnemann from a linear perspective, one misses half the story. Steven Decker's new translation, and his definition of key terms, bring these differences to light. Readers can come closer to seeing as Hahnemann saw

and thinking as Hahnemann thought. An example of this is found in the English word 'knowledge,' typically used to translate both of the German terms *wissen* and *kennen,* which describe fundamentally different types of knowledge and learning. *Wissen* describes intellectual knowledge gained from study, while *kennen* describes knowledge gained through participative experience. In this translation and adaptation, the German terms have been translated with different English words.

As a multi-linguist, Hahnemann was profoundly aware that the name of something is not the thing itself. He conveyed this to the reader by giving multifaceted definitions that play off one another and thereby maintain a vibrancy and dimensionality that is missing in fixed definitions. One way that he did this was by referring to something using two or more words, often rooted in different languages. This information is included in the Glossary.

Hahnemann's original text consisted of a preface, an introduction, and 291 numbered paragraphs of text. A synopsis of paragraphs served as the table of contents. Hahnemann's *Organon* was consistent with the publishing standards of his day. The text in this edition has been formatted so that the reader may easily differentiate between Hahnemann's text and the editorial additions which have been made. The main text is translated and adapted from Hahnemann's original, with the exception of text in square brackets, which are editorial clarifications. Hahnemann's German has been translated into English, using American English spelling. Where Hahnemann uses Latin, Greek or French, the text appears in the original language, followed by a translation in brackets.

Hahnemann's footnotes are numbered. Those in the Preface and Introduction are numbered sequentially. In the main text, a footnote's number coincides with that of the paragraph in which it appears. Hahnemann's notes to footnotes are indicated with a cross (†).

Most of the italics in the main text either represent Hahnemann's emphasis or his use of foreign words and phrases, such as *similia similibus* and *contraria contrariis.* In this edition, names of medicines and medicinal substances, whether Latin or common, appear in roman type, not italics. Also, these names appear in lower case

(contrary to the modern convention of capitalizing the names of homeopathic medicines) since Hahnemann uses the common and the Latin names both in reference to unpotentized substances as well as to potentized medicines.

I have been blessed with excellent help and advice throughout my three and a half years of work on this project. This is reflected throughout this adaptation of Hahnemann's work. The many people who have contributed dynamically and materially to this endeavor will, I hope, recognize the value of all they did in the published result. I cannot adequately thank them. At the same time, I have made many choices which may differ from the choices others would have made in my place, and I take all responsibility for any resultant errors or shortcomings. Many times throughout the project, I had hoped that if I stuck closely enough to Hahnemann's wording in a particular paragraph, all of his meaning would come through to the reader even if I did not fully understand it myself. However, time after time I would do my best with a paragraph and then later come to a realization as to a fuller meaning. In every case, this led to my rewording the paragraph to bring that meaning into better focus. I am keenly aware that there is more in the *Organon* to be discovered as we grow in our understanding, yet I continue to hope that this adaptation will serve to bring the reader very close to Hahnemann's brilliance of thought, to his unparalleled symphony of health and life that is the *Organon of the Medical Art.*

PREFACE

ALLOPATHY: THE OLD SCHOOL OF MEDICINE*

Material view of disease

Generally speaking, the old school of medicine (allopathy) presupposes in the treatment of diseases in order to cure them, nothing but material causes, partly blood excess (plethora) which is non-existent, partly disease materials and acridities. Therefore the adherents of the old school have the life's blood drained off, and they strive to sweep away the fancied disease matter and conduct it elsewhere (through emetics, evacuations, salivation- sweat- and urine-promoting means, drawing plasters, suppurations, fontanels, etc.) under the delusion of being able thereby to weaken and materially eradicate the disease. Instead, they augment the sufferings of the patient thereby, and deprive the organism, through their painkillers, of the life energies [vitality] and nutrient bodily fluids that are indispensable for healing.

Use of large, frequently repeated doses of strong medicines and compound prescriptions

The adherents of the old school of medicine assail the body with large, often protracted and rapidly repeated doses of strong medicine, whose long-lasting, not infrequently terrible effects they do not know, and which they apparently make purposely unrecognizable through the commixture of more such unknown substances into one medicinal formula. The long-continued employment of such formulas inflicts new and, in part, ineradicable medicinal diseases on the sick body.

Use of palliatives that suppress symptoms without curing the disease

Whenever they can (in order to remain popular with patients)[1] the adherents of the old school employ means (palliatives) that, for a short time, immediately suppress and cloak the disease ailments through opposition *(contraria contrariis)* but that leave the basis for these ailments (the disease itself) strengthened and aggravated.

* Hahnemann's Preface briefly summarizes his history of allopathic medicine presented in the Introduction, and his overview of homeopathy presented in Chapter One.

Naming of diseases by the old school

1 With the same view in mind [i.e., popularity with the patient], the skilled allopath invents a fixed name for the malady, preferably a Greek one, in order to make the patient believe that the allopath has known this disease for a long time like an old acquaintance, and therefore is in the best position to cure it.

The adherents of the old school of medicine falsely deem the maladies located on the outer parts of the body as merely local and existing alone there by themselves, and they imagine them to have been cured if they have driven them away through external means, so that it is now necessary for the inner malady to break out at a more vital and critical place.

When it is not aware of anything else to do for a disease that will not yield or is getting worse, the old school undertakes, at the very least, to alter it blindly through what it calls an *alterative,* for example, with a life-undermining calomel, a corrosive sublimate, or with other violent means in large doses.

The unholy chief business of the old medicine (allopathy) seems to be, out of ignorance, to render the majority of diseases (i.e., the protracted ones) if not fatal, then at least incurable through the continuous debilitating and tormenting of the weak patient who, moreover, is already suffering from *a.* his disease plague and *b.* the addition of new destructive diseases. This is *a very easy business* once one has got the knack of this ruinous procedure and has become properly insensitive to the warnings of conscience!

For all these damaging operations, the ordinary physician of the old school has his reasons to set forth; however, these reasons rest solely on the prejudices of his books and teachers, or on the authority of this or that exalted physician of the old school. There, even the most contrary and absurd procedural modes find their defense, their authority — even though the ruinous result speaks ever so much against it. The fewest patients perish and die on the old physician who, after many years of misdeeds, is quietly and finally persuaded of the perniciousness of his so-called art and only treats even the most onerous diseases with strawberry syrups mixed with plaintain water (that is, with nothing).

For vast centuries, this calamitous art has firmly possessed the privilege and power to dispose of the life and death of patients, arbitrarily and at its own discretion. In that time, it has shortened the natural life span of probably ten times the number of people than the most ruinous wars ever have, and it has rendered many millions of patients sicker and more miserable than they originally were. I

Removal of external manifestations of disease without curing the disease

Use of dangerous treatments that alter disease symptoms

Use of treatments that debilitate the patient and worsen the disease

Treatment justifications based on prejudice and false authority

have more closely illuminated this allopathy in the introduction to previous editions of this book.[2]

Now I shall only present its exact opposite, the true medical art, which I discovered and which is now somewhat more perfected.

HOMEOPATHY

Dynamic view of disease

With the medical art of homeopathy, it is entirely different. It can easily persuade every reflecting person that human diseases rest on no material, on no acridity, that is to say, on no disease matter; rather they are solely spirit-like (dynamic) mistunings of the spirit-like enlivening power-force-energy* (the life principle, the life force) of the human body.

Cure by means of the life force's counter-action against a medicine's action

Homeopathy is aware that a cure can only succeed through the counter-action of the life force against the correctly taken medicine. The stronger the life force that still prevails in the patient, the more certain and faster the cure that takes place.

Avoidance of painful and debilitating treatments

Homeopathy therefore *avoids anything that is even the slightest bit debilitating*.[3] Homeopathy avoids as much as possible every arousal of pain because pain also robs the vitality.

Striking cures in olden times resulted from treatments that happened to be homeopathic.

2 In those previous editions, the reader will find examples adduced as proofs that when, in olden times, striking cures were performed here and there, it always happened by means which were fundamentally homeopathic. These means fell into the physician's hands by chance and were contrary to the established therapy of the time. [These examples last appeared in the fourth edition of the *Organon of the Medical Art.* They have been reprinted in the Appendix of the combined fifth and sixth editions of the *Organon,* edited by K.N. Mathur.]

* *Kraft* incorporates the meanings of power, force and energy. Throughout this text, however, *Kraft* is translated as power, force or energy, and *Lebenskraft* is translated as life force. See *life force* in the Glossary.

3 Homeopathy never spills a drop of blood; gives no emetics, purgatives, laxatives or sweat-promoters; drives away no outer maladies through external means; prescribes no hot or unknown mineral baths; prescribes no medicinal clysters; applies no Spanish fly or mustard plasters, no setons, no fontanels; arouses no salivation; and does not burn with moxa

For curing, homeopathy avails itself *only* of those medicines whose capacity to (dynamically) alter and differently tune the condition it *exactly* knows and then it searches out the one medicine whose condition-altering powers (medicinal disease) are in a position to lift the natural disease at hand through similarity *(similia similibus)*. This is administered to the patient as a simple medicine [i.e., unmixed with any other medicinal substance] in subtle doses, that is, in doses so small that they exactly suffice to lift the natural malady without causing pain or debilitation. The result is that, without in the least weakening, tormenting or torturing the patient, the natural disease is extinguished and the patient, while improving, soon grows stronger and thus is cured. This seems so easy, but actually it is a very cogitative, laborious, arduous business; however, it fully restores the patient to health in a short time and without ailment so it becomes a curative and blessed business.

> The use of minute doses of simple, proven medicines to cure disease through the principle of 'like cures like'

Thus homeopathy is an entirely simple medical art, always constant in its principles as well as in its procedures. These principles and procedures, as well as the theory on which they rest (if well grasped) will be found to be self-contained and only in this way helpful. The purity of its theory and of its practice is self-explanatory. It therefore entirely excludes all backsliding into the ruinous routine of the old school (whose contrary it is, as day is to night). If it is other than this, then it ceases to earn the venerable name of homeopathy.

> Purity and constancy of homeopathic principles and practice



Köthen, 28 March 1833
Confirmed Paris, 184 —*
SAMUEL HAHNEMANN



or glowing irons right down to the bone. Homeopathy does, with its own hand, give self prepared, simple medicines, which it knows exactly. It does not give mixtures and never allays pain with opium, etc.

* Hahnemann did not complete the date in his manuscript, probably leaving this until the book went to the printer. February, 1842 is a likely date, according to a manuscript note made by his wife, Melanie Hahnemann.

INTRODUCTION

*A review of the allopathic
and palliative medical practice of the
old medical school up until now*

THEORETICAL SYSTEMS OF MEDICINE*

With civilization, diseases and theories for their treatment multiplied dramatically.

As long as humanity has existed, people have been exposed, individually or collectively, to illnesses from physical or moral causes. In the raw state of nature few means of aid were needed, since the simple way of life admitted but few diseases. With civilization, however, the occasions for falling ill, and the need for help against diseases, grew in equal measure. From then on (soon after *Hippocrates,* therefore for two and a half thousand years) people have occupied themselves with the treatment of ever more self-multiplying diseases. In puzzling out how to help, using intellect and presumptions, they allowed themselves to be seduced by their vanity. Countless differing views about the nature of diseases and their redress sprang from so many very different heads.

They called their theoretical hatchings *systems* (or constructs), each of which contradicted the others and itself. Each of these subtle portrayals set the readers initially into a stupefied amazement on account of the incomprehensible wisdom contained in it. It drew to the system-builder a host of followers who parroted the unnatural sophistry; to none of them, however, was it of the slightest use in being able to cure better. Then a new system would come along, often quite contrary to the first, displace that one and again procure for itself a reputation for a short time. None of them, however, was in harmony with nature and experience. They were theoretical webs woven by subtle heads out of alleged consequences, which could not be made use of in practical treatment at the sick-bed, due to their subtlety and unnaturalness. They were only good for empty disputations.

THE OLD SCHOOL'S MATERIAL VIEW OF DISEASE

Along the way, a treatment-wesen fashioned itself which was independent of all these theories. Mixtures of unknown medicinal substances were employed against arbitrarily erected forms of disease

* Hahnemann's Introduction offers a brief history of medical theory and practice. He describes the broad medical paradigm (and several of its

that were arranged according to material views in contradiction with nature and experience, hence (as may be supposed) with a bad result — such is the old medicine, called *allopathy*.

Without failing to recognize the merits which many physicians have earned in the sciences that are auxiliary to medicine — in the natural sciences of physics and chemistry; in the different branches of natural history, particularly that relating to human beings; in anthropology, physiology and anatomy, etc. — I am dealing here only with the practical part of medicine, with cure itself, in order to show how diseases up until now were so imperfectly treated. Far beneath my notice lies that mechanical routine of treating precious human life according to prescription manuals, the on-going publication of which unfortunately demonstrates their continued frequent use. I leave it entirely unconsidered as a scandalous practice of the lowest class of ordinary medical practitioner. I speak here only about the medical art, as practiced up until now, which (conceited about its antiquity) fancies itself to be scientific.

The adherents of the old school of medicine flattered themselves that they could justly claim for it alone the title of *rational medical art* because they alone sought for and strived to clear away the *cause of disease, and proceed according to the process of nature in diseases. Tolle causam!* [Remove the cause!], they cried repeatedly. But they went no further than this empty exclamation. *They only imagined* they could find the cause of disease, but they did not find it since it is not discernible and is not to be found. Since most diseases (indeed the vast majority of them) are of a dynamic (spirit-like) origin and of a dynamic (spirit-like) nature, their cause is not discernible to the senses. Therefore, the adherents of the old school were intent on devising a cause for themselves. They drew conclusions about the invisible processes in the *internal wesen* of sick people from *a.* viewing parts of normal dead human bodies (anatomy) compared with the visible changes in these inner parts in people who died of disease

variations) which has been dominant for centuries, and which his revolutionary medical paradigm, presented in the body of *The Organon of the Medical Art,* almost diametrically opposes.

(pathological anatomy), and *b.* comparing the appearances and functions in healthy life (physiology) with their endless deviations in the countless disease states (pathology, semiotics).

The old school confounded the supposed cause of disease with the disease itself.

This resulted in a dark fantasy image which theoretical medicine took for its *prima causa morbi* [first cause of disease].[4] This was then supposed to be both the *proximate cause of the disease* and, at the same time, the inner wesen of the disease, *the disease itself.* However, in accordance with sound common sense, the cause of a thing or an event can never be, at the same time, the thing or event itself.

How could they then, without deceiving themselves, make this indiscernible inner wesen into an object to be cured and prescribe a medicine for it whose curative tendency was likewise, for the most part, unknown to them, and indeed prescribe several such unknown medicines mixed together in what are termed prescriptions?

The cure of a chronic disease depends upon the discovery of its origin. The originating cause of all chronic non-venereal diseases is psora.

4 It would have been much more consonant with sound common sense, and with the nature of the matter, had they, in order to be able to cure a disease, regarded the originating cause as the *causa morbi* [cause of disease] and endeavored to discover that. This would have enabled them to successfully employ the plan of cure which had proven itself to be helpful with diseases having the same originating cause, and also with those diseases from the same source [origin]. For example, the same mercury helps with an ulcer on the glans after impure coitus as it does with all previous venereal chancres. If they had discovered the originating cause of all the remaining chronic (non-venereal) diseases to be an infection, at some time or other, with the itch diathesis miasm (with psora), and if they had found for all of these a common method of cure (regard being had for the peculiarities of each individual case) then every single one of these chronic diseases could have been cured. Then they might rightly have been able to praise themselves that they had before their eyes the *only useful* and fruitful *causa morborum chronicorum (non venereorum)* [cause of chronic (non-venereal) disease]. With this as their foundation, they would have been able to cure such diseases with the best success. But down through the many centuries, they could not cure all of the millions of chronic diseases because they did not know that their origin was in the itch diathesis miasm (that was first discovered through homeopathy, which then furnished a helpful method of cure). Nevertheless, they boasted that they alone had kept in view the

This sublime project — to find *a priori,* an inner, invisible cause of disease — resolved itself (at least among the physicians of the old school who thought themselves to be astute) in a search (under the guidance of the symptoms, it is true) for what might be supposed to be the probable general *character* of the case of disease before them.[5] Was it cramp? debilitation? paralysis? fever? inflammation? induration? infarcts of this or that part? blood-excess (plethora)? lack or excess of oxygen, carbon, hydrogen or nitrogen in the bodily fluids? raised or lowered arteriality, venosity or capillarity? an alteration in the relative proportion of the factors of sensibility, irritability or reproduction?

> Old school hypotheses about the general character of diseases

These were all surmises, honored with the title of causal indicator by the old school and regarded as the only possible rationality in medicine. In fact, these were assumptions that were too deceptive and hypothetical to serve any practical purpose — incapable, even had they been well grounded, of indicating the most apt remedy for a case of disease. They were flattering to the vanity of the learned concocters but they usually led practitioners astray. The aim was more at ostentation than at a serious finding of the cure indicator. And how often has it happened that, for example, cramping or paralysis seemed to be in one part of the organism while in another part inflammation was apparently taking place!

On the other hand, where are the surely helpful medicines for each of these alleged general characters to come from? Those that would surely help would not have been any other than the *specific* ones, that is, the medicines which were homogenic,[6] in their action,

> Only homeopathic medicines can cure disease, but these were banned by the old school.

prima causa [first cause] of these diseases in their treatment, and that they alone treated rationally although they had not the least inkling of the only useful knowledge of their psoric origin. Consequently they bungled all chronic diseases!

5 Every physician who treats disease according to such general characters, no matter how much he presumptuously affects the name of homeopath, is and remains indeed a generalizing allopath, since without specializing individualization, homeopathy is not thinkable.

> Homeopathy requires individualized treatment.

6 Called homeopathic.

to the disease irritation. The use of these medicines was, however, forbidden and tabooed by the old school as highly damaging.[7] This is because observation had taught them that such medicines in the conventional large doses proved themselves to be life-endangering due to the [organism's] so highly intensified receptivity for homogenic irritations in diseases. However, the old school had no inkling of smaller doses or of extremely minute doses. Therefore, to cure in a direct (most natural) way, by means of specific homogenic medicines, was not allowed. It also could not be done since most medicinal actions were, and continued to remain, unknown. Even if they were known, it would never be possible to divine the apt remedy with such generalizing views.

OLD SCHOOL EFFORTS TO REMOVE DISEASE MATTER

Adherents of the old school removed disease matter because they did not acknowledge that the spiritual-bodily organism is a potentized wesen and that disease is produced dynamically.

However, perceiving that it was more sensible to seek for another path, a straight one if possible, than to take circuitous courses, the old school of medicine believed it could directly lift diseases through *the removal of the* (alleged) *material cause of disease.* This is because it was next to impossible for the physicians of the ordinary school to free themselves of these material concepts while they were viewing and forming a judgement about a disease, and while they were seeking for the treatment indicator. It was next to impossible for them to acknowledge the nature of the spiritual-bodily organism as a highly potentized wesen, to acknowledge that the changes of its life in feelings and functions, which one calls diseases, had to be determined and produced mainly (in fact, almost solely) through dynamic (spirit-like) impingements and could not be produced differently.

7 Rau writes, "Where experience had taught us to know the curative power of homeopathically acting medicines, whose action could not be explained, one resorted to declaring them specific, thereby lulling further cogitation to sleep with this vacuous expression. The homogenic stimulants, the *specific* (homeopathic) ones, however, had long since been forbidden as highly damaging influences." (Rau, *Ueb. d. homöop. Heilverf* [About the Homeopathic Curative Process], Heidelberg, 1824, pp. 101-102)

The old school thoroughly regarded the materials that were changed through the disease — the abnormal materials that occurred in congestions as well as those that were excreted — as disease arousers, or at least (on account of the materials' alleged back-action) as disease maintainers. They are still considered this way by the old school.

The old school therefore imagined itself to be performing causal treatments as it strived to do away with these fancied and presupposed material causes of disease. Therefore:

Common removal procedures of the old school

1. its industrious removal of bile in bilious fever,
2. its emetics in so-called stomach-vitiations,[8]

8 In a sudden stomach-vitiation, with constant repulsive belching [with the taste] of spoiled foods (usually accompanied by emotional dejection, cold feet and hands, etc.) the ordinary physician has usually gone straight for the deteriorated stomach content, [with the assumption that] an efficient emetic should clear it out completely. He usually attained this intent with tartar emetic, with or without ipecacuanha. But is the patient instantly healthy, lively and cheerful? Oh no! Usually such a stomach-vitiation is of *dynamic origin,* engendered by emotional disturbances (grief, fright, chagrin), a chill, or mental or bodily overexertion just after eating — often after even a moderate meal. These two medicines are not suitable to lift this dynamic mistunement nor is the revolutionary vomiting they bring forth. Furthermore, tartar emetic and ipecacuanha, aside from their other peculiar disease-arousing symptoms, have additional disadvantages for the condition of the patient; the gall-secretion comes into disorder so that, if the sufferer was not entirely robust, he yet for *several* days must find himself ill due to this alleged causal treatment in spite of all this violent expulsion of the complete stomach contents.

Allopathic versus homeopathic treatment of gastric distress

If instead of taking such violent and always disadvantageous evacuant medicines, the patient smells only a single time a globule the size of a mustard seed, moistened with highly diluted pulsatilla juice, whereby the mistunement of his condition in general and of his stomach in particular will certainly be lifted, in two hours he is quite well. And if he yet once more has eructation, the air will be tasteless and odorless — the stomach contents will no longer be spoiled, and at the next meal he will again have his proper appetite. He will be healthy and lively. This is a true causal treatment; the other is an imaginary one which, in fact, is

3. its diligent expurgation of mucous, of maw-worms and maggots in cases of pallor, ravenousness, bellyache, and enlarged tummies in children,[9]

8 *continued*

only a damaging fatigue for the patient. To be sure, even a stomach over-filled with indigestible foods *never* requires a medicinal emetic. In such a case, nature knows best how to rid itself of the excess by way of the esophagus through disgust, nausea and spontaneous vomiting assisted, if need be, by mechanical irritation of the soft palate and throat. In this way, the medicinal side effects of the emetic medicines are avoided. A small quantity of coffee expedites the passage downwards of what remains in the stomach.

But if after excessive overloading of the stomach, the irritability of the stomach is not sufficient to promote spontaneous vomiting, or is lost altogether, so that the tendency to it has expired under great epigastric pains, such an emetic in this paralyzed state would only have the effect of producing a dangerous or deadly visceral inflammation, whereas a small drink of strong coffee, frequently administered, would dynamically lift the diminished irritability of the stomach and alone put it in a position to convey out from above or below its still ever-so-excessive contents. So here also, the ostensible causal treatment is out of place.

Even the corrosive gastric acid, eructations of which patients with chronic diseases are not infrequently subject, may be today violently evacuated by means of an emetic, with great ailment and yet all in vain, for tomorrow or some days later it is replaced by similar corrosive gastric acid and then usually in larger quantities. It recedes by itself if its dynamic origin is curatively lifted through a very small dose of highly diluted sulphuric acid, or still better (if it recurs frequently) by the employment of the subtlest doses of an antipsoric means that also corresponds in similarity to the rest of the symptoms.

And so it is with many of the alleged causal treatments of the old school, whose favorite striving is to clear away the material product of the dynamic mistunement with difficult, wearisome measures and disadvantage, without discerning the dynamic source of the malady and without *curing* it homeopathically, thus intelligently destroying its discharges along with it.

9 These conditions rest solely on a psoric wasting sickness and are easily cured through (dynamic) mild antipsoric means, without emetics or laxatives.

4. its bloodletting for hemorrhages,[10] and especially all sorts of blood-extractions[11] as its treatment-of-choice for inflammations, which it now imagines it encounters in almost every diseased part of the body and feels bound to remove through the application of an often fatal number of leeches (following the procedure of a well-known bloodthirsty Parisian physician [Broussais], like sheep following the bellwether even into the hands of the butcher).

10 Regardless of the fact that, at the base of almost all disease hemorrhages, there lies solely a dynamic mistunement, the old school nevertheless deems the cause to be an excess of blood. It cannot restrain itself in undertaking bloodlettings in order to carry away the presumed overflow of this life juice. It then seeks to palm off onto the malignancy of the disease, the quite obviously bad result, the sinking of vitality and the inclination or even transition to the typhoid condition, *with which it then often cannot cope.* In short it believes, even though now the patient does not recover, that it has executed a treatment after its motto, *causam tolle* [remove the cause]. It believes that, according to its mode of speaking, it has done everything possible for the patient, whatever the result may now be.

Bloodletting for hemorrhages

11 Regardless of the fact that there probably never was a drop too much blood in the living human body, the old school considers the main material cause of all hemorrhages and inflammations to be an alleged excess of blood, which it has to remove and drain off through venesections (bloody cuppings) and leeches. This it deems a rational procedure, a causal treatment.

Bloodletting versus homeopathic treatment of inflammations

In general inflammatory fevers, in acute pleurisy, it regards even the coagulable lymph in the blood, the so-called buffy coat, as the *materia peccans* [offending matter], which it strives to carry away as much as possible through repeated venesections, regardless of the fact that with renewed bloodletting this buffy coat appears still more viscous and thicker. So it spills blood if the inflammatory fever does not want to subside, often to the brink of death, in order to take away this buffy coat or supposed plethora, without suspecting that the inflamed blood is only a product of the acute fever, only a product of the diseased immaterial (dynamic) inflammatory irritation. They do not suspect that this dynamic inflammatory irritation is the only cause of the great storm in the vascular system. The inflamed blood and the immaterial inflammatory irritation can be lifted through the smallest dose of a homogenic (homeopathic) medicine (e.g., a fine globule moistened with decillion-fold

Treatment of general inflammations in acute fevers

11 *continued*

diluted aconite juice, along with avoidance of vegetable acids). In this way, even the *most violent pleuritic fever,* with all its threatening concomitants, is turned into health and *cured without a decrease of blood,* without cooling means. This occurs within *a few hours* (at the most within 24 hours). A blood specimen from the patient's vein then shows no more trace of buffy coat. A similar patient, treated according to the rationality of the old school (if after repeated bloodletting and unspeakable sufferings he, with difficulty, escapes death for the present) still has many months to languish before, emaciated, he is back on his feet again — that is, if a typhoid fever, leukophlegmasia or suppurating pulmonary tuberculosis does not snatch him away in the meantime (which is the more frequent consequence of such maltreatment).

Anyone who has felt the quiet pulse of a man an hour before the occurrence of the rigor that always precedes an attack of acute pleurisy, will not be able to restrain his astonishment if told two hours later, after the outbreak of the heat, that the present monstrous plethora urgently requires frequent bloodletting. He will naturally ask himself by what miracle the pounds of blood that must now be drawn off could have been conjured into the blood vessels of this man within these two hours, which but two hours previously he had felt coursing so quietly. Not a single dram more blood can now be circulating in those vessels than existed when he was in good health, not yet two hours ago!

The allopath withdraws, therefore, no onerous excess of blood from the patient with an acute fever because an excess of blood cannot possibly be present. Rather, he deprives the patient of what is indispensable for life and recovery — the normal amount of blood and, accordingly, of vitality. This is a great loss which no physician's power can replace! Nevertheless he labors under the delusion of having executed a cure according to his (misunderstood) motto: *causam tolle* [remove the cause], yet it is impossible for the *causa morbi* [cause of disease] in this case to be an excess of blood. The only true *causa morbi* here is a diseased dynamic inflammatory irritation of the blood system. This is proven by the rapid and lasting cure of the aforementioned case *(and every similar case)* of general inflammatory fever through one or two incredibly fine and small doses of aconite juice, lifting this irritation homeopathically.

Treatment of local inflammations

The old school errs equally in the treatment of local inflammations with its topical bloodlettings, more especially with the quantities of leeches which are now applied according to the rage of Broussais. The palliative relief that at first ensues from the treatment is far from being

In this way, the adherents of the old school believe they are complying with genuine causal indicators and curing rationally.

They also believe that they are performing causal treatments, and that their patients are thoroughly cured, when they: Surgical procedures of the old school

1. tie off polyps,
2. cut out cold glandular swellings or use local heating means to artificially excite suppuration of the glandular swellings,
3. enucleate encysted (steatoma or melicera) tumors,
4. operate on aneurysms or on lachrymal or rectal fistulas,
5. cut out scirrhous tumors of the breast,
6. amputate a necrotic limb, etc.

They also believe they are performing causal treatments when they: External treatments of the old school

1. use *repellentia* [things that repel],
2. dry up old, ichorous leg ulcers through astringent compresses, through lead-, copper- and zinc-oxides (aided, if need be, by the simultaneous administration of purgatives which merely debilitate, but do not lessen the fundamental wasting sickness),
3. cauterize chancres,
4. topically destroy figwarts,
5. drive the itch diathesis away from the skin with salves of sulphur-, lead-, mercury- and zinc-oxides,
6. suppress eye-inflammations with solutions of lead or zinc,
7. chase away the tearing pains out of the limbs through opodeldoc, volatile liniment, or fumigations with cinnabar or amber.

In every case, they believe they have lifted the malady, conquered the disease and executed a rational causal treatment. But *what a*

crowned by a rapid and perfect cure. On the contrary, the residual weakness and sickliness of the part so treated (frequently also of the whole body), which always remains, sufficiently shows the error that is committed in attributing the local inflammation to a local plethora, and how sad are the consequences of such withdrawals of blood; whereas this solely dynamic, apparently local, inflammatory irritation can be rapidly and permanently expunged through an equally small dose of aconite or, according to circumstances, by belladonna, and the entire malady can be lifted and cured without such unjustifiable spilling of blood.

result! Sooner or later, the thereupon inexorably appearing meta-schematisms which they cause thereby (though they declare them to be new diseases), *which are always worse than the former malady,* refute them sufficiently. These metaschematisms could and should open their eyes to the deeper-lying, immaterial nature of the malady and to its dynamic (spirit-like) origin that is only to be lifted dynamically.

Evacuant procedures of
the old school

In general, up to more recent times (I regret to say, even the most recent times) a favorite idea of the ordinary school was that of disease materials and acridities (even though so subtly conceptualized) which must be carried away through exhalation and perspiration, through the urinary apparatus, through the salivary glands, from the blood and lymph vessels, through the tracheal and bronchial glands as expectoration, or through vomiting or purging from the stomach and intestinal canal. In this way, the body would be purified of the material, disease-arousing cause, and thus a thorough causal treatment would be executed.

By cutting holes in the diseased body, which were converted into long-lasting ulcers kept up for years by the introduction of foreign substances (fontanels, setons), they sought to draw off the *materia peccans* [offending matter] from the (always only dynamically) diseased body, just as one lets sludge run out of a barrel through the tap-hole. They also intended to purify the body of all disease material by drawing off the pernicious bodily fluids through the use of perpetual cantharide plasters and spurge-laurel, but they usually just ended up weakening the sick body to the point of incurability through all these rash, unnatural arrangements.

I concede that it was more convenient for human weakness to assume that, in the disease to be cured, there existed some disease matter that is sensibly conceivable [conceivable to the senses], especially since patients so easily lent themselves to such a representation. In that case, the practitioner had nothing further to take into consideration than where to get enough means to purify the blood and the fluids, to promote urination and perspiration, to promote expectoration, and to scour out the stomach and intestines. Hence, in all the works of materia medica, from Dioscorides up to the lat-

est books on the subject, there is almost nothing written about the actual special action of individual medicines except regarding their supposed use against this or that disease name of the pathology, merely whether they promote the production of urine, sweat, phlegm or menstrual flow, and above all, whether they effect evacuation of the alimentary canal from above or from below. This is because all thoughts and aspirations of practical physicians from time immemorial were, above all, directed towards the evacuation of disease matter and various (fictitious) acridities, lying supposedly at the base of diseases.

These were, however, all vain dreams, ungrounded presuppositions and hypotheses, cleverly devised for the convenience of a therapy that hoped to deal with cure in the easiest possible manner by clearing away disease matter, *si modo essent* [if it exists]!

The wesen of diseases and their cure cannot, however, conform to such dreams or to the convenience of physicians. The diseases cannot cease to be (spiritual) *dynamic mistunements of our spirit-like life in feelings and functions (that is, immaterial mistunements of our condition)* in order to please foolish hypotheses grounded in nothing.

DISEASES ARE DYNAMIC, NOT MATERIAL

The causes of our diseases cannot be material, since the least foreign material substance[12] introduced into our blood vessels, however mild it may appear to us, is promptly expelled by the life force as a poison; and where this is not possible, death results. If even the minutest splinter penetrates a sensitive part, the life principle, which is omnipresent in our body, does not rest until the splinter is

Evidence that diseases are dynamic, not material

12 Life was endangered by injecting some pure water into a vein (see Mullen, quoted by Birch in the *History of the Royal Society*, vol. IV). Atmospheric air injected into the blood vessels caused death (see J.H. Voigt, *Magazin für den neuesten Zustand der Naturkunde* [Magazine for the Newest State of Natural History], I, III, p. 25). Even the mildest fluids introduced into the veins endangered life (see Autenrieth, *Physiologie*, II, §784).

Examples of the endangerment to life from foreign substances injected into the blood

carried away through pain, fever, suppuration or necrosis. Can it be supposed that, in the case of a twenty-year old eruptive disease for example, this indefatigably active life principle would tolerate good-naturedly the presence of a hostile foreign eruptive matter such as a herpetic, a scrofulous, a gout-acridity, etc., in the bodily fluids? What nosologist ever saw, with his own eyes, such a disease-matter, that he could so confidently speak of it and want to build a medicinal system upon it? Has anyone ever succeeded in displaying to view the material of gout or the poison of scrofula?

Even if the application of a material substance to the skin, or to a wound, has propagated a disease by infection, who can prove (as is so often maintained in works of pathology) that some material portion of this substance penetrated into our fluids or was absorbed?[13] The most careful and prompt washing of the genitals does not protect the system from infection with the venereal chancre disease [syphilis]. The slightest breath of air wafting over the body of a person with smallpox can elicit this terrible disease in a healthy child. What is the weight of the material that could have been absorbed into the bodily fluids in this way in order to bring forth, in the first case, an uncured, distressing wasting sickness (venereal disease) that does not extinguish itself until the very end of life, only in death; and in the latter case, however, a quick-killing disease (smallpox) with almost general suppuration?[14] In these and

Surgical treatment of rabies

13 In Glasgow, an eight year old girl was bitten by a rabid dog. *A surgeon immediately cut the bitten area clean out.* Nevertheless, after 36 days she got hydrophobia and died two days later. (*Medical Commentaries of Edinburgh*, vol. II, Dec. 2, 1793)

The old school's hypothesis of disease ferment

14 In order to explain the great quantity of putrid excrement and stinking discharge from sores that often arises in disease, and to be able to declare it to be the matter that engenders and maintains the disease (since upon infection, after all, nothing noticeable of miasm, nothing material could have penetrated into the body) refuge was taken in the hypothesis that the ever-so-subtle infectious matter worked as ferment in the body, bringing the bodily fluids into the same corruption so that the fluids convert themselves into disease ferment that then continues to prolifer-

all similar cases, is it possible to entertain the idea of a disease material being introduced into the blood? A letter written in a sick room and arriving from a great distance, has often communicated to the reader the same miasmatic disease. In this case, is it possible to think of a disease matter permeating the bodily fluids? But what need is there for all this evidence? How often has it happened that an offending word has brought on a dangerous bilious fever? How often has a superstitious prediction of death brought about a demise at the proclaimed time? How often has the abrupt communication of sad or excessively joyful news brought to pass a sudden death? In these cases, where is the disease matter that has physically gone over into the body, there to engender and maintain the disease, and without whose material clearing away and conveying outward no thorough cure should be possible?

The advocates of this clumsy doctrine of assumed disease matter should be ashamed of themselves for having so thoughtlessly overlooked and misjudged the spiritual nature of our life and the spiritual dynamic power of disease-arousing causes. They have thereby lowered themselves to 'physician-sweeps' who, instead of curing through their efforts to drive non-existent disease matter out of the sick body, are destroying life.

ate during the disease and maintain the disease. But through what all potent and all-wise purifying drinks did you then want to have this ever and again self-engendering ferment, this mass of alleged disease matter, so utterly eliminated and cleansed from the human fluids so that there should not remain even a particle of disease ferment which, according to this hypothesis would again, as at first, transform and spoil the fluids into new disease matter? Were this hypothesis true, it would indeed be impossible to cure these diseases in your manner! One can see how all hypotheses, be they ever-so-finely contrived, lead to the most palpable inconsequences if they are founded on falsehood! The most flourishing syphilis may be cured (if the psora with which it is often complicated is dispatched) by one or two small doses of the decillionfold diluted and potentized solution of mercury, whereby the general syphilitic corruption of the fluids is (dynamically) annihilated and dispelled forever.

The substances and impurities that appear in diseases are products, not producers, of disease.

Are then, the foul, often disgusting excretions which occur in diseases the actual matter that engender and maintain them?[15] Rather, are they not *always discharge products of the disease itself, that is, of the life which is merely dynamically disturbed and mis-tuned?* With such false material views about the origin and the wesen of diseases, it was certainly not to be wondered at that, in all the centuries, the aim of the lowly as well as the distinguished practitioners (indeed, even the fabricators of the most sublime medical systems) was always chiefly only the elimination and purging away of fancied disease-making matter. The most frequently given indicator was geared towards:

1. dispersing and setting in motion the disease matter and conveying it outwards through saliva, [secretions from] the tracheal glands, sweat and urine,

2. purifying the blood of disease matters (acridities and impurities) *that never existed,* through the judicious use of drinks made with roots and plants,

3. mechanically drawing off the fictional disease matter through setons, fontanels, through places on the skin kept open and oozing by means of perpetual cantharide plasters or with spurge-laurel bark, and especially,

4. evacuating and purging away the *materia peccans* (or the detrimental materials, as they called them) through the intestinal canal by means of evacuant and purgative medicines which, in order to give them (the infarcts?) a more profound meaning and a more complimentary repute, they called *dissolvents and mild aperients.*

All of these were simply arrangements for the riddance of hostile disease materials which never could be and never were instrumental in engendering and sustaining diseases of the human organism (living as it does, through a spiritual principle) — diseases which never

15 If excretions that occur in disease were the matter that engendered and maintained them then every cold, even the most protracted one, would be unfailingly and rapidly healed merely by carefully blowing and cleansing the nose.

were anything other than the spiritual dynamic mistunement of the organism's life, altered in its feeling and function.

If we take as a premise (a premise which cannot be doubted) that no disease — if it does not result *a.* from swallowing the wrong way [into the windpipe], *b.* from entirely indigestible or otherwise damaging matter getting into the primary body passages [mouth, esophagus, stomach] or other orifices or cavities of the body, or *c.* from foreign bodies having penetrated the skin, etc.— has as its basis any kind of material, rather that each disease only and always is a special, virtual, dynamic mistunement of the condition, then how contrary to purpose a treatment-procedure directed at the exportation[16] of those fictitious materials must appear in the eyes of every intelligent person, since nothing in the principal human diseases (i.e., the

16 The expurgation of worms appears to be necessary in the so-called worm diseases, but this semblance is false. A few maw-worms may be found in several children; some maggots may be found in quite a few others. But the presence of these (as well as an excess of one or the other of this kind of worm) always stems from a general wasting sickness (from psora) paired with an unhealthy lifestyle. If one improves the lifestyle and cures the psoric wasting sickness homeopathically (which is easily done at this age) then none of these worms remain. The children who become healthy in this manner are no longer bothered by them. After mere purgatives, however, even along with cina-seed, the worms soon propagate again in quantity.

"But the tapeworm, this monster created for the torment of humankind," I hear it said, "must surely be expelled with all one's might."

Yes, it is *occasionally* expelled, but with what painful aftermath and danger to life! I would not like to have on my conscience the death of so many hundreds of people who, through the most dreadful, punishing purgatives directed against the tapeworm, have had to forfeit their life, or the long years of wasting away of those who just barely escape the purge-death. And how often does it happen that the worm is not expelled, even after years of health- and life-destroying purgative treatments; or it re-engenders itself!

What if there were not the slightest necessity for all of these violent, sometimes cruel and often life-threatening efforts to expel and kill the worms? The various species of tapeworm are only found along with the

Purgatives versus
homeopathic treatment
for worms

chronic ones) can be won therewith. Rather, there is always enor-
mous damage by such treatments!

In short, the degenerated materials and impurities that become
visible in diseases are, undeniably, nothing more than engendered
products of the disease of the abnormally mistuned organism. These
products are expelled by the organism, often violently enough —
often all too violently — without requiring the aid of the evacuation
art. New products are always engendered by the organism as long as
it is suffering from the disease. These materials present themselves to
the genuine physician as disease symptoms and help him discern the
quality and the image of the disease, in order to be able to cure it
with a similar medicinal disease potence.

16 *continued*

psoric wasting sickness, and disappear whenever that is cured. Even
before the cure is accomplished, however, the worms live — with the per-
son being in tolerably good health — not directly in the bowels but rather,
in the residue of food in the refuse of the bowels, as in their own world,
quite quietly and without bothering one in the least, and find in the
intestinal refuse what they require for their nourishment; there they do
not touch the walls of one's bowels and are harmless. However, if the per-
son in any way becomes acutely ill then the content of the bowel becomes
insufferable to the animal. It writhes, comes in contact with, and irritates
the sensitive walls of the bowels, thus considerably increasing the ail-
ments of the sick person through a special kind of spasmodic colic (just
as the fetus in the womb becomes restless, writhes and kicks only if the
mother is sick, but floats quietly in its water without causing the mother
pain if she is healthy).

It is worth noting that the disease signs of those suffering from tape-
worm are for the most part of a kind that are rapidly allayed (homeopath-
ically) by the smallest dose of tincture of male fern-root [filix mas]. The
aspect of the patient's indisposition that makes this parasitic animal restless
is thereby, for the present, lifted. The tapeworm feels well again and lives
on quietly in the intestinal refuse without particularly molesting the
patient or his bowels. When the antipsoric cure has so far flourished, after
the eradication of the psora, then the worm does not find the intestinal
refuse as suitable nourishment and so forever disappears all by itself from
the belly of the convalescent. This happens without the least purgative.

ALLOPATHIC IMITATIVE AND SUPPRESSIVE TREATMENTS

But the more modern adherents of the old school do not wish to appear as if, in their treatments, they aim at the expurgation of disease matters. They declare that their many and various emptyings are a method of treatment through assisted *drainage* that follows the example of the nature of the sick organism, which strives to help itself with: sweating and urination for fever; nosebleed, sweating and discharge of mucous for pleuralgia; vomiting, diarrhea and rectal bleeding for other diseases; ichorous leg ulcers for joint pains; salivation for throat inflammation, etc. Or, through metastases and abscesses in parts that are remote from the seat of the malady, the nature of the sick organism removes what nature arranges.

Hence, these modern adherents of the old school thought the best thing to do was to *imitate* nature. They went to work in circuitous ways in the treatment of most diseases, as the sick life force does when left to itself. They worked indirectly,[17] arranging (and usually maintaining) evacuations by bringing on stronger, more heterogenic irritations, least related (dissimilar) to the disease formations and in organs remote from the disease site in order, as it were, to *divert* the malady thither.

This drainage, as it is called, was and continues to be one of the main methods of treatment of the hitherto medical school.

In this imitation of self-helping nature (as some call it) they sought to violently rouse new symptoms in formations which were the least diseased and could best bear the medicinal disease. These new symptoms were supposed to draw off[18] the first disease under the

> Drainage and counter-irritant methods of treatment imitate the life force's self-help efforts of evacuation and diversion of symptoms.

17 These adherents of the old school worked indirectly, instead of extinguishing the malady rapidly — without digression or loss of vitality — with homogenic, dynamic, medicinal potences leveled directly at the sick points in the organism itself, as homeopathy does.

18 As if anything non-material could be drawn off! So here too is the notion of material and of disease-matter, however subtle it might be thought to be.

> Unlike these allopathic treatments, homeopathic treatment works directly.

> A material concept underlies the drainage method.

semblance of crisis and under the form of excretions, in order to allow for a gradual lysis by the healing powers of nature.[19]

They carried this out through sweat- and urine-promoting means, through blood-withdrawals, through setons and fontanels, but mostly through purgative irritations of the alimentary canal — partly from above through emetics, partly (and this was their favorite) through evacuations from below. They called these purgative means aperients and dissolvents.[20]

To assist this drainage method, related *antagonistic irritants* [stimulants] were employed:

1. sheep's wool on bare skin,
2. footbaths,
3. nauseants,
4. hunger treatment whereby the stomach and intestines were tormented with the pain of hunger,
5. means that produced inflammation and suppuration in near and distant parts, such as horseradish and mustard poultices, cantharide plasters, spurge-laurel, setons (fontanels), tartar emetic ointment, moxa, cautery, acupuncture, etc.

Here too, they were following the example of crude nature which, left to help itself in diseases seeks to writhe itself free from the dynamic disease through the arousal of pain in distant parts of the body, through metastases and abscesses, through the arousal of

The life force can only reestablish its norm in the wake of moderate acute diseases. It cannot bring about a lysis in severe acute diseases or in chronic diseases.

19 Only the moderate acute diseases are in the habit of neutralizing themselves, so to speak, and quietly concluding when their natural course comes to an end. They do this with or without the application of not-all-too-aggressive allopathic medicines. The self-bracing life force gradually reinstalls its norm in place of the spent [no longer raging] condition-alterations. But raw nature and the old school must back off from the highly acute diseases and (by far the greater part of human diseases) the chronic diseases. Neither the life force through its self-help nor the allopathic imitation of it can bring about a lysis. At most, they can bring about a cease-fire, during which the enemy strengthens itself in order, sooner or later, to break out all the stronger.

The term 'dissolvent' reveals a material concept.

20 This expression likewise betrays that they had in mind and presupposed a dissolvable and removable disease matter.

eruptions and ichorous ulcers [running sores] — all to no avail if the disease is chronic.

It was evidently not intelligible reasons but merely *imitation*, with the view to making practice easy, that misguided the old school into these unhelpful and ruinous indirect treatment methods (both the draining and the antagonistic ones) and that led them to this unhelpful, debilitating, and aggressive practice of apparently ameliorating diseases for a short time, or removing them in such a manner that another and worse disease is awakened to occupy the place of the first. Can one possibly call such corruption curing?

The old school merely followed the operation of crude instinctual nature in its meager strivings[21] to pull through only in moder-

The old school imitated the diseased operations of

21 The ordinary school of medicine regarded as models of treatment worthy of imitation, the self-help efforts made by the nature of the organism in diseases for which no medicine was employed. But *this was a great error.* The lamentable and highly imperfect exertion of the life force to help itself in acute diseases is a spectacle that should summon our active pity and muster all the powers of our intelligent spirit to put an end to this self-torment through genuine curing.

If nature cannot homeopathically cure an already-existing disease in the organism through the employment of another new *similar* disease (§43–§46), an opportunity which is extremely rare (§50), and if the organism is left to itself to overcome a newly arisen disease out of its own powers without outside help (in chronic miasms its resistance is powerless anyway), then we see nothing other than agonizing, often dangerous exertions of the nature of the individual to save itself, cost what it will, ending not seldom with the dissolution of the earthly existence, with death.

As little as we mortals can see into the process in the household of healthy life — which must remain hidden from us creatures just as certainly as this process is exposed to the eye of the all-seeing Creator and Sustainer of his creatures — just as little can we see into the internal process of disturbed life in diseases. The inner process in diseases becomes known to us only through perceptible alterations, ailments and symptoms; this is the only way our life gives utterance to the inner disturbances. For this reason, in each case at hand, we never even come to know which of the disease symptoms are primary actions of the disease

The self-help efforts of the diseased life force are agonizing and often dangerous, showing the observer nothing but suffering.

We can never know which symptoms are the primary actions of the diseased malignity and which are the reactions of the diseased life force.

the life force but the life force, by itself, is not capable of curing disease.

ate attacks of acute disease. They merely mimicked the sustentive power of life when left to itself in diseases which, not being capable of acting according to intellect and deliberation, and resting simply as it does on the organic laws of the body, works only according to

21 *continued*

malignity and which are self-help reactions of the life force. Both the actions and the reactions are inextricably mixed together before our eyes; they present to us an outwardly reflected image of the total internal suffering since the unhelpful exertions of unassisted life are themselves sufferings of the entire organism. Therefore, even in so-called crises (i.e., evacuations which nature usually organizes at the end of rapidly arisen diseases) there is often more suffering than curative help.

What the life force organizes in these so-called crises and *how* it organizes it remains hidden from us, as do all the internal processes of the organic household. One thing, however, is certain: in all these efforts, the life force *sacrifices and destroys more or less of the suffering parts* in order to save the rest.

The self-help efforts of the diseased life force are a sort of allopathy. Its crises in acute disease are destructive and debilitating.

This self-help of the life force for the elimination of an acute disease, going to work only according to the organic arrangement [constitution] of our body and not according to mental deliberation, is mostly only a sort of allopathy. In order, through crises, to free the primary suffering organs, the life force arouses an increased, often stormy activity in the excretory organs to divert the malady of the suffering organs onto the excretory organs; there results vomiting, diarrhea, urination, perspiration, abscesses, etc. in order, through this provocation of remote parts, to achieve a sort of diversion from the originally sick parts, since then the dynamically strained nerve-energy appears to discharge itself, as it were, in the material product.

It is only through the destruction and sacrifice of a part of the organism that the nature of the individual, left unaided, can save itself in acute diseases and, if death does not ensue, reconstitute (though only slowly and imperfectly) the harmony of life — health.

We are given to understand this by the great debilitation of the parts that have been exposed to suffering, indeed the debilitation of the entire body, the emaciation, etc. that remains after self-recoveries.

In short, the entire process of the self-helping organism befallen with diseases shows the observer nothing but suffering, nothing that he could or might imitate if he wishes to proceed in a genuine medically artistic fashion.

these organic laws. They copied crude nature even though, unlike an intelligent physician, crude nature:

1. cannot bring together the gaping lips of a wound and, by their union, effect a cure,
2. does not know how to straighten and adjust the broken ends of a bone which are lying far apart and at an oblique angle, and which are exuding much (often an excess of) new osseous matter,
3. cannot tie off a wounded artery, but in its energy causes the one who is injured to bleed to death,
4. does not understand how to reset a dislocated shoulder, but hinders the art of bone-setting through the swelling that comes quickly around the joint,
5. destroys the entire eye through suppuration in order to remove a splinter stuck in the cornea,
6. with all its exertion, only knows how to liberate a strangulated inguinal hernia through gangrene of the bowels and death,
7. often makes patients far unhappier than they previously were through its metaschematisms in dynamic diseases.

Furthermore, *the life force, lacking intellect, takes up into the body without scruple* the chronic miasms — psora, syphilis, sycosis — which are the greatest tormentors of our earthly existence, the tinders to countless diseases under which tormented humanity has been sighing for centuries and millenia. The life force is not able to lessen a single one of them, let alone remove them from the organism. Rather, it lets them proliferate there until death closes the eyes of the sufferer, often after a long, sad lifetime. In the exercise of such a highly important function as that of the medical pursuit, which demands so much intellect, cogitation and power of judgement, how could the old school (which calls itself rational) choose as its single best teacher, as its blind leader, the intellect-lacking life force, and imitate without misgivings its indirect and revolutionary operations in diseases, imagining these to be the *non plus ultra*, the best conceivable, when that greatest gift of God, the reflective intellect and the unrestrained power of deliberation, was granted to us in order to be able to infinitely exceed the life force in affording help for the well-being of humanity?

> The life force, by itself, is not capable of curing, or even lessening, the chronic miasms.

The old school's indirect
treatments rob vitality
and bodily fluids without
curing disease.

When the old school practitioners (unscrupulously imitating the crude, intellect-lacking automatic life force with their antagonistic and diversionary methods of treatment, which are their routine undertakings) attack innocent parts and organs — either affecting them with overwhelming pain or, more often, compelling them to perform evacuations, whereby vitality and bodily fluids are wasted — their object is to steer the diseased activity of life away from the originally suffering parts and onto the artificially attacked ones, thereby indirectly compelling the natural disease to recede through *the bringing forth of a far greater disease of a different kind*, in the healthier parts. This is a vitality-robbing and mostly painful detour.[22]

If it is acute (and therefore with a course only disposed to short duration anyhow) the disease certainly does vanish, even during these heterogenic attacks on remote and dissimilar parts — but it is not cured. There is nothing that can merit the honorable name of *cure* in this revolutionary treatment which has no straight, immediate pathic relation to the originally suffering formation. Without these critical attacks on the rest of the life, the acute disease would probably have subsided of itself still sooner, and with fewer afterthroes and less sacrifice of vitality. Neither the mode of operation of

Indirect allopathic
treatments are like acts
of war: the land (the
organism) is destroyed
but the enemy remains.

22 Daily experience shows the sad result of this maneuver in chronic diseases, *curing being the least result*. Who would call it a victory if, instead of seizing upon the enemy directly — weapon turned against weapon in order to eradicate him, in order to make an end at once to the hostile incursion — we should, in a cowardly manner and behind his back, pillage, cut off his supplies and consume, scorch and burn down everything for a great way around him? By so doing, we would at length deprive him of all courage to resist, but our purpose would not be achieved. The enemy is by no means destroyed — he is still there, and when he has again procured sustenance and supplies, he will raise his head more embittered still. The enemy, I repeat, is by no means destroyed, but the poor innocent land is so ruined that it can hardly recover for a long time. Allopathy acts in this way in chronic diseases when it runs the organism into the ground through its indirect attacks on innocent parts that are remote from the seat of disease, without curing the disease. These are its uncharitable arts!

the crude power of nature, nor the allopathic copy of it, can for a moment be compared to direct, dynamic (homeopathic) treatment, which sustains vitality, while it directly and rapidly extinguishes the disease.

In cases of chronic disease (by far the greatest number of disease cases) these stormy, debilitating, indirect treatments of the old school almost never accomplish the least good. They suspend for just a few days this or that troublesome disease manifestation, which returns when nature gets used to the remote irritation. The disease then comes back worse than before because the life forces have been brought to foundering due to the antagonistic pains[23] and inexpedient evacuations.

While most physicians of the old school carried out such allegedly useful drainages in their practice, at their discretion, guided in their thoughts by some vague indicator (*imitating in a general way the self-help efforts of crude nature left on its own*) others, pursuing a still higher goal, *undertook to intentionally further the efforts (just showing themselves in diseases) of the life force helping itself through evacuations and antagonistic metastases.* In order to lend it a helping hand, as it were, these physicians amplified these diversions and evacuations. With this detrimental method, they believed themselves to be practicing according to the dictum *duce natura* [guide according to nature] and they believed they could honor themselves with the title *ministri naturae* [helpers of nature].

Since, in protracted diseases, evacuations organized by the nature of the patient announce themselves not infrequently as reliefs —

The old school of medicine misinterpreted the efforts of the life force in disease, both its evacuations and its production of local symptoms.

23 What favorable result has ever ensued from the fetid, artificially maintained ulcers called fontanels? Even if, by antagonism, they seem to somewhat check a chronic malady in the first couple of weeks (as long as they still cause a lot of pain), afterwards, when the organism has gotten used to the pain, they have *no* other result than that of debilitating the patient and procuring still greater scope for the chronic wasting sickness. Or does anyone perchance still imagine himself, in this nineteenth century, to be holding open a tap-hole as an outlet for the *materia peccans?* It almost seems so!

Fontanels debilitate the patient and increase the scope of the chronic disease.

though only brief ones — of troublesome states (terrible pains, paralyses, cramps, etc.), the old school considered these evacuations as the true way to cure diseases when it furthered, maintained or even increased such evacuations. However, the old school did not realize that all those discharges and eliminations (apparent crises) organized by nature left to itself were, in chronic diseases, only palliative short-lasting alleviations which, far from contributing to a true cure, on the contrary, only aggravate the original internal wasting sickness by the squandering of vitality and bodily fluids. No one ever saw any chronically sick patient restored to lasting health through such efforts of crude nature, nor any chronic disease cured through such evacuations accomplished by the organism.[24] Rather, it is obvious that the original wasting sickness continually aggravates itself. After ever shorter and shorter periods of relief, the bad attacks recur more frequently and more severely, in spite of the continuation of the evacuations.

Nature, when left to itself with life-threatening endangerments from an internal chronic malady, also does not know how to help itself other than by bringing forth outer local symptoms to divert the danger from the indispensable parts of life and guide the danger onto those formations dispensable for life (metastases).

However, these arrangements of the energic, intellect-lacking life force, which is incapable of deliberation and foresight, lead to anything but true help or curing. They are merely palliative, short appeasements for the dangerous, internal suffering; they dissipate a great portion of the bodily fluids and vitality without reducing the arch-malady by so much as a hair. Without genuine homeopathic curing, these arrangements of the life force can, at most, delay the inevitable downfall.

The allopathy of the old school not only overestimated by far these exertions of the crude automatic nature-power; it misinterpreted them entirely. It falsely held them to be genuinely salutary and therefore sought to increase and to further them, under the

24 And just as little through the artificially arranged ones.

delusion thereby of being able, perhaps, to destroy and to thoroughly cure the entire malady.

When, in chronic diseases, the life force seemed to soothe this or that troublesome symptom of the internal condition, for example, by means of an oozing skin eruption, a servant of the crude nature-power *(minister naturae)* applied a cantharide-plaster or an exutorium (spurge laurel) to the ensuing ichorous surface in order, *duce natura,* to draw still more moisture from the skin and so to further and to support nature's purpose, namely the cure (by removal of disease matter from the body?).

If the impinging action of the treatment were too violent, the oozing herpes already long-established and the body too irritable, then the treatment would considerably magnify the outer suffering (which is useless for the arch-malady) and the treatment would increase the pains, robbing the patient of sleep and lowering his vitality. The treatment would probably also lead to a virulent erysipelas.

If the effect of the treatment were milder and the local malady perhaps still recent, then the treatment would expel the local symptom (effectuated by nature on the skin for the relief of the inner suffering) from its site by means of a sort of misapplied external homeopathism. This expulsion of the local symptom would renew the inner, more dangerous malady and seduce the life force into the preparation of a worse metaschematism onto other more noble parts. Patients would get dangerous eye-inflammations, deafness, stomach-cramps, epileptic convulsions, asthmatic or apoplectic attacks, mental or emotional diseases, etc.[25]

When the diseased nature-power thrust blood into the veins of the rectum or anus (blind hemorrhoids) the *minister naturae* [helper of nature] under the same delusion of wanting to support the life force in its strivings to cure, applied leeches, often in large numbers, in

Specific imitative treatments of the old school:

Use of irritating plasters to imitate natural discharges

Use of leeches to imitate hemorrhoids

25 These new symptoms are natural consequences of the expulsion of such local symptoms — consequences which the allopathic physician declares to be entirely other, newly arisen diseases.

New symptoms appear due to local symptom removal.

order to provide an outlet for the blood — with but brief, often hardly noteworthy alleviation, but thereby weakening the body and occasioning still stronger congestions towards these parts, without the slightest diminution of the arch-malady.

In almost all cases in which the diseased life force sought to appease a dangerous, internal affliction by evacuating blood through vomiting, coughing, etc., the old school physician, *duce natura*, endeavoured to further these supposedly salutary strivings of nature and let large quantities of blood from the vein, never without disadvantage as a consequence, and with obvious weakening of the body.

In cases of frequently occurring chronic nausea, the old school physician, with the view of furthering the intentions of nature, aroused strong evacuations of the stomach and vigorously administered emetics. This was never with good result, and often with bad, not-infrequently dangerous and even fatal consequences.

Occasionally the life force arouses cold swellings of the outer glands in order to relieve the inner wasting sickness. The old school physician, as the alleged servant of nature, believes he is forwarding the intentions of nature when he uses all kinds of heating embrocations and plasters to inflame the swellings so that when the abscess is ripe he may incise it and let out the evil disease matter (?). However, experience teaches in a hundred different ways, almost without exception, what protracted mischief is caused thereby.

Since the old school physician often noticed that small alleviations of great maladies in protracted diseases resulted from spontaeously arising night sweats or from many liquid stools, he thus imagined himself called upon to follow these hints of nature *(duce natura)* and to further them by arranging and maintaining a complete course of sweating treatments or so-called gentle expurgations continued for years on end, in order to further and increase, in his opinion, these leading efforts of nature (of the intellect-lacking organism's life force) for the cure of the entire chronic suffering, and so to free the patient, all the sooner and more certainly, from his disease (the disease matter?). But he thereby continually produces only the opposite result: aggravation of the original suffering.

In conformity with this preconceived but unfounded opinion, the old school physician goes on thus aiding[26] the drives of the diseased life force and increasing the drainages and evacuations of the patient which *never* lead to a successful end, but *always* lead only to ruin. The old school physician does this without becoming alive to the fact that all the local maladies, evacuations and apparent drainage efforts, organized and maintained for the appeasement of the original chronic suffering by the intellect-lacking life force left to itself, are just the disease itself, the signs of the whole disease, against which, taking them all in all, a homeopathic medicine cho-

26 In contradiction to this procedure, adherents of the old school not-infrequently allowed themselves the very opposite of this, namely, suppression of the efforts of the life force to appease the internal wasting disease. When appeasement efforts of the life force (through evacuations and through local symptoms organized on the outer parts of the body) became troublesome, old school physicians suppressed these efforts through *repercutientia* [reflectants] and *repellentia* [repellants]. They suppressed:

1. chronic pains, insomnias and old diarrheas with daringly intensified doses of opium,
2. vomitings with effervescing salt mixtures,
3. stinking foot sweats with cold footbaths and astringent compresses,
4. skin eruptions with lead and zinc preparations,
5. uterine hemorrhages with vinegar injections,
6. colliquative sweats with alum whey,
7. nightly seminal emissions with a great deal of camphor,
8. frequent heat flushes of the body and face with saltpeter, vegetable and sulphuric acids,
9. nosebleeds by tamponing of the nostrils with plugs dipped in alcohol or astringent fluids,
10. the ichorous discharge from leg ulcers with lead and zinc oxides, etc.

These symptoms were organized by the life force to allay the great internal sufferings. The sad consequences of suppressing them are shown in thousands of cases. With tongue and pen, the old school physician boasts of being a rational physician who seeks out the basis of disease in order to always cure thoroughly. But look, in these cases, his treatment is directed against a single symptom only — always to the detriment of the patient.

Suppressive treatments of the old school

sen according to similar action would have been the only helpful
means of cure and, to be sure, the shortest way.

Nature's imperfect efforts
are better than the
medical treatments that
imitate and further them.

What crude nature does to help itself in diseases (in acute as well
as chronic ones) is highly imperfect and is, in fact, the *disease itself.*
Therefore, it is easy to estimate that the artificial furtherance of
this imperfection and disease could damage still more. At the least,
it cannot improve on the help of nature even in acute maladies,
since the medicinal art has not been in a position to enter into the
hidden ways by which the life force organizes its crises. The medi-
cinal art only undertakes to produce crises through aggressive
means from outside. These are less beneficent than what the
instinctual life force, left to itself, does in its way. In fact, they are
more disturbing and rob more vitality. The even quite imperfect
alleviation that nature produces through its drainages and crises
cannot be achieved by allopathy in a similar manner. It remains
still far behind the miserable help which the life force, left to itself,
is able to furnish.

Nosebleeds to alleviate
headaches

One has sought to elicit nosebleeds, imitating natural ones, using
lacerating instruments to alleviate the attacks of a chronic headache,
for example. In this way, one could doubtless make a large quantity
of blood run out of the nasal passages, which would weaken the
person, but the alleviation therefrom would either be nil or far less
than if, at another time, the instinctual life force, out of its own
drive, let even just a few drops flow out.

Sweating or diarrhea for
sudden illness

A so-called critical sweat or diarrhea from the continually active
life force after suddenly getting sick — occasioned by vexation,
fright, lifting strains or catching cold — will be far more successful
in dispatching the acute suffering, at least for the time, than all the
sweating and purging medicines from the pharmacy which only
make one sicker, as daily experience teaches.

The life force was
ordained to conduct life in
the most perfect way
during health, not to cure
disease.

But the life force (suitable only for working in accordance with
the bodily organization [constitution] of our organism, and not
suitable for acting in accordance with intellect, cogitation and delib-
eration) was not granted to us humans:

1. for the purpose of assuming it to be the best possible healer of
disease,

2. for the purpose of leading those sorry deviations from health
 back to their normal relationship, and still less

3. for physicians to slavishly imitate the life force's imperfect, dis-
 eased efforts to rescue itself from diseases, using indisputably still
 more inappropriate and more aggressive arrangements than the
 life force itself is capable of, thereby *a.* conveniently sparing
 themselves the necessary expenditure of intellect, cogitation and
 deliberation for devising and executing the noblest of all human
 arts, the true medical art, and *b.* passing off a bad copy of that
 little beneficent self-help of the crude nature-power as medical
 art, as *rational medical art!*

What intelligent human being would want to imitate the life
force in its strivings to rescue itself? These efforts are simply the
disease itself, and the disease-affected life force is the engenderer of
the self-manifesting disease! It must, therefore, necessarily follow
that any artificial imitation or suppression of these efforts must
either increase the malady or, through suppression, render it dan-
gerous. Allopathy does both. Those are its injurious practices which
it passes off as medical art, as rational medical art!

No! The life force, that glorious power innate in the human
being, was ordained to conduct life in the most perfect way *during
its health.* The life force, which is equally present in all parts of the
organism (in the sensible as well as the irritable fiber) is the untir-
ing mainspring of all normal natural bodily functions. It was not at
all created for the purpose of helping itself in diseases nor for exer-
cising a medical art worthy of imitation.

No!

1. *True medical art is that cogitative pursuit which devolves upon the
 higher human spirit, free deliberation, and the selecting intellect
 which decides according to well-founded reasons.*

2. *It does so in order to differently tune the instinctual (intellect- and
 awareness-lacking), automatic and energic life force when the life
 force has been mistuned, through disease, to abnormal activity.*

3. *It differently tunes the life force by means of an affection similar to
 that of the disease, engendered by a medicine that has been homeo-
 pathically selected.*

The process by which the
homeopathic medical art
cures disease

4. *By means of this medicine, the life force is rendered medicinally sick to such a degree (in fact to a somewhat higher degree) that the natural affection can no longer work on the life force.*

5. *In this way, the life force becomes rid of the natural disease, remaining occupied solely with the so similar, somewhat stronger medicinal disease-affection against which the life force now directs its whole energy and which it soon overcomes.*

6. *The life force thereby becomes free and able again to return to the norm of health and to its actual intended purpose: that of enlivening and sustaining the healthy organism.*

7. *It can do this without having suffered painful or debilitating attacks by this transformation.*

The homeopathic medical art teaches how to produce this.

Effects of the old school's imitative and suppressive treatments on chronic and acute diseases

With the methods of treatment of the old school I have just detailed, no small number of patients did indeed escape from their diseases, however, not from the chronic (non-venereal) ones, only from the acute ones that were not very dangerous, and only by way of troublesome detours, and often so imperfectly that the treatments could not be called cures executed by a mild art. These innocuous acute diseases were *a.* held down by means of blood withdrawals, *b.* held down by the suppression of one of the chief symptoms through an enantiopathic palliative means *(contraria contrariis)*, or *c.* suspended by means of counter-irritating and draining (antagonistic and revulsive) means at sites other than the sick ones, until the time when the natural course of the short malady was over. These methods were indirect and robbed the patient of vitality and bodily fluids to such an extent that it was left to the individual nature of the patient [the life force] to do the most and best for the complete dispatch of the disease and the restoration of the lost vitality and bodily fluids — it was left to the sustentive power of life to *a.* dispatch the natural acute malady and *b.* conquer the consequences of the inexpedient treatment so that, by its own energy, the sustentive power of life could resume, in innocuous cases, the normal relationship of the functions. However, this was often accomplished laboriously, imperfectly and under many an ailment.

It remains very doubtful whether the recovery process of nature is really foreshortened or alleviated even a bit through this intervention of the hitherto medicinal art in diseases, in that the latter [the hitherto medicinal art] could not go to work in any other way than indirectly just like the former (the life force) but its drainage and antagonistic procedure is far more aggressive and robs far more vitality.

ANTIPATHIC STIMULATING AND STRENGTHENING TREATMENTS

The old school has yet another treatment procedure, which is termed the *stimulating* [arousing] and *strengthening* treatment method[27] (through *excitantia, nervina, tonica, confortantia,* and *roborantia* [excitants, nervines, tonics, comforts and strengtheners]. It is a wonder how it can boast of this method.

Alcohol, cinchona or iron preparations for debilitation

Through the prescription of etheric Rhine wine or fiery Tokay wine, has the old school ever been able to lift the bodily debilitation that is so frequently engendered and maintained (or increased) by a chronic wasting sickness, as it has tried to do countless times? Gradually, the vitality only sinks all-the-more deeply because the engenderer of the debilitation (the chronic disease) could not be cured by wine. The more wine the patient has been talked into taking, the lower the vitality will sink because the life force, in the after-action, opposes artificial excitations with ennervation. Did cinchona, or its misunderstood, ambiguous and variously damaging *amara* [bitters], give vitality in these so frequent cases of bodily debilitation? Did not these vegetable substances (claimed to be tonic and strengthening under all circumstances) as well as iron preparations, out of their peculiar morbific actions, often add still new sufferings to the old ones without being able to dispatch the debilitation that rests upon an old, unknown disease?

27 This stimulating and strengthening treatment procedure is, in actuality, enantiopathic and I will make mention of it in the text of the *Organon* (§59).

Nerve ointments or electric shock for incipient paralysis

Through the use of so-called *unguenta nervina* [nerve ointments] or other spirituous, balsamic embrocations, has one ever (even by the tiniest bit) been able to diminish in the long run, the incipient paralysis of an arm or leg that so often springs from a chronic wasting sickness, without curing the wasting sickness itself? Or in these cases, have electric or voltaic shocks ever had any consequence[28] other than a gradual increase of paralysis, indeed a complete paralysis and deadening of all muscle arousability and nerve irritablity in such limbs?

Excitants or aphrodisiacs for impotence

Did not the praised *excitantia* and *aphrodisiaca* (e.g., ambergris, sea smelt, cantharide tincture, truffles, cardamon, cinnamon, vanilla) always reduce to complete impotence the gradually weakened sexual capacity (in connection with which an unnoticed chronic miasm always lies at the base)?

Antipathic action of excitant and strengthening means

How can one boast of an excitation and strengthening that lasts but a few hours, when the result that follows is its permanent opposite, the incurability of the malady — according to the laws of the nature of all palliatives?

The little good that the *excitantia* and *roborantia* brought forth during recovery from acute diseases (treated in the old way) has been outweighed a thousand-fold by their disadvantage in chronic maladies.

ALTERATIVE TREATMENTS OF THE OLD SCHOOL

When the old school of medicine is not aware of what to do with a protracted disease, it treats it blindly with so-called *altering means (alterantia)*.

When they are used allopathically and in large

Its terrible chief means of alterative treatment are the *mercurialia* (calomel, corrosive sublimate and mercury ointment) which the old

Electric shock for hardness of hearing

28 The hard of hearing improved for a few hours with moderate shocks from the voltaic pile of the apothecary of Jever, but soon these did nothing more. He had to increase the voltage in order to have the same effect until these shocks also helped no more. The very strongest would then at first excite the patients' hearing for a short time, but finally left them stone deaf.

school allows to work in a ruinous way on the sick body (in non-venereal diseases!) often in so great a measure and for so long that finally the entire health is undermined. The old medical practice does indeed engender such great alterations, but invariably ones which are not good, and it continually completely ruins the health with this extremely ruinous metal, given out of place.

When old school practitioners prescribe, in large doses, *cinchona* (which is only homeopathic for those fevers which are true marsh intermittent fevers, if psora does not hinder) for all epidemic intermittent fevers spreading over large geographical areas, these practitioners palpably manifest their rashness. These diseases occur in a different character almost every year and therefore, they almost always demand a different homeopathic medicine for relief, by which they then are always cured in a few days by means of one or a few very small doses.

Since these epidemic fevers also have periodic attacks *(typus),* and since the adherents of the old school see nothing else in all intermittent fevers but their periodic attacks (neither knowing nor caring to know any other remedy for fever than cinchona), these adherents of the old school imagine that if they can simply suppress the *typus* of these epidemic intermittent fevers with heaped doses of cinchona or its expensive extract, quinine (an event which the unintelligent but, in this instance, shrewder life force endeavours to prevent, often for months), then they will have *cured* them. However, the deceived patient, after such a suppression of the periodicity *(typus)* of his fever, becomes *continually* more miserable than he was during the fever itself. The patient — pallid, narrow chested, the hypochondrium constricted as if laced together, with ruined entrails, without healthy appetite, without tranquil sleep, dull and despondent, often with taut swelling of the legs, of the belly, even of the face and the hands — steals out of the hospital, *released as cured.* It usually takes years of laborious homeopathic treatment just to rescue such a profoundly ruined (cured?), artificially cachectic patient from death, let alone to cure him and make him healthy.

The old school is glad to be able to transform, for a few hours, the sluggish senselessness in nerve fevers into a sort of briskness

doses, mercury-based medicines completely ruin the health.

When they are used allopathically and in large doses, cinchona and quinine suppress intermittent fevers but make patients sicker.

Valerian acts antipathically in nerve fevers, first

producing liveliness and
then increasing the
patient's stupor.

through *valerian,* here used antipathically. But since this does not
last, a short invigoration must be extorted through always greater
doses of valerian. It soon comes to pass (in the after-action) that
even the greatest doses do not enliven in the least. Valerian is a pal-
liative that only excites in the initial action, but it ends up laming
the entire life force. Such a patient is certain of a speedy demise
through this *rational treatment procedure* of the old school; no one
can escape. And yet the adherents of this routine art do not see how
certainly they kill their patients with this procedure. Instead, they
ascribe the death to the virulence of the disease.

Digitalis acts antipathically
in cases of chronic disease
with an overly-rapid
pulse, first producing a
slower pulse and then
increasing it.

A still more frightful palliative for chronic patients is digitalis
purpurea, which the hitherto medical school so glories in when it
attempts to forcibly slow down the overly rapid, irritable pulse in
chronic diseases (which is genuinely symptomatic!). This monstrous
means, here employed enantiopathically, strikingly slows the rapid
irritable pulse and decreases the arterial beats *for several hours after
the first dose,* but the pulse soon becomes more accelerated. The
dose is raised in order to make the pulse somewhat slower again, but
it is slowed only for a short time until this dose and also even much
higher palliative doses cease to reduce the pulse at all. The pulse,
which is no longer to be held off, finally becomes far faster (in the
after-action of the foxglove) than it was before the use of this herb;
it now becomes *uncountable,* amid the disappearance of all sleep,
appetite, and vitality. The patient is a sure cadaver — slaughtered.
None of these patients escapes death, except those that end up incur-
ably insane.[29]

This is how the allopath treated disease. Patients *had to* submit to
this sad necessity since they could obtain no better help from the
other allopaths, who had been taught from the same deceptive books.

Hufeland's praise for
digitalis

29 Yet Hufeland (see *Die Homöopathie* [Homeopathy], p. 22), the director
of the old school, extols digitalis for this purpose, priding himself greatly
thereby, with the words: "Nobody will deny (only constant experience
does so!), that a too-vigorous circulation can be *lifted* (?) by means of digi-
talis." Permanently? Lifted? Through a heroic enantiopathic means? Poor
Hufeland!

FLAWS IN THE OLD SCHOOL'S APPROACH
TO CURING DISEASE

The fundamental cause of chronic (non-venereal) diseases, together with the remedies for them, remained unknown to these vainly boastful practitioners with their causal treatments and their research into the *genesis* in their diagnosis.[30] Therefore, how could they hope to lift the monstrous majority of protracted diseases with their indirect treatments, which were only ruinous imitations of the intellect-lacking life force's self-help, not ordained as a model for cure.

They held the supposed character of the malady to be the cause of disease, and therefore directed their alleged causal treatments against cramp, inflammation (plethora), fever, general and partial debilitation, mucus, sepsis, infarcts, etc., which they imagined themselves to be clearing away through their antispasmodic, antiphlogistic, strengthening, stimulating [arousing], antiseptic, dissolving, dispersing, draining, evacuating, antagonistic means (which were only superficially known to them).

But from such general indicators, helpful medicines do not allow themselves to be found, most assuredly not in the materia medica of the hitherto old school which, as I have shown elsewhere,[31] mostly rests upon supposition and false conclusions *ab usu in morbis* [regarding its use in diseases] mixed with lies and deceit.

And just as daringly they took the field against the still more hypothetical so-called indicators — against a defect or excess of oxygen, nitrogen, carbon or hydrogen in the bodily fluids, against an

30 Hufeland, in his pamphlet *Die Homöopathie* [Homeopathy] (p. 20), makes a futile attempt to appropriate this for his old non-art. But since — until the appearance of my book, *The Chronic Diseases* — the 2500-year-old allopathy (as is well known) was unaware of the source of most chronic diseases (psora), was it not obliged to ascribe a false source to the protracted maladies?

31 See "Sources of the Hitherto Materia Medica," before the third part of my *Materia Medica Pura* [entitled "Examination of the Sources of the Common Materia Medica" in the English translation of the *Materia Medica Pura*].

Hufeland's claims regarding the genesis of disease

increase or decrease of the irritability, sensibility, reproduction, arteriality, venosity, capillarity, asthenia etc. — without knowing any helpful means for the attainment of such fantastic purposes. All this was ostentation. These were treatments, but not for the welfare of the patient.

COMPOUND PRESCRIPTIONS

The making of a compound prescription

All semblance of purposeful treatment of diseases disappeared altogether, however, with a practice that was introduced from the oldest times *and was even put into law:* the mixture into *prescriptions* of medicinal substances which were (almost without exception) unknown in their true action and (continually and entirely without exception) divergent from one another.

1. One medicine (the extent of whose medicinal actions was not known) was placed foremost as the principal means (basis) to conquer what the physician assumed to be the chief character of the disease.

2. Another medicine (likewise unknown as to the extent of its medicinal powers) was added for the dispatch of this or that accessory indicator, or as a strengthening means *(adjuvantia).*

3. To this was added an alleged improvement means *(corrigens),* likewise unknown as to the extent of their medicinal powers.

4. These were all *mixed* together (decocted, extracted).

5. Medicinal syrup or distilled medicinal water brought still more medicinal properties into the formula.

It was imagined that each ingredient of this mixture would carry the functions assigned to it (in the thoughts of the prescriber) into effect in the sick body without letting itself be disturbed or led astray by the other additives which, of course, is not at all to be expected.

Effect of compound prescriptions on the health of the patient

In these prescriptions, one ingredient offset the action of another, either entirely or in part, and gave to it or to the others a functional quality and operational direction that was neither suspected nor supposed, so that the expected effect could *not possibly* be reached.

What resulted was not, nor could have been, expected from the inexplicable riddle of mixture: a *new disease mistunement* which was *often* unnoticeable in the tumult of the disease symptoms.

If the prescription was used repeatedly over a long period of time, this new disease mistunement became permanent. Therefore, an added artificial disease (an aggravation of the original disease) compounded itself with and complicated the original disease. If the prescription was not repeated often (rather the first prescription was superseded by one or more new prescriptions, composed of other ingredients, and these were given in rapid succession) then the *very least* that would happen was *an increased sinking of the vitality* because substances prescribed in this way have little or no direct pathic relation to the suffering, nor should they have. On the contrary, they only attack, in a useless and damaging way, the points that are the least stricken by the disease.

The mixture of various medicines, even if the actions of each individual medicine on the human body were exactly known (the prescriber, however, often does not know the thousandth part of their actions), the mixing together into a single formula of several such ingredients (many of which are themselves already manifoldly compounded and whose exact single action is as good as unknown but which always differs fundamentally from that of the others) to be taken by the patient in large doses, often repeatedly — for the prescriber to expect to achieve any one certain intended curative action by the administration of this incomprehensible medley is an imprudence which fills each thinking, unprejudiced person[32] with indignation.

32 Even men of the ordinary school of medicine have realized how nonsensical medicinal mixtures are, although they have continued to practice this eternal routine in just the same way against their own insight. Marcus Herz (in Hufeland's journal, vol. II, p. 33) expresses the stirring of his conscience in the following words:

> If we wish to lift the inflammation state, we make use of neither saltpeter, nor ammoniac, nor plant acid alone; rather we ordinarily mix

Writings against the use of compound prescriptions

The result naturally contradicts any definite expectation. Alterations and results do indeed arise, but no expedient ones, no good

32 *continued*

together several and frequently all-too-many so-called antiphlogistic means, or we let them be used simultaneously. If we have to offer resistance to putrefaction, it is not sufficient for us to expect our final purpose to be gained from one of the known antiseptic medicines, given alone in great quantity (e.g., cinchona bark, mineral acids, arnica, serpentina, etc.) rather, we put several of the same together and rely on the commonality of their action, or indeed throw many things together with each other out of ignorance as to which action is the most appropriate in the existing case, and leave it as though to chance, letting one of them bring forth the intended change.

Thus we seldom arouse perspiration, improve the blood (?), dissolve stagnancies (?), further discharge or empty even the primary body passages through single means; our prescriptions are always compounded towards this final purpose, almost never simple and pure. Consequently, experiences with respect to the actions of their single, contained materials are never under consideration. Indeed, we institute a sort of academically proper hierarchy among the means in our formulas and name one the *basis*, to which we actually consign the action, and the others, *helpers, supporters* (adjuvantia), *improvers* (corrigentia), etc. But mere arbitrariness obviously lies at the base of this characterization. The *helpers* and *supporters* have just as much a share in the entire action as the *chief means* although, due to the lack of a standard of measurement, we cannot determine the degree of the same. In like manner the influence of the *improvers* cannot be entirely indifferent upon the powers of the rest of the means; they must heighten them, tone them down, or give them a different direction. Therefore, we must always regard the salutary (?) alteration which we produce through such a formula as the result of its entire combined contents, and *we can never win therefrom a pure experience of the exclusive efficacy of a single item of the formula. In fact, however, our insight into that, upon which our essential knowlege of all the means rests (as well as the knowledge of the myriad relationships they can enter into with one another through their mixture) is much too fragile. Therefore we cannot declare with certainty how great and diverse the activity of the material (which by itself seems so insignificant) can be when it is brought into the human body joined with other materials.*

ones — only damaging, ruinous ones! I would like to see the person who wants to call such blind working of one's way into the sick human body *curing*.

FROM ALLOPATHY TO HOMEOPATHY

Cure can only be expected when the patient's remaining supply of life principle is tuned to the right activity [function] through the appropriate medicine, not from an artful enervation of the body, driven to the point of death. Yet the adherents of the old school are aware of nothing better to do with patients that have protracted diseases than to work their way into the sufferers with torturing, life-shortening means, wasting vitality and bodily fluids. Can they save while they ruin? Does the old school deserve any other name than that of a *calamitous art*? It acts *lege artis* [according to the law of the art] as inappropriately as possible and it does (apparently almost *on purpose*) αλλοια [other things]* that is, it does the opposite of that which it should do. Can it be praised? Can it be tolerated any further?

In more recent times, the adherents of the old school have altogether surpassed themselves in their cruelty against their sick fellow human beings and in the inexpediency of their practices — as each unprejudiced observer must admit and as even physicians of their own school, upon the awakening of their conscience (like Krüger-Hansen), have had to confess to the world. It was high time that the wise and benevolent Creator and Sustainer of humanity put a stop to these atrocities, bid these tortures cease, and brought a medical art to the light of day which is the opposite of all this, which:

1. does not squander the life fluids and vitality through emetics, years' long intestinal sweepings, warm baths and means that cause perspiration or salivation, or through the spilling of the life's blood,

Margin notes:

Old school physicians do the opposite of what they should do.

The recent increased cruelty of allopathic treatments set the stage for the homeopathic art of cure.

* The Greek word αλλοια [*alloia*], meaning 'other' or 'different,' is the root of the word allopathy.

2. does not torment and debilitate through painkillers,

3. does not (instead of curing those who suffer from diseases) foist new chronic medicinal diseases upon patients to the point of incurability by means of the protracted obtrusive use of false medicines of an aggressive sort, whose action is unknown to the prescribers,

4. does not put the cart before the horse by using violent palliatives according to the old popular axiom: *contraria contrariis curentur* [let opposites be cured by opposites],

5. does not, in short, lead patients onto the path to death instead of onto the path to help, as is done by practitioners of the merciless routine.

which, on the contrary, spares the patient's vitality as much as possible and, in the most gentle way, brings patients — unencumbered, directly and permanently — to cure and health by means of a few, well-pondered, simple medicines, in the finest doses, selected according to their proven actions, according to the only curative law in conformity with nature: *similia similibus curentur* [let similars be cured by similars]. It was high time that He allowed homeopathy to be found. Through observation, cogitation and experience I found that, contrary to the old allopathy, the true, correct, best cure is to be found in the maxim: *In order to cure gently, rapidly, certainly and permanently in each case of disease, choose a medicine which can, of itself, arouse a similar suffering* (ομοιοσ παθοσ *) *to the one it is supposed to cure!*

TRACES OF HOMEOPATHY FOUND IN
PREVIOUS PRACTICES

All real cures by the old school involved medicines that were homeopathic to the disease.

Up until now, no one *taught* this homeopathic way of cure; no one *carried it out.* If, however, the truth lies solely in this procedure (as my readers will discover) then it is to be expected that, even if it

* The word homeopathy is derived from the Greek words ομοιοσ παθοσ [*homoios pathos*], meaning similar suffering.

were not *acknowledged* for thousands of years, actual traces of it would nevertheless be discoverable in all ages.[33]

And so it is. In all ages, the patients *who were effectively, rapidly, permanently and visibly cured by a medicine* — and who did not *a.* recover by some fortuitous event, *b.* recover because the acute disease ran its course, or *c.* finally recover by a gradual preponderance, over time, of the bodily powers during [in spite of] allopathic and antagonistic treatments (for the direct cure differs very greatly from recovering in an indirect way) — such patients have been cured (although without the cognizance of the physician) solely through a homeopathic medication, that is, a medication that had the power, of itself, to generate a similar disease state.

Even in *real* cures with various compounded medicines, which were extremely rare, one finds that the predominant means was always of a homeopathic sort. But this is much more strikingly persuasive in cases in which physicians sometimes rapidly brought a cure to pass with one simple medicinal substance (contrary to the usual custom that admitted of none but mixtures of medicines in the form of prescriptions). Surprisingly, we see that this always occurred by means of a medicine which is fit to engender, *by itself,* a suffering similar to that contained in the case of disease. These physicians were not immediately aware of what they were doing; they acted in an attack of forgetfulness of the contrary doctrines of their school. They prescribed a medicine which was just the opposite of what they should have used according to the conventional therapy, and *only* in this way were the patients rapidly cured.[34]

33 For truth is of the same eternal origin with the all-wise, benevolent Deity. Humanity can leave it long unnoticed until the time ordained by Providence when its ray shall irresistibly break through the mist of prejudices as rosy dawn at the break of day, in order to brightly and inextinguishably light humankind to its welfare.

 Truth originates with God.

34 Examples of this can be found in previous editions of the *Organon of the Medical Art.* [These examples, omitted by Hahnemann from the fifth and sixth editions of the *Organon,* appear in the Appendix to the combined fifth and sixth editions of the *Organon,* edited by K.N. Mathur (New Delhi: B. Jain, 1970).]

If we discount the cases in which the *empirical practice of common folk* (rather than the invention-art of physicians) furnished ordinary physicians with the specific means for the direct cure of an unvarying disease (for example, mercury for venereal chancre disease [syphilis], arnica for contusion disease, cinchona for intermittent marsh fever, sulphur powder for freshly arisen itch diathesis, etc.) then we find that all the remaining treatments for protracted diseases by old school physicians with their superior airs are, almost without exception, debilities, agonies and torments leading only to the aggravation and ruin of the already suffering patients along with ruinous expense for their families.

While blind experience occasionally led them to a homeopathic treatment of disease, they did not intuit the natural law according to which these cures resulted and must result.[35]

Homeopathic treatments used by the old school: Elder blossom tea for fever with sweating

35 [There are several examples of cures that were blindly executed by adherents of the old school.]

1. They believed they were driving out allegedly stagnant cutaneous perspiration through the skin after a chill when, during the cold phase of a catarrhal fever, they had the patient drink an elder blossom infusion, which can lift such a fever through a peculiar similarity of action (homeopathically) and restore the patient most rapidly and in the best possible manner, without sweat, when he takes just a little of this drink and nothing else.

Warm poultices for inflammation

2. They apply very warm, frequently renewed, poultices to hard acute swellings whose over-violent inflammation, amid intolerable pains, hinders their transition to suppuration, and behold! The pains decrease rapidly of themselves with speedy formation of the abscess (of which they become aware by the yellowish gleaming prominence and palpable softness). They imagine that they have softened the hardness through the *wetness* of the poultice but, in fact, they have homeopathically stilled the excess of inflammation through the stronger *warmth* of the poultice, thus making possible the speediest formation of pus.

Red oxide of mercury for eye inflammations

3. Why do they employ with benefit in many eye inflammations, St. Yve's ointment, the chief ingredient of which is red oxide of mercury, which can inflame the eyes if anything can? Is it difficult to realize that they are proceeding homeopathically here?

It is therefore extremely important for the welfare of humanity to examine how these curative treatments, as rare as they are excellent, actually take place. The elucidation which we meet with here is of the highest significance. These cures never resulted in any way other than through medicines of homeopathic power, that is, through medicines with a similar disease-arousing power to the disease state to be cured. They resulted rapidly and permanently through medicines whose prescribers were often unaware of what they did or why

4. Why should a little parsley juice so evidently help *a.* that not-infrequently futile, anxious urge to urinate in small children, as well as *b.* the common gonorrhea, which is especially discernible through a very painful, frequent and almost futile urge to urinate, if this fresh juice could not on its own surely bring to pass (and thus help homeopathically) a painful, almost futile urge to urinate in healthy people. **Parsley juice for a painful urge to urinate**

5. They happily challenged the so-called mucous quinsy with pimpernel root which arouses a great deal of mucous secretion in the air passages and throat. **Pimpernel root for mucous quinsy**

6. They quelled some uterine hemorrhages with something from sabina leaves, which brings forth uterine hemorrhage on its own. They did this without discerning the homeopathic law of cure. **Sabina leaves for uterine hemorrhage**

7. In cases of constipation from strangulated hernias and intestinal colic, several physicians found that, in small doses, opium (which retards evacuation) was one of the most excellent and surest means of helping. Nevertheless, they did not divine the homeopathic curative law that was governing here. **Opium for constipation**

8. They cured non-venereal throat ulcers by small doses of mercury, which was homeopathic in these instances. **Mercury for throat ulcers**

9. They quelled various cases of diarrhea with small doses of the cathartic rhubarb. **Rhubarb for diarrhea**

10. They cured rabies with belladonna, which is capable of bringing forth a similar malady. **Belladonna for rabies**

11. They removed, as if by magic, the impending danger threatened by the comatose state in high fevers, with a small dose of opium, which is inflammatory and stupefying. **Opium for a comatose state with high fever**

Nevertheless, they rail at homeopathy and pursue it with a rage that only the awakening of a bad conscience can engender in a heart incapable of improvement.

they did it. They seized these medicines as if by chance, in contradiction to the theories of all the hitherto systems and therapies. Thus, against their will, they confirmed in practice the necessity of the only law of cure that conforms with nature, that of homeopathy — a law of cure which, despite the many facts and innumerable hints that pointed to it, no physicians of past epochs had strived to discover, blinded as they were by medicinal prejudices.

HOMEOPATHIC FOLK REMEDIES

Even the non-medical classes of people, endowed with a healthy sense of observation, found many times over through their experience in domestic practice, that this medical mode was the surest, most thorough and most infallible one.

Cold applications for frostbite

Frozen sauerkraut was placed on recently frozen limbs or the limbs were rubbed with snow.[36]

Isopathy versus homeopathy

36 It is on such examples of domestic practice that Mr. M. Lux erected his so-called medical mode by *equals* and *idem* which he called isopathy, and which some eccentric thinkers have already taken as the *non plus ultra* of medical methods, without being aware of how they could implement this. If we precisely examine the examples presented by him, we see an entirely different matter.

The impinging action upon the organism of physical versus medicinal powers

The purely physical powers are of a different nature than the dynamic medicinal ones in their impinging action on the living organism. Warmth or cold of the surrounding air or water or of foods and drink do not *in themselves (as warmth or cold)* do absolute harm to a healthy body. In their alternations, warmth and cold belong to the sustaining of a healthy life; consequently, they are not medicinal in themselves. Thus, warmth and cold do not act as remedies in bodily ailments by virtue of their wesen (therefore not as warmth and cold *per se*, not as things detrimental in themselves, as do perhaps the medicines rhubarb, cinchona etc., even in the finest doses) rather, merely by virtue of their greater or lesser quantity, that is, according to their degree of temperature. In the same way (in order to give another example of purely physical forces) a great lead weight painfully bruises my hand, not by virtue of its wesen as lead, but due to its quantity and weight in bulk, while a thin lead plate

would not bruise me. Therefore, if cold or warmth prove to be helpful in bodily ailments such as frostbite and burns, they prove so solely because of their degree of temperature just as they also inflict damage on the healthy body due to extremes in the degree of their temperature.

[The examples of successful domestic practice involving warmth or cold, which are cited by Lux as isopathic, prove to be homeopathic. For example:]

1. The frostbitten limb was not restored isopathically by the persistent employment of that degree of cold wherein the limb froze; it would have become quite lifeless and dead thereby. Rather, it was restored by a cold that only came close to the original temperature and that was gradually toned down to a comfortable temperature (homeopathy), as frozen sauerkraut applied to a frozen hand at room temperature soon melts away and gradually warms up from 1° C [34° F] to 2° and so on up to room temperature, even if the room is only 10° C [50° F], and thus the limb is restored by physical homeopathy.

2. A hand scalded with boiling water is not restored *isopathically* by the application of boiling water, but is only restored through a somewhat lesser heat (e.g., by holding the hand in a dish of liquid that is heated to 60° C [140° F] which then becomes somewhat less hot each minute and finally reaches room temperature, whereupon the scalded part is restored through homeopathy.

3. Water which is in the process of becoming ice [i.e., that is at the freezing point] will not draw the frost out of potatoes and apples *isopathically*, but only water that is near the freezing point.

Thus, to give another example of physical impinging action, the damage resulting from a blow to the forehead by a hard object (a very painful bump) is quite soon diminished in pain and swelling when one vigorously presses the site with the ball of the thumb, strongly at first and then gradually more gently — homeopathically. The bump is not diminished through an equal hit with an equally solid body that, isopathically, would just make the injury worse.

Other examples of cures by isopathy given by Lux in his book, include the following:

1. Muscular contractions in humans and paralysis of the lower spine in a dog, both arising by means of cold, have been rapidly cured through cold bathing.

This event is falsely explained by isopathy. Cold ailments only have the name of cold, but they come about, in bodies prone thereto, even

Homeopathic use of warmth and cold:

Cold treatment for frostbite

Hot water for a scald

Freezing water to thaw frozen foods

Other false examples of isopathy

Heat for burns

The experienced cook holds his scalded hand close to the fire, paying no attention to the initial increase in pain, since he is aware from experience that he can thereby in a very short time, often in a few minutes, restore the scalded site into healthy painless skin.[37]

Other intelligent non-physicians (for example, the lacquerers) apply to the scalded site a similar *burn*-arousing means, such as

36 *continued*

from exposure to a sudden draft that was not at all cold. The various effects of a cold bath on the living organism in the healthy and the sick state are not at all to be encompassed by a single concept, upon which one could then found such an audacious system!

2. Snake bites would be cured most surely through snake parts.

This will remain a fable from the days of yore until such an improbable assertion is confirmed through indubitable observations and experiences, and it will probably never come to that.

3. The saliva of a mad dog administered to a man already raving from hydrophobia (in Russia) is *supposed to* have cured him.

This '*supposed to*' would not mislead any conscientious physician into dangerous imitation or into the construction of a so-called isopathic system which, in its extended application, is as dangerous as it is highly improbable. This is what has been done, not by the modest author of the little book, *The Isopathy of Contagions* (Leipzig: Kollman), but by its eccentric devotees, especially Dr. Gross (see *Allg. hom. Ztg.* [General Homeopathic Newspaper], II, p. 72). Dr. Gross cries up isopathy *(aequalia aequalibus* [equal things for equal things]) as the only correct curative principle, and insists on seeing in *similia similibus* [similar things for similar things] only a stop-gap measure — thanklessly enough, however, since he owes his fame and fortune solely to this principle.

Homeopathic treatment of burns with heat

37 Fernelius (*Therap.*, lib. VI, chap. 20) also considers that the best means of helping a scalded part is to bring it near the fire so that the pain might cease. John Hunter (*On the Blood, Inflammation, etc.,* p. 218) cites the great disadvantages in treating burns with cold water, and by far prefers placing them close to the fire. This is not according to the traditional medical doctrines which, in cases of inflammation, call for chilling things *(contraria contrariis)*. Rather, experience teaches that a similar heat *(similia similibus)* is the most salutary.

strong, well-warmed *alcohol*[38] or *turpentine oil.*[39] By this means, they restore themselves within a few hours, whereas cooling salves,

38 Sydenham (*Opera*, p. 271) says, "Alcohol, repeatedly applied, is to be preferred to every other means for burns." Benjamin Bell (*System of Surgery*, 3rd ed., 1789) also honors experience, which shows that homeopathic means are the sole curative ones. He says, "One of the best means for all burns is alcohol. Upon application, the pain appears to increase for a moment (§157) but this soon subsides, resulting in a pleasant, soothing sensation. The treatment is strongest when one immerses the parts in alcohol. When this cannot be done, the parts should be uninterruptedly covered with linen cloths moistened with alcohol."

> To this I would add: *Warm, and indeed very warm, alcohol is much more rapidly and certainly helpful, for it is much more homeopathic than when it is not heated.* This is confirmed, astonishingly enough, by every experience.

[margin note: Homeopathic treatment of burns with alcohol]

39 Edward Kentish (*Essay on Burns*, London, 1798, second essay), who had to treat workers in coal pits, so often dreadfully burned by the explosion of choke-damp, "applied *heated* turpentine or alcohol — the most excellent rescue means in cases of the most extensive and severe burns." No treatments can be more homeopathic than these, and also there are none more salutary.

The honest and highly experienced Heister (*Institut. Chirurg.* [Institution of Surgery], vol. I, p. 333) confirms this from his experience and praises "the application of turpentine oil, alcohol and the *hottest* possible pastes for this end, as hot as one can stand it."

When *pure* experiments have been conducted in which both opposing medical methods were employed, by comparison, in the same body and with burns of equal degree, one sees most irrefutably the astonishing advantage of applying homeopathic means to the burn-inflamed parts (i.e., means which are homeopathic in these instances because they have the power, in themselves, to arouse heat and a burning sensation) as opposed to applying the palliative cooling and chilling means.

Thus John Bell (in Kuhn's *Phys. Med. Journale* [Journal of Physical Medicine], Leipzig, June 1801, p. 428) had a lady, who was scalded, moisten one arm with *turpentine oil* and immerse the other in *cold water.* The first arm was *well* in half an hour, but the other continued to hurt for six hours. When it was pulled out of the cold water for just a

[margin note: Homeopathic versus antipathic treatment of burns]

as they are well aware, would not effect a cure in as many months, and cold water[40] would just make matters worse.

Liquor for heat exhaustion

The old experienced reaper, even when he otherwise drinks no brandy, nevertheless in a case where he has worked himself into a heated fever in the blazing sun, will never drink cold water *(contraria contrariis);* he knows how ruinous this procedure is. Rather, he takes a little of a *heat*-producing liquid, a moderate swig of brandy. Experience, the teacher of the truth, has persuaded him of

39 *continued*

moment, *she felt far greater pains in it, and it needed a far longer time to heal than did the arm treated with turpentine oil.*

Thus John Anderson (in Edward Kentish, *Essay on Burns*, London, 1798, p. 43) also treated a woman who had burned her face and arm with boiling fat. "The face, which was very red and burned and violently pained her, was covered after a few minutes with turpentine oil, but she had already stuck the arm in cold water and wished to treat it that way for several hours. After seven hours, her face already looked far better and was relieved. She had often renewed the cold water for the arm, however, she complained greatly about the pain when she took it out and, in fact, the inflammation had *increased.* The following morning, I found that she had had great pains in the arm during the night. The inflammation extended above the elbow; several large blisters had come up and thick scabs had formed on the arm and hand, on which a warm paste was now placed. The face was completely painless, while the arm, on the contrary, had to be bandaged with emollients for a fortnight before it healed."

Who could fail to discern the infinite superiority of the (homeopathic) treatment by similar impinging means over the miserable procedure by opposition (contraria contrariis) *according to the age-old, common medical art?*

Antipathic treatment of burns with cold water

40 John Hunter [cited above, in *fn* 37] is not the only one to write of the great disadvantages of cold water for the treatment of burns. W. Fabric von Hilden (*De combustionibus libellus* [A Book on Burns], Basel, 1607, chap. 5, p. 11) states, "Cold compresses are highly detrimental and give rise to the worst states, resulting in inflammation, suppuration and sometimes gangrene."

the great merit and salutariness of this homeopathic procedure. His heat is rapidly taken away as well as his fatigue.[41]

PAST WRITINGS ON HOMEOPATHIC CURES

There were even physicians from time to time who had *inklings* that medicines cure disease states through their power to arouse analogous disease symptoms.[42]

So the author of the book Περι τοπον των κατ᾽ ανθρωπον [On the Place of Things which Regard Man],[43] which is among the writings attributed to Hippocrates, has the following remarkable words: δια τα ὁμοια νουσος γινεται, και δια τα ὁμοια προσψερομενα εκ νοσευντων ὑγιαινονται — δια το εμεειν εμετος παυεται. [Disease is born of like things, and by the attack of like things people are healed — vomiting ends through vomiting.] Latter day physicians have likewise felt and pronounced the truth of the homeopathic curative mode. For example:

1. Boulduc realized that the purging property of rhubarb was the cause of its diarrhea-staunching power.[44] **Rhubarb for diarrhea**

2. Detharding divined that an infusion of senna leaves stills colic among adults, due to its colic-arousing action in healthy people.[45] **Senna for colic**

41 Zimmerman (*Ueber die Erfahrung* [On Experience], II, p. 318) teaches that the inhabitants of hot countries proceed likewise with the best result; after overheating, they take some spirituous liquor. **Liquor for overheating**

42 I am citing the following passages from authors who had inklings of homeopathy, not as proofs of the groundedness of this theory, which indeed stands firmly in and of itself, but rather, in order to escape the reproach of having concealed these inklings in order to secure the priority of the idea for myself.

43 Hippocrates (?), *On the Place of the Things which Regard Man*, Basel: Froben, 1538, p. 72.

44 Boulduc, *Mémoires de l'Académie Royale* [Dissertations of the Royal Academy], 1710.

45 Detharding, *Eph. Nat. Cur. Cent.* X, obs. 76.

3. Bertholon states that electricity dulls and annihilates that pain which is the most highly similar to the pain it arouses itself.[46]

4. Thoury attests that positive electricity, in itself, accelerates the pulse, but when the pulse is already morbidly too rapid, it is slowed by the electricity.[47]

5. Von Stoerck comes upon the thought, "If stramonium deranges the spirit and generates insanity among healthy people, should one then not be permitted to see if it could again bring about a healthy intellect among lunatics through rearrangement of the ideas?"[48]

This concept has been articulated most distinctly by a Danish army physician named Stahl, who states, "The rule generally acted on in the medicinal art — to treat by opposite means *(contraria contrariis)* — is quite false and preposterous. On the contrary, one is persuaded that diseases yield to, and are cured by, means that engender a similar suffering *(similia similibus)* — burns by approaching the fire, frostbitten limbs by the application of snow and the coldest water, inflammation and contusions by distilled spirits. In like manner, one cures a tendency to acidity of the stomach by a very small dose of sulphuric acid with the most fortuitous result, in cases where a number of absorbing powders have been fruitlessly employed."[49]

One was at times so near the great truth! But one let it rest at a transient thought, and so the indispensable changeover of the ancient medical management of disease — of the hitherto inexpedient treatment of disease — into a genuine, true and certain medical art remained unaccomplished up until our times.

46 Bertholon, *Medicin. Electrisität* [Medicinal Electricity], II, pp. 15 and 282.

47 Thoury, *Mémoire Lu à l'Academie de Caen* [Dissertation read at the Academy of Caen].

48 Von Stoerck, *Libell. de stram.* [Book of Stramonium], p. 8.

49 Stahl, in Hummelii, Jo. *Commentatio de arthritide tam tartarea, quam scorbutica, seu podagra et scorbuto* [A treatise on diseases of the joint, both hellish and scurvy-like: gout and scurvy], Büdingae, 1738, 8, pp. 40-42.

CHAPTER I

Principles of Cure

§ 1 - § 71

THE HIGHEST IDEAL OF CURE

§1

The physician's highest and *only* calling is to make the sick healthy, to cure, as it is called.[1]

§2

The highest ideal of cure is the rapid, gentle and permanent restoration of health; that is, the lifting and annihilation of the disease in its entire extent in the shortest, most reliable, and least disadvantageous way, according to clearly realizable [in-seeable] principles.

§3

Requirements of a medical-art practitioner

To be a genuine practitioner of the medical art, a physician must:
1. clearly realize what is to be cured in diseases, that is, in each single case of disease *(discernment of the disease, indicator),*
2. clearly realize what is curative in medicines, that is, in each particular medicine *(knowledge of medicinal powers),*
3. be aware of how to adapt what is curative in medicines to what he has discerned to be undoubtedly diseased in the patient, according to clear principles.

Theoretical medicine

1 The physician's calling is not to spin so-called systems from empty conceits and hypotheses concerning the inner wesen of the life process and the origins of disease in the invisible interior of the organism (on which so many physicians mongering for fame have hitherto wasted their time and energy). The physician's calling is not to make countless attempts at explanation regarding disease appearances and their proximate cause (which must ever remain concealed) holding forth in unintelligible words or abstract and pompous expressions in order to appear very learned and astonish the ignorant, while a sick world sighs in vain for help. Of such learned fanaticism (to which the name *theoretical medicinal art* is given, and for which special professorships are instituted) we have had quite enough. It is high time for all those who call themselves physicians, once and for all, to stop deceiving suffering humanity with idle talk, and to *begin* now to *act,* that is to really help and to cure.

In this way, recovery must result.

Adapting what is curative in medicines to what is diseased in patients requires that the physician be able to:

1. adapt the most appropriate medicine, according to its mode of action, to the case before him *(selection of the remedy, that which is indicated)*,
2. prepare the medicine exactly as required,
3. give the medicine in the exact amount required (the right *dose*),
4. properly time the repetition of doses.

Finally, the physician must know the obstacles to recovery in each case and be aware of how to clear them away so that the restoration of health may be permanent.

[If the physician has this insight, discernment, knowledge and awareness*] *then he understands how to act expediently and thoroughly, and he is a genuine practitioner of the medical art.*

§4

He is likewise a sustainer of health if he knows the things that disturb health, that engender and maintain disease, and is aware of how to remove them from healthy people.

Requirements of a sustainer of health

CAUSES OF DISEASE

§5

It will help the physician to bring about a cure if he can find out the data of the most probable *occasion* of an acute disease, and the most significant factors in the entire history of a protracted wasting sickness, enabling him to find out its *fundamental cause*. The fundamental cause of a protracted wasting sickness mostly rests upon a

The physician should ascertain the occasion and the fundamental cause of disease.

* Throughout the *Organon,* Hahnemann uses various terms to refer to different modes of knowledge, understanding and perception. These include references to intellectual knowledge as well as knowledge based upon participative experience. See *knowledge* and *realize* in the Glossary.

chronic miasm. In these investigations, the physician should take
into account the patient's:

1. discernible body constitution (especially in cases of protracted
 disease),
2. mental and emotional character [character of the *Geist* and the
 Gemüt],
3. occupations,
4. lifestyle and habits,
5. civic and domestic relationships [relationships outside and with-
 in the home],
6. age,
7. sexual function, etc.

DEFINITION OF DISEASE AND CURE

§6

All the perceptible signs, befallments and symptoms of disease represent the disease in its entirety.

The unprejudiced observer, even the most sharp-witted one —
knowing the nullity of supersensible speculations which are not
born out in experience — perceives nothing in each single case of
disease other than the alterations in the condition of the body and
soul, *disease signs, befallments, symptoms,* which are outwardly dis-
cernible through the senses. That is, the unprejudiced observer only
perceives the deviations from the former healthy state of the now
sick patient, which are:

1. felt by the patient himself,
2. perceived by those around him, and
3. observed by the physician.

All these perceptible signs represent the disease in its entire extent,
that is, together they form the true and only conceivable gestalt of
the disease.[6]

It is ridiculous for phyicians to seek causes of disease in the hidden

6 I do not know [am not aware] how physicians at the sickbed could sup-
pose that they ought to seek and could find what was to be cured in dis-
ease only in the hidden and indiscernible interior, without paying

§7

In cases of disease where there is no obvious occasioning or maintaining cause *(causa occasionalis)* to be removed,[7a] we can perceive nothing but the disease signs. Therefore, it must be the symptoms alone by which the disease demands and can point to the appropriate medicine for its relief, along with regard for any contingent miasm and with attention to the attendant circumstances (§5).

The totality of symptoms (along with the patient's circumstances and any contingent miasm) determines the most appropriate remedy in

careful attention to the symptoms or being precisely guided by those symptoms in their treatment. I do not know [am not aware] how they could be so ridiculous and presumptuous as to attempt to discern what has changed in the invisible interior of the body without paying much attention to the symptoms, or how they could attempt to set it right again with unknown (!) medicines and then call this the only thorough and rational treatment.

interior of the body while ignoring clearly perceptible symptoms.

The medical-art practitioner can never see the spiritual wesen, the life force, that creates the disease, and he never needs to see it. In order to cure, he only needs to see and experience its diseased effects. Therefore, in the eyes of the medical-art practitioner, is not that which reveals itself to the senses by disease signs the disease itself? What else is the old school looking for in the hidden interior of the organism as a *prima causa morbi* while at the same time rejecting and haughtily disdaining the disease presentation that is clearly perceptible to the senses, that is, the symptoms that audibly speak to us? What else do they want to cure in disease but these symptoms?

7a It goes without saying that the intelligent physician would immediately clear away any occasioning or maintaining causes, after which the indisposition usually gives way of its own accord. For example, the physician would:

Examples of occasioning or maintaining causes to be removed by physicians

1. remove from the room the strong smelling flowers that are arousing faintness and hysterical plights,
2. extract from the cornea the splinter that is arousing inflammation of the eye,
3. loosen the overtight bandage on a wounded limb that is threatening to cause gangrene, and apply a more suitable one,
4. lay bare and tie off the injured artery that is inducing faintness,
5. seek, through vomiting, to expel belladonna berries, etc. that have been swallowed,

cases of disease where
there is no obvious cause
to be removed.

The totality of these symptoms is the *outwardly reflected image of the inner wesen of the disease, that is, of the suffering of the life force.* The totality of symptoms must be the principal or the only thing whereby the disease can make discernible what remedy [curative means] it requires, the only thing that can determine the choice of the most suitable helping-means. Thus, in a word, the totality[7b] of symptoms must be the most important, indeed the only thing in every case of disease, that the medical-art practitioner has to discern and to clear away, by means of his art, so that the disease shall be cured and transformed into health.

§8

When all the symptoms of
disease have been lifted,
the disease is also cured
in the interior.

It is not conceivable, nor can it be shown through any experience in the world that, after the lifting of all the symptoms of the disease and of the entire complex of perceptible befallments, anything else besides health remains or could remain such that the diseased alteration in the interior would be left unexpunged.[8]

7a *continued*

 6. extract foreign substances from the orifices of the body (nose, throat, ears, urethra, rectum, genitalia),

 7. crush bladder stones,

 8. open the imperforate anus of the newborn infant, etc.

Symptomatic treatment:
the suppression of single
disease symptoms with
antipathic medicines

7b From time immemorial, adherents of the old school (often unaware of any other expedient) have used medicines in an attempt to combat and, wherever possible, to suppress *a single one* of the various symptoms of a disease. This *one-sidedness,* called *symptomatic treatment,* has rightly aroused general contempt because through it, not only is nothing won but much is also spoiled.

 A single symptom of disease is no more the disease itself than a single foot is the man himself. This procedure is so much the more reprehensible because the single symptom is treated with an opposed means which acts in an enantiopathic and palliative manner. After a short period of relief, the symptom is only made all the worse.

The old school's material
view of disease

8 When someone has been restored from his disease by a true practitioner of the medical art, in such a manner that no sign of the disease, no dis-

THE LIFE FORCE IN HEALTH AND DISEASE

§9

In the healthy human state, the spirit-like life force (autocracy) that enlivens the material organism as dynamis, governs without restriction and keeps all parts of the organism in admirable, harmonious, vital operation, as regards both feelings and functions, so that our indwelling, rational spirit can freely avail itself of this living, healthy instrument for the higher purposes of our existence.

In health, the life force keeps all parts of the organism in harmony.

§10

The material organism, thought of without life force, is capable of no sensibility, no activity, no self-preservation.[10] It derives all sensibility and produces its life functions solely by means of the immaterial wesen (the life principle, the life force) that enlivens the material organism in health and in disease.

The material organism functions solely by means of the immaterial wesen, the life force.

ease symptom remains, and all the signs of health have permanently returned, how can anyone, without insulting the human intellect, maintain that the whole bodily disease continues to dwell in the interior? And yet Hufeland, the former director of the old school, asserted, "Homeopathy can lift the symptoms but the disease remains," (Hufeland, *Die Homöopathie*, p. 27, line 19). This he maintained partly out of grievance over the progress made by homeopathy for the welfare of humanity, and partly because he still holds an entirely material concept of disease. He has not yet been able to think of disease as a state of being in which the organism is dynamically altered by a morbidly mistuned life force — as a modified condition. Rather, he views disease as *a material thing* which, after the cure is accomplished, could still be left lying in some corner of the organism in order, some day during splendid health, to break forth at will with its material presence! This is how crass the blindness of the old pathology still is! No wonder that it could only engender a medical system which is solely occupied with scouring out the poor patient.

10 Without life force, the material organism is dead and is only subject to the power of the physical external world. It decays and is again resolved into its chemical constituents.

The organism without life force is dead.

§11

In disease, the life force is
first dynamically mistuned
and then manifests its
mistunement through
symptoms.

When a person falls ill, it is initially only this spirit-like, autonomic life force (life principle), everywhere present in the organism, that is mistuned through the dynamic[11] influence of a morbific agent inimical to life. Only the life principle, mistuned to such abnormality, can impart to the organism the adverse sensations and induce in the organism the irregular functions that we call disease. The life principle is a power-wesen invisible in itself, only discernible by its effects on the organism. Therefore, its morbid mistunement only makes itself known [discernible] by manifestations of disease in feelings and functions (the only aspects of the organism accessible to the senses of

Definition of 'dynamic'

11 What is dynamic influence, dynamic power? We perceive that, by some secret invisible force, our earth conducts its moon around itself in twenty-eight days and a few hours, and the moon, in turn, raises our northern seas to *flood tide* at set hours and, in an equal number of hours, lets it sink again to *ebb tide* (allowing for some variation at the full and new moons). We see this and are amazed because our senses do not perceive how this happens. Obviously this does not happen through material instruments, nor through mechanical arrangements like human works. We also see about us a great many other events as the effect of one substance upon another where one cannot discern any sense-perceptible connection between the cause and the effect. Only someone who is cultivated and therefore exercised in comparison and abstraction can form a kind of supersensible idea of this, keeping far from his thoughts all that is material or mechanical. He terms such actions *dynamic, virtual,* taking place by the absolute, specific, pure power and action of one [substance] upon another.

In the same way, the dynamic action of morbific influences on the healthy person, as well as the *dynamic* power of medicines on the life principle in order to make the person healthy again, are nothing other than contagion. They are as utterly non-material, as utterly non-mechanical, as the power of a bar magnet is when it forcibly attracts to itself a piece of iron or steel lying next to it.

Dynamic action of
magnets on iron or steel

A magnet's action upon a nearby piece of iron or a steel needle is neither material nor mechanical. One sees that the piece of iron is attracted

by one end (pole) of the magnet but one does *not* see *how* this takes place. This invisible power of the magnet needs no mechanical (material) helping-means, no hook or lever to attract the iron. It attracts it to itself and acts upon the piece of iron or on the steel needle by means of its own (pure) immaterial, invisible, spirit-like energy, that is, it does so *dynamically*. Morever, the magnet invisibly (dynamically) transmits magnetic energy to the steel needle which, in turn, becomes magnetic, even at a distance, without the magnet touching it. The steel needle can then transmit the same magnetic property to other steel needles (dynamically).

In a similar way, a child with smallpox or measles transmits the disease to a nearby healthy child, even without touching him. This contamination takes place invisibly (dynamically) at a distance, without something material having come (or having been able to come) into the affected child from the contagious one, just as there is no material transmission between the magnet and the steel needle. A solely specific, spirit-like impingement communicates smallpox or measles from one child to another nearby, just as a magnet communicates the magnetic property to a steel needle nearby.

Dynamic transmission of disease

The action of medicines on the living human is to be judged in a similar way. Natural substances that prove to be medicines are only medicines in so far as they possess (each their own specific) power to alter the human condition by a spirit-like impingement (via a living sensitive fiber) on the spirit-like, life-managing life principle. What is medicinal in those natural substances that, in a narrower sense, we call medicines refers solely to their power to elicit alterations in the condition of our animal life. It only extends its condition-altering spirit-like (dynamic) influence to the spirit-like life principle, just as the proximity of one pole of a magnet can impart only magnetic energy to the steel (through a kind of contagion, to be sure) but not other properties (not, for example, hardness or malleability, etc.). And so, each special medicinal substance also alters the human condition through a kind of contagion in a way exclusively peculiar to itself and not in a way that is inherent in any other medicine, as certainly as the proximity of a child sick with smallpox will communicate only smallpox to a healthy child and not measles. This impingement of the medicines upon our condition happens *dynamically*, as by contagion, entirely without communication of any material parts of the medicinal substance.

Dynamic action of medicines

the observer and the medical-art practitioner). In other words, the morbid mistunement of the life principle makes itself discernible by disease symptoms; in no other way can it make itself known.

§12

The manifestations of a disease reveal the whole

It is the disease-tuned life force alone that brings forth diseases.[12] These diseases are expressed by the disease manifestations percep-

Dynamic action of potentized medicines

11 *continued*

The smallest dose of a medicine dynamized in the best manner (wherein, after committed calculation, only so little material can be found that its smallness cannot be thought of or grasped, even by the best mathematical brain) gives out, in the appropriate disease case, *more* curative energy *by far* than large doses of the same medicinal substance. This finest dose is almost nothing but pure, freely unveiled, spirit-like medicinal energy, and carries out — only *dynamically* — such great actions as could never be achieved by the raw medicinal substance, even when it is taken in a large dose.

The specific medicinal energy of these highly dynamized medicines does not depend on their corporeal atoms nor on their physical or mathematical surfaces (ideas that are the product of futile and still materialistic theorizing about dynamized medicines, whose energy is higher). Rather, there lies invisible in the moistened globule or its solution — uncovered and freed as much as possible from the medicinal substance — a specific medicinal energy which, through contact with the living animal fiber, impinges dynamically on the entire organism (however without communicating to it any matter, howsoever finely conceived). This dynamic action is more and more powerful as the medicinal energy becomes freer and more immaterial through progressive dynamization (§270).

Is it then so utterly impossible for our age, celebrated for its wealth of clear thinkers, to think of dynamic energy as something incorporeal when we see around us everyday so many befallments that cannot be explained in any other way? If you look at something disgusting and it makes you sick to your stomach, did some material emetic perchance get into your stomach that forced this peristaltic movement? Was it not solely the dynamic action of the disgusting sight upon your imagination? And when you lift up your arm, does it happen, perhaps, by means of a material, visible instrument? a lever? Is it not solely the spirit-like, dynamic energy of your will that lifts it?

In order to cure, the physician does not need to

12 The medical-art practitioner can derive no benefit from probing into how and why the life force brings the organism to the manifestations of

tible to our senses conjointly with all internal alterations. These [internal and external] disease manifestations express the entire morbid mistunement of the inner dynamis and bring the entire disease to the light of day. On the other hand, the disappearance, by curative means, of all disease manifestations (i.e., all noticeable alterations deviating from the healthy life process) just as certainly involves the restoration of the integrity of the life principle and, consequently, it necessarily presupposes the return of the health of the entire organism.

disease, and their disappearance indicates complete recovery.

§13

Therefore disease (excluding surgical cases) is not what allopaths believe it to be. Disease is not to be considered as an inwardly hidden wesen separate from the living whole, from the organism and its enlivening dynamis, even if it is thought to be very subtle. Such an absurdity[13] could only arise in brains of a materialistic stamp. It is this absurdity that has for thousands of years given to the hitherto system of medicine all those ruinous directions that have fashioned it into a truly calamitous art.

It is absurd to view disease as separate from the living whole.

§14

There is nothing curably diseased nor any curable, invisible disease alteration in the human interior that, by disease signs and symptoms, would not present itself to the exactly observing physician for discernment — quite in keeping with the infinite goodness of the all wise Life-sustainer of humanity.

Everything curably diseased makes itself known to the physician by signs and symptoms.

§15

The suffering of the morbidly mistuned, spirit-like dynamis (life force) enlivening our body in the invisible interior, and the complex of the outwardly perceptible symptoms portraying the present malady, which are organized by the dynamis in the organism, form a

The life force and the material organism form an indivisible whole, as do the mistunement of the

disease, that is, how it creates disease. This will remain eternally hidden from him. The Lord of life laid before his senses only what was necessary and fully sufficient for him to be aware of for curative purposes.

13 *Materia peccans* [offending matter]!

know how the life force brings forth disease.

life force and the complex
of perceptible symptoms.

whole. They are one and the same. The organism is indeed a material instrument for life, but it is not conceivable without the life imparted to it by the instinctual, feeling and regulating dynamis, just as the life force is not conceivable without the organism. Consequently, the two of them constitute a unity, although in thought, we split this unity into two concepts in order to conceptualize it more easily.

§16

Disease only occurs and
can only be cured through
dynamic impingement
upon the life force.

Our life force, as spirit-like dynamis, cannot be seized and affected by damaging impingements on the healthy organism (through inimical potences from the external world that disturb the harmonious play of life) other than in a spirit-like, dynamic way. In like manner, the only way the medical-art practitioner can remove such morbid mistunements (the diseases) from the dynamis is by the spirit-like (dynamic,[16] virtual) tunement-altering energies of the serviceable medicines acting upon our spirit-like life force. These energies are perceived through the ubiquitous feeling-sense of the nerves in the organism. Accordingly, curative medicines can reestablish health and life's harmony only through dynamic action on the life principle. The curative medicines reestablish health after the alterations in the patient's condition that are noticeable to our senses (i.e., the symptom-complex) have portrayed the disease to the attentively observing and investigating medical-art practitioner as completely as is necessary for the cure of the disease.

§17

The only thing the
physician has to do to
remove the entire disease
is take away the entire
symptom complex.

When a cure occurs through the taking away of the entire complex of perceptible signs and befallments of disease, the internal alteration of the life force which is lying at its base (consequently the totality of the disease) is simultaneously lifted.[17a] It follows, there-

The highest diseases are
brought to pass by means

16 See footnote 11.

17a The highest disease can be brought to pass through sufficient mistunement of the life principle by means of the imagination, and it can be

fore, that the medical-art practitioner has only to take away the symptom complex in order to simultaneously lift and annihilate the internal alteration (i.e., the morbid mistunement of the life principle) and consequently the totality of the disease, the *disease itself*.[17b] When the disease is annihilated, health is restored. This is the highest, the only goal of the physician who knows the meaning of his calling which is to help, not to engage in learned-sounding prattle.

§18

It is an undeniable truth that nothing can, by any means, be discovered in diseases whereby they could express their need for aid besides the totality of symptoms, with consideration for the accompanying circumstances (§5). Therefore, it follows incontestably that the complex of all the symptoms and circumstances perceived in

The totality of symptoms and circumstances in each individual case of disease must be the sole indicator in choosing a remedy.

taken away again in the same manner. A premonitory dream, a superstitious fancy or a solemn fateful prophecy of death on a certain day or at a certain hour has not-infrequently brought all the signs of arising and increasing disease and approaching death and even death itself at the indicated hour. This could not happen without the simultaneous production of an internal alteration corresponding to the outwardly perceptible state. In such cases, all the features of disease indicating approaching death have not-infrequently been scared off through some artificial deception or persuasion to the contrary, and health suddenly reestablished. This would not have been possible without the removal, by means of this merely moral remedy, of both the internal and external morbid alterations that prepared for death.

of the imagination and can be cured by altering patients' beliefs.

17b God, the sustainer of humanity, reveals His wisdom and goodness by openly setting forth for the medical-art practitioner what has to be taken away in the diseases that befall humanity here below, in order to annihilate them and so to establish health. What would we think of His wisdom and goodness if He shrouded in a mystical darkness that which is to be cured in diseases (as is asserted by the hitherto school of medicine, that affected to have a divinatory insight into the inner wesen of things) and shut it up in the interior, thus making it impossible for humanity to distinctly discern the malady, consequently making it impossible to cure?

God openly sets forth what is to be taken away in diseases. He does not shroud it in mystical darkness.

each individual case of disease must be the *only indicator*, the only reference in choosing a remedy.

THE POWER OF MEDICINES TO CURE

§19

Medicines cure by differently tuning a person's condition.

Since *diseases* are nothing other than *alterations of condition in healthy people* which express themselves through disease signs, and since *cure* is likewise only possible through an *alteration of the patient's condition into the healthy state*, then it is easily seen that *medicines* would in no way be able to cure if they did not possess the power to differently tune the human condition that resides in feelings and functions. Indeed, it is evident that the curative power of medicines must rest solely upon this, their power to alter the human condition.

§20

A medicine's curative power can only be known through the experience of its effects on human health.

This hidden spirit-like power in the inner wesen of medicines to alter the human condition and thus to cure diseases is, in itself, in no way discernible with mere intellectual exertion. It is only by experience, only through its manifestations while it is impinging on the human condition that we can distinctly perceive it.

§21

A medicine's power to cure is revealed in the symptoms it engenders in healthy people. These symptoms reveal the medicine's particular disease-engendering power which is the same as its disease-curing power.

Since:

1. the curative wesen in medicines is not, in itself, discernible (which no one can deny), and
2. in pure experiments conducted with medicines [i.e., in provings], the most sharp-witted observer can perceive nothing about medicines that can constitute them as medicines, or curative means, except their power to bring forth distinct alterations in the condition of the human body, and especially their power to differently tune the *healthy person* in his condition and to arouse several particular disease symptoms in him,

then it follows that when medicines act as curative means, they likewise can only bring their curative capacity into execution

through this, their power to differently tune the human condition by means of engendering peculiar symptoms. Therefore, we only have to abide by [act in conformity with] the disease befallments that medicines engender in the healthy body as the only possible revelation of their in-dwelling curative power. From these disease befallments, we experience the disease-engendering power which is, at the same time, the disease-curing power that each single medicine possesses.

SIMILAR, DISSIMILAR AND OPPOSITE SYMPTOMS PRODUCED BY MEDICINES AND DISEASES

§22

Since:

1. nothing is exhibited in diseases that must be taken away in order to transform them into health besides the complex of their signs and symptoms, and

2. medicines can exhibit nothing curative besides their tendency to engender disease symptoms in the healthy and to take them away from the sick,

it therefore follows that:

1. medicines only become remedies [curative means], capable of annihilating diseases, by arousing certain befallments and symptoms (i.e., by engendering a certain artificial disease state) thereby lifting and eradicating the symptoms already present, namely, the natural disease state we wish to cure, and

2. for the symptom complex of the disease to be cured, that medicine must be sought which has proven to have the greatest tendency to engender either *similar* or *opposite* symptoms,[22] accord-

> *Medicines cure by engendering a disease state that removes the one to be cured.*

22 The other possible manner of employing medicines against disease besides these two [the homeopathic and the antipathic] is the allopathic method. In the allopathic method, medicines are prescribed whose symptoms have no direct pathic reference to the disease state; the medicinal symptoms are neither similar nor opposite to the disease symptoms, but rather entirely heterogenic to them. This practice plays an irresponsible,

> *Allopathic treatment: Medicines are given that produce symptoms which are neither similar nor opposite to those of the disease.*

ing to what experience shows to be the kind of medicinal symptoms (those *similar* or *opposite* to the disease) to lift disease symptoms and transform them into health most easily, certainly and permanently.

22 *continued*

murderous game with the life of the patient, as I've already shown elsewhere [see the Introduction], by means of:

1. medicines, given in large and frequent doses, that are dangerously violent in their actions (and whose actions are unknown) and that were chosen based on empty presumptions,

2. painful procedures that are supposed to direct the disease to other locations, and

3. decreasing the patient's vitality and bodily fluids by emptying him from above and below, by making him sweat or salivate or, worst of all (as the currently reigning routine would have it), by blindly and unsparingly wasting his irreplaceable blood.

The life force was instilled in our organism to continue life on a harmonious course as long as the organism is healthy, not to cure itself in diseases.

These procedures are used on the pretext that the physician should imitate and assist diseased nature in its strivings to help itself. However, it is completely irrational to imitate and further these highly imperfect, mostly inexpedient strivings of the merely instinctual, intellect-lacking life force, which was only instilled in our organism to continue our life on a harmonious course as long as the organism is healthy, but not to cure itself in diseases. If it had an ability so worthy of imitation, then it would not allow the organism to get sick at all.

Once the life force has fallen ill due to malignities, it can only express its mistunement by means of the disturbance of the organism's healthy course of life and by feelings of suffering whereby it calls upon the intelligent physician for help. If help does not appear, then it strives to save itself by intensifying the sufferings — primarily however, by violent evacuations. This often involves tremendous sacrifice, sometimes the sacrifice of life itself.

The morbidly mistuned life force has so little ability to cure that it certainly does not deserve to be imitated, since all the symptoms and changes in condition it engenders in the organism are indeed just the disease itself! What intelligent physician, who is unwilling to sacrifice his patient, would want to imitate it?

§23

However, every pure experience and every exact experiment persuades us that persistent disease symptoms are so little lifted and annihilated by the symptoms of the medicine that *oppose* the disease symptoms (in the *antipathic, enantiopathic* or *palliative* method) that, after short-lasting apparent relief, the disease symptoms break forth again, only in an all-the-more strengthened degree, and they obviously worsen (see §58-§62, §69).

Antipathic treatment: Persistent disease symptoms are made worse by the opposite medicinal symptoms of antipathic medicines.

§24

There remains, therefore, no other manner of medicinal application promising aid against disease, except the homeopathic one. In homeopathy, a medicine is sought for the totality of symptoms of the disease case, with regard for the originating cause (when it is known) and for the accessory circumstances — a medicine is sought which (among all medicines whose condition-altering abilities are known from having been tested in healthy individuals) has the power and the tendency to engender the artificial disease state most similar to that of the case of disease in question.

Homeopathic treatment: A medicine is given that can produce an artificial disease state most similar to that of the natural disease.

§25

In all careful experiments, pure experience[25] (the only and infallible oracle of the medical art) teaches us the following: A medicine which, in its impingement on healthy human bodies, has proven that it is able to engender the greatest number of symptoms *similar* to those found in the case of disease to be cured, does also (in properly potentized and diminished doses) rapidly, thoroughly and per-

Medicines, in appropriate doses, cure those diseases whose symptoms most nearly resemble their own.

25 I do not mean that kind of experience of which ordinary practitioners of the old school boast, after having rummaged about for years with a heap of compounded prescriptions used against a host of diseases that they never precisely examine but recognize only according to the categories of orthodox pathology. These practitioners imagine that they can detect in diseases some fancied disease matter or they impute to them some other hypothetical internal abnormality. They always see something but they

Uselessness of old school experience

manently lift the totality of symptoms of this disease state (see §6-
§16). It lifts the entire disease that is present, transforming it into
health. All medicines, without exception, cure those diseases whose
symptoms most nearly resemble their own, and leave none of them
uncured.

§26



When two very similar
dynamic affections meet
in a living organism, the
stronger extinguishes the
weaker. This is the law of
similars upon which every
real cure is based.



This rests upon the following homeopathic natural law which was
divined here and there from time immemorial, but was not hither-
to fully acknowledged, and which lies at the foundation of every
real cure that has ever taken place:

> *In the living organism, a weaker dynamic affection is permanently
> extinguished by a stronger one, if the stronger one (while differing from
> it as to mode) is very similar to the weaker one in its manifestation.*[26]

25 *continued*
are never aware of what it is. They obtain results that no human being,
but only a god, could decipher from the multiple of forces impinging on
an unknown object. These are results from which nothing can be learned,
no experience gained. Fifty years' experience of this kind is like fifty years
of looking into a perpetually turning kaleidoscope crammed with
unknown colored objects that are constantly rotating — thousands of fig-
ures transforming themselves forevermore and no accounting for them!



Stronger similars that
extinguish weaker ones:

Daylight extinguishes the
sight of Jupiter.

Snuff extinguishes the
perception of bad odors.

The fife and drum
extinguish sounds of war.



26 Both physical affections and moral maladies are cured in this way [i.e. by
very similar, but stronger dynamic affections].

1. How can luminous Jupiter disappear in the early morning from the
 optic nerve of the beholder? Jupiter vanishes from sight because the
 optic nerve is acted upon by a stronger, very similar impinging
 potence — the brightness of the breaking day!

2. How does one effectively placate olfactory nerves that have been
 insulted by foul odors? By snuff, which seizes the sense of smell in a
 similar but stronger way! Neither music nor pastries can cure this
 olfactory disgust because they relate to other senses.

3. How did the cunning warrior drown out the pitious cries of wounded
 soldiers from the ears of compassionate bystanders? By the high-
 pitched sounds of the fife, paired with the noisy drum roll! How did
 he cover the distant thunder of the enemy's cannon which aroused

§27

The curative capacity of medicines therefore rests upon their symptoms being similar to the disease but with power that outweighs it (§22-§26). Each single case of disease is most surely, thoroughly, rapidly and permanently annihilated and lifted only by a medicine that can engender, in the human condition, a totality of symptoms that is the most complete and the most similar to the case of disease but that, at the same time, exceeds the disease in strength.

A disease is most surely, thoroughly, rapidly and permanently removed by a medicine that can engender a totality of symptoms most similar to the disease, but stronger.

§28

This natural law of cure has authenticated itself to the world in all pure experiments and all genuine experiences; therefore it exists as fact. Scientific explanations for *how it takes place* do not matter very much and I do not attach much importance to attempts made to explain it. The following view, however, is verifiably the most probable since it is based on nothing but empirical premises:

How homeopathic medicines cure

§29

1. Any disease (which is not strictly a surgical case) consists solely of a specific dynamic disease mistunement of our life force (life principle) in our feelings and functions.

fear in his army? By the deeply reverberating boom of the great drum! He could not have obtained such results by reprimanding the regiment or distributing glittering uniforms.

4. Mourning and grief are extinguished in the emotional mind on hearing an account of another's still greater bereavement, even if the account is only fictitious.

A sorrowful story can extinguish lesser grief.

5. The negative effects of an all-too-lively joy are removed by drinking coffee, which engenders a state of excessive joy.

Coffee extinguishes the effects of excessive joy.

6. A people like the Germans, who for centuries were gradually more and more degraded into will-less apathy and a subservient sense of slavery, first had to be still more deeply trodden into the dust by the conqueror from the West [Napoleon] until the situation became intolerable. Only in this way was their self-disparagement over-tuned and lifted so that they felt their human dignity again and raised their heads, for the first time, as German men anew.

The Napoleonic conquest extinguished German apathy.

2. The life principle, which has been dynamically mistuned by the natural disease, is *seized,* during homeopathic cure, by the similar yet somewhat stronger artificial disease-affection which results from the application of the medicinal potence, selected exactly according to symptom similarity.

3. The feeling of the natural (weaker) dynamic disease-affection is extinguished and disappears for the life principle and, from then on, no longer exists for the life principle which is occupied solely by the stronger artificial disease-affection.

4. The artificial disease-affection soon plays itself out, leaving the patient free and recuperated.[29] The dynamis, thus freed, can now continue life again, in health.

This most highly probable process rests upon the following propositions:

§30

Medicines cure diseases by acting more effectively on the human body. This is due, in part, to our ability to regulate their dose.

1. The human body seems to allow itself (in its condition) to be more effectively altered in its tuning by medicines than by natural disease irritants (partly because dose adjustment is in our power) — for through suitable medicines, natural diseases are cured and overcome.

§31

The power of natural diseases to make us sick

2. The — partly psychical and partly physical — inimical potences in life on earth (which we call disease malignities) do not possess

Medicines can be overcome by the life force more easily than can natural diseases because of the short duration of medicinal action.

29 The short duration of the action of the artificial morbific potences which we call medicines, makes it possible for them (even though they are presently stronger than the natural diseases) to be far more easily overcome by the life force than are the weaker natural diseases which, solely on account of their longer, mostly lifelong effective duration (psora, syphilis, sycosis) can never be vanquished and extinguished by the life force alone. They can only be vanquished and extinguished when the medical-art practitioner more strongly affects the life force with a very similar, but stronger, morbific potence (of homeopathic medicine). The diseases of many years' standing that (according to §46) were cured by an outbreak of smallpox and measles (both of which also run their course in only a few weeks) are similar processes.

an absolute power to morbidly mistune the human condition.[31] We become diseased by them only when our organism is just exactly and sufficiently disposed and laid open to be assailed by the cause of disease that is present, and to be altered in its condition, mistuned and displaced into abnormal feelings and functions. Hence these inimical potences do not make everyone sick every time.

§32

3. It is entirely different with the artificial disease potences which we call medicines. Every true medicine works at *all* times, under *all* circumstances, on *every* living human being, and arouses in him its peculiar symptoms. These symptoms will be distinctly conspicuous if the dose is large enough. It is evident, therefore, that every living human organism must be affected throughout and, as it were, infected by the medicinal disease at all times and absolutely *(unconditionally)* which is, as said before, not at all the case with natural diseases.

§33

It proceeds undeniably from all experience[33] that the living human organism is far more disposed and inclined to allow itself to be

31 When I call disease a tunement or mistunement of the human condition, I am far from wanting to give, thereby, a hyperphysical explanation about the inner nature of diseases generally, or of a single case of disease in particular. This expression is only meant to imply what diseases, as has been proven, are not and cannot be. They are not mechanical or chemical alterations of the material substance of the organism; they are not dependent on material disease matter. They are solely spirit-like, dynamic mistunements of life.

33 The following is a striking example of this: Until 1801, epidemics of scarlet fever (i.e., Sydenham's smooth scarlatina) still reigned. They broke out from time to time and befell, without exception, all children who had not weathered it in a previous epidemic. However, in the Königslutter epidemic which I experienced, *all* the children who took a very small dose of Belladonna early enough remained free of this highly contagious childhood disease. If medicines can protect us from the contagion of a

aroused and have its condition differently tuned by medicinal powers than by ordinary disease malignities and infectious miasms. In other words, *disease malignities possess a power to differently tune the human condition which is subordinate and conditional, often very conditional, while medicinal energies possess an absolute unconditional power far outweighing the power possessed by disease malignities.*

health unconditionally while natural disease energies only affect health under certain conditions.

§34

The greater strength of the artificial disease that a medicine can produce is, however, not the only requirement for its being able to cure a natural disease. *Above all, a medicine must be capable of producing an artificial disease as similar as possible to the disease to be cured. With its somewhat stronger energy, it will thus be able to displace the instinctual life principle (which is not capable of any deliberation or recollection) into a disease-tunement very similar to the natural one. It does this not only to obscure the feeling of the natural disease mistunement in the life principle but to entirely extinguish and so to annihilate that feeling.*

To cure, a medicine must not only be stronger than the disease to be cured, it must be able to produce an artificial disease as similar as possible to the natural one.

This is so true that no older disease can be cured, even by nature itself, through a new, supervening *dissimilar* disease, be it ever so strong. Just as little can it be cured by medicinal treatments (such as the allopathic ones) which are incapable of engendering a *similar* disease state in the healthy body.

DISSIMILAR DISEASES

§35

To make this clear, we will consider the following:
1. the process in nature wherein two dissimilar diseases meet together in one person, and

33 *continued*
 raging disease, so must they possess a preponderant power to differently tune our life force.

2. the result of the ordinary medical treatment of diseases with unfitting allopathic medicines, which are incapable of producing an artificial disease state similar to the disease to be cured.*

From this, it will become apparent that:

1. not even nature can lift a dissimilar disease that is already present through a stronger, unhomeopathic disease, and
2. the unhomeopathic employment of ever-so-strong medicines is just as incapable of curing any disease.

§36

I. If two *dissimilar* diseases meet together in the human being and they are either of equal strength, or the *older* one happens to be *stronger*, then the older disease will keep the new one away from the body. [If the older disease is the same strength or stronger, it will fend off the new one.]

1. Someone who is already suffering from a serious chronic disease will not be infected by an autumnal dysentery or other moderate epidemic disease. [Severe chronic diseases fend off moderate epidemic ones.]
2. The levantine plague does not break out where scurvy reigns, according to Larrey.[36a] [Scurvy fends off the plague.]
3. People suffering from eczema are also not infected by the levantine plague, according to Larrey.[36b] [Eczema fends off the plague.]
4. Richitis prevents smallpox vaccination from taking effect, according to Jenner. [Rachitis fends off smallpox vaccination.]
5. People with ulcerous pulmonary tuberculosis are not infected by epidemic fevers that are less severe, according to von Hildenbrand. [Pulmonary tuberculosis fends off moderate epidemic fevers.]

* Hahnemann considers these two situations in the following three cases: *a.* where the older disease is the same strength or stronger than the new dissimilar disease (§36-§37), *b.* where the new dissimilar disease is stronger than the older one (§38-§39), and *c.* where a complicated disease is formed from the two dissimilar diseases (§40-§41).

36a Larrey, "Mémoires et observations," in *Déscription de l'Egypte* ["Reminiscences and observations," in *Description of Egypt*], vol. I.

36b Ibid.

§37

Moderate allopathic treatments do not alter or cure stronger chronic diseases, even if the treatments go on for years.

So also, *under ordinary medical treatment,* an old chronic malady remains uncured and as it was when it is gently treated *allopathically* (according to the common treatment mode) that is, when it is treated with medicines incapable of engendering in healthy individuals a condition-state similar to the disease. An old chronic malady does not respond to gentle allopathic treatment even when the treatment lasts for years.[37] Since this is seen daily in practice, it requires no confirming examples.

§38

If the new dissimilar disease is stronger, it will suspend the older disease, but never cure it.

II. Or the *new dissimilar disease is stronger.* In this case, the weaker disease that the patient already has is postponed and suspended by the stronger supervening disease until the new one has run its course or been cured, and then the old one comes forth again *uncured.*

Ringworm suspended epilepsy.

1. Two children afflicted with a kind of epilepsy remained free from epileptic attacks after infection with ringworm *(tinea capitis)* but as soon as the eruption on the head passed, the epilepsy was there again just as before, according to Tulpius.[38a]

Scurvy suspended the itch diathesis.

2. The itch diathesis disappeared on the occurrence of scurvy, but after the scurvy was cured, the itch diathesis came to light again, according to Schöpf.[38b]

Typhus suspended pulmonary tuberculosis.

3. A case of ulcerous pulmonary tuberculosis stood still while the patient was seized by a violent typhus, but continued its progress after the typhus had run its course, according to Chevalier.[38c]

Mania suspends pulmonary tuberculosis.

4. If mania occurs in a person with pulmonary tuberculosis, the tuberculosis with all it symptoms is taken away by the mania.

Violent allopathic means produce other maladies.

37 If, on the other hand, the old chronic malady is treated for years with violent allopathic means, then maladies of another kind, that are still more wearisome and life-threatening, will be formed in its place.

38a Tulpius. *Obs.,* lib. I, obs. 8.

38b Schöpf, in Hufeland's *Journal der practischen Arzneikunde* [Journal of Practical Medicine], vol. XV, p. 2.

38c Chevalier, in Hufeland's *Neuesten Annalen der französischen Heilkunde* [Newest Annals of the French Medical Art], vol. II, p. 192.

But if the mania passes off, the tuberculosis immediately returns and kills, according to Reil.[38d]

5. When measles and smallpox were reigning at the same time, and both infected the same child, the measles that had already broken out was usually halted in its course by the smallpox that broke out somewhat later. The measles did not resume its course until after the smallpox healed.

Smallpox suspended measles.

6. [Manget, Hunter and Rainey all report cases of reaction to small-pox vaccination being suspended by measles.] Manget noticed that an eruption from smallpox vaccination was not-infrequently suspended for four days by the emergence of measles, resuming its course to the end after the desquamation of the measles.[38e] John Hunter reported that even six days after a smallpox vaccination had already taken, a case of measles broke out and the inflammation from the vaccination stood still. The pox did not break out until the measles had completed its course of seven days.[38f] Rainey wrote about many cases in a measles epidemic in which the measles came on four or five days after the smallpox vaccination and impeded the pox from forming. The pox came forth and ran its course only after the measles had completely run its course.[38g]

Measles suspended the formation of pox pustules following smallpox vaccination.

7. Sydenham's true, smooth, erysipelas-like scarlet fever[38h] with sore throat, was checked on the fourth day by the outbreak of cowpox, which ran its course fully to the end. Not until it was ended did the scarlet fever resume. But since these two diseases seem to be of

Cowpox suspended scarlet fever and scarlet fever suspended cowpox.

38d *"Mania phthisi superveniens eam cum omnibus suis phaenomenis aufert, verum mox redit phthisis et occidit, abeunte mania."* [Mania coming on top of tuberculosis removes it and all of its symptoms, but the tuberculosis soon returns and is fatal, once the mania departs.] (Reil, *Memorab.*, fasc. III, p. 171).

38e Manget, in *Medical Commentaries of Edinburgh,* vol. I, p. 1.

38f John Hunter, *On the Venereal Diseases,* p. 5.

38g Rainey, in *Medical Commentaries of Edinburgh,* vol. III, p. 480.

38h Sydenham's true, smooth, erysipelas-like scarlet fever is also very accurately described by Withering and Plenciz. It differs greatly from the pur-

Mania suppresses tuberculosis.

Confusion between scarlet fever and purpura miliaris

equal strength, it has also happened that scarlet fever suspended cowpox. Jenner reports that cowpox was interrupted on the eighth day by the beginning of a case of Sydenham's true, smooth scarlet fever. The red areola of the cowpox disappeared until the scarlet fever was over, whereupon the cowpox immediately resumed its course and went on to its regular termination.[38i]

Measles suspended cowpox.

8. Kortum observed a case of cowpox that was suddenly suspended near its fullness, on the eighth day, by the outbreak of measles. The cowpox remained stationary until after the desquamation of the measles, when the cowpox resumed its regular course to completion. It resumed its course in such a way that it appeared on the sixteenth day as it normally would have on the tenth.[38j]

Measles suspended smallpox vaccination.

9. Kortum also reported a case where a cowpox inoculation was given after the measles had already broken out. The inoculation took, but it ran its course only after the measles was over.[38k]

Smallpox vaccination suspended mumps.

10. I myself saw a case of mumps *(angina parotidea)* immediately disappear when a cowpox inoculation had taken effect and nearly attained its fullness. It was only after the full course of cowpox and the disappearance of its red areola that the feverish swelling of the parotid and submaxillary glands emerged again from its own miasm (the mumps) and ran its regular course of seven days. And so it is with all dissimilar diseases: the stronger suspends the weaker (unless they complicate one another, which is seldom the case with acute diseases) but they never cure one another.

§39

Aggressive allopathic medical treatments

For centuries, adherents of the ordinary school of medicine have seen the action of natural diseases upon one another. They have seen

38h *continued*
 pura miliaris (or roodvonk) fever which has also, falsely, been called scarlet fever. It is only in recent years that the two, which were originally very different diseases, have come to resemble each other in their symptoms.

38i Jenner, in *Medicinische Annalen* [Medical Annals], August 1800, p. 747.

38j Kortum, in Hufeland's *Journal der practischen Arzneikunde* [Journal of Practical Medicine], vol. XX, no. 3, p. 50.

38k Ibid.

that nature itself cannot cure a single disease through the supervention of another disease, be it ever so strong, if the supervening disease is *dissimilar* to the one that is already dwelling in the body. What must we think of this school of medicine that, nevertheless, has gone on treating chronic diseases allopathically, that is, with medicines and prescriptions capable of engendering God knows what disease state — invariably, however, one *dissimilar* to the malady to be cured?

Even if these physicians did not hitherto observe nature exactingly enough [to notice this], as a result of their procedure's miserable consequences, they should have become alive to the fact that they were pursuing a counterproductive, false path. Did they not see that their usual practice of using aggressive allopathic treatments against a protracted disease only created a *dissimilar* artificial disease that merely suppressed and suspended the original malady for as long as the treatment was kept up? Did they not see that the original disease always came to light again — and had to come to light again — as soon as the patient's decreased vitality no longer permitted the allopathic attacks on his life to continue? For example:

1. The itch diathesis eruption disappears quite soon from the skin through frequently repeated, violent purgatives, but when the patient can no longer endure the forced *(dissimilar)* intestinal disease and has to stop taking the purgatives, then either the skin eruption blooms as before or the internal psora develops some virulent symptom. Then the patient, in addition to his undiminished original malady, has to endure a painful deranged digestion and lost vitality.

2. If, in order to expunge a chronic disease, the ordinary physicians maintain artificial skin ulcers and fontanels on the exterior of the body, they can *never* attain their objective. They can *never* cure a chronic disease that way since such artificial disease ulcers are entirely foreign and allopathic to the internal suffering. However, since the irritation aroused through several fontanels is a *dissimilar* malady that is at least sometimes stronger than the indwelling disease, the original disease is sometimes silenced and suspended for a couple of weeks. But it is suspended for a very short time *only*, while the patient gradually wastes away.

merely suppress and suspend a chronic disease for as long as treatment is kept up, after which the disease always comes to light again, as bad as before or worse.

Purgatives suppress the itch diathesis.

Fontanels never cure chronic diseases.

Fontanels suppress
epilepsy.

3. Epilepsy, suppressed for many years by fontanels, continually comes to light, and in an aggravated form, when the fontanels are allowed to heal up, as Pechlin[39] and others attest.

Compound prescriptions
are just as allopathic and
attacking as purgatives
and fontanels.

4. Purgatives for the itch diathesis and fontanels for epilepsy cannot be more foreign, cannot be more dissimilar tunement-altering potences, cannot be more allopathic, more aggressive treatments than are the customary prescriptions, composed of unknown ingredients, used in ordinary practice for innumerable, nameless forms of disease. These prescriptions, also, merely debilitate. They suppress and suspend the malady for a short time only, without being able to cure it. Through protracted use, these prescriptions always add a new disease state to the old malady.

§40

Sometimes two diseases
of equal strength form a
complicated disease in
which each of the two
occupies a different part
of the body.

III. It can also happen that the *new disease,* after impinging for a long time on the organism, *joins the old one that is dissimilar to it,* and they form a *complicated* disease. Each disease takes in its own region in the organism, that is, it takes the organs especially appropriate for it. As it were, it takes only the peculiar place that is proper to it, leaving the rest of the organism to the dissimilar disease.

Venereal disease
complicated with psora

1. A venereal patient may become psoric and vice versa *but the two dissimilar diseases cannot lift one another; they cannot cure one another.* When the itch diathesis eruption begins to appear in a person with venereal disease, the venereal symptoms keep silent and become suspended. But in time (since the venereal disease is at least as strong as the itch diathesis) the two associate themselves with one another,[40a] that is, each takes for itself only those

39 Pechlin, *Obs, phys. med.,* lib. 2, obs. 30.

In complicated diseases of
itch diathesis and syphilis,
the two diseases exist side
by side rather than fusing
with one another.

40a From exact experiments and cures of complicated diseases of this kind, I am now firmly persuaded that no real fusion of the two diseases takes place. The two diseases exist *beside* one another in the organism, each in the parts that are suitable for it. The cure of the diseases will be completely produced by the timely alternation of the best antisyphilitic means with the best means for curing the itch diathesis [i.e., the best antipsoric medicine], each prepared in the most appropriate way and given in the most appropriate dose.

parts of the organism that are appropriate for it. The patient is thereby rendered more diseased and more difficult to cure.

2. When two dissimilar acute infectious diseases meet (such as small-pox and measles), one usually suspends the other, as has been adduced [§38]. There have, however, been rare instances in violent epidemics where two dissimilar acute diseases occurred simulta-neously in one and the same body and so, as it were, complicated themselves for a short time. [For example, there are several accounts of smallpox and measles occurring at the same time in one person.] In an epidemic where smallpox and measles reigned at the same time, there were close to 300 cases in which these dis-eases avoided or suspended one another. The measles would only break out twenty days after a smallpox outbreak befell a person, and the smallpox would only break out 17 to 18 days after a measles outbreak would befall someone such that the earlier dis-ease would first fully run its course. Nevertheless, Russel came across a case in which both dissimilar diseases were in the same person at the same time.[40b] Rainey saw the simultaneous occur-rence of smallpox and measles in two girls.[40c] Maurice states that he observed only two such cases in his entire practice.[40d] Similar cases are found in Ettmüller[40e] and in the writings of a few others.

Smallpox complicated with measles

3. Zencker saw cowpox retain its regular course along with measles and also with miliary fever.[40f]

Cowpox complicated with measles and miliary fever

4. A case of cowpox went on its way undisturbed during a mercu-rial treatment for syphilis, according to Jenner.

Cowpox complicated with syphilis treatment

§41

Incomparably more frequent than natural dissimilar diseases associ-ating and complicating themselves in the same body are those disease

Complicated diseases occur in nature, however

40b P. Russel, in *Transactions of a Society for the Improvement of Med. and Chir. Knowledge,* vol II.

40c Rainey, in *Medical Commentaries of Edinburgh,* vol. III, p. 480.

40d J. Maurice, *Med. and Phys. Journ.,* 1805.

40e Ettmüller, *Opera,* vol. II, pt. I, chap. 10.

40f Zencker, in Hufeland's *Journal der practischen Arzneikunde* [Journal of Practical Medicine], vol. XVII.

they result much more frequently from protracted allopathic treatment. The natural disease and the artificial medicinal disease pair up and render the patient doubly diseased.

complications that the inexpedient medical procedure (the allopathic mode of treatment) tends to bring to pass through the protracted use of unsuitable medicines. As a result of the persistent repetition of unfitting medicines, new, often very protracted disease states (corresponding to the nature of the allopathic medicines) associate themselves to the natural disease to be cured. These new disease states gradually pair up and complicate themselves with the dissimilar chronic malady that the unsuitable medicines could not cure through similar (i.e., homeopathic) action.

In this way, a new, dissimilar, artificial chronic disease is added to the old natural disease, thus making the hitherto simply diseased individual doubly diseased, that is, much more diseased and more incurable, sometimes even entirely incurable. This double disease often kills. Several disease cases presented for consultation in medical journals, as well as other cases in the medical literature, document this.

Cases of already complicated natural diseases, which are further complicated by allopathic treatment, are incurable or extremely difficult to cure.

Of the same kind are the frequent cases where syphilis is complicated with the itch diathesis, as well as the less frequent cases where syphilis is complicated with the wasting sickness of the figwart gonorrhea. These already complicated diseases are not cured under protracted, frequently repeated treatments with large doses of unfitting mercurial preparations. Rather, the already complicated disease takes its place in the organism beside the chronic mercurial wasting sickness[41] which has gradually been engendered. These form an often ferocious monster of complicated disease (under the general name of masked venereal disease) which is either entirely incurable or is only restored with the greatest difficulty.

Effect of large doses of mercury on syphilis and on complicated diseases involving syphilis

41 This occurs because mercury has in its mode of action, besides the symptoms which are similar to those of venereal disease (by which it can cure venereal disease homeopathically) still many other symptoms which are dissimilar to syphilis, such as bone-swelling, caries, etc. Therefore, the application of large doses of mercury, especially in the so-frequent complications of syphilis with psora, gives rise to new maladies and disturbances in the body.

§42

In some cases, as has been stated [§40], nature itself allows two (or even three) natural diseases to meet in one and the same body. However (as one must notice) this complication only occurs with diseases that are *dissimilar* to one another — diseases which, according to eternal natural laws, cannot lift, annihilate or cure one another. Indeed, it appears that the two (or three) diseases share the organism, as it were, each taking for itself the peculiarly appropriate parts and systems. Because of the dissimilarity of these maladies to each other, this can happen without detriment to the unity of life.

SIMILAR DISEASES

§43

The result is totally different when two similar diseases meet in the organism (i.e., when a stronger disease joins a similar one that is already present). Here we are shown *how* cure can result in the course of nature and *how* we ought to cure.

> When two similar diseases meet, the stronger new disease cures the older, weaker one.

§44

Two *similar* diseases can neither *fend off* one another (as was said about dissimilar diseases in point I, §36-§37) nor *suspend* one another so that the older disease comes again after the new one has run its course (as was shown about dissimilar diseases in point II, §38-§39). Nor can two *similar* diseases *exist next to one another* in the same organism, or form a *double* complicated disease (as has been shown about dissimilar diseases in point III, §40-§41).

§45

No! Two diseases, differing as to mode[45a] but very similar in their manifestations and actions, in the sufferings and symptoms they cause, always and everywhere annihilate one another as soon as they meet in the organism; that is, the stronger disease annihilates the

45a See footnote 26.

weaker one. It is not difficult to guess the cause of this: Due to its active similarity, the stronger additional disease potence claims, by preference, *precisely* the *same* parts in the organism that were, until then, affected by the weaker disease irritant. Consequently, the weaker disease can no longer impinge upon those parts, and it expires.[45b]

In other words, as soon as the similar but stronger disease potence masters the feeling of the patient, the life principle (on account of its unity) can no longer feel the weaker similar one. The weaker one is extinguished — it exists no more — for it never was anything material, but rather only a dynamic, spirit-like affection. The life principle remains affected only by the new, similar but stronger disease potence of the medication, although this is only temporary.

§46

Examples of cure by similar diseases:

There are many examples of diseases which, in the course of nature, have been homeopathically cured by other diseases with similar symptoms. Here, however, we wish to present only that information which is determinate and indubitable. For that reason, the cases presented below are limited to those (few) unvarying diseases which arise from a fixed miasm and hence merit a definite name. Prominent among them is smallpox which, on account of the great number of its violent symptoms, has already lifted and cured numerous maladies with similar symptoms.

Smallpox vaccinations have cured eye inflammations and blindness.

1. How common are the violent eye inflammations of smallpox that even mount to the point of blindness. Dezoteux[46a] reports one case and Leroy[46b] reports another in which smallpox vaccination completely and permanently cured a protracted eye inflammation. A blindness of two years duration which arose from suppressed scald-head completely yielded to a smallpox vaccination, according to Klein.[46c]

45b Just as the image of a lamp's flame is rapidly over-tuned and wiped away in the optic nerve by the stronger solar rays falling in our eyes.

46a Dezoteux, *Traité de l'inoculation* [Treatise on Inoculation], p. 189.

46b Leroy, *Heilkunde für Mütter* [Medical Art for Mothers], p. 384.

46c Klein, *Interpres clinicus* [The Clinical Interpreter], p. 293.

2. How often smallpox engenders deafness and dyspnea! J.Fr. Closs observed that smallpox lifted both of these protracted maladies as it climbed to its peak.[46d]

Smallpox has lifted deafness and dyspnea.

3. Testicular swelling, even very violent, is a frequent symptom of smallpox, and therefore smallpox could cure through similarity a large, hard swelling of the left testicle that arose from a contusion, as Klein[46e] observed. Another observer reports that it cured a similar testicular swelling.[46f]

Smallpox has cured testicular swellings.

4. Among the troublesome befallments of smallpox is a dysentery-like bowel movement. Wendt reports that smallpox, as a similar disease potence, conquered a case of dysentery.[46g]

Smallpox has conquered dysentery.

5. It is well known that when smallpox comes on shortly after a cowpox inoculation, it will at once, entirely lift the cowpox homeopathically, not allowing it to come to completion. This is due to its greater strength as well as its great similarity. If, however, the cowpox is near maturity when the smallpox comes on, then the cowpox, due to its great similarity to smallpox, will at least substantially diminish the smallpox (homeopathically) and make it much more benign,[46h] as Mühry[46i] and many others attest.

Smallpox has lifted recently inoculated cowpox, and cowpox inoculation has prevented or greatly diminished smallpox.

6. The lymph of the inoculated *cowpox* contains, in addition to the substance that protects against smallpox, a different substance

Inoculated cowpox has cured skin eruptions.

46d J.Fr. Closs, *Neue Heilart der Kinderpocken* [New Medical Mode for Child-pox], Ulm, 1769, p. 68, and *Specim.*, obs. 18.

46e Klein, op. cit.

46f *Nov. Act. Nat. Cur.*, vol. I, obs. 22.

46g Fr. Wendt, *Nachricht von dem Krankeninstitut zu Erlangen* [News from the Institute for Disease at Erlangen], 1783.

46h This seems to be the reason for the beneficent, remarkable result of the widespread use of Jenner's cowpox inoculation. Smallpox has never again appeared as epidemically nor as virulently. Forty to fifty years ago, a city would lose at least half and often three-quarters of its children from this wretched pestilence.

Effectiveness of Jenner's smallpox vaccine, made from cowpox

46i Mühry, in Robert Willan's *Über die Kuhpockenimpfung* [On Cowpox Inoculation].

which is tinder to a general skin rash of another nature. This rash consists of small dry (rarely, larger festering) pimples sitting on red patches. The pimples are often intermixed with red round skin patches. This rash, which not-infrequently itches violently, may appear several days before or, more often, *after* the red areola of the cowpox appears. It then passes away in a couple of days, leaving behind small, hard, red spots. There are many reports of children with skin eruptions, often very old and troublesome ones, being completely and permanently cured by the inoculated cowpox, after the inoculation takes in them. This is due to symptom similarity with the accessory miasm in the inoculated cowpox.[46j]

Cowpox has cured a swollen, half-paralyzed arm.

7. Cowpox, whose peculiar symptom is to cause arm swelling,[46k] cured after its outbreak, a *swollen*, half-paralyzed arm, according to Stevenson.[46l]

Cowpox has cured intermittent fevers.

8. The cowpox fever, which appears at the time the red areola arises, cured (homeopathically) two cases of intermittent fever, according to Hardege the younger.[46m] This confirms what John Hunter had already noticed: that two fevers (similar diseases) cannot exist in one body at the same time.[46n]

Measles temporarily protected children from whooping cough.

9. The fever of *measles*, and the quality of its cough, are quite similar to whooping cough. In one epidemic where both measles and whooping cough reigned simultaneously, Bosquillon noticed that

46j This has been reported by Clavier, Hurel and Desormeaux, in *Bulletin des Sciences Médicales,* publié par les membres du comité central de la Societé de Médecine du Départment de L'Eure [*Bulletin of the Medical Sciences,* published by the members of the central committee of the Medical Society of the Department of L'Eure], 1808; also in *Journal de Médecine Continu* [Journal of Continuing Medicine], vol. XV, p. 206.

46k Balhorn, in Hufeland's *Journal der practischen Arzneikunde* [Journal of Practical Medicine], vol. X, p. 2.

46l Stevenson, in Duncan's *Annals of Medicine,* lustr. II, vol. I., part 2, no. 9.

46m Hardege the younger, in Hufeland's *Journal der practischen Arzneikunde* [Journal of Practical Medicine], vol. XXIII.

46n John Hunter, *On the Venereal Diseases,* p. 4.

many children who had already had the measles remained free from the whooping cough.[46o] They would all have become free from whooping cough and uninfectable by measles in that and all subsequent epidemics if measles and whooping cough were more than just partially similar, that is, if whooping cough also had a skin rash similar to that of measles. For this reason, measles protected many, but not all, of the children and it did so only in the epidemic of whooping cough that prevailed at the time.

10. On the other hand, when *measles* meets a disease that is similar to it in its main symptom (i.e., the skin eruption) then it unquestionably lifts and cures the disease homeopathically. Thus a protracted eruption of herpes was cured at once, entirely and permanently,[46p] by an outbreak of measles, as Kortum observed.[46q]

Measles permanently lifted an eruption of herpes.

11. An extremely burning, miliary-like fever eruption on the face, neck and arms that was renewed by each change of weather and that had lasted six years, turned into a swollen skin surface upon accession of the measles. After the course of the measles, the miliary fever was cured and did not come again, according to Rau.[46r]

Measles cured a burning skin eruption with fever.

§47

It is impossible for there to be a more distinct and persuasive instruction for the physician than this, as to what manner of artificial disease potence (medicine) has to be selected in order to cure certainly, rapidly and permanently according to the process of nature.

§48

Neither in the course of nature, as we see from all the above examples, nor by the physician's art, can an existing suffering or ill-

46o Bosquillon, in Cullen's *Eléments de Médecine Pratique* [Elements of Practical Medicine] French translation, pt. II, I, 3, chap 7.

46p Or at least that symptom was taken away.

46q Kortum, in Hufeland's *Journal der practischen Arzneikunde* [Journal of Practical Medicine], vol XX, no. 3, p. 50.

46r Rau, *Ueber d. Werth des homöop. Heilverfahrens* [On the value of the homeopathic procedure of treatment], Heidelberg, 1824, p. 85.

being be lifted and cured by a dissimilar disease potence, be it ever so strong, but *solely by one that is similar in symptoms and is somewhat stronger*, according to eternal, irrevocable natural laws, which have hitherto been misconstrued.

§49

We would have been able to find many more natural, genuine homeopathic cures of this kind if the attention of observers had been more directed to them, and if nature were not so lacking in helpful homeopathic diseases.

WHY MEDICINES ARE BETTER AT CURING THAN ARE NATURAL DISEASES

§50

Disadvantages of diseases as instruments of cure:

[As instruments of homeopathic cure, natural diseases are lacking for the following reasons:]

Number of curative natural diseases available

1. Great nature itself has almost only the few established miasmatic diseases as aid: the itch diathesis, measles and smallpox.[50] Consequently, few diseases can be cured by other natural diseases.

Safety of use

2. Some of these disease potences (namely, smallpox and measles) are more life-threatening and atrocious than the maladies to be cured.

Duration of action

3. Others, like the itch diathesis, [are chronic]. After they have accomplished the cure of a similar disease, they themselves need curing in order to be eradicated in their turn.

Both of these circumstances [points 2 and 3 above] make their use as homeopathic remedies difficult, uncertain and dangerous.

Number of disease states curable by the fixed miasmatic diseases

4. How very few human disease states there are that find their similar (homeopathic) remedy in smallpox, measles or the itch diathesis! That is why, in the course of nature, only a very few maladies can be cured with these dubious and precarious homeopathic means.

50 And the above-mentioned skin-eruption tinder, found in the cowpox lymph [§46, p. 91-92].

5. Success shows itself only with danger and great ailment because Strength of the dose
the doses of these disease potences do not lend themselves to
reduction according to the circumstances as can be done with
medicinal doses. On the contrary, someone who is afflicted with
an old similar malady is covered over with the entire dangerous
and troublesome suffering — the entire disease of smallpox,
measles or the itch diathesis — in order to recover from the old
malady.

Nevertheless, from this fortuitous concurrence, we have some
beautiful homeopathic cures to exhibit. These are all so many
speaking vouchers for the single, great curative natural law that
governs in them: *Cure by symptom similarity!*

§51

This curative law became known to the capable human spirit from Advantages of medicines
such facts which were sufficient hereto. On the other hand, see what as instruments of cure:
advantages man has over the crude nature of chance events!

1. There are many more thousands of homeopathic disease potences Number of curative
available to us for the relief of our suffering brethren in the medi- potences available
cinal substances spread throughout creation. In them, we have
disease-engenderers of all possible varieties of action.

2. These disease potences (medicinal substances) can render homeo- Number of diseases
pathic aid for all the countless conceivable and inconceivable nat- curable by medicinal
ural diseases. substances

3. Once they have completed their curative application, the power Duration of action
of these medicines is conquered by the life force and disappears
of itself without requiring repeated help to expel it again, as is the
case with the itch diathesis.

4. The physician can dilute, divide, potentize and decrease the Strength of the dose
dosage of artificial disease potences to an infinite extent, to the
point where the medicine remains only slightly stronger than the
similar natural disease to be cured.

5. With this matchless curative mode, no violent attack upon the Safety of use
organism is required in order to extirpate even a stubborn old
malady. The cure takes place only by a gentle, unnoticeable and

yet often swift transition from the tormenting natural suffering to the permanent health that is desired.

HOMEOPATHIC VERSUS ALLOPATHIC MEDICAL TREATMENT

§52

Homeopathy is based on observation, experiment and experience while allopathy is based on assumptions and suppositions.

There are just two main modes of medical treatment, the homeopathic and the allopathic. The *homeopathic* mode bases all that it does on the exact observation of nature, careful experiments and pure experience. It has *never*, before me, been intentionally applied. The *allopathic* (or *heteropathic*) mode does not do this. Each mode is diametrically opposed to the other. Only a person who does *not* know both could surrender to the delusion that they could ever approach one another, let alone ever let themselves be united. Only such a person could make himself so ridiculous as to practice sometimes homeopathically and sometimes allopathically, according to the pleasure of the patient. Such a practice may be called a treasonous betrayal of divine homeopathy.

§53

The homeopathic curative mode

True, gentle cures only take place in a homeopathic way which, as we have found through experience and deduction (§7-§25), is incontestably the correct way. It is the way in which one attains the cure of diseases most certainly, rapidly and permanently, by means of art, because this curative mode rests upon an eternal, infallible natural law. The *pure homeopathic* curative mode is the only correct one, the single most direct curative way possible by means of human art, as certainly as there is only one single straight line possible between two given points.

§54

The allopathic mode of treatment

The *allopathic* mode of treatment has reigned since time immemorial, appearing in many different forms, called systems. It undertook many different things against disease but always only improper

ones (αλλοια [different ones]). Each of these systems, following one another from time to time and deviating quite a lot from one another, honored itself with the name of *rational medical art.*[54a]

Each builder of these systems had the haughty opinion of himself that he was able to behold and clearly discern the inner wesen of life in the healthy as well as the sick. Accordingly, he issued the prescription as to *what* damaging material[54b] was to be taken away from the diseased patient and *how* it was to be taken away in order to make him healthy. All of this was done according to empty presumptions and arbitrary presuppositions, without consulting nature sincerely or listening, without prejudice, to experience.

Diseases were declared to be states that always reappeared in pretty much the same manner. Therefore, most systems conferred names on their fictional disease images, and each system classified them differently. Based upon presumptions, actions that were supposed to lift and cure these abnormal states were attributed to different medicines (see the numerous pharmacological text books).[54c]

ANTIPATHIC MEDICAL TREATMENT

§55

Soon after the introduction of each of these systems and methods of treatment, the public was persuaded that adhering exactly to the system only increased and heightened patients' sufferings. One

Antipathic treatments deceive patients with rapid palliative relief.

54a As if a science that rests solely on observation of nature and that is only to be grounded in pure experiments and experience could be founded through idle brooding and scholastic reasoning.

54b For up to the most recent times one sought for a *material* to be taken away in the disease to be cured, since one could not lift oneself to the concept of a dynamic (*fn* 11) action of disease potences (such as medicines) upon the life of the animal organism.

Material view of disease

54c In order to fill the measure of their self-delusion to overflowing, there were always several, indeed many, different medicines compounded (very learnedly) into so-called prescriptions and administered frequently and in large doses. In this way precious human life, so easily destroyed, was

Use of compound prescriptions and other dangerous treatments

would have long since abandoned these allopathic physicians if it were not for the *palliative relief* obtained at times from certain empirically discovered means whose almost instantaneous flattering action was conspicuous to the patient. To some extent, this bolstered the physicians' credit.

§56

This *palliative (antipathic, enantiopathic)* method was introduced seventeen centuries ago, following Galen's teaching of *contraria contrariis.* By this method, physicians could still most certainly hope to win the trust of patients by deceiving them with almost instantaneous improvement. How fundamentally unhelpful and detrimental this mode of treatment is (in diseases not running a rapid course) we shall see from the following. It is certainly the only one of the allopaths' modes of treatment that has any manifest relation to a part of the symptoms of the natural disease, but what relation! Truly only an inverted one which should be avoided if we do not want to deceive or to mock the chronically ill patient.[56]

54c *continued*

endangered many times over in the hands of these perverse ones, especially since bloodletting, emetics, and purgatives were used as aids, and also drawing plasters, fontanels, setons, caustics and cauterization.

Isopathy

56 There are those who would like to create a third application of medicines against disease, through *isopathy* as it is called, namely, the cure of a present disease with the same miasm. But even granted that one could do this (since the miasm administered to the patient would be highly potentized and consequently changed) isopathy would nevertheless only produce a cure through a *simillimum* opposed to the *simillimo.* But this *wanting to cure* through the *an entirely identical* disease potence (per idem) contradicts all healthy common sense, and therefore also all experience. Those who first broached the subject of so-called isopathy presumably had hovering before them the benefit which humanity received through cowpox inoculation. Those who were inoculated remained free from all future smallpox infection and were cured of the disease in advance, as it were. But cowpox and smallpox are only very similar; they are in no way entirely the same disease. They differ from one another in

§57

In order to proceed antipathically, the ordinary physician focuses on a single troublesome symptom from among the many other symptoms of the disease which he does not regard. For this symptom, the physician gives a medicine that is known to bring forth the exact opposite of the disease symptom to be allayed, from which he can accordingly expect the speediest (palliative) relief. Age-old medicine has instructed him to do this for more than fifteen hundred years: *contraria contrariis.*

For example, the physician:

1. gives strong doses of opium for pains of all sorts because opium rapidly benumbs sensibility. He administers the same means for diarrhea, because it rapidly inhibits the peristaltic action of the intestinal canal and makes it immediately insensible. He also gives opium for insomnia because it rapidly brings to pass an anesthetizing, vacuous sleep.
2. gives purgatives when the patient has suffered long from constipation.
3. has a burned hand immersed in cold water, which (because of the cold) seems to momentarily spirit away the burning pain.
4. puts the patient who complains of chilliness and lack of vital heat into warm baths, which, however, only warm him momentarily.
5. has the person with protracted debilitation drink wine, whereby he becomes momentarily enlivened and refreshed.

Antipathic treatment focuses on a single disease symptom, bringing forth a medicinal symptom which is opposite to the disease symptom.

Opium for pain, diarrhea and insomnia

Purgatives for constipation

Cold water for burns

Warm baths for coldness

Wine for debilitation

many respects, namely in that cowpox has a more rapid course and is gentler, and especially in that cowpox never infects the human being through proximity. Widespread inoculation with cowpox so effectively put an end to all epidemics of the deadly, terrible smallpox that the present generation has no vivid conception of that former horrible smallpox-plague. In this way, to be sure, certain other animal diseases will present us with medicinal and curative potences for *very similar,* important human diseases, happily supplementing our stock of homeopathic medicines. But wanting to cure a human disease (e.g., the itch diathesis or maladies arisen therefrom) with an identical human disease matter (e.g., with a psoricum taken from the itch diathesis) is going too far! Nothing results from it but calamity and aggravation of the disease.

In like manner, the physician employs other antipathic relief measures, but he has only a few besides these, since the ordinary medical art only knows the peculiar initial action of a few means.

§58

Faults in the antipathic approach:

Only a small part of the whole disease is treated.

1. This is a *very faulty, merely symptomatic* treatment (see *fn* 7b) wherein only a *single symptom*, thus only a small part of the whole, is *one-sidedly* provided for. It is evident that aid for the totality of the disease, which is alone what the patient desires, is not to be expected.

After a short amelioration, antipathic treatments produce an aggravation of the whole disease.

2. Even if I wanted to pass over this circumstance in my judgement of this medicinal application, one must, on the other hand, ask experience: Has there ever been one single case in which such antipathic use of medicine against a protracted or persistent ailment did not (after accomplishing short-lasting relief) result in a greater aggravation of the ailment that was at first allayed in a palliative manner — an aggravation, indeed, of the entire disease? Every attentive observer will agree that, after such a short antipathic alleviation, aggravation results *every time and without exception*. The ordinary physician is, however, in the habit of giving his patient another explanation for this subsequent aggravation. He either ascribes it to the virulence of the original disease now revealing itself for the first time, or he ascribes it to the emergence of a new disease.[58]

Other writings about the aggravation resulting from antipathic treatment

58 Little as physicians have hitherto been given to observation, the certain aggravation resulting from such palliatives could not escape their notice. A striking example of this is to be found in J.H. Schulze's *Diss. qua corporis humani momentanearum alterationum specimina quaedam expenduntur* [Dissertation showing certain cases of brief alterations in the human body], Halae, 1741, §28.

Willis attests to something similar (*Pharm. rat.*, sec. 7, chap. 1, p. 298): "*Opiata dolores atrocissimos plerumque sedant atque indolentiam procurant, eamque aliquamdiu et pro stato quodam tempore continuant, quo spatio elapso dolores mox recrudescunt et brevi ad solitam ferociam augentur.*" [Opiates generally assuage the most severe pains and bring on insensibility, and they continue the insensibilitiy for some time and for a fixed period. When that period has elapsed the pains soon flare up again,

§59

Important symptoms of persistent diseases have *never* in this world been treated by such palliative opposites without the contrary occurring, without the return — indeed a manifest aggravation — of the malady after a few hours. For example:

1. For a protracted tendency to daytime drowsiness, the physician prescribed coffee due to its initial rousing action. When it had exhausted its action, the drowsiness increased.

2. For frequent waking at night, the physician gave opium in the evening, without heeding the other symptoms of the disease. Due to its initial action, opium brought on a stupefying, dull sleep, but the following nights were more sleepless than ever.

3. Chronic diarrheas were opposed by the initial constipative action of the very same opium, without regard for the other signs of disease. After a short retardation of the diarrhea, it became all the worse.

4. Frequently recurring pains of all sorts were suppressed for a short time with feeling-benumbing opium, then they always came back heightened, often intolerably heightened, or other far worse maladies came in their place.

5. For nocturnal cough of long standing, the ordinary physician is aware of nothing better than giving opium, whose initial action is to suppress every irritation. The cough falls silent on the first night perhaps, but it returns on subsequent nights all the more aggressively. If it is again and again suppressed by this palliative in highly increased doses, fever and night sweats also come.

Aggravation of symptoms by antipathic treatments

Coffee for daytime drowsiness

Opium for insomnia

Opium for diarrhea

Opium for various pains

Opium for nocturnal cough

and in short order increase to their accustomed severity.] And also on p. 295: *"Exactis opii viribus illico redeunt tormina, nec atrocitatem suam remittunt, nisi dum ab eodem pharmaco rursus incantantur."* [When the opium's strength is spent, the intestinal pains return straightaway, nor do they slacken their severity unless they are charmed away again by the same drug.]

In like manner, John Hunter (*On the Venereal Diseases*, p. 13) says that wine increases the active energy of weak people without imparting true strength. Afterwards, their vitality sinks as much as it was at first aroused so that they receive no advantage. In fact, vitality is, for the most part, lost.

Cantharides for weakness of the bladder

6. Weakness of the bladder, with consequent retention of urine, was sought to be conquered by means of the antipathic opposite, cantharis tincture, which provokes the urinary tract, forcing an initial voiding of urine. Subsequently, the bladder becomes even less stimulable and less able to contract until paralysis of the bladder is imminent.

Purgatives and laxative salts for constipation

7. With purgative medicines and laxative salts which, in strong doses, stimulate frequent intestinal evacuation, one meant to lift the old tendency to constipation, but in the after-action the bowels became still more constipated.

Wine for protracted debilitation

8. The ordinary physician claims to lift protracted weakness by means of wine. Wine rouses during the initial action, with the vitality sinking all-the-more deeply in the after-action.

Bitters and hot spices for a weak and cold stomach

9. By means of bitter substances and hot spices, the physician tries to strengthen and warm the long-lastingly weak and cold stomach, but in the after-action of these palliatives, which are only exciting in their initial action, the stomach becomes even more inactive.

Warm baths for chilliness and lack of vital heat

10. Long-persistent lack of vital heat as well as chilliness are supposed to yield to prescribed warm baths, but afterwards patients become all the more languid, colder and chillier.

Cold water for burns

11. Severely burned parts feel momentary alleviation, of course, upon treatment with cold water, but subsequently, the pain from the burns is incredibly increased. The inflammation spreads all around and climbs to an even higher degree.

Sternutatory means for protracted nasal blockage

12. By sternutatory means (errhines), one tries to lift an old inveterate catarrh, not noticing however, that by means of this opposite, it worsens more and more (in the after-action), the nose only getting more stopped up.

Electricity and galvanism for weak and almost paralyzed limbs

13. Limbs which were weak, almost paralyzed, for a protracted period of time were rapidly set into more active motion with electricity and galvanism, potences which, in the initial action, strongly stimulate muscle movement; but the consequence (the after action) was the entire deadening of all muscle-stimulability, and complete paralysis.

Bloodletting for congestion of blood

14. One claimed to take away the protracted rush of blood towards the head and other parts (e.g. heart palpitations) with bloodlet-

tings, but thereupon there always resulted greater blood congestion in these organs, stronger and more frequent heart palpitations, etc.

15. To treat the enervative torpor of the mental and bodily organs, paired with insensibility, which prevails in many kinds of typhus, practitioners of the common medicinal art are aware of nothing better than large doses of valerian, because this is one of the most robust rousing and mobilizing medications. Out of ignorance, however, they did not know that this is merely the initial action after which, in the after-action (counter-action) the organism lapses, every time and with certainty, into an all the greater stupor and immobility, that is, enervation of the mental and bodily organs, even death. These physicians did not see that precisely those patients given the most valerian (used in this case in antipathic opposition) were, unfailingly, the most likely to die.

Valerian for mental and bodily enervation

16. The old school physician[59] is jubilant to have forcibly slowed, for several hours, the small rapid pulse in cachexias with the first dose of digitalis purpurea, which slows the pulse in its *initial action*. However, the pulse's rapidity soon returns, doubled. Repeated, strengthened doses of digitalis produce less and less reduction of the pulse rate and finally none at all. Rather, the pulse becomes uncountable in the *after-action*. Sleep, appetite and vitality recede, and a speedy death is inevitable, unless insanity arises. How often, in a word, the disease was strengthened or something even worse was brought about by the after-action of such opposed (antipathic) means, the false theory does not realize, but experience teaches with horror.

Digitalis for a small rapid heartbeat

§60

When these ill-consequences arise from the antipathic employment of medicines (as may very naturally be expected) the ordinary physician believes he can aid his cause by giving, with each renewed aggravation, a stronger dose of the medicine. This results, likewise,

When these ill effects are countered with stronger and stronger doses of the antipathic medicine, a

59 See Hufeland's pamphlet *Die Homöopathie* [Homeopathy], p. 20.

in only a short-lasting pacification.[60] Since this necessitates an ever higher intensification of the palliative, there ensues either another greater malady or frequently even incurability, danger to life, or death itself, *but never cure* of a malady that is old or very old.

Broussais' system of
bloodletting, warm baths
and food deprivation

60 As one can see here, all ordinary palliatives for the patient's sufferings have for their after-action a heightening of the same sufferings. Therefore, the older physicians had to repeat the doses in ever stronger measure to bring forth a similar abatement which, for all that, was never permanent, never sufficient to prevent an amplified return of the suffering. Twenty-five years ago, Broussais contested, and in France ended, the senseless practice of mixing several drugs in one prescription (for which humanity is justly obliged to him) and he introduced through his so-called physiological system (without regard for the already widespread homeopathic medical art) a manner of treatment which was applicable to *all* human diseases and which, unlike the usual palliatives, *effectively* decreased patients' sufferings *while permanently hindering symptoms from returning worse than before.*

Being unable to really *cure* and restore health with mild, harmless medicines, Broussais found the *easier way* to gradually quell the sufferings of patients, more and more at *the cost to their life*, finally extinguishing the life entirely. Unfortunately, this treatment mode sufficed for Broussais' shortsighted contemporaries.

The more vitality the patient still has, the more striking are his ailments and the more vividly he feels his pains. He whimpers, he groans, he screams, he calls for help more and more strongly, so that bystanders cannot hurry fast enough to the physician in order to provide tranquility for him. For Broussais, it was only necessary to tone down the life force of the patient, to lower it more and more and see! The more frequently he had the patient bled and the more he had the life juice sucked out of him by leeches and cupping glasses (for the innocent irreplaceable blood was supposed to be guilty of almost all sufferings) the more the patient lost the power to feel pains or to express his aggravated state by vehement complaints and gestures. The weaker the patient becomes, the calmer he looks. Bystanders are pleased with his apparent improvement and hurry again to those means which already so beautifully calmed him and which give prospect of repeated tranquilization when the cramps, the asphyxiation, the anxiety attacks or the pains are on the point of renewing themselves.

In protracted diseases, if the patient was still somewhat energetic, he was already deprived of nourishment and made to stay on a bare subsistence diet in order to successfully tone down the life all the more and to put a stop to the disquieting states. The already so very debilitated patient feels himself incapable of protesting against further debilitation by bloodletting, leeches, blistering plasters, warm baths, etc., or to refuse them. That death must result with such *frequently repeated* reduction and exhaustion of the life force, the patient (less and less in command of his awareness) no longer notices. With respect to the last suffering of the patient, his relatives are so lulled to sleep due to some abatement of suffering by means of the bloodletting and lukewarm baths, that they are in wonderment at how the patient could so unexpectedly depart from them, right out from under their noses. "After all," they reason, "God knows he was not treated violently on his sickbed. The prick of the lancet for bleeding was not really painful; the gum Arabic solution *(eau de gomme,* almost the only medicine that Broussais allowed) was mild in taste and without visible action; the bite of the leeches was gentle and they quietly drew off the amount of blood prescribed; and the lukewarm baths could only have been soothing. So the disease must have been fatal from the beginning and the patient was meant to leave this earth, in spite of all the efforts of the physician." In this way, the relatives of the dearly departed consoled themselves — especially his heirs!

The physicians in Europe and elsewhere consented to this so *comfortable treatment of all diseases, using the same mold* [one size fits all] since it spared them all cogitation (the most laborious work under the sun!). They only had to worry about soothing the memories of conscience and perhaps consoling themselves that they were not the originators of this system and mode of treatment, that all the thousands of other followers of Broussais were doing the same thing, and that perhaps everything was over at death anyway as their master had publically taught them. Thus many thousands of physicians (unmindful of the thunderous words of the oldest of our lawgivers: "Thou shalt spill no blood, for the life is in the blood.") were miserably seduced into cold-heartedly spilling in streams the warm blood of their *curable* patients, thus *gradually* robbing millions more of their lives than ever fell tempestuously in Napoleon's battles.

Was it perhaps decreed by God that the system of Broussais, which medically destroyed the lives of curable patients, was to precede homeopathy in order to open the eyes of the world to the only true medical art? With homeopathy, all curable patients find recovery and revival when

HOMEOPATHIC VERSUS ANTIPATHIC
MEDICAL TREATMENT

§61

The homeopathic mode of cure, based on symptom similarity and minimal doses, is the exact opposite of the antipathic treatment of disease symptoms. Instead of transient relief followed by aggravation, there is permanent and perfect cure.

Had physicians been capable of reflecting upon such sad results of opposed medicinal application, they would have long since found the great truth: THE TRUE, ENDURING CURATIVE MODE MUST BE FOUND IN THE EXACT OPPOSITE OF SUCH AN ANTIPATHIC TREATMENT OF DISEASE SYMPTOMS. They would have become alive to the fact that, just as a medicinal action opposed to the disease symptoms (i.e., an antipathically employed medicine) provides only short-lasting relief, always bringing aggravation in its wake, so must the reverse procedure, the *homeopathic application of medicine* according to symptom similarity, necessarily bring to pass a permanent, complete cure, if the opposite of their large doses, namely the very smallest doses are given. But neither:

1. the short-lasting relief followed by aggravation that ensued from their antipathic treatments [§59], nor
2. the fact that no physician ever produced a permanent cure of old or very old maladies if a proactive homeopathic medicine was not by chance to be found in his prescription, nor
3. the fact that all rapid, complete cures ever brought to pass by nature (§46) were always produced only by means of a *similar* disease coming upon the old one,

led them, in the great span of centuries, to this sole cure-bringing truth.

INITIAL AND COUNTER-ACTIONS

§62

Whence stems the ruinous result of the palliative, antipathic procedure and the salutariness of the reverse homeopathic one is ex-

60 *continued*
 this most difficult of all arts is practiced purely and conscientiously by
 tireless and sharp-witted physicians.

plained by the following experiences, extracted from manifold observations. These never caught anyone's eye before me, no matter how near they lay and no matter how evident and endlessly important they are for curative purposes.

§63

Each life-impinging potence, each medicine, alters the tuning of the life force more or less and arouses a certain alteration of a person's condition for a longer or shorter time. This is termed the *initial action*. While the initial action is a product of both the medicinal energy and the life force, it *belongs more* to the impinging potence [of the medicine]. Our life force strives to oppose this impinging action with its own energy. This back-action belongs to our sustentive power of life and is an automatic function of it, called the *after-action* or *counter-action*.

Each potence that impinges upon the life force produces an initial action which elicits an automatic reaction from the life force, termed an after-action or counter-action.

§64

As seen from the following examples, during the initial action of the artificial disease potences (medicines) upon our healthy body, our life force appears to comport itself only conceptively (receptively, passively as it were) and appears as if it were forced to allow the impressions of the artificial potence impinging from without to occur in itself, thereby modifying its condition.

Initial action

The life force then appears to rally in one of two ways:

Counter-actions

1. Where there is such a one, the life force brings forth the exact opposite condition-state *(counter-action, after-action)* to the impinging action *(initial action)* that has been absorbed into itself. The counter-action is produced in as great a degree as was the impinging action (initial action) of the artificial morbific or medicinal potence on it, proportionate to the life force's own energy.

2. If there is no state in nature exactly opposite to the initial action, the life force appears to strive to assert its superiority by extinguishing the alteration produced in itself from without (by the medicine), in place of which it reinstates its norm *(after-action, curative-action)*.

§65

Examples of initial actions upon the life force which are followed by opposing counter-actions (point 1 above) are familiar to all:

1. A hand bathed in hot water is at first much warmer than the other unbathed hand (initial action), but once it is removed and thoroughly dried, it becomes cold after some time, and then much colder than the other hand (after-action).

2. A person heated by vigorous exercise (initial action) is afterwards assailed with chilliness and shivering (after-action).

3. To someone who yesterday was heated by drinking a lot of wine (initial action), today every light breeze is too cold (counter-action of the organism, after-action).

4. An arm immersed in the coldest water for a long time is at first far paler and colder than the other one (initial action), but once it is removed from the cold water and dried off it becomes not only warmer than the other but hot, red and inflamed (after-action of the life force).

5. Excessive liveliness results from drinking strong coffee (initial action) but sluggishness and sleepiness remain for a long time (counter-action, after-action) unless this is taken away over and over again by drinking more coffee (palliative for a short time).

6. The heavy, stuporous sleep caused by opium (initial action) is followed the next night by greater insomnia (counter-action).

7. After the constipation engendered by opium (initial action), diarrhea ensues (after-action).

8. After the purging produced by bowel-stimulating medicines (initial action), constipation of several days' duration results (after-action).

And thus, after each initial action of a potence that in large dosage strongly modifies the condition of the healthy body, our life force always and everywhere brings to pass, in the after-action, the exact opposite (when, as stated, there really is such).

§66

In the healthy body, with the impinging action of quite small homeopathic doses of tunement-altering potences, a conspicuous

opposed after-action will not be perceived. This is understandable. To be sure, all of these potences, in small doses, bring forth an initial action that is perceptible with due attention, but the living organism produces, in return, only as much counter-action (after-action) as is required for the restoration of the normal state.

perceptible initial action, but the life force's counter-action is inconspicuous.

INITIAL AND COUNTER-ACTIONS IN HOMEOPATHIC VERSUS ANTIPATHIC TREATMENTS

§67

These irrefutable truths, spontaneously presenting themselves from nature and experience, explain to us the helpful process in homeopathic cures. They also demonstrate the perversity of the antipathic and palliative treatment of diseases with opposite-acting medicines.[67]

Initial and counter-actions in homeopathic treatments

67 Palliatives or antagonistic treatments are only justified in highly urgent cases, in sudden accidents to previously healthy people where danger to life and imminent death permit no time for a homeopathic helping-means to act — not hours, quarter-hours or even minutes. Examples include cases of asphyxiation, apparent death by lightning, suffocation, freezing, drowning, etc. Only in such cases is it permissible and expedient, at least for the time being, to rouse the irritability and sensibility (the physical life) again by means of a palliative, for example, by gentle electric shock, clysters of strong coffee, excitative olfactory means [e.g., smelling salts], gradual warmings, etc. Once the physical life is again roused, the play of the life organs goes on its previous healthy course, because no disease is to be done away with here, but rather only an obstruction or suppression of the life force which, in itself, is healthy.[†]

Appropriate use of antipathic treatments for emergencies

† And yet, the new hybrid sect invokes this footnote (in vain) to encounter everywhere exceptions to the rule in diseases, and to smuggle in their allopathic palliatives accompanied by all their other ruinous allopathic rubbish. They do this simply to spare themselves the effort of searching out the apt homeopathic remedy in each case of disease, thus conveniently appearing to be homeopathic physicians without being such. But their deeds are in accordance with the system they pursue; they are pernicious.

§68

In *homeopathic* cures — following the uncommonly small medicinal doses (§275-§287) which are necessary in this curative mode and which were just sufficient, through symptom similarity, to over-tune the similar natural disease and drive it away from the feeling of the life principle — experience shows us that, at times, initially some small amount of medicinal disease still continues on *alone* in the organism after the eradication of the natural disease. However, because of the extraordinary minuteness of the dose, the transitory medicinal disease disappears so easily and so quickly by itself, that the life force has no more considerable counter-action to take up against this small artificial mistunement of its condition than the counter-action of elevating the current condition up to the healthy station (that is, the counter-action suitable for complete recovery) to which end, the life force requires little effort, after extinguishing the previous disease mistunement (see §64, point 2).

§69

Initial and counter-actions in antipathic treatments

In the antipathic (palliative) mode of treatment, just the reverse takes place. The medicinal symptom that the physician uses to oppose the disease symptom (for example, the insensibility and stu-por engendered by opium in its initial action against sharp, intense

67 *continued*

Also belonging in this category are various antidotes to sudden poi-sonings:

1. alkalis for swallowed mineral acids,
2. hepar sulphuris for metal poisonings,
3. coffee, camphor and ipecac for opium poisonings, etc.

Use of medicines that are homeopathic to the stronger, characteristic disease symptoms, but are antipathic to some of the less important disease symptoms

A homeopathic remedy is not necessarily inappropriately [unfittingly] selected for a case of disease just because it corresponds antipathically to some of the intermediate and minor disease symptoms. If the rest of the symptoms — the stronger, especially distinguished (characteristic) and exceptional symptoms of the disease — are covered and satisfied by the same medication through symptom similarity (homeopathically), that is, if they are over-tuned, eradicated and extinguished, so also do the few opposed symptoms fade away by themselves after the duration of action of the medication has elapsed, without in the least delaying the cure.

pain) is, to be sure, not foreign to the disease symptom; it is not fully allopathic. A manifest connection between the medicinal symptom and the disease symptom is visible, but it is the *inverse* connection. It is here intended that the annihilation of the disease symptom take place with an *opposite* medicinal symptom, which is impossible. To be sure, the antipathically selected medicine just as certainly touches the same disease point in the organism as the similar morbific, homeopathically selected medicine, but the antipathically selected medicine, as an opposite, only lightly conceals the opposed disease symptom, making it unnoticeable to our life principle for a short time only.

In the first moment of the impingement of the palliative, the life force feels nothing unpleasant from either the disease symptom or from the opposed medicinal symptom since both appear to have mutually lifted and, as it were, dynamically neutralized one another in the feeling of the life principle. For example, the stupefying energy of opium neutralizes pain. In the first minutes, the life force feels healthy and is sensible of neither the stupor of the opium nor the pain of the disease. However, the opposite medicinal symptom *cannot* (as in the homeopathic procedure) occupy the place in the organism (in the feeling of the life principle) held by the present disease mistunement as a *similar, stronger* artificial disease. It *cannot* (like a homeopathic medicine) affect the life principle with a very similar artificial disease so as to step into the place of the natural disease mistunement. Therefore, the palliative medicine must leave the disease mistunement uneradicated, since the medicine is entirely a deviation, through opposition, from the disease mistunement.

As has been said, the palliative medicine renders the disease mistunement initially unfeelable to the life force by a semblance of dynamic neutralization[69a] but it soon expires by itself, like every medicinal disease, and not only leaves the disease behind, as it was

69a In the living human being, no lasting neutralization of contending or antagonistic sensations takes place, as happens perchance with substances of opposing properties in the chemistry lab where, for example, sulphuric acid and potash unite themselves into quite another wesen [entity],

Unlike opposed chemical substances, opposed sensations in the human

before, but also (since, like all palliatives, it had to be given in large
dosage in order to achieve a pseudo-assuagement) compels the life
force to bring forth an opposite state (§63-§65) to the palliative
medicine, the opposite of the medicinal action. Hence, the similar
of the present unexpunged natural disease mistunement is pro-
duced. This addition which is brought forth by the life force (the
counter-action to the palliative) necessarily amplifies and augments
the natural disease mistunement.[69b]

The disease symptom (that single part of the disease opposed by
the palliative) *consequently becomes worse after the duration of action
of the palliative has lapsed. The symptom is all the worse, the larger
the dose of the palliative has been.* Therefore (to stay with the same
example) the larger the dose of opium given to conceal the pain, the
more the pain will increase its original intensity as soon as the
opium has exhausted its action.[69c]

69a *continued*

**sensorium do not
neutralize one another.**

a neutral salt, which then is no longer either acid or alkali and does not
break down again, even in fire. Such fusions and intimate unions into
something lastingly neutral and indifferent never take place, as was said,
during dynamic impressions of an opposed nature in the implements of
our sensibility [the sensorium]. Only a semblance of neutralization and
mutual suspension initially occurs, but the opposed feelings do not lift
[cancel] one another permanently. A sad person's tears are dried for only
a short time by an amusing play; however, he soon forgets the jests and
his tears flow more copiously than before.

**Misunderstanding about
initial and counter-actions**

69b As plain as this is, this concept has been misunderstood. Some people
have objected that the palliative should cure by means of its after-action
(which would be the similar to the present disease) just as well as the
homeopathic medicine cures by means of its initial action. What must be
understood is that the after-action is *never* an engenderment of the medi-
cine. Rather, it is *always* an engenderment of the counter-acting life force
of the organism. Therefore, when a palliative is administered (with an
initial action antagonistic to the disease symptom) the life force's counter-
action is a state similar to that of the disease symptom, which was left un-
expunged by the palliative. Consequently, the counter-action of the life
force amplifies the disease symptom.

**Antipathic treatment is
like a brief bright light.**

69c As in a dark dungeon, where the prisoner could only gradually, with
effort, make out nearby objects and suddenly a lamp is lit, all at once

SUMMARY OF THE PRINCIPLES OF CURE

§70

From what has already been submitted to the reader, the following can be stated unmistakably:

1. Everything that the physician can find that is really diseased and that is to be cured in diseases consists only in the state and the ailments of the patient and the alterations of his condition that are perceptible to the senses. In a word, they consist only in the totality of those symptoms by which the disease demands the suitable medicine for its aid. On the other hand, every inner cause falsely attributed to the disease, every hidden quality or fancied material disease matter is nothing but an idle dream.

2. This condition-mistunement, which we call disease, can only be brought to health by another tunement-alteration of the condition of the life force, by means of medicines whose single curative power can consist only in the alteration of the human condition, that is, in the peculiar arousal of morbid symptoms. The curative power of these medicines is discerned most distinctly and purely in provings of these medicines on the healthy body.

3. According to all experience, a natural disease can never be cured by a medicine that, of itself, can arouse in a healthy person a foreign disease state (dissimilar morbid symptoms) which is dissimilar to and *deviating* from the disease to be cured — never therefore by an allopathic treatment; that is, no cure is to be met with, even in nature, whereby an indwelling disease is lifted, annihilated and cured by a second supervening disease that is dissimilar to the first, even if the new one is ever so strong.

4. According to all experience, only a rapid transitory relief is produced by antipathic medicines, that is, medicines which have a tendency to arouse in the healthy person an artificial disease

A patient's totality of symptoms is all that is to be cured in a disease. By these symptoms, the disease demands the medicine suitable for its aid.

Disease can be converted into health through the use of medicines that have the power to alter the tunement of the condition.

Allopathic medicines can never cure disease, just as a natural disease cannot cure another, dissimilar natural disease.

Antipathic medicines can never cure disease; they only provide temporary

consolingly illuminating everything around the unhappy wretch. When the lamp is extinguished, however, the brighter the flame was previously, the blacker is the night which now envelops him, rendering everything about him more invisible than before.

alleviation of the
symptom followed by
aggravation.

symptom *opposite* to the single disease symptom to be cured. These antipathic medicines never produce a cure of an older ailment; rather, pursuant to the transitory alleviation, they produce an aggravation of the single disease symptom that was at first alleviated. In a word, this antipathic and merely palliative procedure is thoroughly inexpedient in older, serious maladies.

Homeopathic medicines,
which engender symptoms
most similar to the
totality of disease
symptoms, are the only
medicines that can
produce a cure of disease.

5. The third and only other possible procedural mode is the *homeopathic* one, by means of which a medicine is used for the *totality of the symptoms* of a natural disease — a medicine capable of engendering the most similar symptoms possible in healthy people. When given in suitable dosage, it is the only helpful curative mode whereby diseases, which are solely dynamic mistuning irritants, are over-tuned and extinguished in the feeling of the life principle by the stronger, similar mistuning irritant of the homeopathic medicine. The diseases, being thus easily, completely and permanently extinguished, necessarily cease to exist. For this procedural mode, free nature leads the way for us with its example of those accidental events in which a new, similar disease supervenes upon an old disease, whereby the old disease is rapidly and forever annihilated and cured.

WHAT A PHYSICIAN NEEDS TO KNOW TO CURE THE SICK

§71

It is now no longer a matter of doubt that human diseases consist merely of groups of certain symptoms which are only annihilated and transformed into health by means of medicinal substances capable of artificially engendering similar disease symptoms. Such is the process in all genuine cures. Therefore, the medical pursuit limits itself to the following three points:

Fathoming the disease

I. How does the physician investigate what he needs to know [be aware of] about a disease for curative purposes? [Chapters 2-3]

Fathoming the actions of
medicines

II. How does the physician investigate the implements ordained for the cure of natural diseases, the morbific potence of medicines? [Chapter 4]

III. How does the physician most expediently employ these artificial disease potences (medicines) for the cure of natural diseases? [Chapters 5-11]

Employing medicines expediently

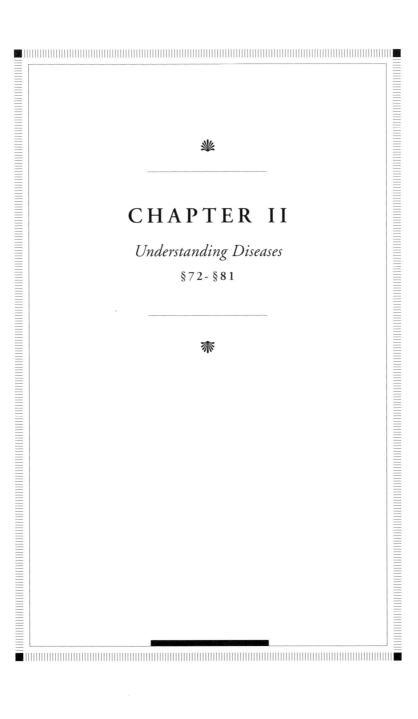

CHAPTER II

Understanding Diseases

§72-§81

DEFINITIONS OF ACUTE AND CHRONIC DISEASE

§72

With respect to the first item [§71], the following serves first of all as a general overview. The diseases of humanity are in part acute, and in part chronic. *Acute diseases* are rapid illness-processes of the abnormally mistuned life principle which are suited to complete their course more or less quickly, but always in a moderate time. *Chronic diseases* are those which (each in its own way) dynamically mistune the living organism with small, often unnoticed beginnings. They gradually so remove it from the healthy state [i.e., they gradually remove it from the healthy state in such a way and to such an extent] that the automatic life energy (called the life force, life principle) which was ordained to sustain health, opposes them. It does so, both in the beginning and in their continuance, with only imperfect, inexpedient, useless resistance. The life force, which cannot extinguish these diseases by its own power, in and of itself, must allow them to proliferate and it must allow its tuning to be more and more abnormally altered up to the final destruction of the organism. Chronic diseases arise from dynamic infection by a chronic miasm.

ACUTE DISEASES*

§73

Most individual acute febrile diseases are passing flare-ups of latent psora which then becomes dormant again.

An acute febrile disease that befalls a person individually is occasioned by malignities to which just this person has been particularly exposed. Examples of occasions of such acute fevers are excesses in pleasures or their deprivation, violent physical impressions [i.e., physical traumas], becoming chilled, becoming overheated, fatigue, strains from lifting, etc.; or psychical arousals, affects, etc. Fundamentally, however, individual acute fevers are mostly only transient

* Acute diseases may be individual, sporadic or epidemic. A few of the epidemic diseases are acute miasms.

flare-ups of latent psora which spontaneously returns to its dormant state if the acute fevers are not too violent and are soon dispatched.

Sporadic acute diseases attack several people at the same time, here and there, *sporadically*, occasioned by meteoric or telluric influences and malignities. Only a few people possess the receptivity to become disease-aroused at the same time.

Bordering sporadic diseases are those acute diseases that seize many persons with very similar complaints from a similar cause *(epidemically)*. These diseases tend to become contagious when they spread over thickly congregated masses of people. Then fevers arise.[73a] Each epidemic disease has a fever with its own nature. Since every case of disease in a given epidemic has the same origin, the disease puts all those who have fallen ill into the same kind of disease process. When left to itself, this disease process ends either in death or recovery in a moderate period of time. Epidemic diseases are not-infrequently occasioned and engendered by the calamities of war, floods and famine.

Some acute epidemic diseases are particular *acute miasms* that recur in the same manner and are therefore known by a traditional name. They either befall a person only once in a lifetime (such as smallpox, measles, whooping cough, mumps, or the old, smooth, bright red scarlet fever of Sydenham,[73b] etc.) or they are diseases that recur often in a rather similar way (such as the levantine plague, coastal yellow fever, Asiatic cholera, etc.).

Margin notes:

A sporadic acute disease attacks several people in different places at the same time.

An epidemic acute disease seizes many people at the same time in a very similar way, typically in places where people are thickly crowded. All cases in a given epidemic have the same origin.

Some epidemic diseases are acute miasms.

73a The homeopathic physician is not caught up in prejudices devised by the ordinary school, which established names for some fevers (outside of which, great teeming nature would not dare produce any others) in order to treat them according to a definite mold. The homeopathic physician does not acknowledge such names as dungeon fever, bilious fever, typhus fever, putrid fever, nerve fever, or mucous fever; rather, he cures each one according to its own peculiarity, without giving it a fixed name.

The homeopathic physician does not give fixed names to diseases that are variable.

73b Since 1801, physicians have been confusing a kind of purpura miliaris (roodvonk) that came from the West [Belgium] with scarlet fever, even though they have quite different signs. Scarlet fever (which was always epidemic) found its preventative and curative means in belladonna, while roodvonk (which was most often sporadic) found its preventative and

Treatment of purpura miliaris fever versus scarlet fever

CHRONIC AND OTHER PROTRACTED DISEASES*

§74

Chronic diseases caused by prolonged, violent allopathic treatment are the most incurable.

Among chronic diseases, we must unfortunately still include those widespread diseases that are artificially induced by allopathic treatments and by prolonged use of violent, heroic medicines in large and increasing doses — diseases induced by the misuse of calomel, mercury sublimate, mercurial ointment, silver nitrate, iodine and its ointment, opium, valerian, cinchona and quinine, digitalis, prussic acid, sulphur and sulphuric acid, perennial purgatives, bloodletting in torrents,[74a] leeches, fontanels, setons, etc. The life force is, in part, mercilessly weakened by these treatments and, in part (if indeed it does not succumb) it is gradually abnormally mistuned (by each means in its own peculiar way) to such an extent that, in order to uphold life against these hostile and destructive attacks, the life force must alter the organism, thereby:

1. taking away the arousability or the sensibility from this or that part, or heightening these unduly,

2. dilating or contracting parts,

73b *continued*

curative means in aconite. In recent years, the two diseases sometimes seem to have combined themselves into an eruptive fever of its own kind, for which neither aconite nor belladonna alone is exactly homeopathically fitting.

* Of the different kinds of protracted diseases, those caused by prolonged allopathic treatment and by chronic miasms are truly chronic. Other diseases linger due to obstacles to recovery.

Harmfulness of Broussais' treatment of bloodletting and starvation diet

74a Of all the methods which have been devised as help against disease, no more allopathic, no more nonsensical, no more inexpedient one can be thought of than Broussais' debilitating treatment of bloodletting and starvation diet which, over the course of the past several years, has spread throughout a large part of the world. No intelligent human being can think that there is anything medical, anything medicinally helpful about this treatment. Real medicine, even blindly seized and administered to the patient, has here and there improved a case of disease because it was acci-

3. slackening or hardening parts,
4. quite annihilating parts, or
5. bringing about organic defects here and there in the interior and exterior, crippling the body internally and externally.

dentally homeopathic, but from bloodletting, healthy common sense can expect nothing except the inevitable diminution and shortening of life.

It is a deplorable and completely groundless confabulation that most, indeed all, diseases consist of local inflammations. Even for true local inflammations, the most certain, rapid cure is to be found in medicines which dynamically take away the arterial irritation that lies at the base of the inflammation without the least loss of bodily fluids or vitality, while local blood withdrawals, even at the disease site, subsequently only increase the tendency to repeated inflammation of these parts. In general, in cases of inflammatory fever, it is just as inexpedient — in fact, it is murderous — to drain off many pounds of blood from the veins, since a little commensurate medicine takes away (often in a few hours) this arterial irritation that is driving the previously so quiet blood, along with the disease lying at its base, without the least loss of bodily fluids or vitality. Such a great loss of blood is manifestly irreparable for the rest of a patient's life. The organs intended by the Creator for the production of blood have been so deeply weakened that, even though they can manufacture blood in the same quantity, they can never again manufacture blood of equally good quality. It is impossible that the fancied plethora (which one decreed be drained off with multiple bloodlettings) could have been engendered so quickly since, after all, but an hour ago (before the shivery chills of the fever) the pulse of the now so hot patient still beat so quietly. No person, no sick person, ever has too much blood† or too much vitality. On the contrary, every sick person lacks vitality; otherwise his life principle would have warded off the emergence of the disease. Therefore, to cause an even greater debilitation in the already weak patient — the worst imaginable — by shedding his blood without taking away his disease (which, being only dynamic, can only be lifted through dynamic potences) is as nonsensical as it is cruel. It is merely a murderous malpractice founded on a theory snatched out of thin air.

† The only possible case of plethora occurs in a healthy woman a few days before her monthly period when she senses a certain fullness in her uterus and breasts, without any inflammation.

It alters the organism in order to protect it from complete destruc-
tion of life by the ever-renewed hostile attacks of such ruinous
potences.[74b]

§75

Of all the chronic diseases, these botchings of the human condition
brought forth by the allopathic calamitous art (at its worst in recent
times) are the saddest and the most incurable. I regret to say that
when they have been driven to some height, it seems to be impos-
sible to invent or devise any curative means for them.

§76

No human medical art can reverse the harm done by calamitous allopathic treatments.

Only for natural diseases has the all-beneficent One granted us help
through homeopathy. As for the unsparingly forced (often years long)
debilitations by means of false art (through wasting of blood, emaci-
ation, setons and fontanels) and the internal and external botchings
and cripplings of the human organism by harmful medicines and
inexpedient treatments, *the life force itself would have to reverse*
[countermand] them (with expedient help against any chronic miasm
that may still be lying in the background) if it has not already been
too debilitated through such misdeeds, and if it can spend several
years, undisturbed, for this enormous pursuit. A human medical art
for the normalization of the countless abnormalities so often wrought
by the calamitous allopathic art, there is not and cannot be.

Abnormalities found during autopsy are often caused by the treatment, not the disease.

74b If the patient finally dies, the physician who executed the treatment
 presents the inner organic deformities, found during the autopsy, as
 results of the original incurable malady instead of his artless treatment.
 See my book *Allopathy: A Word of Warning to All Sick Persons* (Leipzig:
 Baumgärtner) [translated in *The Lesser Writings*]. Illustrated anatomical
 pathology books, deceptive mementos, contain the products of such
 deplorable bunglings. *Autopsies are not typically performed on country peo-
 ple and the urban poor, who die of natural diseases without such bungling by
 detrimental means.* Of course, one would never find such corruptions and
 deformities in these cadavers. From this, one can judge the cogency of
 those beautiful illustrations and the integrity of the genteel writers of
 these books.

§77

Those diseases are improperly called chronic that are suffered by people who:

1. continually expose themselves to *avoidable* malignities,
2. habitually partake of harmful food or drink,
3. abandon themselves to intemperances of all kinds, which undermine health,
4. undergo prolonged deprivation of things that are necessary for life,
5. live in unhealthy places (especially marshy areas),
6. reside only in cellars, damp workplaces or other confined quarters,
7. suffer lack of exercise or open air,
8. deprive themselves of health by excessive mental or bodily exertions,
9. live in constant vexation, etc.

These kinds of ill-health that people bring upon themselves disappear spontaneously under an improved lifestyle, provided no chronic miasm lies in the body. These cannot be called chronic diseases.

Diseases caused by continual exposure to avoidable noxious factors are not true chronic diseases. Health returns spontaneously when the obstacle to cure is removed, provided there is no chronic miasm in the body.

§78

The true, natural, chronic diseases are those that arise from a chronic miasm. When left to themselves (without the use of remedies that are specific against them) these diseases go on increasing. Even with the best mental and bodily dietetic conduct, they mount until the end of life, tormenting the person with greater and greater sufferings. Besides those diseases that are engendered by medical malpractice (§74), these are the most numerous and greatest tormentors of human race, in that the most robust bodily anlage, the best regulated lifestyle, and the most vigorous energy of the life force are not in a position to eradicate them.[78]

True, natural chronic diseases arise from a chronic miasm.

78 In the most blooming years of youth and with the commencement of regular menstruation, coupled with a beneficial lifestyle for spirit, heart and body, these chronic diseases often remain indiscernible for several

Chronic miasmatic diseases often become dormant in one's youth,

§79

Syphilis

Until now, only syphilis has been known, to some extent, as a chronic miasmatic disease which, left uncured, only expires with the end of life.

Sycosis

Uncured sycosis (figwart disease) likewise cannot be eradicated by the life force. Sycosis was not recognized as an internal chronic miasm of its own kind, as it indisputably is. Rather, people believed that the disease was cured with the destruction of the outgrowths on the skin. They did not heed the continuing residual wasting sickness.

§80

Psora is by far the most important of the chronic miasms. It is the fundamental cause of countless forms of chronic disease.

The internal monstrous chronic miasm of psora is immeasurably more widespread, and consequently more significant, than the two chronic miasms just named. While syphilis marks its specific internal wasting sickness with the venereal chancre and sycosis does so with cauliflower-like growths, psora documents itself (only after the complete internal infection of the whole organism) by means of a peculiar skin eruption, sometimes consisting of only a few vesicles, accompanied by an unbearably tickling voluptuous itch and a specific odor. Psora is the true *fundamental cause* and engenderer of almost all the other remaining forms of disease which are numerous, indeed countless.[80]

78 *continued*

coming to the fore again with age and adverse circumstances.

years. Those afflicted appear in the eyes of their relatives and acquaintances as if they were completely healthy and as if the disease, implanted in them through infection or heredity, were completely vanished. However, it inevitably comes to the fore again in later years and with adverse events and relationships in life. The more the life principle has been deranged through debilitating passions, grief and worry, and especially through inexpedient, medicinal treatment, the more rapidly the disease increases and the more onerous its character.

Discovery of psora as the source of countless forms of disease

80 It took me twelve years of research to find the source of that incredible myriad of protracted sufferings, to investigate and to ascertain this great truth (which remained unknown to the former as well as the contemporary world) and at the same time, to discover the most excellent (antipsoric) remedies which were, for the most part, equal to this thousand-

In pathology books, these countless forms of disease are considered to be self-contained diseases with names such as: nervous debility, hysteria, hypochondria, mania, melancholia, imbecility, frenzy, epilepsy and convulsions of all kinds, bone-softening (rachitis), scrofula, scoliosis and kyphosis, bone caries, cancer, fungus hematodes, neoplasms, gout, hemorrhoids, jaundice and cyanosis, dropsy, amenorrhea and hemorrhage from the stomach, nose, lungs, from the bladder and the uterus, asthma and suppuration of the lungs, impotence and infertility, migraine, deafness, cataracts and blindness, kidney stones, paralyses, defects of the senses, and pains of a thousand kinds, etc.

§81

It is, to some extent, understandable how psora could now unfold itself in so many countless disease forms in all the human race since this age-old infectious tinder has gone, little by little, through many millions of human organisms over the course of hundreds of gener-

How psora came to manifest itself in such a wide variety of forms

headed monster of a disease in its so very different manifestations and forms. I have set forth my experiences about this in *The Chronic Diseases* (4 vols., Dresden: Arnold, 1828-1830; and 2nd ed. in 5 vols., [Düsseldorf]: Schaub). Before I was in the clear with this knowledge, I could only teach about the collected chronic diseases as isolated individual diseases to be treated with medicinal substances whose pure action had been proven in healthy people up until then. Therefore, each case of protracted disease was treated by my students in the same way as a peculiar disease (i.e., according to the symptom group that was met with in the case) and was often cured to such an extent that sick humanity could rejoice at the extensive remedial riches already amassed by the new medical art. How much more satisfying it can be, now that sick humanity has come so much closer to the desired goal, since the additionally found, far more specific homeopathic remedies for the chronic sufferings germinating forth from psora [the antipsoric remedies] have been published [in *The Chronic Diseases*], along with special instructions for their preparation and employment. From among these antipsoric remedies, the genuine physician can now select those whose medicinal symptoms correspond the most homeopathically to the chronic disease to be cured, thereby almost universally producing complete cures.

ations, thus attaining an incredible proliferation. This is all the more understandable when we consider the multitude of circumstances[81a] that have tended to contribute to the formation of this great diversity of chronic diseases (secondary symptoms of psora), as well as the indescribable variety of human congenital bodily constitutions, which already, in and of themselves, deviate so greatly from one another.

It is also no wonder that so many different malignities, impinging from within and without (often lastingly) upon such a variety of organisms permeated with the psoric miasm, would produce untold different deficiencies, deteriorations, mistunements and sufferings. These have been falsely listed in the pathology books, under a multitude of names, as diseases existing in and of themselves.[81b]

Circumstances that have contributed to the diversity of psoric disease manifestations

81a Some of these causes that modified the formation of psora into chronic maladies include:

1. climate and the particular natural quality of the location in which one lives,
2. very irregular upbringing of youth — the neglected, distorted or over-refined development of body or spirit,
3. misuse of body or spirit in one's vocation or in life relationships,
4. dietary regimen,
5. human passions,
6. customs, practices and habits of many kinds, etc.

The pathology books have also lumped a variety of different disease states under one name.

81b These books contain so many improper, ambiguous names, under each of which are included highly different disease states that often only resemble one another in a single symptom, for example: *ague, jaundice, dropsy, consumption, leukorrhea, hemorrhoids, rheumatism, stroke, convulsions, hysteria, hypochondria, melancholia, mania, quinsy, palsy,* etc. These are declared to be unvarying, fixed diseases in and of themselves and are dealt with according to the name, following ordinary established practice! How could the bestowal of such a name justify uniform medicinal management? And if the treatment is not always to be the same, then why use the identical name, which is misleading and presupposes the same treatment?

"Nihil sane in artem medicam pestiferum magis unquam irrepsit malum, quam generalia quaedam nomina morbis imponere iisque aptare velle generalem quandam medicinam" [Indeed, no more deadly evil has ever stolen

into the art of medicine than the imposition of certain general names on diseases as well as the wish to adapt a certain general medicine to them], says Huxham (*Op. phys. med.*, tome I), whose insight and sensitive conscience command respect. Likewise, Fritze (*Annalen* [Annals], vol I, p. 80) complains that essentially different diseases are called by one name.

Even those common acute diseases that are indeed able to propagate themselves *within each single epidemic* (by an infectious matter of their own which remains unknown to us) are documented by the old school of medicine as if they were already known, fixed diseases that always recur in the same form. [These are designated with names] such as *typhus fever, hospital fever, dungeon fever, camp fever, putrid fever, typhoid nerve fever, mucous fever* etc., even though every epidemic of such circulating fevers distinguishes itself each time as a different *new* disease, never before entirely extant, and diverging greatly as to its course, several of its most striking symptoms, and its entire conduct. Each epidemic differs so greatly from all preceding ones that one would have to disavow all logical conceptual precision to give them the same name and treat them the same, in accordance with this faulty label. Only the sincere Sydenham (*Opera.*, chap. 2, "De Morb. Epid.," p. 43) saw this, for he insists that no epidemic disease should be taken for any previous one and treated in the same way, since they are all indeed different from one another, howsoever many of them gradually appear:

Animum admiratione percellit, quam discolor et sui plane dissimilis morborum epidemicorum facies; quae tam aperta horum morborum diversitas tum propriis ac sibi perculiaribus symptomatis tum etiam medendi ratione, quam hi ab illis disparem sibi vindicant, satis illucescit. Ex quibus constat, morbos epidemicos, utut externa quatantenus specie et symptomatis aliquot utrisque pariter convenire paullo incautioribus videantur, re tamen ipsa, si bene adverteris animum, alienae esse admodum indolis et distare ut aera lupinis. [It strikes the mind with wonder how varied and clearly dissimilar are the presentations of epidemic diseases. The obvious diversity of these diseases is made sufficiently clear, both by their own characteristic and peculiar symptoms and by the methods of curing them, which in their difference from one another demonstrate the disparity. From which it follows that, however much some epidemic diseases may seem to the slightly incautious to agree in their outward forms and symptoms, in reality — if you pay careful attention — they are quite different in nature and stand apart from each other as real money does from play money.]

81b *continued*

From all this it becomes clear that these useless and wrongful disease names may not have any influence on the treatment mode of a genuine medical-art practitioner who is aware that he is to judge and to cure not according to the nominal similarity of a single symptom, but according to the entire complex of all the signs of the individual state of each single patient whose sufferings he has the duty to exactly spy out, never permitting himself to merely hypothetically presuppose them.

However, if one still believes that occasionally it is necessary to use certain disease names in order to be succinctly understood by ordinary people, then one should use these disease names only collectively and say, for example, that the patient has *a kind* of St. Vitus' dance, *a kind* of dropsy, *a kind* of nerve fever, *a kind* of ague; never however (so that the delusion in these names may finally cease once and for all) that he has *the* St. Vitus' dance, *the* nerve fever, *the* dropsy, *the* ague, since there certainly are not any fixed, unvarying diseases by these or any similar names.

CHAPTER III

Taking the Case

§82- §104

INDIVIDUALIZING THE EXAMINATION OF EACH
CASE OF DISEASE

§82

Careful investigation of
the case is needed for
individualized treatment
of disease.

With the discovery of psora, that great source of chronic diseases, and with the finding of more specific homeopathic remedies for psora, the medical art has come some steps closer to the nature of the majority of diseases to be cured. Even so, the homeopathic physician's duty to carefully apprehend the investigable symptoms and peculiarities of these diseases remains just as indispensable as before, for the formation of the indicator for each chronic (psoric) disease to be cured. No genuine cure of the psoric diseases, or any of the remaining diseases, can take place without the strict individualized treatment of each case of disease.

Differences in taking an
acute and a chronic case

In this investigation, some distinction is to be made between sufferings that are acute, rapidly arising diseases and those that are chronic. In acute diseases, the principal symptoms become more rapidly conspicuous and discernible to the senses so that a much shorter time is needed to note down the disease image. Since most of the acute disease presents itself spontaneously, there is much less that needs to be asked.[82] Gradually advanced, chronic diseases of several years duration are discovered far more laboriously.

GUIDELINES FOR CASE-TAKING

§83

This individualizing *examination of a disease case,* for which I am giving only general instructions here (and from which the disease examiner should retain only what is applicable to each single case) demands nothing of the medical-art practitioner except freedom from bias and healthy senses, attention while observing and fidelity in recording the image of the disease.

82 Therefore, the following schema for investigating symptoms only partly concerns cases of acute disease.

§84

The patient complains of the process of his ailments. The patient's relations tell what he has complained of, his behavior and what they have perceived about him. The physician sees, hears and notices through the remaining senses what is altered or unusual about the patient. He writes everything down with the very same expressions used by the patient and his relations. The physician keeps silent, allowing them to say all they have to say without interruption, unless they stray off to side issues.[84] Only let the physician admonish them to speak slowly right at the outset so that, in writing down what is necessary, he can follow the speaker.

Let the patient talk.

Obtain information from the patient's relations.

Observe the patient.

Write the case accurately.

Do not interrupt.

§85

The physician begins a fresh line with every new symptom or circumstance mentioned by the patient or relation so the symptoms are all ranged separately, one below the other. The physician can add to any one that is initially stated all-too-indefinitely, but afterwards more clearly.

Start a fresh line for each symptom or circumstance mentioned.

§86

When the narrator has finished what he wanted to say of his own accord, the physician enters a closer determination of each particular symptom in the following way: He reads through the single symptoms reported to him and asks for further particulars about this or that one. For example:

Ask for more precise information about each symptom.

1. At what time did this befallment take place?
2. Did the befallment occur before the medicine was used, while taking the medicine, or only some days after setting it aside?
3. What kind of pain, what sensation (described exactly) took place at this spot?
4. What exact spot was it?

84 Every interruption disturbs the narrator's train of thought. All he would have said at first does not occur to him again in precisely the same way after the interruption.

Why a patient's narrative should not be interrupted

5. Did the pain ensue in fits and starts at different times, or was it persistent, incessant?
6. How long did the pain last?
7. At what time of day or night, and in what position, was the pain the worst? At what time, and in what position, did it stop entirely?
8. Described in clear, plain words, how was the befallment or circumstance exactly constituted?

§87

Ask only open-ended questions.

In this way, the physician makes a closer determination of each single statement, without ever asking a question that would put words into the patient's mouth or that would be answerable with a simple yes or no. Otherwise, the patient would be misled into affirming something untrue or half-true or denying something that really exists, out of convenience or to please the interviewer, whereby a false image of the disease and an unsuitable mode of treatment must arise.[87]

§88

Ask general questions about any areas not mentioned.

If nothing has been mentioned in these voluntary statements about several parts or functions of the body, or about the patient's emotional mood, the physician should then ask what is still to be recalled with respect to these parts and functions and the mental and emotional state.[88] The physician should do this in general expressions only, so that the commentator is obliged to respond with specifics.

Avoid leading questions.

87 For example, the physician should not ask, "Wasn't this or that circumstance also present, perhaps?" The physician should never be guilty of seducing the patient into giving false answers and making false statements with any leading questions or suggestions.

Examples of general questions

88 For example:
1. How are the bowel movements?
2. How does the urine pass?
3. How is sleep, both during the day and at night?

§89

Only after the patient has finished freely relating the pertinent information upon simply being invited to do so, and upon being prompted [with general questions], thereby providing a fairly complete image of the disease, is it allowable and indeed necessary for the physician to ask more precise and specific questions if he feels he has not yet been fully informed.[89]

Ask more precise questions only after the patient has freely given his account.

4. How are the emotions, temper, mental power constituted?
5. How is the appetite, the thirst?
6. How is the taste in the mouth, all by itself?
7. What foods and drinks taste the best? Which ones are the most repugnant to the patient?
8. Does each food have its full natural taste or some other strange taste?
9. How is the patient after eating or drinking?
10. Is there anything to recall about the head, the limbs, the abdomen?

89 For example:

Examples of more specific questions

1. How frequent are his bowel movements? What is the exact quality of the stools? Was the whitish bowel movement, mucous or fecal matter? Were there any pains upon defecation, or not? Exactly what kind of pains and where?
2. What did the patient vomit?
3. Is the vile taste in the mouth putrid, bitter, sour, or something else? Does it come before, during or after eating or drinking? At what time of the day is it the worst? What is the taste of any eructations?
4. Does the urine become cloudy on standing or is it cloudy immediately upon being passed? What is its color when it is first passed? What color is the sediment?
5. How does the patient gesticulate and express himself in his sleep? Does he whimper, groan, talk or cry out in his sleep? Does he get frightened during sleep? Does he snore on breathing in or breathing out? Does he lie only on his back, or on his side; which side? Does he cover up snugly, or can he not stand being covered? Does he wake easily, or does he sleep too soundly? How does he feel immediately after waking?
6. How often does this or that ailment occur?
7. What occasions the ailment? Does it come on while sitting, lying, standing, or with movement? Only on an empty stomach, or at least

The patient's own account
of his sensibilities is
usually the most reliable.

Of the accounts received from the patient and from others, most belief is to be attributed to the patient's own account with respect to his sensibilities (except in feigned diseases).

§90

Observe the patient and
note which indications
were present during
health.

When the physician has finished writing down these statements, he then notes what he himself perceives about the patient,[90] and he inquires as to what [of all these indications] was proper to the patient in his healthy days.

89 *continued*

 early in the morning? Only in the evening, or after a meal, or when does it usually occur?

 8. When did the chill come? Was it only a chilly sensation or was the patient cold at the same time? In what parts? Or was the patient hot to the touch during the chilly sensation? Was it merely a sensation of cold without shivering? Was he hot without being flushed in the face? What parts were hot to the touch? Or did he complain about heat without being hot to the touch? How long did the chill last; how long the heat? When did the thirst come? With the chill? With the heat? Before or after the heat or the chill? How strong was the thirst and for what? When did the sweat come? At the beginning or at the end of the heat? Or how many hours after the heat? While asleep or while awake? How strong was the sweat? Was it hot or cold? On which parts? What was the odor? What ailments did the patient complain of before or with the chill? With the heat? After the heat? With or after the sweat?

 9. With respect to the female gender, how are the menses or other discharges? etc.

Examples of the
physician's observations

90 For example:

 1. How does the patient gesticulate during the visit?

 2. Is he vexed, quarrelsome, hasty, inclined to weep, anxious, despairing or sad; or is he comforted, calm, etc.?

 3. Is he drowsy or generally dull-witted?

 4. Does he speak in a demanding manner, very faintly, inappropriately, or in any other way?

 5. How is the color of his face and eyes, and the color of his skin in general?

 6. How is the vivacity and energy of his expression and eyes?

§91

The befallments and condition of a patient during some previous course of medication do not give the pure image of the disease. On the other hand, symptoms and ailments suffered *before the use of the medicine or several days after discontinuing its use* give the genuine, fundamental concept of the *original* gestalt of the disease, and the physician must record these in particular.

Treatment of patients on medication

When the patient has a protracted disease and has been taking medicine up until the time of the visit, the physician could also leave him several days entirely without medicine or give him something non-medicinal [i.e., a placebo], postponing for several days the more exact scrutiny of the disease signs in order to apprehend the enduring, unmixed symptoms of the old malady in their purity, and then be able to sketch an unmistakable image of the disease.

§92

If, however, the disease is one that runs its course rapidly and whose urgent state admits of no delay, and if the physician cannot ascertain what symptoms were present prior to medication, then the disease state altered by the medicines must suffice for him. He will at

7. How is the tongue?
8. How is the smell of the mouth?
9. How is the respiration?
10. How is the hearing?
11. How much are the pupils dilated or constricted? How rapidly do they alter in the dark or light?
12. How is the pulse?
13. How is the abdomen?
14. How damp or dry, cold or hot to the touch is the skin in general, or this or that part of it?
15. Does the patient lie with his head bent back? With his mouth half or wide open? With his arms placed over his head? Does he lie on his back or in another position?
16. With what exertion does the patient straighten himself up?
17. Anything else the physician can perceive about him that is strikingly noticeable.

least be able to put together the present gestalt of the malady (that is, the original disease united with the medicinal disease) into a total image. Due to the use of inexpedient means, the medicinal disease united with the original disease is usually more extensive and dangerous than the original disease, and thus often urgently requires an expedient aid. The physician will then be able to conquer this disease with a fitting homeopathic remedy so that the patient will not die of the damaging medicine he has taken.

§93

Investigate events that caused or occasioned the disease.

If the disease has been caused by a remarkable event — either recently or, in the case of a protracted malady, some time ago — the patient (or at least his relations, when questioned privately) will then readily declare it, either of his (or their) own accord or upon cautious inquiry.[93]

§94

Carefully consider circumstances that may act as obstacles to recovery.

While inquiring into the state of a chronic disease, carefully ponder and scrutinize the particular affairs of the patient (ordinary occupations, usual living habits and diet, situation at home, etc.) to find out what there is in them that may arouse or maintain disease, and whose removal may further recovery.[94]

Find out about any dishonoring occasions of disease.

93 Through astutely phrased questions or other private inquiries, the physician must seek to trace the possible dishonoring occasions of diseases which the patient or his relations do not readily confess, at least not of their own free will. To these belong: poisoning or attempted suicide; onanism; debaucheries of common or unnatural lust; overindulgence in wine, liquor, punch or other heating drinks, tea, or coffee; gluttony in general or with particular detrimental foods; infection with a venereal disease or with the itch diathesis; unhappy love; jealousy; domestic discord; vexation; grief over family misfortune; abuses; dogged revenge; offended pride; financial problems; superstitious fear; hunger; or perhaps bodily infirmity in the private parts (e.g., a hernia, a prolapse), etc.

Factors to consider in chronic diseases of women

94 In chronic diseases of women, one should pay special attention to such things as pregnancy, infertility, sexual desires, deliveries, miscarriages, breast-feeding, vaginal discharges and the state of the menses. With particular regard for the menses, the following should be ascertained:

§95

In cases of chronic disease, the investigation of the above mentioned and all remaining signs of disease must be conducted as carefully and minutely as possible, and one must go into the smallest details. This is because:

Pay special attention to the smallest details in cases of chronic disease.

1. In chronic diseases, these details are the most peculiar and least resemble the signs of rapidly passing [acute] diseases. These cannot be taken too exactly if a cure is to be achieved.

2. Chronically ill patients become so accustomed to their long sufferings that they pay little or no attention to the smaller, often very characteristic accompanying befallments which are so decisive in singling out the remedy. They view them as almost a part of their natural state, nearly mistaking them for health, whose true feeling they have fairly well forgotten during the course of their fifteen to twenty year long suffering. It hardly occurs to them to believe that these accompanying symptoms, these remaining smaller or greater deviations from the healthy state, could have a connection with their main malady.

§96

Patients vary widely in their cast of emotional mind. Some present their complaints in a far too glaring light, characterizing their ailments with extravagant expressions in order to incite the physician

Patients differ in how they describe their complaints.

1. Does the menstrual period recur at intervals that are too short or too long?
2. How many days does it last?
3. Is the flow continuous or interrupted at intervals?
4. How heavy is it?
5. How dark is its color?
6. Is there leukorrhea? If so, is it before or after the menstrual flow? How is it constituted? What sensations attend its flow? What is the quantity? Under what conditions does it occur? What brings it on?
7. Especially, what ailments of body and soul, and what sensations and pains does the patient have before, during and after a menstrual period?

to help them. These patients are, above all, the so-called hypochondriacs and those other very feeling and insufferable persons.[96]

§97

Patients of an opposing stamp hold back a host of ailments, characterize them in vague terms, or declare several of them to be insignificant. (They do so partly from languor, partly from false modesty, and partly from a kind of genteel mentality or bashfulness.)

§98

Give the most credence to the patient's own words, but also investigate the case with circumspection, scrupulousness, knowledge of human nature, cautious inquiry and patience.

It is certain that, on hearing about a patient's ailments and sensibilities, one has to ascribe belief principally to the patient himself, especially to his own expressions with which he can render an account of his sufferings. (These are wont to be altered and falsified in the mouths of relations and attendants.) However, it is just as certain that the investigation of the true complete image of the disease and its details requires (with all diseases, but principally with the protracted ones) special circumspection, scrupulousness, knowledge of human nature, cautious inquiry and patience — all to a high degree.

§99

In acute cases, the physician needs to ask fewer questions.

On the whole, the inquiry into acute or otherwise recently arisen diseases is easier for the physician because all befallments and deviations from health but recently lost remain still fresh in memory, still new and conspicuous for the patient and his relations. Here

Accuracy of symptom reporting by fabricators of disease, the insane and hypochondriacs

96 A pure fabrication of befallments and ailments will never indeed be met with in hypochondriacs, even the most insufferable ones. This is demonstrated by a comparison of the ailments they complain of at different times while the physician gives them nothing at all or something unmedicinal [i.e., a placebo]. However, something must be deducted from their exaggerations, or at least the strength of their expressions should be attributed to their excessive feeling. The high pitch of their expressions about their sufferings becomes, in itself, a significant symptom in the remaining set of symptoms from which the image of the disease is to be composed. It is a different matter with the insane and the willful fabricators of disease.

also, of course, the physician must know [be aware of] everything; however he needs to *investigate* far less since, in large part, everything is told to him spontaneously.

§100

In the investigation of the symptom complex of epidemic or sporadic diseases, it makes no difference if something similar has ever appeared before under the same or any other name. The novelty or peculiarity of such a contagion makes no difference, either in its examination or its cure, since the physician presupposes that the pure image of each and every presently reigning disease is new and unknown. He must explore it for himself from the ground up if he wants to be a genuine, thorough medical-art practitioner who never puts conjecture in the place of perception and never assumes (without carefully spying out all of the disease manifestations) that the treatment for a case of disease entrusted to him is either entirely or partially known. This is all the more the case here since each reigning epidemic is in many regards a phenomenon of a particular kind that is found, by exact investigation, to deviate greatly from all former epidemics (which have been falsely labeled with certain names). This is true of all contagious diseases except those that stem from an invariable infectious tinder, such as smallpox, measles, etc.

> Take a thorough case when investigating an epidemic or sporadic disease. With few exceptions, each reigning epidemic differs from all previous ones.

§101

It may well be that the physician does not get a perception of the complete image of the epidemic disease with the first case he encounters since each such collective disease only brings the complex of its symptoms to the light of day with the closer observation of several cases. Meanwhile, the carefully investigating physician can often come so close to the true state, even with the first or second patient, that he becomes alive to the characteristic image of the disease, and then finds a fitting, homeopathically commensurate remedy for it.

> The symptom complex of an epidemic disease only comes to light through the observation of several cases involving different bodily constitutions.

§102

Upon recording the symptoms of several cases of this kind, the sketch of the disease image becomes more and more complete —

not larger and more verbose, but more characteristic, more encompassing of the peculiarity of this collective disease. On one hand, the general signs (e.g., loss of appetite, sleeplessness) obtain their own narrower determinations. On the other hand, the more marked, particular, and (at least in this connection) rarer symptoms, belonging to only a few diseases, emerge and form what is characteristic for this epidemic.[102]

To be sure, all those afflicted by the epidemic at that time have the *same* disease, flowing from one and the same source. However, the entire extent of such an epidemic disease and the totality of its symptoms (knowledge of which belongs to the overview of the complete disease-image, so one can choose the most fitting homeopathic remedy for this symptom-complex) cannot be perceived in a single patient, but can only be completely abstracted and gathered [inferred] from the sufferings of several patients of different bodily constitutions.

§103

Chronic miasmatic diseases are collective diseases with an extremely large totality of symptoms. The wesen of the many different forms of psoric disease is the same, just as different cases of disease in the same epidemic are, in essence, the same disease.

Just like the mostly acute epidemics [§102] the chronic wasting sicknesses remain the same as to their wesen. Just as I did with the epidemics, I had to investigate the chronic wasting sicknesses (namely and principally psora) much more exactly than ever before. I had to do this because of the extent of the symptoms in these chronic diseases and also because one patient carries only a part of the symptoms in himself, while a second or third patient, etc. suffers from some other befallments which likewise, as it were, are only a part torn off from the totality of the symptoms that make up the entire extent of the one and the same disease. Therefore, the complex of all the symptoms belonging to such a miasmatic wasting sickness (in particular, psora) can only be ascertained from *very many* such individual chronic patients. Without such a complete overview and

Finding the most fitting homeopathic remedy for an epidemic disease

102 For the physician who has already, in the first cases, been able to choose a remedy that approximates the specifically homeopathic one, subsequent cases will either confirm the suitability of the chosen medicine or direct the physician to an even more fitting, the most fitting homeopathic remedy.

total image, the medicines that are homeopathically curative for the whole wasting sickness (namely the antipsorics) cannot be searched out. These medicines are, at the same time, the true remedies for the individual patients that are suffering from these chronic maladies.

USES OF A WELL-TAKEN CASE

§104

Once the totality of the symptoms that principally determine and distinguish the disease case — in other words, the image of any kind of disease — has been exactly recorded,[104] the most difficult work is done. During the treatment (especially of a chronic disease), the medical-art practitioner then has the total disease image always before him. He can behold it in all of its parts and lift out the characteristic signs. He can then select (from the lists of symptoms of all the medicines which have become known according to their pure actions) a well-aimed similar, artificial disease potence, in the form of a homeopathically chosen medicinal means, to oppose the total disease image. During treatment [at a follow-up examination of the patient], when the medical-art practitioner inquires as to the result of the medicine and the altered condition of the patient, all he needs to do with his new disease findings is refer to the original list of symptoms and omit those that have improved, note what is still present, and add whatever has, perchance, come up in the way of new ailments.

104 In their treatments, the physicians of the old school made it extremely easy for themselves in this regard. They made no exact inquiry about all of the patient's circumstances. Indeed, the physician often interrupted patients in the account of their individual ailments in order not be disturbed in the rapid writing up of the prescription, which was compounded of several ingredients that were unknown to the physician as to their true action. No allopathic physician, as said, insisted upon learning all the exact circumstances of a case, and *still fewer of these circumstances did he ever write down.* When he saw the patient again after several days, he was aware of little or nothing about the few circumstances he had

The old school method of case-taking and case management

104 *continued*

heard at first since he had seen so many other, different patients since
then. He had let it all go in one ear and out the other. At subsequent vis-
its, he only asked a few general questions, made as if he felt the pulse and
looked at the tongue before writing another prescription (likewise with-
out reason) or continuing the first, in more handsome portions several
times a day, then he hurried off with elegant gestures to thoughtlessly
visit the fiftieth or sixtieth patient of the morning. This is how the most
cogitative of all pursuits — the conscientious, careful investigation of the
state of each single patient, and the special cure to be grounded thereon —
was practiced by people who called themselves physicians and *rational
medical-art practitioners*. The result was almost invariably bad, as is nat-
ural. Patients had to go to such people partly because there was nothing
better and partly for the sake of etiquette and established convention.

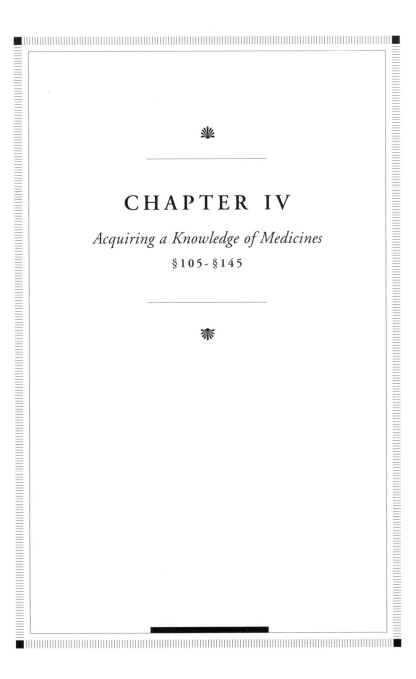

CHAPTER IV

Acquiring a Knowledge of Medicines

§105-§145

PROVINGS

§105

The *second item* of business for the genuine medical-art practitioner concerns *the investigation of the implements appointed for the cure of natural diseases*, the investigation of the disease-making power of medicines, in order (where there is something to be cured) to be able to single out one medicine from whose set of symptoms an artificial disease can be composed that is as similar as possible to the totality of main symptoms of the natural disease to be cured.

§106

The symptoms that are engendered by each medicine must be observed by giving the medicine to healthy people.

The entire disease-arousing efficacy of the individual medicines must be known; that is, all the disease symptoms and condition-alterations that each medicine is especially able to engender in healthy people must first have been observed before one can hope to be able to find and select from among the proven medicines, the apt homeopathic remedy for most of the natural diseases.

§107

A medicine's actions cannot be distinctly perceived in a sick person because the medicinal alterations are confounded with the symptoms of disease.

If, in order to perform this investigation, medicines are only given to *sick* persons (even when only one simple and singly prescribed medicine is given) one sees little or nothing definite of their pure actions since the particular condition-alterations expected from the medicines are mingled with the symptoms of the present natural disease, and are therefore seldom distinctly perceptible.

§108

Medicinal actions must be studied by observing what alterations of condition are brought forth in healthy persons by moderate amounts of single medicines.

Therefore there is no other possible way to unerringly experience the peculiar actions of medicines upon the human condition — there is no single, surer, more natural arrangement for this intent than to administer each single medicine experimentally, in a moderate amount, to *healthy* persons in order to learn what alterations, symptoms and signs of its impinging action each medicine particularly brings forth in the condition of body and soul, that is, what

disease elements each medicine is able to and tends to arouse.[108] As has been shown (§24-§27), all of a medicine's curative power lies in its power to alter the human condition; this is illuminated from observation of the human condition.

§109

I was the first to blaze this trail with a perseverance that could only arise and be maintained by the great truth speeding humanity that the certain cure of human diseases is only possible[109a] through the

108 As far as I am aware, not one single physician in the past 2500 years came upon this so natural, so absolutely necessary, sole genuine test of the pure, peculiar tunement-altering actions of medicines upon the human conditon in order to learn what disease states each medicine is capable of curing, except the great and immortal Albrecht von Haller. In the preface to his *Pharmacopeia* (Basel, 1771, p. 12 fol.), he states:

> *Nempe primum in corpore* sano *medela tentanda est,* sine peregrina ulla miscela; *odoreque et sapore ejus exploratis, exigua illius dosis ingerenda et ad omnes, quae inde contingunt, affectiones, quis pulsus, qui calor, quae respiratio, quaenam excretiones, attendendum. Inde ad ductum phaenomenorum, in sano obviorum, transeas ad experimenta in corpore aegroto, etc.* [In truth a remedy must first be tried on a *healthy* body *without any foreign admixture.* Once one has tested its odor and taste, one should take a small portion of the dose and pay attention to any effects which ensue: what are the pulse rate, the temperature, the respiration rate, the excretions. After observation of the succession of clear effects in a healthy body, one may proceed to trials on a sick one, etc.]

Though not a practicing physician, he alone besides me saw the necessity of doing this, but *nobody,* not one single physician, paid attention or followed these, his inestimable hints.

109a It is impossible that there can be another true, best method of curing dynamic (i.e., non-surgical) diseases besides pure homeopathy, just as it is impossible to draw more than one straight line between two points. A person who imagines that there are other modes of curing diseases could not have gotten to the bottom of homeopathy [i.e., fundamentally understood it] or practiced it with sufficient care, nor could he have seen or

Previous writings on provings

Homeopathy is the only true method of curing dynamic diseases.

homeopathic use of medicines.[109b]

§110

Symptoms from poisonings
agree with those from
provings.

In the medical literature, there are reports of poisonings where healthy individuals (accidentally, for the purposes of suicide or murder, or under other circumstances) ingested large amounts of a medicinal substance. I have seen that the actions of the morbid malignities described in these reports agreed with my observations upon testing the same substances on myself and other healthy individuals. The writers of these toxicological reports recorded these previous cases as proof of the disadvantage of these violent things, usually only to warn against them; partly also to extol their art when, while using their means against these dangerous befallments, recovery gradually set in; and partly, when people thus afflicted died during treatment, to exonerate themselves by proclaiming the danger of these substances which they then called poisons.

109a *continued*

read cases of correctly motivated homeopathic cures. Such a person could not have pondered the baselessness of all allopathic modes of treating diseases or inquired about their bad, often frightful, results if with such lax indifference, he places the only true medical art on an equal footing with these detrimental modes of treatment or even passes them off as sisters of homeopathy, which homeopathy could not do without! May my conscientious successors, the genuine, pure homeopaths, with their almost never failing felicitous cures, set them straight.

109b The first fruits of this labor (as ripe as it could be then) were published in the *Fragmenta de viribus medicamentorum positivis, sive in sano corpore humano observatis* [Fragments on the positive forces of medicines; that is, observed in the healthy human body] (Lipsiae, 1805, pts. I, II, vol. 8, ap. J.A. Barth). The riper fruits were presented in *Reine Arzneimittellehre* [Materia Medica Pura] (vol. I, 3rd ed.; vol. II, 3rd ed., 1833; vol. III, 2nd ed., 1825; vol. IV, 2nd ed., 1825; vol. V, 2nd ed., 1826; vol. VI, 2nd ed., 1827). [The English translation of Hahnemann's *Materia Medica Pura* is published in two volumes.] These riper fruits were also presented in the second, third and fourth parts of *Die chronischen Krankheiten* [The Chronic Diseases] Dresden: Arnold, 1828, 1830 (2nd ed., with a fifth

None of these observers suspected:

1. that these symptoms, recounted by them only as proofs of the harmfulness and toxicity of these substances, contained sure reference to the power of these drugs to be able to curatively extinguish similar ailments in natural diseases,

2. that these disease arousals were indications of their homeopathic curative action, and

3. that the only possible investigation of their medicinal powers rests upon the observation of the condition-alterations brought forth by the medicines in healthy organisms.

The pure, peculiar powers of medicines for curative purposes are not to be discerned through *a.* specious *a priori* sophistry, *b.* the smell, taste or appearance of the medicines, *c.* chemical processing of the medicines, or *d.* the use in diseases of one or several medicines in a mixture (prescription). One did not suspect that these histories of medicinal diseases would some day supply the first rudiments of the true, pure materia medica which, from the outset up until now, consisted only in false conjectures and fabrications, and which was as good as non-existent.[110]

§111

The agreement of my observations of the pure actions of medicines [in provings] with these older reports [of poisonings] written irrespective of curative purposes, and even the accord of these reports [of poisonings] with others of this kind from different writers, easily persuades us that medicinal substances act in their morbid alteration of the healthy human body *according to definite, eternal natural laws* and, by virtue of these, are able to engender *certain, reliable disease symptoms, each substance engendering particular ones, according to its peculiarity.*

Each medicinal substance engenders a certain, unique set of symptoms.

part, Düsseldorf: Schaub, 1835-1839). [These appear in Part II of the English translation.]

110 See what I have said on this subject in "Examination of the Sources of the Common Materia Medica," prefixed to the third part of my *Materia Medica Pura*. [This appears in Volume II of the English translation.]

Critique of common pharmocology reference books

§112

In those older descriptions of the often life-endangering actions of
medicines ingested in excessive doses, one also perceives states
which showed themselves not at the beginning but at the end of
such sad events and which were of an entirely opposite nature to
those at the beginning. These symptoms that oppose the *initial
action* (which is actually the impinging-action upon the life force,
§63) are the counter-action of the organism's life principle. There-
fore, they are its *after-action* (§62-§67). In provings with moderate
doses upon healthy bodies, this after-action is seldom or almost
never in the least to be sensed; with small doses, nothing at all is to
be sensed. In the homeopathic curative pursuit, the living organism
produces only as much counter-action against these small doses as
is necessary to again raise the condition up to the natural healthy
state [§68].

§113

The narcotic medicines appear to be the only exception in this regard.
During the initial action, partly they take away the sensitivity and
sensibility, and partly they take away the irritability. Then, even
with moderate test doses in healthy bodies, a heightened sensitivity
(and greater irritability) is frequently noticeable in the *after-action.*

§114

With the exception of these narcotic substances, in provings with
moderate doses of medicine in healthy bodies, one only perceives
the initial action of the medicine, that is, those symptoms whereby
the medicine alters the tuning of the person's condition and, for a
longer or shorter time, generates a disease state in and on the per-
son's condition.

§115

Some medicines have not-a-few symptoms which are partially, or
under certain attendant circumstances, opposite to other symp-
toms that have previously or subsequently appeared, but which are

not therefore to be regarded as an actual *after-action* or simple counter-action of the life force, but which only form the reciprocal state to the various initial-action paroxysms. These are called *reciprocal actions*.

§116

In provings, some symptoms are brought to pass more frequently and others more rarely; that is, some symptoms appear in many healthy bodies while others appear in only a very few.

Idiosyncratic provers reveal a medicine's power to cure all sick people with similar symptoms.

§117

Belonging to this latter category are the so-called *idiosyncracies*. These are [cases] in which a given individual bodily constitution, although otherwise healthy, has a tendency to be displaced into a more or less diseased state by certain things which *seem* to make absolutely no impression or alteration in many other people.[117a] However this lack of impression on some persons is only apparent. Two things are required for a substance to be able to bring forth these and all other human condition-alterations:
1. the indwelling power of the impinging substance, and
2. the ability of the spirit-like dynamis that enlivens the organism to be aroused by this impinging substance.

Therefore, the conspicuous illnesses in the so-called idiosyncrasies cannot be attributed solely to these particular bodily constitutions but must, at the same time, be derived from these occasioning things in which must lie the power to make the same impression on all human bodies. It is just that few among the healthy bodily constitutions are inclined to let themselves be displaced by these things into a so conspicuous disease state. That these potences really make this impression on each body can be seen from the fact that they afford aid as homeopathic remedies to

117a A few persons can faint from the smell of roses, or get into various other morbid, occasionally dangerous states from partaking of mussels, crab or barbel roe, by touching the foliage of some kinds of sumach, etc.

Idiosyncratic people

all sick persons for disease symptoms similar to the ones which they themselves can arouse, although apparently only in so-called idiosyncratic persons.[117b]

§118

Every medicine exhibits particular actions in the human body which do not come about in exactly the same way from any other medicinal substance of a different kind.[118]

§119

As certainly as each kind of plant is different in its outer form, in its own way of life and growth, in its taste and smell from every other plant species and genus; as certainly as each mineral and each salt in its outer as well as its inner physical and chemical properties (which alone should have prevented any and all confusion) differs from every other; just as certainly are they all different and divergent from one another in their morbific, thus also, in their curative actions.[119a]

117b In this way, Princess Maria Porphyrogeneta helped her brother, Emperor Alexius, who suffered from faintings, by sprinkling him with rosewater — το των ῥοδων σταλαγμα [the liquid drop of roses]— in the presence of his aunt Eudoxia (*Hist. byz. Alexius*, lib. XV, p. 503, ed. Poßer). Also, Horstius considered rose vinegar to be helpful in cases of faintings (*Opera*, III, p. 59).

118 This fact was also perceived by Albrecht von Haller who wrote (in the preface to his *Hist. stirp. helv.*):

> *Latet immensa virium diversitas in iis ipsis plantis, quarum facies externas dudum novimus, animas quasi et quodcunque caelestius habent, nondum perspeximus.* [A great diversity of strength lies hidden in these plants themselves, whose external features we have long known but whose souls, as it were, and whatever divine element they have, we have not yet perceived.]

119a Anyone who knows precisely and understands the value of the so singularly different actions of each single substance upon the human condition from the actions of every other single substance also easily realizes that among them, from a medical point of view, there can be absolutely no equivalent means, no *surrogates*. Only those who do *not* know the

Each of these substances works in its own different, but determinate way (which forbids all confusion), engendering modifications in the state of health and in the condition of human beings.[119b]

§ 120

Therefore the medicines upon which the life and death, the disease and health of human beings depend must be exactly, painstakingly

Medicines must be thoroughly tested on the

pure, positive effects of different medicines can be so foolish as to try to persuade us that one medicine can, in the same disease, be just as serviceable as another. This is the way in which ignorant children confuse things which are essentially different, because they barely know them on the outside, much less by their worth, their true meaning, their inner, highly divergent properties.

119b If this is pure truth (which it is) then no physician who does not want to be regarded as devoid of intellect, and who does not want to violate his good conscience (the sole testimony of genuine human worth) could possibly treat a disease with any medicinal substance unless he exactly and completely knows it in its true meaning, unless he has sufficiently tested its virtual action on the condition of healthy people in order to be exactly aware of its ability to engender a disease state very similar to the one to be cured, more similar than that of any other medicine that has become known to him. As has been shown above, neither man nor great nature can completely, rapidly and permanently cure except with a homeopathic means. Henceforth no genuine physician can exclude himself from such tests, especially on himself, in order to attain this knowledge which most necessarily belongs to the curative purpose and which has hitherto been so disdainfully neglected by the doctors of all centuries.

Why every physician should do provings

In all past centuries (future generations will hardly believe this) physicians contented themselves with blindly prescribing for diseases, *unproven* medicines whose importance was unknown as to their highly divergent, pure dynamic action on human conditions. Indeed, physicians generally mixed several of these unknown, so very different powers into one formula, leaving it to *chance* how the patient would fare afterwards. This is like a madman getting into an artist's studio and grabbing *handfuls of very different tools which are unknown to him* in order (he imagines) to work on the art objects standing about. Needless to say, these works of art would be ruined — probably quite irreparably ruined — by his senseless work.

healthy to ascertain each
medicine's powers and
true actions and to
differentiate the
medicines from one
another.

distinguished from one another. For this reason, through careful, pure experiments, they must be tested as to their powers and true actions in the healthy body so that we may become exactly acquainted with them and avoid every mistake in their use with diseases, since only an apt selection of medicine can quickly and permanently restore the greatest of earthly blessings, the well-being of body and soul.

GUIDELINES FOR CONDUCTING PROVINGS

§121

In provings with
unpotentized medicines,
substances of different
strengths should be
proven in different
quantities.*

In medicinal provings, with respect to their actions in the healthy body, one must bear in mind the following:
1. Even in small doses, the strong, so-called heroic substances tend to arouse condition-alterations, even in robust persons.
2. In these experiments, substances of milder power must be administered in more considerable doses.
3. For the action of the weakest medicines to be perceived, they can only be tested upon persons who are free of disease and who are delicate, excitable and sensitive.

§122

Medicinal substances used
in provings should be
perfectly well-known.

The substances used in provings should be perfectly well-known, and their purity, genuineness and full vigor should be thoroughly assured. This is because the certainty of the entire medical art and the welfare of all future human generations depends on these experiments.

§123

How to prepare
unpotentized medicines
for provings

Each of these medicines must be taken in a quite simple, unadulterated form.
1. Medicines made from indigenous [local] plants should be taken as freshly expressed juice mixed with some alcohol to prevent spoilage.

* In §121 and §123, Hahnemann gives directions for the use of unpotentized substances in provings. In §128, he presents the advantages of using potentized substances, and gives directions for doing so.

2. Exotic [non-local] plants should be made into a powder or they should be extracted fresh and made into a tincture prepared with alcohol. When administered, they should be mixed with several parts of water.
3. Salts and gums should be dissolved in water immediately before being taken.
4. If the plant is only to be had in its dry form and if, according to its nature, its powers are naturally weak, an infusion should be made from it by pouring boiling water over the crushed herb. It should be drunk immediately after being prepared, while still warm. This is because all expressed plant juices and all infusions of plants using water, without alcohol added, rapidly begin to ferment and spoil, losing their medicinal power.

§124

Each medicinal substance must be employed entirely alone and pure, without mixing in any foreign substance or otherwise taking any foreign medicinals on the same day or on subsequent days, as long as one intends to observe the actions of the medicine.

Provers should take nothing medicinal during a proving except the substance being tested.

§125

During the proving, the diet must also be arranged quite moderately:
1. It must be simple, nutritious, and as much as possible without spices.
2. Side dishes of green vegetables and roots,[125a] all salads, and soup herbs should be avoided because they always retain some disturbing medicinal power, no matter how they are prepared.
3. Beverages should be those usually taken, and they should be as little stimulating as possible.[125b]

A prover's diet during the proving must be simple, nutritious, non-stimulating and non-medicinal.

125a Young green peas in the pod, green beans, steamed potatoes and, if need be, carrots are permissible since these are the least medicinal vegetables.

Permissible vegetables

125b Provers must not have the habit of drinking wine, brandy, coffee or tea. If they did have the habit, they must have completely broken it long before the proving. Partly, these beverages are stimulating; partly, they are medicinally detrimental.

Drinks to avoid before and during provings

§126

The selected prover must *above all things be known as credible and conscientious.* During the course of the proving, a prover must:

1. guard against mental and bodily exertion,
2. guard against all excesses and disturbing passions,
3. have no urgent business to deter one from proper observation and, with good will, direct exact attention to oneself without being disturbed,
4. be bodily healthy, after one's fashion [i.e., what is good health for the prover],
5. possess the necessary intellect to be able to name and describe one's sensibilities in distinct expressions.

§127

Testing on males and females is necessary in order to bring to light gender-related condition-alterations.

§128

Both the recent and the most recent experiences have taught that, in provings done with medicinal substances in their raw state, the substances do not manifest nearly the full wealth of their hidden powers as they do in provings using substances in potentized form (i.e., highly attenuated through proper trituration and succussion). By means of this simple processing, the powers that lie hidden and, as it were, dormant in the medicinal substance's raw state are developed and awakened into activity to an incredible degree. Therefore, even substances deemed weak with regard to their medicinal powers are best investigated by having the prover take, daily on an empty stomach, four to six of the finest globules of the 30th potency [30 C] of such a substance, moistened with a little water, or rather dissolved in a larger or smaller amount of water and well succussed. This should be continued for several days.

§129

When only weak actions of such a dose come to light, one can increase the dosage with a few more globules daily until the actions become more distinct and stronger, until the condition-alterations

become more perceptible. Few persons are immediately strongly attacked by a medicine. In fact, there is great diversity in this respect. Occasionally, an apparently weak person is hardly aroused by a medicine known to be very powerful while the same person is strongly enough aroused by several other, far weaker medicines. On the other hand, there are very robust persons who sense very appreciable disease symptoms from an apparently mild medicine while from stronger medicines, they sense less, etc. Since this is not known beforehand, it is very advisable to begin, at first, with a small medicinal dose [for everybody] and when it is appropriate and necessary, to increase it to a higher and higher dose from day to day.

§130

If, right at the outset, a properly strong medicinal dose has been administered, then one has the advantage of being able to record the exact sequence of symptoms that the prover experiences, and the times when each appears. This is very instructive for knowledge of the medicine's character because the order of the initial actions, and also the reciprocal actions, comes to light most unambiguously. Even a very moderate dose is often sufficient for the proving if the prover is fine-feeling enough and very attentive (as much as is possible) to his condition. The duration of a medicine's action only becomes known through the comparison of several tests [in which only one dose is taken].

Provings made with only one dose provide information about the order in which symptoms appear. The duration of a medicine's action can only be ascertained from several experiments using only one dose.

§131

If however, in order to experience anything at all, one must give, as a test, the same medicine in ever-heightened doses [i.e., an increased amount of globules] to the same person several days in a row, then to be sure, one experiences the various disease states which this medicine can in general bring to pass, but not their sequence. Also, the subsequent dose often curatively takes away one or another symptom aroused by the previous dose; or it takes away symptoms in bringing forth the opposite state. These symptoms must be bracketed as ambiguous until subsequent purer tests show whether they are counter- and after-actions of the organism or reciprocal actions of the medicine.

The action of a medicine is less clear when a prover must take increasing doses on successive days.

§132

However, when one wants to investigate only the symptoms themselves (especially of a weak-powered medicinal substance) without regard for the sequentiality of the befallments or the duration of the medicine's action, the preferred arrangement is to administer a dose that is heightened [i.e., given in greater quantity] every day for several days in a row. Then the action of even the mildest, as-yet-unknown medicine will come to light, especially when it is tested on sensitive persons.

§133

Determine the exact character of each symptom and its modalities.

Upon becoming sensible [i.e., upon feeling and becoming conscious] of this or that medicinal ailment, it is serviceable, indeed requisite for the exact determination of the symptom, to place oneself in different situations and to observe whether the befallment increases, lessens or passes away and whether, perhaps, the befallment returns when one is once again in the initial situation.

1. Does the befallment increase, lessen or pass away:
 — by movement of the part in question?
 — by walking in a room or in the fresh air?
 — by standing, sitting or lying?
2. Does the symptom alter itself:
 — by eating?
 — by drinking?
 — under some other condition?
 — by speaking, coughing, sneezing, or during another bodily function?
3. What time of the day or night is the symptom especially wont to come?

In this way, what is peculiar and characteristic about each symptom becomes evident.

§134

Different symptoms of a medicine appear in different provers and in

All external potences, preeminently medicines, bring forth a particular kind of alteration in the condition of the living organism, each in its own peculiar way. However, all the symptoms belonging to a

given medicine do not appear in one person, nor all at once, nor in the same experiment. When one person takes the substance in three different experiments, some symptoms may appear in the first experiment and others in the second or third. Other people may experience different sets of symptoms, however, in such a manner that some or several of the befallments that take place with the fourth, eighth or tenth person may already have appeared with the second, sixth or ninth person, etc. Also, symptoms do not appear at the same hour every time.

different tests with the same prover.

§135

The complex of all disease elements which a medicine is capable of engendering is only brought near to completeness by means of multiple observations employed upon many differing qualified persons, both male and female. One can only be assured of having thoroughly proven a medicine for the disease states which it can arouse (i.e., for its pure powers in altering the human condition) when subsequent provers can notice little about the medicine that is new and they almost always perceive in themselves the same symptoms that have already been observed by others.

To fully prove a substance multiple tests, with provers of both genders and various constitutions, are needed.

§136

A medicine, during its proving in the healthy state, cannot bring forth all of its condition-alterations in one person, but only in many different, diverging body- and soul-constitutions. Nonetheless, the tendency thus lies in it (§117) to arouse all of these symptoms in each person according to an eternal, immutable natural law by virtue of which all of a medicine's actions, even those seldom brought forth in healthy people, are brought to bear in each person to whom it is administered who is in a disease state of similar ailments. Homeopathically chosen, the medicine then silently arouses, even in the least dosage, an artificial disease state in the patient that approximates the natural disease state. This artificial disease state rapidly and permanently (homeopathically) frees and cures the patient of his original malady.

Even those symptoms that are only rarely brought forth in the proving of a medicine can be cured by that medicine when the symptoms appear in a sick person.

§137

Moderate proving doses
yield better information,
and are safer, than large
doses.

For such experiments, up to a certain degree, the more moderate the medicinal dose used, the more distinctly the initial actions emerge, and only those that are the most worth knowing [being aware of] without any after-actions or counter-actions of the life principle. This is the case provided one endeavors to facilitate the observation by the selection of a fine-feeling person who loves the truth, is moderate in every regard, and who directs the most intense attention to himself.

On the contrary, with excessively large doses, not only are there several after-actions to be met with among the symptoms, but also the initial actions crop up in such confused haste and violence that nothing may be exactly observed, not to mention the danger of excessively large doses [for the prover]. This cannot be a matter of indifference to anyone who has regard for humankind and who prizes the least of the people as his brother.

§138

During a proving, all
ailments, befallments and
alterations in the prover's
condition should be
attributed to the
medicine.

For the duration of a medicine's action, all ailments, befallments and alterations in the prover's condition stem solely from this medicine, provided the above conditions for a pure experiment are complied with (§124-§127). All of these must be regarded as belonging peculiarly to this medicine as its symptoms, and recorded as such [in one's proving journal]. This is the case even if the prover perceived similar befallments in himself *a considerable time previously*. Their reappearance during the proving only indicates that this person, by virtue of his particular bodily constitution, is especially disposed to being aroused to such befallments. In our case, it has been done by the medicine. The symptoms come now (while the ingested efficacious medicine masters the prover's entire condition) not of themselves, rather they stem from the medicine.

§139

Provers should keep
detailed proving journals.

If the physician is conducting a proving with someone other than himself as the prover, then the following instructions should be followed:

1. The prover should write down distinctly each of his sensibilities, ailments, befallments and condition-alterations at that point in time when each one takes place.
2. The prover should indicate the time elapsed from the ingestion of the medicine to the arising of each symptom.
3. The prover should note the duration of the symptom, if it lasts a long time.

The physician should look over the essay, in the presence of the prover, immediately after the completion of the proving, or daily if the proving lasts for several days. The physician should do this in order to question the prover about the exact nature of each incident while everything is still fresh in his memory. The physician should write alongside any more detailed circumstances about these incidents, and he should modify the record as necessary, according to the prover's testimony.[139]

Provers should be interviewed daily by the supervising physician.

§140

If the prover cannot write, the physician should interview him daily as to what may have happened to him and how. For the most part, it should be a solely voluntary account of the prover. Nothing that is written down as findings should be guessed at, nothing supposed, and as little as possible should be pumped out of the prover. Everything must be done with the same caution I have indicated above on case-taking and finding out about the image of natural diseases (§84-§99).

§141

Of all the provings of the pure actions of simple medicines in altering the human condition, and of the artificial disease states and symptoms that they engender in the healthy person, the most excellent provings remain those that the healthy, unprejudiced, conscientious and fine-feeling *physician* employs *upon himself,* with all the

The best provings are those that the physician employs upon himself.

139 The person who makes known to the medical world the results of such experiments is responsible for the reliability of the prover and his statements, and rightly so since the welfare of suffering humanity is at stake.

The author of proving reports is responsible for their accuracy.

care and caution taught here. He knows [is aware] with the greatest certainty that which he has perceived in himself.[141]

141 These self-provings have other irreplaceable advantages for the physician.

1. First of all, the great truth becomes an undeniable fact for him, that what is medicinal about all medicines (wherein their curative power rests) lies in the condition-alterations undergone by means of the self-proven medicines and in the disease states self-experienced by means of these medicines.

2. By means of such remarkable observations, he will develop an understanding appreciation of his own sensibilities, of his mode of thinking and emotions which is the basis [basic wesen] of all true wisdom, γνωθι σεαυτον [know thyself].

3. By observing himself so closely, he will develop into a good observer, [a skill in which] no physician dare be lacking. None of the observations we make on others are nearly as appealing as those we make on ourselves.

4. The observer of others must always worry lest the prover of a medicine has not felt distinctly just what he says, nor stated and characterized his feelings with the exactly fitting expression. There is always a lingering doubt as to whether the physician is not being at least partly deceived. This insurmountable obstacle to the discernment of truth in the inquiry into the artificial disease symptoms of medicines in others falls entirely by the wayside in self-provings. The self-prover is aware, with certainty, of what he has felt.

5. Each self-proving is a new impetus for the physician in the investigation of the powers of several medicines.

Thus, by continuing to observe himself (the one person who will not deceive him and upon whom he can most rely) the physician becomes more and more practiced in the art of observing, which is of such importance to him. He will do these self-provings all the more eagerly since they promise the knowledge of the mostly still missing implements for cure [i.e., proven medicines], according to their true worth and meaning, and without deceiving him.

Let him not imagine that such small illnesses from taking proving medicines are generally detrimental to his health. On the contrary, experience teaches that, through the various attacks on the healthy condition, the prover's organism only becomes the more practiced in warding off everything from the external world that is inimical to his body, along with all the artificial and natural disease malignities. By means of such

§142

It is difficult to investigate the pure actions of medicines in diseases* [i.e. with sick people, §107]. Distinguishing between the symptoms of the simple medicine used for cure and the ailments of the original disease (even in diseases that are mostly invariable, especially the chronic ones)[142] is the object of the art of higher judgement and should be left only to masters of observation.

Clinical data: The investigation of medicines by studying their actions in sick people should be left to masters of observation.

COMPILING A TRUE MATERIA MEDICA

§143

It is only by proving a considerable number of simple medicines on healthy individuals, and carefully and faithfully recording all the disease elements and symptoms that each medicine (as an artificial disease potence) is capable of engendering, that we can have a true materia medica. A true materia medica is a collection of the genuine, pure, unmistakable[143] modes of action of simple medicinal substances. It is a codex of nature:

A true materia medica is a collection of the genuine, pure, unmistakable modes of action of simple medicinal substances.

moderate self-provings with medicines, the prover's organism also becomes more seasoned [hardened] against everything that is detrimental. His health becomes more invariable; he becomes more robust, as all experience teaches.

* To clarify the meaning of this paragraph, Hahnemann's synopsis (p. 271) has been included here as the first sentence of the paragraph.

142 It is extremely difficult to distinguish between symptoms of the entire disease (including those from a long time ago) from symptoms never noticed before which are, consequently, new symptoms belonging to the medicine.

Difficulty in distinguishing between medicinal and disease symptoms

143 Lately, provings of medicines have been commissioned and published, using distant, unknown provers who were paid for their work. But in this way the most important pursuit, ordained to be the only basis of the true medical art, and demanding the greatest moral certainty and reliability, seems unfortunately to become ambiguous and unsure in its results and loses all worth. The false statements to be expected therefrom, which at some future time are accepted as true by homeopathic physicians, must prove in their application to the patient to be of the greatest disadvantage.

Use of paid provers

1. in which stands recorded, from each efficacious medicine thus investigated, a considerable set of particular condition-alterations and symptoms as they came to the notice of the observer, and
2. in which are present in similitude, the disease elements which are homeopathic to the several natural diseases to be cured by them one day. These disease elements contain artificial disease states that offer, for similar natural disease states, the only true homeopathic (i.e., specific) curative implements for certain and permanent recovery.

§144

Let all that is supposition, merely asserted or even fabricated, be entirely excluded from such a materia medica. Let everything be the pure language of nature, carefully and sincerely interrogated.

§145

Only a very considerable supply of known medicines will enable us to find the most fitting remedy for each case of disease. So far, a fairly fitting remedy can be found for almost every disease.

Of course, only a very considerable supply of medicines, exactly known according to this, their pure mode of action in altering the human condition, can enable us to find a homeopathic remedy — a fitting analogue of an artificial (curative) disease potence — for *each* of the infinitely many disease states in nature, for *each* wasting sickness in the world.[145a] Meanwhile (thanks to the truth of the symptoms and the abundance of disease elements that each one of the efficacious medicinal substances has shown in its impinging action on healthy bodies) there are only a few cases of disease left for which a fairly fitting homeopathic remedy is not to be met with, among

Achievements that will be possible when several physicians are doing reliable self-provings

145a Initially, some forty years ago, I was the only one who made the proving of pure medicinal powers his most important pursuit. Since then I have been supported by some young men who have done provings on themselves and whose observations I have gone through diligently. A few others have since done some genuine testing of this kind. But what will we be able (only then) to curatively achieve within the entire sphere of the infinite domain of disease, when several *accurate and reliable* observers have distinguished themselves through careful *self-provings* for the enrichment of this one genuine materia medica! Then the medical pursuit will approach the mathematical sciences in reliability.

the ones now already proven as to their pure action,[145b] a remedy that brings health again gently, surely, and permanently without any particular ailments. These homeopathic medicines do so *infinitely* more certainly and surely than all the general and special therapies of the hitherto allopathic medicinal art, with its unknown compound means that merely alter and aggravate but cannot cure chronic diseases, that protract rather than promote the cure of acute diseases, and that often even bring about endangerment to life.

145b See footnote 109a.

CHAPTER V

Homeopathic Treatment of Diseases

§146-§203

THE POWER OF HOMEOPATHIC MEDICINES
TO CURE DISEASES

§146

The *third item* of business for the genuine medical-art practitioner concerns *the most expedient employment* of the artificial disease potences *(medicines)* which have been proven for their pure action in healthy humans for *the homeopathic cure of natural diseases.*

§147

Among those medicines whose human condition-altering power has been investigated, the medicine whose observed symptoms are most similar to the totality of symptoms of a given natural disease will and must be the most fitting, the most certain homeopathic remedy. In this medicine is found the *specificum* for this case of disease.

§148

Natural diseases are dynamically engendered by potences that mistune the life force. Medicines cure by dynamically overtuning the life force with a similar but stronger artificial disease.

A natural disease is never to be regarded as some noxious *matter* situated somewhere inside or outside the person (§11-§13). Rather, natural disease is engendered by a spirit-like inimical potence that disturbs, as if by a kind of contagion (*fn* 11), the spirit-like life principle that reigns, with its instinctual governance, in the entire organism. Like an evil spirit, it torments the life principle, forcing it to engender certain sufferings and disorders in the course of its life. These are known as symptoms or diseases.

If the feeling of the impinging action of the inimical agent that strove to produce and continue this mistunement is again withdrawn from the life principle, that is, if the physician lets an artificial disease potence impinge on the patient against the inimical agent — an artificial disease potence which is able to morbidly mistune the life principle most similarly and which continually exceeds the natural disease in energy (§33, §279) even in the smallest dose — then the life principle loses the sensibility of the original disease agent during the impinging action of this stronger, similar, artificial disease. From then on, the malady exists no more for the life principle. It is annihilated.

If, as was said, the fittingly selected homeopathic medicine is properly employed, then the acute natural disease that is to be over-tuned passes away unnoticed; if it arose shortly beforehand, it often passes away in a few hours. A somewhat older natural disease (like-wise along with all traces of indisposition) passes away somewhat later, after application of a few more doses of the same, more highly potentized medicine, or after the careful selection[148] of one or another still more similar homeopathic medicine.

Recent natural diseases pass away quickly with homeopathic treatment. Somewhat older natural diseases require longer treatment.

148 The search for the remedy that is homeopathically the most suitable, in all regards, for a given disease state is a laborious, occasionally a very laborious, pursuit. While there are praiseworthy books for facilitating this process [i.e., repertories and materia medica] it is still necessary to study the sources themselves [i.e., reports of provings]. Many-sided circumspection and serious consideration is also required. The best reward for this is the awareness of a duty truly fulfilled. How could this labor-ious, painstaking work (which alone produces the best possible cure of diseases) suit those gentlemen of the new mongrel sect who vaunt the honorable title of homeopath and who, for show, give out medicines that are homeopathic in form and appearance but which they only lay hold of in a perfunctory way (*quidquid in buccam venit* [whatever comes into the mouth]*)? When the inexact means does not immediately help, they lay the blame for it on homeopathy, instead of on their inexcusable indo-lence and fecklessness in dealing with the most important and most cri-tical of human affairs. They accuse homeopathy of being very imperfect when, in fact, the problem is that the most appropriate homeopathic remedy for each disease state does not spontaneously fly into their mouths like roasted pigeons, without any effort on their part! Being the adroit people that they are, they know how to quickly console themselves about the inefficacy of their scarcely half-homeopathic means by bring-ing to bear the allopathic toadies which are more familiar to them (including one or more dozens of leeches placed at the site of suffering, small innocent venesections of eight ounces or so, etc.). These cut a right stately figure. If the patient pulls through in spite of all this, these gen-tlemen then praise their venesections, leeches etc. "without which the patient would not have been able to be preserved." They give one to

The proper practice of homeopathy, which is laborious, versus the practices of lazy and irresponsible practitioners who call themselves homeopaths

* This is a paraphrasing of the Latin proverb *Quod in buccam venerit scribita* [That which comes into the mouth is written down].

Health, recovery (and nothing else) then ensues in unnoticeable, often rapid, transitions. The life principle feels free again and able to continue the life of the organism in health; and vitality is there again.

§149

Complicated chronic wasting sicknesses take far longer for recovery. Those complicated by prolonged, violent, allopathic treatments may be incurable.

The old (and especially the complicated) wasting sicknesses require relatively more time for cure — especially those chronic medicinal wasting sicknesses so often engendered by allopathic artlessness, along with the natural disease that has been left uncured by such artlessness. These require a far longer time for recovery. Often, indeed, these cases are incurable due to *a.* the insolent robbery of the patient's vitality and bodily fluids by venesection, purgatives, etc., *b.* the often long-continued application of large doses of violently acting means, administered according to empty, false suppositions about their alleged use in similarly *appearing* disease cases, and *c.* the prescription of unsuitable mineral baths, etc. — that is, all the usual heroic deeds of allopaths in their so-called treatments.

DISTINGUISHING BETWEEN MINOR INDISPOSITIONS AND MORE SERIOUS DISEASES

§150

Indispositions requiring modifications of regimen

If the patient complains to the physician of one or two trivial befallments which have only been noticed recently, the physician is not to regard this as a complete disease needing serious medicinal aid. A

148 *continued*

> understand, in no uncertain terms, that these operations (transmitted, without much brain-racking, from the ruinous routine of the old school) were fundamentally the best element in the treatment. But if the patient dies (as is not seldom the case) they seek to appease the disconsolate relations by saying that "they themselves were witnesses that, after all, everything possible had been done for the dearly departed." Who would do this feckless and harmful brood the honor of calling them, after the very laborious but curative art, *homeopathic physicians*? May their just reward await them of being treated in the same manner once they fall ill!

small modification in diet or regimen usually suffices to wipe away this indisposition.

§151

If, however, the patient complains of a couple of severe ailments the investigating physician will usually find several collateral, although more minor, befallments that give a complete image of the disease.

Diseases requiring medicinal aid

STRANGE, RARE AND PECULIAR SYMPTOMS

§152

The worse an acute disease is and the more numerous and striking the symptoms making it up usually are, then the more certainly a fitting remedy may be found for it if a sufficient number of medicines, known for their positive action, are available for selection. Among the symptom sets of the many medicines, it will not be difficult to find *one* out of whose component disease elements an artificial curative disease image may be put together that is very similar to the symptom complex of the natural disease. This is the desirable remedy.

Remedies are more easily found for acute diseases with numerous and striking symptoms.

§153

In the search for a homeopathically specific remedy, that is, in the comparison of the complex of the natural disease's signs with the symptom sets of the available medicines (in order to find among them an artificial disease potence that corresponds in similarity to the malady to be cured) the more *striking, exceptional, unusual, and odd* (characteristic) signs and symptoms[153] of the disease case are to be especially and almost solely kept in view. *These, above all, must correspond to very similar ones in the symptom set of the medicine*

Strange, rare and peculiar symptoms are the most important in the search for a homeopathic remedy.

153 In arranging the characteristic symptoms of homeopathic medicines in his *Repertory*, Baron von Boenninghausen has earned our esteem, as has Dr. G.H.G. Jahr with his *Handbook of Chief Indications*, now in its third printing under the title *Grand Manuel*.

Repertories of Boenninghausen and Jahr

sought if it is to be the most fitting one for cure. The more common and indeterminate symptoms (lack of appetite, headache, lassitude, restless sleep, discomfort, etc.) are to be seen with almost every disease and medicine and thus deserve little attention unless they are more closely characterized.

§154

The most fitting medicine for a disease is the one that has in its symptom set, the greatest number of characteristic symptoms with the greatest similarity to the disease symptoms.

If the counter-image that is put together from the set of symptoms of the most apt medicine contains the characteristic signs (i.e., those that are special, uncommon, odd, and distinguishing) of the disease to be cured, in the greatest number and in the greatest similarity, then *this* medicine is the most fitting, homeopathic, specific remedy for *this* disease state. If the disease is of not-too-long duration, it will be lifted and extinguished without significant ailment, usually by the first dose.

§155

Medicines capable of producing many symptoms cure without significant ailment because the minute doses used are too weak to produce significant symptoms in disease-free parts of the body.

The disease is lifted and extinguished *without significant ailment* because, in the use of this fitting homeopathic medicine, only the medicinal symptoms of the remedy that correspond to the disease symptoms are in operation. The medicinal symptoms take up the place of the (weaker) disease symptoms in the organism, that is, in the feeling of the life principle, and annihilate the disease symptoms by means of over-tunement. Finding no employment in the existing case of disease, the other symptoms of the homeopathic medicine (which are often numerous) remain entirely silent. Almost nothing of the medicinal symptoms is to be noticed in the patient's condition, which improves by the hour, because the medicinal dose necessary for homeopathic use is so deeply diminished [minute] that it is much too weak to express its remaining, non-homeopathic symptoms in the disease-free parts of the body. Consequently, it can only permit the homeopathic symptoms to act in the parts of the organism already most irritated and excited by the similar disease symptoms, thus allowing the sick life principle to feel only the similar, but stronger medicinal disease, whereby the original disease expires.

SMALL HOMEOPATHIC AGGRAVATIONS

§156

Meanwhile, especially when the dose is not sufficiently diminished, there is seldom a medication (even one that is apparently fittingly selected homeopathically) that does not bring to pass, in irritable and fine-feeling patients, at least one small ailment which is not habitual for the patient — a small new symptom — during the duration of its action. This is because it is almost impossible for the symptoms of the medicine and those of the disease to cover one another as exactly as two triangles with equal sides and angles. In a good case, however, this insignificant deviation is easily wiped away by the living organism's own energy activity (autocracy). It does so without even being noticed by patients, except those of immoderate delicacy. In any case, the restoration proceeds on to the goal of recovery as long as it is not hindered by foreign medicinal influences on the patient, by errors in regimen or through passions.

Homeopathic remedies usually produce at least one small new symptom in people who are fine-feeling and easily stimulated.

§157

While it is certain that a homeopathically selected remedy, on account of its appropriateness and the smallness of its dose, quietly lifts and annihilates an *acute* disease that is analogous to it without amplification of its non-homeopathic symptoms (that is, without the arousal of newer, more significant ailments), it is nevertheless usual (but likewise only with a dose not properly diminished) for it to produce some kind of *small* aggravation in the first hour or few hours immediately following its ingestion. (The aggravation will last for several hours if the dose is somewhat too large.) This aggravation is so similar to the original disease that it appears to the patient to be an aggravation of his own malady. In fact, it is nothing other than a highly similar *medicinal disease* that is somewhat stronger than the original malady.

A homeopathic aggravation is the medicinal disease, not a worsening of the original disease.

§158

This small *homeopathic aggravation* in the first hours is a very good portent that the *acute* disease will be mostly finished by the first

A small homeopathic aggravation is a good

indication in an acute
disease.

dose. Such an aggravation is not infrequent, since the medicinal disease must naturally be somewhat stronger than the malady in order to over-tune and extinguish it, just as a natural disease can only lift and annihilate another similar natural disease if it is stronger than the other one (§43-§48).

§159

Smaller doses produce
smaller homeopathic
aggravations.

The smaller the dose of the homeopathic means in the treatment of *acute* diseases, the more minor and shorter is the apparent exacerbation [heightening] of the disease in the first hours.

§160

Since the dose of a homeopathic remedy can hardly ever be prepared so small that it could not improve, over-tune, indeed fully cure and annihilate the recently arisen, unspoiled, natural disease that is analogous to it (see footnotes to §249), it therefore becomes understandable why a fitting homeopathic medicine that is not in the smallest possible dose brings to pass in the first hour after ingestion a noticeable, homeopathic aggravation of this kind.[160]

Examples of homeopathic
aggravations that were
observed but misunder-
stood by other physicians

160 This heightening of the medicinal symptoms over the disease symptoms analogous to them, which is similar to an aggravation, has also been observed by other physicians when a homeopathic remedy played into their hands by chance. When the itch diathesis patient complains about increased eruption after the ingestion of sulphur, his physician (not aware of the cause of this) consoles him with the assurance that the itch diathesis must come out more than ever before it can heal up. He is not aware that this is a sulphur eruption that only assumes the appearance of an increase in the itch diathesis.

"The facial eruption that was cured by *Viola tricolor* was, at first, aggravated by it," assures Leroy (*Heilkunde für Mütter* [Medical Art for Mothers], p. 406). Leroy was not aware that the apparent aggravation stemmed from a too-large dose of the pansy which was to some extent homeopathic here.

Lysons states, "Elm bark most certainly cures those cutaneous eruptions which it increases at the beginning of its use." (*Medical Transactions*, London, 1772, vol. II). If he had not administered the bark in enormous

§161

When I place the so-called homeopathic aggravation (i.e., the initial action of the homeopathic medicine which appears to somewhat heighten the symptoms of the original disease) within the first hour or the first few hours, this is thus certainly the case with the more acute, recently arisen maladies. However, when medicines of longer duration of action have to combat *an old or very old wasting sickness,* no such apparent heightenings of the original disease should show themselves during the course of treatment; and they will not show themselves if the aptly selected medicine is administered in properly small, only gradually heightened doses which become somewhat modified every time by new dynamization (§247). Such heightenings of the original symptoms of the chronic disease can then only come to light at the end of such treatments when the cure is almost or entirely completed.[161]*

Chronic diseases treated with fifty-millesimal potencies should only have a homeopathic aggravation towards the end of treatment.

TREATING DISEASES WITH AN INADEQUATE STOCK OF MEDICINES

§162

Because there are still only a moderate number of medicines which are exactly known as to their true, pure action, it sometimes happens that only *a portion* of the symptoms of the disease to be cured are

Making the first prescription with an imperfect medicine

doses (as is usual in the allopathic medicinal art) but in quite small doses as must be done when it is used homeopathically (i.e., by symptom-similarity of the medicine) he would have cured without, or almost without, seeing this apparent disease heightening (the homeopathic aggravation).

161 If the doses of the best-dynamized medicine (§270) are small enough, and the dose is modified each time by succussion, then even medicines of long duration of action can be repeated after short intervals, even in cases of chronic disease.

* The second half of §161 (beginning with "no such apparent heightenings...") along with *fn* 161, were written by Hahnemann for the sixth edition of the *Organon,* giving instructions for the use of fifty-millesimal (LM) potencies in these cases.

Treatment with fifty-millesimal potency medicines

met within the set of symptoms of the still best-fitting medicine. Consequently, this imperfect medicinal disease potence must be employed for lack of a more perfect one.

§163

Accessory symptoms
emerge when an
imperfect medicine
is used.

In such cases, a complete, untroublesome cure cannot be expected because when the imperfect medicine is used, some befallments will then emerge which were not to be found earlier in the disease. These are accessory symptoms of the not-completely-fitting medicine. To be sure, this will not hamper a considerable part of the malady (i.e., the disease symptoms that are similar to the medicinal symptoms) from being expunged by this medicine, and a fair beginning of the cure arising by this means, although not without accessory ailments. With properly small medicinal doses, these accessory ailments will be moderate.

§164

Even a few symptoms
shared by a medicine and
a disease can lead directly
to a cure if the symptoms
are characteristic.

A small number of homeopathic symptoms, met with in the best selected medicine, does no damage to the cure in those cases *where these few medicinal symptoms are of an uncommon kind* (characteristic) *that especially distinguish the disease.* The cure then ensues without particular ailments.

§165

A medicine that shares
common but not
characteristic symptoms
with a disease is not
homeopathic to the
disease.

But if:
1. there is nothing among the symptoms of the selected medicine that is in exact similarity to the distinguishing (characteristic), exceptional, uncommon symptoms of the disease case,
2. the medicine corresponds to the disease in question only in general, indeterminate states (e.g., nausea, lassitude, headache, etc.) and not in more closely designated ones, and
3. among the known medicines, there is no more homeopathically fitting one to be found,

then the medical-art practitioner has no directly advantageous result to promise himself from the employment of this unhomeopathic medicine.

§166

Such a case, however, is *very rare* due to the recent increase in the number of medicines known according to their pure actions. If such a case should appear, its disadvantages diminish as soon as a subsequent medicine of apt similarity can be selected.

§167

In cases of acute disease, if accessory ailments of some moment arise with the use of this first-employed, imperfectly homeopathic medicine, one should not let this first dose fully finish its work, abandoning the patient to the medicine's full duration of action. Rather, one should examine anew the now altered disease state and bring the original symptoms that remain into connection with the newly arisen ones in order to record a new disease image.

If significant new symptoms arise from the first imperfect medicine, do not wait for the medicine to finish its work. Select a second medicine based on the new disease image formed by the remaining original symptoms and the newly arisen ones.

§168

In this way, one will more easily find an analogue, from among the known medicines, that corresponds to this new disease image. Even just a single dose of this [second] medicine, while not entirely annihilating the disease, will bring the case much closer to cure. And so one continues along (if even this medicine is not fully sufficient to restore health) examining again and again the disease state that still remains and selecting a homeopathic medicine that is as fitting as possible for it until the intention to place the patient in full possession of health is reached.

§169

If, on the first examination of a disease and the first selection of a medicine for it, no one medicine's disease elements sufficiently cover the symptom complex of the disease (owing to an insufficient number of known medicines) but two medicines contend for preference in terms of suitability — one medicine homeopathically fitting one portion of the disease signs and the other medicine fitting another portion — it is not advisable, after using the superior of the two medicines, to automatically give the other without examining

Do not make a second prescription without re-examining the case.

the case.[169] The medicine that before proclaimed itself second best may, under the altered circumstances, no longer fit the remaining symptoms. In this case, a more fitting homeopathic medication must be selected in place of the second medicine for the newly recorded stock of symptoms.

§170

In every case where an alteration of the disease state has proceeded, the stock of symptoms that still remain must be ascertained anew and (regardless of the medicine that initially seemed to fit as the second medicine) a new homeopathic medicine must be selected that is as appropriate as possible to the new current state. If it should happen that the medicine which at first appeared to be the second best still shows itself to be well adapted to the disease state that remains (which is rarely the case) it would thus earn our confidence all the more as the medicine to be preferentially employed.

§171

Chronic non-venereal diseases may require several antipsoric remedies in succession.

In chronic diseases that are not venereal (therefore those most usually arising from psora) one often needs to employ several antipsoric remedies in succession to bring about a cure, each to be homeopathically selected in accordance with the result of an examination of the group of symptoms that remain after the previous means has completed its action.

TREATING DISEASES WITH TOO-FEW SYMPTOMS

§172

A similar *difficulty* [to that of too-few proven medicines] arises when the disease to be cured has *all-too-few* symptoms. [In both cases, the physician's first prescription is likely to be imperfect.] This circumstance deserves our careful attention since, by disposing of it,

169 And it is still far less advisable to give the two medicines together (§273).

almost all the difficulties of this most perfect of all possible medical methods are lifted (except that the apparatus of homeopathically known medicines [i.e. the materia medica] is not yet complete).

§173

Diseases that appear to have only a few symptoms are termed *one-sided* because only one or two main symptoms stand out, almost obscuring the rest of the befallments. Because of this, these diseases, which belong chiefly to the class of chronic diseases, are more difficult to cure.

One-sided diseases chiefly belong to the chronic diseases.

§174

The main symptom may be either:
1. an internal suffering (e.g., a headache of many years' duration, diarrhea of many years' duration, an old cardialgia, etc.), or
2. a more external one. The more external sufferings are usually called *local diseases*.

A one-sided disease may have either an internal or an external main symptom.

§175

Diseases with an internal main symptom that appear to be one-sided are, in fact, *often* not one-sided. Rather, the medical observer, due to inattentiveness, has not completely tracked down the befallments that are at hand for the completion of the outline of the disease-gestalt.

Cases of apparently one-sided disease with an internal main symptom usually reflect incomplete case-taking.

§176

Nevertheless, there are a few maladies of this kind which, after all initial investigation (§84-§98), outside of a couple of strong, intense befallments, only allow one to indistinctly observe the rest of the befallments.

In rare cases, a disease will be truly one-sided.

§177

True cases of one-sided disease are *very rare*. To meet with success in these cases, one should, at first, select the medicine that has been homeopathically singled out according to one's best estimation, guided by these few symptoms.

Making the first prescription for a one-sided disease

§178

It will no doubt occasionally happen that this medicine, chosen with careful observation of the homeopathic law, offers the apt similar artificial disease for the annihilation of the malady. This is all the more likely when these few disease symptoms are very striking, definite and of a rare kind, that is, when they are especially characteristic.

§179

More frequently, however, the medicine first selected will be able to only partially, that is, not exactly fit the case since there was not a majority of the symptoms to guide one to an apt choice.

§180

Imperfectly homeopathic medicines may bring forth new or previously unnoticed befallments. These are a part of the disease even though they were brought forth by the medicine.

In this case, a medicine has been selected as well as possible but, due to the one-sided nature of the disease, it is only imperfectly homeopathic, that is, it is only partially analogous to the disease. Consequently, the medicine will arouse accessory ailments, just as in the above-mentioned case (§162) where the dearth of homeopathic remedies left the selection incomplete. The medicine will mix several befallments from its own set of symptoms into the condition of the patient. These befallments *are, however, at the same time, ailments of the disease itself, although they have rarely or never been felt by the patient up until now.* Befallments that the patient had not perceived at all before will disclose themselves, or befallments that the patient had perceived only indistinctly will develop themselves to a higher degree.

§181

Imperfectly prescribed medicines complete the symptom content of one-

Let it not be interjected that the accessory ailments that now appear and the new symptoms of this disease are due only to the medication that was just used. The ailments do come from the medicine,[181]

Sources of symptoms and ailments other than the medicine

181 That is, the symptoms and ailments come from the medicine unless they are caused by an important error in living habits, a violent passion or a stormy development in the organism (e.g., the onset or cessation of menses, conception, childbirth, etc.).

but they are only those symptoms whose appearance *this* disease was itself capable of engendering in *this* body. The medicine, as a self-engenderer of similar symptoms, merely prompted the symptoms to appear. In a word, one has to accept the entire symptom complex that has now become visible as belonging to the disease itself, as the present true state, and to further manage it accordingly.



sided diseases, thus facilitating the finding of a second, more apt medicine.



§182

The imperfect selection of the medication, which was here almost inevitable on account of the all-too-small number of symptoms present, nevertheless thus renders the service of completing the symptom content of the disease and, in this way, it facilitates the finding of a second, more apt, fitting homeopathic medicine.

§183

Therefore, as soon as the first dose of the medicine produces nothing further that is beneficial, new findings of the disease must again be gathered, the *status morbi* [disease state] must be recorded as it is now, and a second homeopathic means must be selected that exactly fits the present, the current state. This second means should be all the more appropriate since the group of symptoms has become more numerous and complete.

A second prescription should be made based on the new, more complete group of symptoms.

One should wait until the first medication produces nothing further that is beneficial unless the newly arisen ailments are serious and, on account of their intensity, demand more prompt aid [§249]. This, however, is almost never the case in very protracted diseases due to the smallness of the doses of homeopathic medicines.[183]

183 There are cases where the patient feels very ill, but experiences only scant symptoms. This state can be ascribed to a dulling of the nerves which does not allow the patient's pains and ailments to be distinctly perceived. (This occurs very rarely in chronic diseases, while it is less rare in acute diseases.) In these cases, opium expunges this stupor of the inner feeling sense, and the symptoms of the disease come distinctly to light in the after-action.

Use of opium to bring symptoms to light more distinctly

§184

And so it goes: After the action of each medicine is completed — when it is no longer found to be fitting and helpful — the state of the still remaining disease is surveyed anew as to its remaining symptoms, and a homeopathic medicine that is as fitting as possible is singled out according to the group of befallments that is found, and so on up to recovery.

LOCAL MALADIES: ONE-SIDED DISEASES WITH AN EXTERNAL MAIN SYMPTOM

§185

Among the one-sided diseases, an important place is occupied by the so-called *local maladies*. This term refers to one-sided diseases whose alterations and ailments appear on the outer parts of the body. It has hitherto been taught that these external parts alone have become diseased, without the participation of the rest of the body. This is an absurd theoretical precept which has seductively led to the most ruinous medical treatment.

§186

The only local maladies to merit the name are very minor ones caused by an external injury of proportionate violence.

The so-called local maladies that have arisen quite recently from an external damage [e.g., an injury] seem foremostly to merit the name *local* malady, however, only in cases where the damage is very negligible and therefore without particular significance. This is because maladies of any import whatsoever, which have been inflicted on the body from without, draw the entire living organism into sympathy. Fevers arise, etc. Surgery occupies itself with such things. This is only appropriate when a mechanical aid is to be brought to bear on the suffering parts in order to eradicate external obstacles to cure. For example, it is appropriate to mechanically restore dislocations, suture or bandage wounds, mechanically restrain and stanch arterial bleeding, remove foreign bodies that have penetrated living parts, open a body cavity to extract a bothersome substance, drain collected fluids, set broken bones, etc.

However, while these interventions can mechanically remove external obstacles to cure, the cure itself can only be expected by means of the life force. When the entire living organism demands (as it *always* does) active *dynamic* help with such damages in order to be placed in a position to accomplish the work of healing (e.g., when the stormy fever from extensive contusions or torn flesh, tendons or vessels is to be dispatched through internal medicine or when the external pain of burned or corroded parts is to be taken away homeopathically) then this is the business of a dynamic physician and his homeopathic aid.

Significant injuries require dynamic aid in addition to mechanical removal of obstacles to cure.

§187

Those alterations and ailments appearing on external parts that have not been caused by an external damage, or that have only been occasioned from small external injuries, arise in quite another manner; these have their source in an internal suffering. To pass them off as only local maladies and to treat them only or almost only with local applications or other similar means (surgically, as it were) as the hitherto medicine has done throughout the centuries, is as absurd as it is detrimental in its consequences.

External maladies not caused by injuries of proportionate violence arise from internal causes and involve the entire organism.

§188

These maladies were considered to be merely local, and therefore were called *local maladies*. They were considered to be illnesses that occurred almost exclusively in these parts, in which the organism took little or no part; that is, they were considered to be sufferings of these single, visible parts of which, so to speak, the remaining living organism knew nothing.[188]

§189

Little cogitation is needed for it to dawn on us that no external malady (except those that arise from particular external damages) can arise without internal causes, can persist in its place or even grow

188 This is one of the many, ruinous chief follies of the old school.

worse, without the cooperation of the entire (consequently, sick) organism. Such external maladies could not come to light at all without the concurrence of the entire rest of the condition and without the participation of the living whole, that is, without the participation of the life principle that governs in all the other sensible and irritable parts of the organism. The emergence of such an external malady will not even allow itself to be thought of apart from its being occasioned by the whole of the mistuned life, so intimately do all the parts of the organism cohere and form an indivisible whole in feelings and functions. Therefore, no eruption on the lips, no whitlow occurs without a previous and simultaneous internal indisposition.

§190

All genuine medical treatment must be directed towards the whole disease, not just its local symptoms.

All genuine medical treatment of a malady that has arisen on external parts of the body (and that involves little or no damage from the outside) must therefore be directed towards the whole, towards the annihilation and cure of the general suffering by means of internal remedies. Only in this way will the treatment be expedient, sure, helpful, and thorough.

§191

This is confirmed unambiguously by experience which shows in all cases of a so-called *local malady* (even those on the most external parts of the body) that every efficacious internal medicine, immediately after its ingestion, causes significant alterations in the rest of the patient's condition, especially in the external suffering parts (which appear to the ordinary medicinal art to be isolated). To be sure, if one selects an internal medicine, directed at the whole, which is fittingly homeopathic, it will cause the most salutary alteration, the recovery of the whole human being, along with the disappearance of the external malady, without the assistance of an external means.

§192

This alteration happens most expediently when, in articulating the disease case, one simultaneously unites [draws into coalescence] the

exact constitution of the local suffering with all the noticeable alter-
ations, ailments and symptoms in the rest of the condition (includ-
ing those noticed previously, while no medicine was being taken).
One thereby sketches a complete disease image before seeking a
remedy (among the medicines known according to their peculiar
disease actions) that corresponds to this totality of befallments, in
order to hit upon a homeopathic selection among them.

§193

By means of this medicine, taken only internally, the general disease
state of the body is lifted simultaneously with the local malady
(often with the first dose if the malady has arisen only recently).
The general disease state and the local suffering are cured at the
same time, proving that the local suffering depended simply and
solely on a disease of the rest of the body and was only to be re-
garded as an inseparable part of the whole, as one of the biggest
and most striking symptoms of the total disease.

The general disease state
and its local symptoms
will be lifted by the
homeopathic medicine,
taken only internally.

§194

It is not useful (either with rapidly arising, acute local sufferings or
with long-standing local maladies) to rub in or apply external means
on the site. This is the case even if the means would be homeo-
pathically specific and salutary if it were used internally, even if it
were to be used internally at the same time.

No external means should
be directly applied to local
symptoms.

Acute topical maladies (e.g., inflammations of single parts,
erysipelas, etc.) which have not arisen from an external damage of a
violence proportionate to the malady, but through dynamic or
internal causes, yield most surely to an internal means from the gen-
eral supply of proven medicines [i.e., an apsoric medicine] that is
homeopathically appropriate to the present, outwardly and in-
wardly perceptible condition-state. The malady will generally yield
to this treatment without any other aid. If the malady does not
completely yield in this way — if some residue of the disease remains
at the site of suffering, and in the whole condition, which the life
force is not in a position to lift again to normalcy (even though the
patient is following a good regimen) — then the acute malady is a
flare-up of psora which has hitherto remained dormant in the inte-

Acute topical maladies not
cured by the most
appropriate internal
apsoric medicine are acute
flare-ups of psora.

rior and which is on the verge of developing itself into an overt chronic disease. Such a case is not rare.

§195

To achieve a thorough cure in such not-rare cases, an appropriate antipsoric treatment (as taught in my work, *The Chronic Diseases*) should be undertaken after the acute state has been dispatched to a tolerable extent. The antipsoric treatment should be directed against

1. the ailments that remain after the acute state has been dispatched, and
2. the diseased condition-states that were habitual for the patient prior to the acute disease.

In chronic local diseases that are not obviously venereal, the antipsoric internal cure is necessary anyway.[195]

§196

It might seem that the cure of such diseases would be accelerated by employing, both internally and externally, the medication that has been correctly discerned as homeopathic for the entire symptom complex since the action of a medicine, brought to bear on the site of the local malady, could bring forth a more rapid alteration.

§197

However, such treatment is thoroughly reprehensible for local symptoms which have the psoric miasm as a basis (and also for those having the syphilitic or sycotic miasm as a basis) because, *in diseases whose chief symptom is a constant local malady, the topical application of the remedy simultaneous to its internal use* will give rise to the following great disadvantage: the local malady (which is the chief symptom)[197] will usually disappear from view sooner than the annihilation of the internal disease. We shall now be deceived

195 As I have stated in my book *The Chronic Diseases*.
197 The local maladies which are the chief symptoms of the psoric, syphilitic and sycotic miasms are the recent itch diathesis eruption, the chancre and the figwart, respectively.

by the semblance of a complete cure. At the least, the premature disappearance of this local symptom will make it more difficult (and in some cases impossible) to judge whether the total disease has also been annihilated by the supplemental use of the internal medicine.

§198

Topical application alone of a medicine that would be curative if given internally is reprehensible for the same reason. If the local malady of a chronic disease is lifted locally and in a one-sided manner, the internal treatment indispensable for a complete restoration of health remains in the dark. With the disappearance of the chief symptom (the local malady) one is left with less discernible symptoms which are less constant and less lasting. These are often not sufficiently peculiar, not characteristic enough, to portray the image of the disease in distinct and complete outline.

§199

If the local symptom has been annihilated by a caustic or dessicative external treatment or by surgery (because the remedy appropriate for the disease had not yet been found)[199] then the case becomes far more difficult. This is because the symptoms that remain are too indefinite (uncharacteristic) and inconstant, and the external main symptom (the one that would have been best able to guide and determine the selection and internal application of the most apt remedy, up to the point of the entire annihilation of the disease) has been withdrawn from our observation.

§200

If the local symptom had still been present during the internal treatment, the homeopathic remedy for the total disease would have been discoverable. If the remedy were found and then used only internally, the continued presence of the local malady would show

199 This was the situation before I discovered the remedies for figwart disease (and the antipsoric medicines).

that the cure had not yet been completed. But if the local symptom were cured at its site, untouched by any external suppressive means, then this would prove persuasively that the malady had been extirpated right down to the root and that recovery from the total disease had flourished all the way to the desired goal. The local malady thus provides an inestimable, indispensable advantage in arriving at a complete cure.

§201

The life force makes and sustains symptoms on the exterior to silence chronic internal disease.

When the human life force is burdened with a chronic disease that it cannot overwhelm by its own powers, it obviously decides (in an instinctual way) to form a local malady on a given external part. It makes and sustains the local malady on an external part which is not indispensable to life merely with the intent to allay the internal malady that threatens to annihilate vital organs and rob the patient of life. It does so in order to transfer (so to speak) the internal malady to a representative local malady — to divert it there, as it were. In this way, the presence of the local malady reduces the internal disease to silence for the present, however, without being able to cure it or to essentially curtail it.[201] In the meantime, the local malady always remains nothing more than a part of the total disease, but a part exaggerated one-sidedly by the organic life force, shifted onto a more harmless (outer) location of the body in order to allay the internal suffering.

Local symptoms of chronic disease grow worse in order to continue to appease the worsening internal disease.

While the presence of this local symptom silences the internal disease for awhile, little is won on the side of the life force towards either diminishing the total malady or curing it. On the contrary, the internal suffering gradually increases and nature is compelled to enlarge and worsen the local symptom more and more in order that

Fontanels act like metastases. They briefly allay chronic sufferings without curing the underlying disease.

201 The fontanels used by old-school physicians do something similar. As artificial ulcers on external parts, they allay some internal chronic sufferings, but only for a very short time (as long as they cause a painful irritation to which the sick organism is unaccustomed) and they cannot cure the sufferings. Rather, they debilitate and ruin the whole condition-state far more than the instinctual life force does through most of the metastases that it organizes.

it may still suffice as a representative for the enlarged internal disease and for its appeasement. For example:

1. Old thigh ulcers get worse as long as internal psora is uncured.
2. The chancre enlarges as long as internal syphilis is uncured.
3. The figwarts multiply and grow as long as sycosis is uncured, whereby the sycosis becomes more and more difficult to cure.

The internal total disease also grows of itself with time.

§202

If the local symptom is topically annihilated by external means (by a physician of the hitherto school who is of the opinion that he has thereby cured the whole disease), nature makes up for this by awakening the internal suffering and the rest of the symptoms that already existed and are lying dormant along with the local malady; that is, nature makes up for this by heightening the disease. In these cases, one tends to say, *incorrectly,* that by external means, the local malady has been *driven back* into the body or upon the nerves.

Removal of local symptoms results in a heightening of the whole disease.

§203

Every external treatment for clearing away such local symptoms from the surface of the body, without having cured the internal miasmatic disease (e.g., the eradication of the itch diathesis from the skin by all kinds of salves, the cauterization of chancres, and the annihilation of figwarts just by cutting, tying or burning them off) — these hitherto universal, external, ruinous treatments (which have been all too common) have become the most prevalent source of all the countless named and unnamed chronic sufferings under which humanity so generally sighs. This practice is one of the most criminal acts of which the medical guild could make itself guilty, and yet it has been the commonly established one and it has been taught from the rostrums [of medical schools] as the only one.[203]

203 This is because the additional medicines that were administered internally served only to aggravate the malady since these means possessed no specific curative power for the totality of the disease. Rather, these medicines attacked the organism, weakened it and, in addition, inflicted other chronic medicinal diseases upon it.

Removal of local symptoms is a common practice of the old school because their internal medicines do not cure.

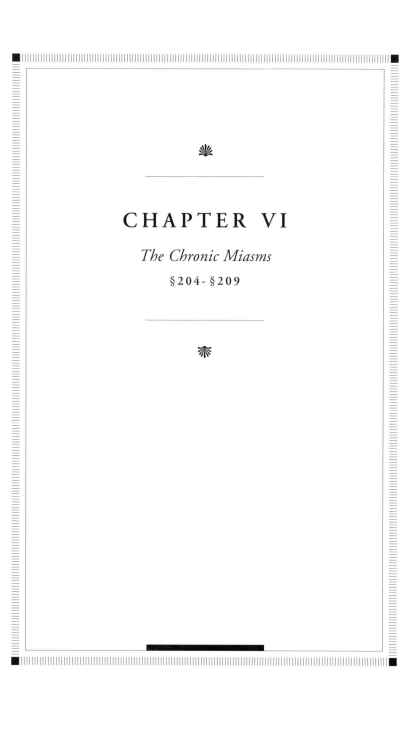

CHAPTER VI

The Chronic Miasms

§204- §209

SYPHILIS, SYCOSIS AND PSORA

§204

The entire organism is pervaded by the miasm before its primary symptom appears. The primary symptom serves to prevent the outbreak of the internal disease.

If we do not count

1. all the protracted maladies, ailments and diseases that depend on a persistent, unhealthy lifestyle (§77), and
2. those countless medicinal wasting sicknesses (see §74) that arise from imprudent, persistent, aggressive and ruinous treatments employed by physicians of the old school (often even for minor diseases),

then the greatest part of the remaining chronic sufferings stems from the development of the three chronic miasms: internal syphilis, internal sycosis, but especially (in unequally greater proportion) internal psora. Each of these miasms was already in possession of the whole organism, having pervaded it in all of its parts, before the appearance of the primary, representative local symptom that prevented the outbreak of the internal disease (the itch diathesis eruption in psora, the chancre or inguinal bubo in syphilis, and the figwart in sycosis).

When its representative local symptom is removed, the miasm expresses itself through the development of characteristic chronic diseases.

If, by external means, these miasms are robbed of their representative local symptoms (which allay the general suffering) sooner or later the characteristic diseases that the Originator of nature has appointed for each of the miasms must inevitably unfold and erupt, thus spreading all the nameless misery and the incredible quantity of chronic diseases which have tormented humankind for centuries and millennia. None of these diseases would have come so frequently into existence had physicians intelligently striven to thoroughly cure these three miasms solely by the internal homeopathic medicines proper for each of them, and to extinguish them in the organism without resorting to topical means for their external symptoms (see *fn* 282).

§205

Homeopathic physicians treat the underlying

The homeopathic physician never uses local means (neither external, dynamically acting ones[205a] nor mechanical ones) to treat

Local removal of malignant tumors

205a Therefore I cannot recommend, for example, the local extirpation of the so-called lip or facial cancer (which is, perhaps, the fruit of highly

these primary symptoms of chronic miasms, nor does he use local means to treat any of the secondary maladies that have germinated from the miasm's further development. When either primary or secondary symptoms appear, he cures the great miasm lying at their base. In this way, the primary and secondary symptoms, together with the great miasm, vanish all by themselves (except in some inveterate cases of sycosis [*fn* 282]).

Unfortunately, however, the homeopathic physician mostly finds himself with cases in which the primary symptom[205b] has already been outwardly annihilated by the old school physician who previously treated the case. Therefore, the homeopathic physician now generally has to deal with the secondary symptoms (i.e., the maladies stemming from the eruption and development of these indwelling miasms). Mostly, he has to deal with the chronic diseases that have developed from internal psora. (I refer the reader to *The Chronic Diseases*, in which I have endeavored to present the internal cure of these miasms as far as any one physician could

miasm with internal homeopathic remedies rather than treating the miasm's primary or secondary symptoms with local means.

developed psora, sometimes combined with syphilis) by means of Cosmo's arsenical preparation. It is extremely painful and often fails; but more importantly, when the bodily site is locally freed of the malignant ulcer by this means, the fundamental malady has not been diminished in the least. The sustentive power of life is therefore required to transfer the focus for the great internal malady to a still nobler site (as it does with all metastases) allowing blindness, deafness, insanity, suffocative asthma, dropsy, apoplexy, etc. to follow. Moreover, this ambiguous local liberation of the site from the malignant ulcer by the topical arsenical means only succeeds when the ulcer is not yet large and not of venereal origin, and when the life force is still very energetic. But it is in precisely such cases that a complete internal cure of the whole original malady is still feasible.

The result is the same when facial or breast cancers are removed surgically or when encysted tumors are enucleated without previously curing the indwelling miasm. Something worse ensues or, at the very least, death is hastened. This has been the result in times without number, but the old school still goes on blindly wreaking the same misfortune in each new case.

205b That is, the itch diathesis eruption, the chancre (or inguinal bubo), or figwarts.

Primary symptoms of psora, syphilis and sycosis

bring them to light, after many years of cogitation, observation and experience.)

HOW TO TREAT CHRONIC MIASMATIC DISEASES

§206

Identify which chronic miasms are involved in the case:

Before beginning the treatment of a chronic malady, the most careful inquiry is required in order to determine whether or not the patient has had a venereal infection, either syphilis or the rarer figwart disease [gonorrhea].[206]

Syphilis or sycosis alone

1. If the only symptoms present are those of syphilis or gonorrhea, the treatment must be directed against this alone. However, in recent times, such pure cases are very rare.

Psora complicated with syphilis or sycosis

2. In any case of psora with a history of venereal infection, the venereal infection must be taken into consideration as it will have complicated the psora. This is always the case when the signs are not those of pure psora. Almost always, when the physician imagines that he has a case of old venereal disease before him, he in fact has a case that is principally associated with (complicated with) psora. This is because the internal itch diathesis (psora) is by far *the most frequent fundamental cause of chronic diseases.*

Differentiating between actual causes of disease and occasions of the appearance of symptoms

206 In inquiries of this kind, one must not be misled by the frequent assertions of patients or their relations regarding the cause of protracted diseases (including the greatest and most protracted ones) attributing them to such things as a cold suffered many years ago (from getting soaked or drinking something cold while overheated), a former fright, a strain from lifting, a vexation, sometimes even a bewitchment, etc. These occasions are much too minor to engender a protracted disease *in a healthy body*, to maintain it for years, and to increase it from year to year, as is the tendency with all chronic diseases from developed psora. Much more important causes than these recollected noxious factors must lie at the base of the inception and continuation of any significant, obstinate, inveterate malady. Those alleged occasions can only serve as moments of enticement for a chronic miasm.

3. Occasionally, the physician will have to combat both the miasms of psora and syphilis which are further complicated with sycosis, in chronically diseased bodies in which sycotic infections had once occurred independently.

Psora complicated with syphilis and sycosis

4. Much more frequently, the physician will find cases in which psora is the only fundamental cause of all the remaining chronic sufferings (whatever they may be called) which, on top of it all, have often been bungled by allopathic artlessness, and have thereby been monstrously heightened and deformed.

Psora alone, or complicated by allopathic treatment

§207

Once the above-mentioned information has been gained, the physician must inquire as to what allopathic treatments the chronic patient has received (what invasive medicines were chiefly and most frequently used, what mineral baths were used and with what results) in order to understand, to some extent, the degeneration from the patient's original state and either to improve, in part, these artificial ruinations (if this is possible) or at least to avoid the medicines that have already been misused.

Ascertain what treatments the patient has received to date.

§208

In order to discover what things in the patient's life might tend to increase his malady, or to what extent they could favor or hinder his treatment, the physician should take into consideration the patient's:
1. age,
2. lifestyle and diet,
3. occupations,
4. domestic situation,
5. civic relations, etc.

Consider the patient's circumstances and his mode of thought and emotions. Ascertain any obstacles to cure.

In the same way, his mode of thought and emotions should be considered to determine whether it hinders treatment, and to determine whether it should be psychologically guided, fostered or modified.

§209

Only after this is done, should the physician seek, in several interviews, to sketch the disease image of the sufferer as completely as

Over the course of several interviews, sketch a

complete image of the
disease, tracing out the
characteristic symptoms.

Start treatment with the
most homeopatic
antimiasmatic medicine.

possible (according to the instructions given above) in order to be able to trace out the most striking and singular (characteristic) symptoms.

Based on these symptoms, the physician starts the treatment by selecting the (antipsoric, etc.) medication that has the utmost possible similarity of signs to those of the disease, and so forth.

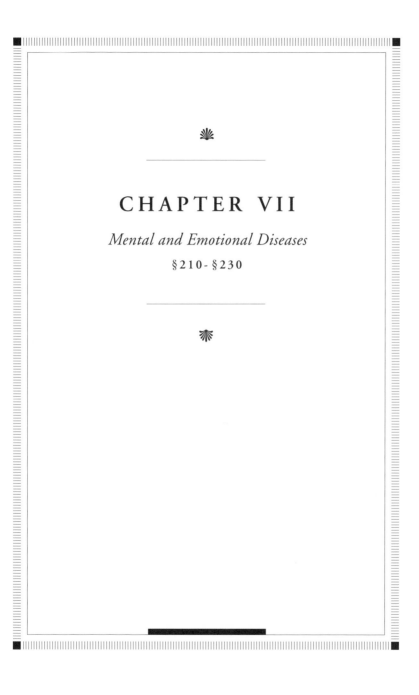

CHAPTER VII

Mental and Emotional Diseases

§210- §230

THE MENTAL AND EMOTIONAL STATE:
CHIEF INGREDIENT OF ALL DISEASES

§210

Mental and emotional
diseases are not sharply
separated from other
classes of disease because
in every disease, the
mental and emotional
state is altered.

Almost all of the diseases that I have termed one-sided belong to psora. These diseases appear to be more difficult to cure because of this one-sidedness (where all the rest of the disease symptoms vanish, as it were, before a single, great, prominent symptom). The so-called *mental and emotional diseases** are of this kind. They do not, however, constitute a class of diseases that is sharply separated from the rest of the diseases because, in all the so-called somatic diseases as well, the mental and emotional frame of mind is *always* altered.[210] In all cases of disease to be cured, the patient's emotional state should be noted as one of the most preeminent symptoms, along with the symptom complex, if one wants to record a true image of the disease in order to be able to successfully cure it homeopathically.

* 'Mental' is translated from *Geist* (spirit) and 'emotional' is translated from *Gemüt* (the emotional mind). See *mental* and *emotional* in the Glossary.

Examples of mental and
emotional alterations in
disease

210 For example, one often encounters patients with the most painful, protracted diseases who have a mild, gentle emotional mind such that the medical-art practitioner feels impelled to bestow attention and sympathy upon them. If the physician conquers the disease and restores the patient again (which is not a rare possibility with the homeopathic mode of treatment) the physician is often astonished and startled at the dreadful alteration of the patient's emotional mind. The physician often meets with ingratitude, hard-heartedness, deliberate malice and the most degrading, the most revolting tempers of humanity — qualities that were precisely those possessed by the patient in former, healthy days.

One often finds that people who were patient in healthy times become, in disease: stubborn, violent, hasty, and even insufferable, self-willed and in due succession, impatient and despairing [i.e., impatient then despairing, etc.]. Those who were formerly chaste and modest often become lascivious and shameless. Not seldom, one finds that bright people become dull-witted, those who are usually feeble-minded become more clever (as it were, more sensible) and the slow-witted occasionally become full of presence of mind and rapid resolve, etc.

§211

This preeminent importance of the emotional state holds good to such an extent that the patient's emotional state often tips the scales in the selection of the homeopathic remedy. This is a decidedly peculiar sign which, among all the signs of disease, can least remain hidden from the exactly observing physician.

The patient's emotional state often decides the choice of remedy.

§212

The Creator of curative potences has also preeminently taken into consideration this chief ingredient of all diseases, the altered mental and emotional state, in that every efficacious medicinal substance in the world very noticeably alters the mental and emotional state of the healthy individual who proves it and, to be sure, each medicine does so in a different way.

All medicines alter the mental and emotional state, each in a different way.

§213

For this reason, one will never cure in accordance with nature, that is, one will never cure homeopathically unless:

1. one attends to the symptom of the mental and emotional alterations, together with the other symptoms, in every case of disease, even acute ones, and
2. for aid, one selects, from among the remedies, a disease potence that, along with the similarity of its other symptoms with those of the disease, is *of itself* capable of engendering a mental or emotional state similar to that of the disease.[213]

A remedy must be able to engender mental and emotional symptoms similar to those of the disease in order to cure it.

§214

Therefore, what I have to teach about the cure of the mental and emotional diseases can be confined to a very few remarks, since

Treat mental and emotional diseases in the

213 Thus aconite will seldom or *never* produce either a rapid or permanent cure if the patient's emotional state is quiet and uniformly calm. Nux vomica will not cure if the patient has a mild and phlegmatic emotional state. Pulsatilla will not cure if the patient's emotional state is glad, cheerful and stubborn. Ignatia will not cure if the patient's emotional state is unchangeable and not inclined to fright or vexation.

The mental and emotional state engendered by a medicine must match that of the patient.

same way as other diseases.

these diseases are to be cured in the same manner as all the other diseases (and not at all differently), that is, by means of a remedy that offers a disease potence as similar as possible to a given case of disease (with respect to the remedy's symptoms that were brought to light in the body and soul of the healthy prover).

CHRONIC ONE-SIDED MENTAL AND EMOTIONAL DISEASES*

§215

Almost all mental and emotional diseases are one-sided diseases in which the somatic symptoms have diminished and the mental and emotional symptoms have heightened.

Almost all so-called mental and emotional diseases are nothing other than somatic diseases in which the symptom of mental and emotional mistunement that is peculiar to each disease heightens itself as the somatic symptoms diminish (more rapidly or more slowly) right up to the most striking one-sidedness until finally the disease transfers itself (almost like a local malady) to the invisibly subtle mental and emotional organs.

§216

The cases are not rare in which a so-called somatic disease that threatens to be fatal — suppuration of the lungs, corruption of some other noble organ, or some other heated (acute) disease (e.g., during childbirth, etc.) — degenerates, by rapid ascent of the hitherto emotional symptom, into an insanity, a kind of melancholia or a frenzy, thereby making all deadly peril of the somatic symptoms vanish. In the meantime, the somatic symptoms improve almost up to the point of health, or rather they decrease to such a degree that their crepuscular presence can only be discerned by the subtly observing physician who perseveres in his observations. In this way,

* In §215-§227, three kinds of mental and emotional disease are discussed:
 1. *Chronic one-sided diseases* — diseases in which mental and emotional symptoms have become heightened, masking the somatic symptoms.
 2. *Acute flare-ups of psora* — flare-ups of insanity or mania from a patient's usually quiet state.
 3. *Emotional diseases spun and maintained by the soul* — emotional diseases that develop outward from the emotional mind.

the disease degenerates into a one-sided, as it were, local disease in which the symptom of the emotional mistunement that was previously mild enlarges itself into the main symptom which then, for the most part, represents the rest of the symptoms (the somatic symptoms) and palliatively allays their intensity. In a word, the maladies of the coarser bodily organs are, as it were, transferred and diverted onto the almost spiritual, mental and emotional organs, which have never been reached, and are unreachable, by any dissecting scalpel.

§217

1. In these maladies, the investigation of the whole complex of signs must be undertaken with care. One must carefully investigate the somatic symptoms and, preeminently, one must exactly apprehend the definite individuality (i.e. the character) of the malady's chief symptom: the special, always prevailing, mental and emotional state.

2. This should be done in order to find a homeopathic medicinal disease potence, among the remedies known according to their pure actions, that will extinguish the total disease — a remedy which, in its symptom content, offers not only the somatic symptoms that are present in this disease case but which also, preeminently, offers the greatest possible similarity of the mental and emotional state.

How to treat chronic one-sided mental and emotional diseases:

Get a picture of the whole disease, both the somatic and especially the mental and emotional state.

Select the remedy whose symptoms most resemble not only the somatic symptoms in the case, but especially the mental and emotional state.

§218

3. The first depiction of these symptoms should include an exact description of all the befallments of the former so-called somatic disease before it degenerated into the one-sided heightening of the mental symptom, that is, before it degenerated into the mental and emotional disease. This will come to light in interviewing the patient's relations.

Find out about the patient's somatic disease before it degenerated into a mental and emotional disease.

§219

A comparison of these former somatic disease symptoms with the more indistinct vestiges that still remain will serve as a confirmation of the continuing concealed presence of these somatic symp-

toms. Even now, these somatic symptoms will put themselves forth if a lucid interval occurs and there is a temporary abatement of the mental disease.

§220

Seek an antimiasmatic remedy capable of arousing similar symptoms to those of the disease, especially its mental symptoms.

4. By adding the patient's mental and emotional state[220] (accurately observed by the patient's relations and by the physician himself) to the patient's somatic symptoms, a complete image of the disease is put together. In order to homeopathically cure the malady (if the mental disease has already lasted for some time) a medicine must be sought from among the (antipsoric, etc.) medications which is capable of arousing aptly similar symptoms and, especially, the similar mental derangement.

ACUTE FLARE-UPS OF PSORA

§221

Acute flare-ups of insanity or frenzy almost always arise from internal psora. They should first be treated with apsoric medicines, followed by continued antipsoric (and possibly antisyphilitic) treatment.

An insanity or frenzy that suddenly breaks out as an acute disease from the patient's usually quiet state may be occasioned by fright, vexation, drinking alcohol, etc., but it almost without exception springs from internal psora that, as it were, flares up like a flame. Such a case cannot be treated straight away, in its acute onset, with antipsoric medicines. Rather, it must first be treated with medicines (such as aconite, belladonna, stramonium, hyoscyamus, mercury, etc.) selected from the other class of proven remedies [i.e., the apsorics]. These should be given in highly potentized, subtle homeopathic doses in order to dispatch the acute flare-up to such an extent that the psora returns for the present to its previous, almost latent state, whereupon the patient appears to recover.

Diseases in which different mental and emotional states alternate

220 Not seldom, mental and emotional states appear to alternate periodically. For example, several days of stormy insanity or rage are followed by days of profound quiet sadness, etc. Sometimes, indeed, a particular mental and emotional state only returns during certain months of the year.

§222

However, a patient who recovers from an acute mental and emotional disease by means of apsoric medicines should never be regarded as cured. On the contrary, once the acute outbreak has passed, the patient should be given, as soon as possible, a continued antipsoric (and possibly antisyphilitic) treatment in order to entirely free him from the chronic miasm,[222] from the psora, which is now latent again, but which is very liable to re-erupt in the form of attacks of the previous mental and emotional disease. If such treatment is given, there will be no need to fear any similar future attack, as long as the patient faithfully adheres to the dietary regimen prescribed for him.

§223

But if the antipsoric (and possibly antisyphilitic) treatment is not given, then we can almost assuredly expect a new, more prolonged and bigger attack, from a much slighter occasion than with the first appearance of the insanity. During this new attack, the psora is wont to develop itself fully and turn into either a periodic or a constant mental derangement, which is then more difficult to cure with antipsorics.

222 On very rare occasions, an already somewhat protracted mental or emotional disease subsides by itself. In these cases, the internal wasting sickness passes over again into the grosser bodily organs. This is what has happened in the few cases in which an inmate of a mental institution has been discharged, apparently recovered. Except for these rare discharged cases, mental institutions remain crammed to capacity. No new space becomes available in them for the many insane people awaiting admission, except when a patient dies. *No one in mental institutions is ever really and permanently cured by the old school.* This is a telling proof (among many others) of the entire nullity of the hitherto calamitous art which has been ridiculously honored by allopathic boasting with the title of *rational medical art.* On the other hand, the true medical art (genuine, pure homeopathy) has very often restored such unfortunate beings to mental and bodily health, giving them back again to their delighted relations and to the world!

Patients in mental institutions are never cured by old school methods. On rare occasions, their mental and emotional symptoms spontaneously disappear.

DIFFERENTIATING BETWEEN DIFFERENT KINDS OF
MENTAL AND EMOTIONAL DISEASES

§224

The patient's reaction to psychological approaches will help the physician differentiate between a mental disease that stems from a somatic disease and one that stems from bad practices, etc.

If the mental disease is not yet fully developed and if there is still some doubt as to whether it arose from somatic suffering or whether it stemmed from faulty upbringing, bad habits, perverted morality, neglect of the spirit, superstitions or ignorance, the way to decide the point is as follows:

1. If it stems from the latter [faulty upbringing, bad habits, etc.], then the mental disease will subside and improve with understanding, well-intentioned exhortations, consolation, or with earnest and rational expostulations.
2. If it is a mental or emotional disease that is really based upon a somatic disease, it will rapidly worsen with such treatment. The melancholic patient will become still more downcast, plaintive, disconsolate and withdrawn; someone who is maliciously insane will become still more embittered; and senseless talk will become obviously more nonsensical.[224]

EMOTIONAL DISEASES SPUN AND
MAINTAINED BY THE SOUL

§225

Some emotional diseases develop outward from the emotional mind.

By comparison, there are certainly a few emotional diseases that have not simply degenerated from somatic diseases. In these cases, the emotional disease develops in an inverse manner. With but little

Possible explanation for the aggravation that psychological approaches elicit in certain cases of mental or emotional disease

224 In such cases where understanding and exhortations, etc. aggravate the mental or emotional disease, it appears as if the soul of the patient feels, with exasperation and sadness, the truth of these rational expostulations and acts directly upon the body as if it wanted to restore the harmony that has been lost; but it appears as if the body, by means of its disease, reacts too strongly back upon the mental and emotional organs, throwing them into an even greater uproar through a renewed transference of its sufferings upon them.

infirmity, it develops outward from the emotional mind due to persistent worry, mortification, vexation, abuse, or repeated exposure to great fear or fright. While initially there is but little infirmity, in time emotional diseases of this kind often ruin the somatic state of health to a high degree.

§226

It is only these emotional diseases, which were first spun and maintained by the soul, that allow themselves to be rapidly transformed into well-being of the soul by psychotherapeutic means (displays of trust, friendly exhortations, reasoning with the patient, and even well-camouflaged deception). With appropriate living habits, these diseases apparently also allow themselves to be transformed into well-being of the body. However, such approaches will be effective *only if the emotional disease is new and has not yet deranged the somatic state all too much.*

This is the only kind of disease which can be rapidly transformed by psychotherapeutic means into well-being of the soul.

§227

These cases, as well, are based upon a psoric miasm which, however, is not yet entirely near its full unfoldment. To ensure against a relapse into a similar mental disease (which can easily happen) the convalescing patient should be given a thorough antipsoric (and probably also an antisyphilitic) treatment.

These diseases are also based upon a psoric miasm.

BEHAVIOR TOWARDS PATIENTS

§228

Mental and emotional diseases that arise from somatic diseases can only be cured by homeopathic medicine that is directed against the internal miasm, in conjunction with carefully adapted living habits. It is also important that the patient's physician and relations observe a psychically fitting approach towards the patient as an assisting diet for the soul. To raging insanity, they must oppose quiet fearlessness and cold-blooded [unemotional] firm will. To distressing, plaintive lamentation, they must oppose silent regret in their looks and ges-

Mentally and emotionally ill patients should be treated with calm and firmness and without reproach.

tures. To senseless chatter, they must oppose a silence not wholly inattentive. Disgusting and atrocious behavior and chatter should be opposed with complete inattentiveness. They must safeguard against property damage *without reproaching the patient for this,* arranging everything so that corporal punishments and torments are thoroughly abolished.[228] This is all the more easily effected since in the homeopathic administration of medicine (administration of medicine being the only case in which compulsion could be justified as an excuse) the small doses of helpful medicine are never conspicuous to the taste and can therefore be given in the patient's drink without his being aware of it so that all compulsion becomes unnecessary.

§229

On the other hand, the following behaviors are entirely out of place: contradiction, eager agreements, violent reprimands and vituperations, as well as weak, timid compliance. These are equally detrimental treatments for the spirit and the emotional mind of such patients. Above all, these patients are embittered, and their disease is worsened, through scorn, deceit and noticeable deceptions. *The physician and attendants must always appear as if they credit such patients with reason.*

Cruelty of the physicians in several mental institutions

228 One must be astonished at the hard-heartedness and indiscretion of physicians in several mental institutions. These cruel physicians, without seeking the true medical mode for such diseases — the only helpful, homeopathic *medicinal* (antipsoric) way — content themselves with tormenting these most pitiable of all human beings by means of the most violent beatings and other excruciating martyrdoms. By these unconscionable and revolting procedures, they lower themselves far beneath the level of prison guards, for prison guards execute such punishments only because it is the duty of their official position and they do so upon criminals. These physicians, on the other hand (humiliated due to their medical ineptitude) seem to vent their spite against the presupposed incurability of mental and emotional diseases by being tough on the pitiable, innocent sufferers. These physicians are too ignorant to furnish aid and too indolent to adopt an expedient curative procedure.

On the contrary, one should seek to remove all kinds of external disturbances to their senses and emotions. There are no entertainments for their befogged spirit, no beneficent diversions, no advice, no soothing words, books or objects for their indignant soul languishing in the fetters of a sick body. There is no refreshment for them except cure. Only when the tunement of their bodily condition is altered towards improvement do quiet and comfort radiate back once more upon their spirit.[229]

> All external disturbances to the senses and emotions should be removed.

SUCCESS OF HOMEOPATHIC TREATMENT

§230

In cases of mental or emotional disease (which are incredibly various), if the selected remedy for a particular case is entirely appropriate for the truly sketched image of the disease state, then the smallest possible doses are often sufficient to produce the most striking improvement, which is often quite rapid. This is never achieved by medicating the patient to death with huge, frequent doses of all other unsuitable (allopathic) medicines. The unflagging search for the most fitting homeopathic remedy is more easily achieved (if enough medicines of this kind, known according to their pure actions, are available for selection) because the mental and emotional state of such a patient, which is the main symptom, comes to light with unmistakable distinctness. I can assert from much experience that the sublime advantage of the homeopathic medical art over all other conceivable methods of treatment is nowhere displayed in a more triumphant light than in old mental and emotional diseases that originally arose from somatic sufferings or even arose simultaneously with them.

> Homeopathic treatment can produce rapid and striking results in cases of mental and emotional disease.

229 The treatment of insane, raging and melancholic patients can only be accomplished in a specifically arranged institute, not in the patient's family circle.

> Necessity of institutional care for certain diseases

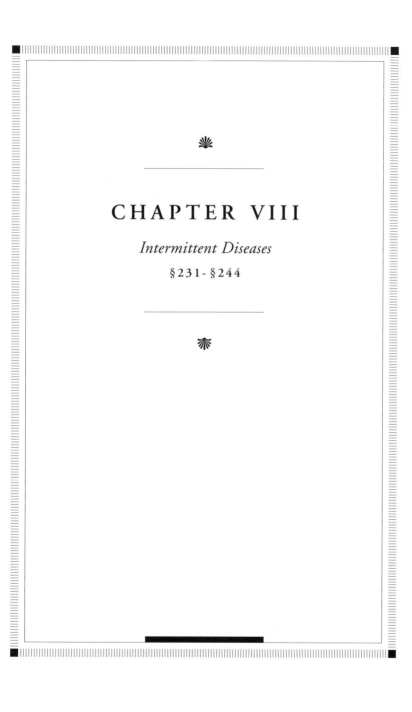

CHAPTER VIII

Intermittent Diseases

§231- §244

DISEASES THAT RECUR AT DEFINITE
AND INDEFINITE INTERVALS

§231

The *intermittent diseases* deserve their own consideration, both:

1. those diseases that recur at definite intervals (which include the large number of intermittent fevers, as well as the apparently non-febrile ailments that recur like intermittent fevers), and
2. those diseases in which certain reciprocal disease states alternate at indefinite intervals; that is, those diseases in which certain disease states alternate with states of a another kind.

§232

Intermittent diseases in which two or three

These latter intermittent diseases [point 2, above] are also very diverse [232] but they are all numbered among the chronic diseases.

Examples of intermittent diseases in which two or three reciprocal states alternate at indefinite intervals

232 In these diseases, two or even three states may alternate with one another. The following are examples of two reciprocal states alternating with one another:

1. Certain unremitting pains in the feet, etc., can appear as soon as an eye inflammation subsides, which then comes up again as soon as the pain in the limb has temporarily passed.
2. Spasms and cramps can directly alternate with any other suffering of the body or one of its parts.

The following is an example of three reciprocal states in a persistent infirmity: A patient's customary moderate indisposition is suddenly replaced by a period of apparently heightened health with a tense heightening of the mental and bodily powers (an exaggerated hilarity, an all-too-active liveliness of the body, an excess of comfort, inordinate appetite, etc.) whereupon there then appears, just as unexpectedly, a somber, melancholic temper, an intolerable, hypochondriacal emotional mistunement with disturbance of several vital functions (digestion, sleep, etc.) which in turn, reverts just as suddenly to the customary moderate indisposition. In this manner, there can be several other manifold reciprocal states.

Often there is no longer any noticeable trace of the previous state when the new one sets in. In other cases, there are only a few traces of the preceding reciprocal state that are still present; there is little left over from the symptoms of the first state upon emergence and continuation of the second. Occasionally, reciprocal disease states will be completely

Most of them are the engenderment of effloresced psora only. Occasionally, although seldom, they are the engenderment of psora which is complicated with a syphilitic miasm. In the first case they are cured with antipsoric medicines, while in the latter case they are cured with antipsoric medicines alternated with antisyphilitic ones, as is taught in my book *The Chronic Diseases.*

reciprocal states alternate at indefinite intervals are always chronic and usually purely psoric.

§233

The *typical intermittent diseases* [point 1, above] are those in which an unvarying disease state returns at fairly definite intervals and recedes again at equally definite intervals. In between these outbreaks, the patient appears to be in good health. This disease pattern, where symptoms come and go at regular intervals, is found both in the apparently non-febrile intermittent diseases as well as in the febrile one: the many intermittent fevers.

Intermittent diseases in which constant disease states recur at fairly definite intervals may be either febrile or apparently non-febrile.

§234

The intermittent disease states that appear to be without fever typically affect isolated individuals, that is, they are not usually sporadic or epidemic. These apparently non-febrile diseases are always chronic and most of them are purely psoric. Only seldom are they complicated with syphilis. Consequently, they can be successfully treated with antipsorics. Sometimes, however, the intercurrent use of a very small dose of potentized cinchona solution is necessary in order to entirely extinguish their intermittent fever-like typus.

The apparently non-febrile intermittent diseases are always chronic and usually purely psoric.

INTERMITTENT FEVERS*

§235

When it comes to reigning sporadic or epidemic *intermittent*

Sporadic and epidemic

opposite to one other; for example, periods of melancholia will alternate with periods of jovial insanity or frenzy.
* Intermittent fevers occur in various forms, including:
 Sporadic — a few cases of the same disease, occurring at the same time in widely scattered localities.

intermittent fevers:
symptom pattern and
recommended treatment

fevers [235a] (not those endemically dwelling in marshy regions) we often find every attack (paroxysm) likewise composed of two opposite reciprocal states [*fn* 232] that alternate with one another (cold-heat, heat-cold). Even more often, each paroxysm is com-

* *continued*

Epidemic — numerous cases of the same disease occurring at the same time and in the same area, outside of regions where such diseases are endemic.

Endemic — cases of intermittent fever that occur in regions where such diseases are continuously present.

Isolated — individual cases of intermittent fever that occur outside of regions where such fevers are endemic.

Psoric — cases that develop from untreated or poorly treated cases of epidemic intermittent fever, in patients where psora is already present.

These various forms of intermittent fever and their treatment are discussed in §235-§244.

Examples of different
intermittent fevers

235a The hitherto pathology, still in its non-rational childhood, is only aware of a single *intermittent fever*, which it also calls *cold fever* [ague]. It makes no distinctions other than the intervals at which the attacks recur (e.g., daily, every three days, every four days, etc.). There are, however, far more important distinctions among these fevers than their intervals of recurrence. There are countless variations of intermittent fevers, for example:

1. There are many intermittent fevers that cannot be called *cold fever* at all because their attacks consist only of heat.
2. Other intermittent fevers only have attacks of cold, with or without sweat afterwards.
3. There are others in which the patient is cold all over but feels hot internally, or the patient is hot to the touch but feels cold.
4. There are others in which one paroxysm consists only of shivering or simply feeling cold, followed by feeling well. This is followed by a paroxysm of heat, with or without subsequent sweat.
5. In other fevers, the heat comes first, followed by chill.
6. There are other fevers where the chill and the heat are followed by a period of no fever, and then (often many hours later) there is an attack of sweat only.
7. In some fevers, no sweat follows.
8. In still others, the attack consists only of sweat, without heat or chill.
9. In other fevers, there is sweat but only during the heat.

posed of three states (cold-heat-sweat). For this reason, the remedies selected for these intermittent fevers (chosen from the general class of proven medicines, not usually from the antipsorics) must be able to similarly arouse both or all three intermittent states in healthy provers (which is the surest); or as much as possible, they should homeopathically correspond in symptom similarity to the strongest and most peculiar reciprocal state (the cold, the heat or the sweat) along with the accessory symptoms of that state. But especially, the selection of the most apt homeopathic remedy must be guided by the symptoms of the patient's condition in the fever-free time.[235b]

There are innumerable other differences that show themselves, especially in the accessory symptoms: a particular headache, a bad taste in the mouth, nausea, vomiting, diarrhea, thirstlessness or intense thirst, particular pains in the trunk or limbs, sleep symptoms, delirium, emotional mistunements, cramps, etc. These accessory symptoms may occur before, during or after the cold, the hot or the sweating stage. And there are still other countless variations.

Accessory symptoms in intermittent fevers

All of these intermittent fevers are obviously very different and each one demands, quite naturally, its own (homeopathic) treatment. To be sure, almost every one of these intermittent fevers can be suppressed (as so often happens) by large, monstrous doses of cinchona or its pharmaceutical sulphuric acid extract, called *quinine*. These extinquish a fever's periodic return (its *typus*) but patients with fevers for which cinchona is not suitable (such as all those epidemic intermittent fevers that cover whole regions, even mountainous ones) are not cured by this extinguishing of their typus. No! They remain sick in a different way, often much sicker than before, with peculiar chronic quinine wasting sicknesses. Even with genuine medical art, these wasting sicknesses often cannot be restored to health for a long time; sometimes they can never be restored to full health again. And they want to call that *curing*!

Homeopathic versus allopathic treatment of intermittent fevers

235b It was Baron von Boenninghausen who in the beginning best elucidated this subject (which requires so much circumspection) and facilitated the selection of the most effective remedy for the different epidemic fevers, through his writing of *Versuch einer homöopathischen Therapie der Wechselfieber* [Attempt at a Homeopathic Therapy for Intermittent Fevers], Münster at Regensberg, 1833.

Boenninghausen's writings on the homeopathic treatment of epidemic intermittent fevers

§236

Administer a remedy
after or at the end of a
paroxysm to avoid the
action of the medicine
coinciding with the
natural recurrence of
symptoms.

In this case, the medicinal dose is most expediently and most help-fully given immediately or, at least, very soon after completion of the attack, as soon as the patient has somewhat recovered from it. Then it has time to produce all its possible alterations of the organism towards health, without storm and without violent attack. On the other hand, if the medicine (no matter how specifically appropriate it may be) is administered just before a paroxysm, its action will coincide with the natural resumption of the disease and it will occasion such a counter-action in the organism, such a violent opposition that, at the very least, such an attack will rob much vitality, if it does not endanger life altogether.[236] If, however, one gives the medicine immediately after the completion of the attack (that is, at the time when the fever-free interim has come on, and far in advance of the preparation for the next paroxysm) then the organism's life force is in the best possible shape to allow itself to be quietly altered by the remedy, and thus transposed into a state of health.

§237

If the fever-free time is very short, as happens with some very bad fevers, or if it is distorted by the after-throes of the previous paroxysm, then the homeopathic medicinal dose should be administered when the sweating begins to abate or when the later befallments of the elapsing attack begin to ease.

§238

Recommended medicine
and number of doses for
intermittent fevers

Not infrequently, the appropriate medicine will expunge several attacks with only one small dose, probably restoring health all by itself, however, in most cases, one must administer a new dose after each attack. In the most favorable cases (i.e. those cases in which the nature of the symptoms has not been altered) doses of the same medicine are to be given. Due to the recent discovery of the best

Danger of administering
medicine in the middle of
a paroxysm

236 This can be seen in those (by no means rare) fatal cases in which a moderate dose of opium, given in the midst of the chills of the fever, rapidly takes the patient's life.

repetition of doses, repeated doses can be administered without ill effect (see footnote to §270).* The medicinal solution should be succussed 10–12 times before administering each successive dose.

In rare cases, the intermittent fever returns after the patient has felt well for several days. This recurrence of the same fever after an interval of health is only possible when the malignity that first aroused the intermittent fever continues to impinge upon the convalescing patient, as it does in marshy regions. In such cases, a permanent restoration of health is only possible by removal of the arousing cause (for example, by staying in a mountainous region in the case of an intermittent marsh fever).

Removal of the arousing cause of the intermittent fever may be necessary for a permanent restoration of health.

§239

Almost every medicine, in its pure action, arouses its own specific fever that deviates from all of the fevers generated by other medicines. This even includes a kind of intermittent fever with its reciprocal states. Therefore, homeopathic help for the numerous natural intermittent fevers is to be found in the great realm of medicines. For many such fevers, help is already available in the moderate number of medicines proven on healthy bodies up until now.

Since almost every medicine arouses its own specific fever, there are many medicines that can be homeopathically used against the numerous intermittent fevers.

§240

If during an epidemic of intermittent fever, one or another patient is not perfectly cured by the homeopathic remedy found to be specific to that epidemic, this is always due to the hindrance of the psoric miasm (assuming the cure has not been hindered by the patient's living in a marshy region). Such a case must be treated with antipsoric medicines until complete aid has been afforded.

Persistent intermittent fevers may be due to psora.

§241

Those epidemics of intermittent fever that occur outside areas where such fevers are endemic have the nature of chronic diseases

To find the remedy that is best for almost all

* In *fn* 270f, Hahnemann discusses the advantages of fifty-millesimal (LM) potency medicines over centesimal (C) potencies. With fifty-millesimal potencies, one may repeat the dose even at short intervals and even with medicines of long-lasting action.

patients in an epidemic
who are not suffering
from developed psora,
discover the symptom
complex common to all.

composed of single, acute attacks. Each epidemic has its own self-same character which is common to all of the individuals who are taken ill. If the character of the epidemic disease is discovered according to the symptom complex common to all the patients [i.e., the genus epidemicus], this will point to the homeopathically fitting (specific) remedy for the totality of the cases. This remedy almost always helps in those patients who enjoyed tolerably good health before the epidemic, that is, who were not chronically sick with developed psora.

§242

Psoric intermittent fevers
may develop in untreated
or poorly treated cases of
epidemic fever.

If the first attacks of such an epidemic intermittent fever are left uncured, or if the patient is debilitated by allopathic mistreatment, then the indwelling, dormant psora (which unfortunately is already in so many human beings) develops and takes on the typus of the epidemic intermittent fever; that is, the psoric disease, to all appearances, plays out the role of the epidemic intermittent fever. In these cases, the medicine that would have been helpful for the initial paroxysms is no longer fitting and can help no more. We now have a case of psoric intermittent fever only. It is usually vanquished by the subtlest doses of sulphur or hepar sulphuris in high potency.

§243

Isolated cases of
intermittent fever are
often due to psora on the
point of development.

There are cases of intermittent fever that befall single individuals outside of marshy regions [where such fevers are endemic]. These are often very virulent. In these cases, treatment should be *started* by using, for several days, a general remedy from among the proven medicines, not an antipsoric. (This is how acute cases in general should be treated, which these fevers resemble with respect to their psoric origin.) If, after several days, recovery is nevertheless delayed, it means that this is a case of psora on the point of its development. Only antipsoric remedies can provide thorough [fundamental] help.

§244

Intermittent fevers
endemic to marshy and

Intermittent fevers endemic to marshy regions and places where flooding is frequent have given the old school physicians a lot of

trouble. Yet, a healthy young person can accustom himself even to marshy regions, and remain healthy in such surroundings, provided his regimen is faultless and he is not oppressed from deprivation, fatigue or destructive passions. The intermittent fevers endemic to the place will, at most, only seize him when he is a newcomer. One or two *of the smallest* doses of highly potentized cinchona solution would, along with an orderly way of life, soon free him of the disease.

If people cannot be freed of intermittent marsh fever with one or two such small doses of cinchona, along with proper exercise and a healthy mental and bodily diet, then this always means that psora, striving to develop itself, lies at the base of their malady. The intermittent fever cannot be cured in the marshy region without antipsoric treatment.[244]

It sometimes happens that such patients, if they are not yet deeply sunken in disease (i.e., if the psora is not yet fully developed and can return to its latent state), can exchange the marshy region for a dry mountainous one without delay, and recovery apparently ensues (i.e., the fever leaves them). But they can never become healthy without antipsoric help.

frequently flooded regions are effectively treated with small doses of cinchona and a faultless regimen, unless psora lies at the base of the disease.

244 Larger, frequently repeated doses of cinchona (as well as concentrated cinchona preparations such as *chininum sulphuricum* [quinine]) can indeed free such patients from what is typical of intermittent marsh fevers [i.e. the periodic attacks] but such people, deceived into believing they are cured, are not. They are left suffering in a different manner, as was already noted above [*fn* 235a], from a cinchona wasting sickness which is occasionally incurable (see footnote 276b).

Effect of large, frequent doses of cinchona or quinine on intermittent marsh fevers

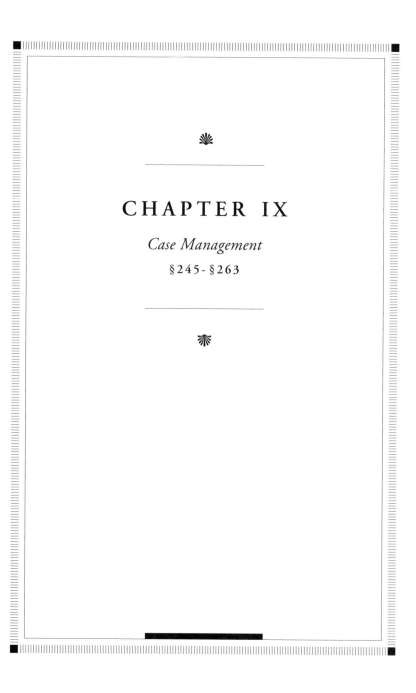

CHAPTER IX

Case Management

§245- §263

MEDICAL TREATMENT AND REGIMEN

§245

We have seen what consideration should be given, in homeopathic cures, to the main varieties of disease and to the particular circumstances connected with them. We now move on to the subject of *remedies, the manner of employing them, and the regimen to be observed.*

FIFTY-MILLESIMAL (LM) POTENCY MEDICINES

§246

While it is generally the case that a medicine should not be repeated as long as the patient's state is improving, fifty-millesimal potencies can be repeated, with a heightening of each dose.

Cures of chronic diseases can be achieved more rapidly, using gradually increased potencies of fifty-millesimal medicines.

During treatment, every noticeably progressing and conspicuously increasing improvement is a state which, as long as it persists, generally excludes any repetition of the medicine being used because all the good being produced by the medicine is still hastening towards completion. This is not seldom the case in acute diseases.

On the other hand, with somewhat chronic diseases, there are, to be sure, some cases that have slow, continuous improvement based on one dose of an aptly selected homeopathic medicine (taking 40, 50, 60, 100 days to complete the cure, depending on the nature of the medicine) but this is very seldom the case. Also, it must be a matter of great importance, to the physician as well as to the patient, to foreshorten this period, if possible, by half, three-quarters, indeed even more, in order that a far more rapid cure might be attained. The most recent and frequently repeated experiences have taught me that such rapid cures can be favorably carried out under the following conditions:

1. Select with all circumspection, the aptly homeopathic medicine.
2. Use a highly potentized [fifty-millesimal] dose, dissolved in water.
3. Administer a properly small dose of this to the patient.
4. Give a dose of the solution at intervals that experience has shown to be the most distinctly appropriate for the best possible acceleration of the treatment.

5. Prior to each administration of a dose of the solution, alter the degree of potency of the dose. *It is very important that the degree of potency of each dose deviate somewhat from the previous and subsequent ones.* This is so that the life principle, whose tunement is to be altered to that of the similar medicinal disease, may never feel itself agitated to adverse counter-actions and enraged, as happens when repeated, unmodified doses are given, especially when such doses are rapidly repeated one after another.[246]

§247

It is an unexecutable project to repeat the same, unmodified dose of a medicine even once, let alone many times (and at short intervals in cases where treatment ought not be delayed).[247] The life principle does not accept such *entirely identical* doses without opposition, that is, without other symptoms of the medicine (i.e., the ones not similar to those of the disease to be cured) becoming pronounced. The previous dose has already carried out the expected alteration of the life principle's tunement, leaving a second unaltered dose of the same medicine of entirely equal dynamization with nothing more

The life force resists repeated, unchanged doses, which aggravate the patient's condition. When each new dose is slightly heightened in potency, the life force is brought closer to cure without ill effect.

246 What I said in a long footnote to this paragraph in the fifth edition of *The Organon of the Medical Art* was all that my experience allowed me to say at the time. It was written with the purpose of preventing these adverse reactions of the life principle. However, during the last four to five years, all such difficulties have been fully lifted through the modifications I have made since then, resulting in my new, perfected procedure [for fifty-millesimal potency medicines]. The same well-chosen medicine can now be given daily, even for months when necessary. In the treatment of chronic diseases, after the lowest degree of potency has been used up (in one or two weeks) one proceeds in the same way to higher degrees of potency (for in the new [fifty-millesimal] manner of dynamization, use begins with the lowest degrees, as is taught in the following paragraphs).

247 Therefore, one should not allow the patient to take a second or third dose of medicine in the same potency — even if it is the best homeopathically chosen medicine which was so well received the first time. For example, if one dry pellet was taken, another dry pellet in the same potency should not be taken a second or third time. If one takes, for a

Advantages in using fifty-millesimal potency medicines

Repetition of modified versus unmodified doses

to carry out on the life principle. The patient can only become sick in a different way by such an *unmodified* dose — fundamentally sicker than he already was — because now the only symptoms of the medicine that remain in effect are those not homeopathic to the original disease. The result is an actual aggravation of the patient's condition, rather than progress towards cure.

But as soon as one slightly modifies each new dose, by dynamizing it to a somewhat higher degree of potency (§269-§270), the sick life principle allows itself to be further unburdened by the same medicine without ill effect, allowing itself to be further altered in its tuning. Its feeling of the natural disease is further decreased and it is thereby brought closer to cure.

Directions for the use of fifty-millesimal potencies:

§248

Potentize the solution anew before each dose.

1. *Before each administration* of the medicinal solution,[248] potentize the solution anew with about eight, ten or twelve succussions of

247 *continued*

second or third time, an equal or smaller dose of the same medicine dissolved in water (where the water has *remained standing undisturbed)* then this same medicine will not be well received by the patient, even if the subsequent doses are taken after intervals of a couple of days. This is the case even if the original preparation was potentized with ten succussions (or only two succussions, as I later proposed [in *fn* 280 of the fifth edition of the *Organon*] in order to avoid this disadvantage and, to be sure, only for the above cited reasons). *But by modifying each dose in its degree of dynamization,* as I teach here, no shock takes place, even with more frequent repetition of the doses, no matter how highly potentized the medicine may be, with ever so many succussions. One might almost say that even the best chosen homeopathic medicine can best withdraw the morbid mistunement from the life principle and, in chronic diseases, extinguish the mistunement, *only* if the medicine is applied to the life principle in *several different forms.*

Preparation of medicines in fifty-millesimal potency

248 Make up solutions with 40, 30, 20, 15 or 8 tablespoons of water. Add some alcohol or a piece of charcoal to keep the solution from spoiling. If charcoal is used, suspend it on a thread in the bottle and remove it when succussing the bottle.

the bottle. Then give the patient one or, ascendingly, several tea-spoons of this.

2. In protracted diseases, give the medicine daily or every second day. In acute diseases, give the medicine every six, four, three or two hours. In the most urgent cases, give the medicine every hour or even more frequently. In chronic diseases, every correctly chosen homeopathic medicine, even one whose action is of long duration, may be repeated daily for months with ever-increasing success [when fifty-millesimal potencies are used].

The frequency of administration depends on the disease.

3. When a solution is used up, in 7–8 or 14–15 days, it is necessary to add to the next solution one or (rarely) several globules of the same medicine of another (higher) potency, if the medicine is still indicated. One should continue in this way as long as the patient continues to sense more improvement without undergoing one or another important ailment that he never had in his life.

Use the same medicine, in increasing potencies, as long as the patient improves with no important new ailments.

Instead of using large quantities of water, solutions can be made up with only 7–8 tablespoons of water, as follows:

1. Place one globule of the properly dynamized medicine in a bottle with 7–8 tablespoons of water. (It is rarely necessary to use more than one globule of a properly dynamized medicine.)
2. *Vigorously succuss the bottle.*
3. Pour one tablespoon of this into a glass containing 8–10 tablespoons of water.
4. Stir several times *vigorously*.
5. Administer the determined dose of this to the patient.

If the patient is unusually excitable and sensitive, a teaspoonful of this solution may be put in a second glass of water, vigorously stirred again, and a teaspoon of this (or somewhat more) administered to the patient. There are patients of such high excitability that it is necessary to employ a third or fourth glass, prepared in a similar way, to properly thin the medicinal solution for them. Every day after ingestion, one should pour out the contents of the one (or several) prepared drinking glasses in order to prepare the solution anew each day. It is best to crush the globule of highly potentized medicine into a few grains of powdered milk sugar so that all the patient has to do is put it into a bottle that holds the deter-mined amount of water.

4. If the patient undergoes one or another important ailment that he never had before in his life, and the rest of the disease appears in a group of altered symptoms, then another medicine, more homeopathically appropriate, must now be selected in place of the one that was used. The new medicine should be administered in just such repeated doses. Again, each dose of the solution should be modified with the proper vigorous succussions in order to somewhat alter and heighten its degree of potency.

5. If so-called homeopathic aggravations (§161) appear towards the end of treatment of a chronic disease, after almost daily repetition of the fully homeopathically fitting medicine (i.e., so that the remaining disease symptoms seem to be somewhat heightened), then this is an indication that the medicinal disease, which is so similar to the original disease, is now audible almost all by itself. Therefore, the doses must be reduced still more and repeated at longer intervals, or even entirely suspended for several days in order to see whether or not any more medicine is needed for recovery. If no more medicine is needed, these apparent symptoms (stemming merely from the overflow of the homeopathic medicine) will soon disappear by themselves, leaving behind unclouded health.

If the medicine is administered by olfaction daily (or every two, three or four days) the medicine must also be vigorously succussed before each olfaction. Medicine to be administered by olfaction is prepared as follows:

1. One globule of the medicine is dissolved, by succussion, in one dram of dilute alcohol.
2. The medicine is thoroughly succussed eight to ten times prior to each olfaction.

WHAT TO DO WHEN A MEDICINE DOES NOT WORK

§249

Every medicine prescribed for a case of disease which, in the course of its action, brings forth new and troublesome symptoms that are

not peculiar to the disease to be cured, is not capable of engendering true improvement. Such a medicine is not to be deemed as homeopathically selected.[249a]

1. If the aggravation is significant, it should be partly extinguished by an antidote, given as soon as possible. Then the next means should be given, which has been more precisely selected according to its similarity of action.
2. If the troublesome symptoms are not all-too-violently adverse, then the next means should be administered at once, to take the place of the incorrectly selected one.[249b]

§250

In urgent cases, after six, eight or twelve hours, it may already be revealed to the sharp-sighted medical-art practitioner who accurately investigates according to the disease state, that he has mis-selected the medicine last given. The patient's state grows distinctly (even if only ever-so-slightly) worse from hour to hour, as new symptoms and ailments arise. In these cases, it is not only permitted but the

[margin notes:]
some symptoms was not homeopathically selected.

A poorly selected medicine should be replaced by the most appropriate homeopathic remedy for the present disease state.

249a According to all experience, almost no dose of a highly potentized, specifically fitting homeopathic medicine can be prepared so that it is too small to bring forth a distinct improvement in the disease for which it is suited (§161, §279). Therefore, one would be practicing inexpediently and detrimentally (as happens with the hitherto method of treatment) if one wanted to repeat or even increase the dose of the same medicine when there is no improvement or when there is a small aggravation, under the delusion that the medicine was not able to be of service on account of its small quantity (i.e., its all-too-small dose). *Every aggravation involving new symptoms* (when nothing untoward has occurred in the mental or bodily regimen) *always means that the previously taken medicine was inappropriate to this case of disease. It never indicates that the dose was too weak.*

249b Antidotes will never be necessary in the practice of a well-trained and conscientiously careful physician if the physician begins treatment by giving his well-selected medicine in the smallest possible dose, as he should do. An equally minute dose of a better-selected medicine will put everything in order again.

[margin notes:]
Aggravations never result from a too-small homeopathic dose. Aggravations with new symptoms indicate unhomeopathic treatment.

Antidotes will not be necessary when treatment is begun with the smallest possible dose.

physician is duty-bound to make good the mistake he has made by selecting and administering a homeopathic remedy which is not merely tolerably fitting, but which is the most appropriate possible for the present disease state [i.e., the disease state as it now appears, with the old symptoms that remain and the new symptoms] (§167).

§251

When a medicine that has reciprocal states is not effective on first being administered, a second dose will usually be effective.

There are some medicines whose power to alter the human condition consists, for the most part, of reciprocal actions. Examples of such medicines are ignatia, probably bryonia and rhus toxicodendron, and in part, belladonna. These medicines have initial-action symptoms that are, in part, opposed to one other. Should the medical-art practitioner find no improvement upon prescribing one of these medicines (according to strict homeopathic selection) he should give another, equally minute dose of the same medicine. He will thereby soon attain his purpose in most cases (and in cases of acute disease, after just a few hours).[251]

§252

In chronic cases that do not improve with homeopathic treatment, look for an obstacle to cure.

But if [apart from these cases involving medicines with reciprocal actions] one finds, in a case of chronic disease, that the best homeopathically selected medicine, given in the appropriate (smallest) dose, does not promote improvement, then this is a *certain* sign that the cause maintaining the disease still persists. Some circumstance is to be found in the regimen or the environment of the patient which must be gotten rid of if the cure is to permanently come to pass.

DETERMINING WHETHER A CASE IS GETTING BETTER OR WORSE

§253

The patient's mental and emotional state

In all diseases, especially the rapidly arising (acute) ones, the patient's emotional state and entire behavior are the surest and most

251 I have explained this in greater detail in the preface to *Ignatia* in the *Materia Medica Pura*.

enlightening of the signs showing a small beginning (not visible to everyone) of amelioration or aggravation. When there is an ever-so-slight beginning of improvement, the patient will demonstrate a greater degree of comfort, increasing composure, freedom of spirit, increased courage — a kind of returning naturalness. When there is an ever-so-slight beginning of aggravation, the patient will demonstrate the opposite of this, exhibiting a more self-conscious, more helpless state of emotional mind, of the spirit, of the whole behavior and of all attitudes, positions and performances — a state which draws more pity to itself. This can be easily seen if one observes with exact attentiveness, but it cannot be easily described in words.[253]

> and whole behavior give the first indications of aggravation or amelioration.

§254

Either the appearance of new, foreign befallments of the disease to be cured or the decrease of the original symptoms without the addition of any new ones will soon dispel any doubt, for the keenly observing and investigating practitioner, about aggravation or amelioration, even in those patients who, by nature, are incapable of giving an account of this amelioration or aggravation or are unwilling to admit it.

> Changes in the symptom picture will soon confirm whether the patient's condition is aggravated or ameliorated.

253 Signs of mental and emotional improvement can only be expected soon after ingestion of the medicine if the dose has been *properly minute* (i.e., as small as possible). An unnecessarily larger dose of even the homeopathically most fitting medicine acts too violently. It initially disturbs the spirit and emotions too much and too persistently for one to *soon* become aware of the improvement in the patient; not to mention the other disadvantages (§276) from doses that are all-too-large.

I remark here that this very necessary rule is sinned against mostly by conceited beginners in homeopathy and by physicians from the old school, who are passing over to the homeopathic medical art. Due to old prejudices, those who come from the old school avoid using the smallest doses of the higher dynamizations of medicines. Hence, they do not experience the great advantages and blessings of this procedure which has been found, in thousands of experiences, to be the most salutary. They are unable to achieve all that genuine homeopathy can do and thus unjustly pass themselves off as its students.

> Effect on the spirit and emotions of too-large doses of even the most homeopathic medicines

§255

Even with such patients, a physician will come to closure on the question of amelioration or aggravation by going through the disease image recorded in his case notes, symptom by symptom with the patient, as well as inquiring about any new, unusual ailments.

Amelioration

If *a.* the patient complains of no new, unusual ailments, *b.* none of the old befallments has worsened, and *c.* one has already observed a mental and emotional improvement, then the medicine must also have brought forth an altogether essential decrease of the disease or, if little time has elapsed, it will do so soon. Assuming that the remedy is appropriate, if the visible improvement of the patient is delayed too long, this indicates either some error of conduct on the part of the patient or it indicates that some other circumstances [obstacles to cure] are hindering improvement.

§256

Aggravation

If, on the other hand, the patient mentions some newly arisen befallments and symptoms of consequence — features of a medicine that was not fittingly homeopathic in its selection — then we must regard the patient's state as having taken a turn for the worse, as it will soon be perfectly apparent that it has. We should conclude that his condition is worse even if the patient good-naturedly assures us that his condition is improving.[256]

ONE SHOULD NEITHER FAVOR CERTAIN MEDICINES NOR AVOID OTHERS

§257

The genuine medical-art practitioner will know how to avoid making favorites of certain medicines that he has happened to find indicated rather often and has used with success. Otherwise, he will

Innacurate assurances of improvement by patients

256 Such inaccurate assurances from patients are not infrequent among consumptives with suppuration of the lungs [pulmonary tuberculosis].

often overlook more rarely used medicines that would be more homeopathically fitting and therefore more helpful.

§258

By the same token, the medical-art practitioner will not (out of mistrustful weakness) avoid medicines, in his further medical pursuit, that he previously employed with disadvantage because he had incorrectly selected them (therefore, his own fault) or for other (ungenuine) reasons. He will only avoid a medicine for the reason that it is unhomeopathic for a given case of disease. He will bear in mind that the only medicine that deserves his attention and preference is always the one that, in each case of disease, most aptly corresponds in similarity to the totality of characteristic symptoms, and he will not allow petty passions to interfere with this serious choice.

RECOMMENDED REGIMEN FOR CHRONIC DISEASES

§259

Due to the necessary, as well as expedient, minuteness of the dose used in the homeopathic procedure, it is easy to grasp why, during treatment, everything else that could in any way act medicinally must be removed from the *diet and regimen,* so that the subtle dose will not be over-tuned and extinguished, or even disturbed, by any foreign medicinal irritant.[259]

> Remove any substances that may interfere with a remedy's action.

§260

For the chronically ill, it is all the more necessary to carefully seek out such obstacles to cure since the disease has usually been aggravated by such malignities and by other morbific actions. Often,

> Remove any obstacles to cure, especially in cases of chronic disease.

259 The gentlest tones of a distant flute in the still of the night, which would raise a soft heart to over-earthly feelings and melt it away into religious rapture, become inaudible and futile amid the extraneous clamor and noise of the day.

> Subtle homeopathic doses are like the gentlest tones of a distant flute.

these are errors in the patient's regimen which have not been discerned.[260]

§261

While patients with chronic diseases are using medication, the most expedient regimen is based upon the removal of any of these ob-

Examples of obstacles
to the cure of chronic
diseases

260 Patients with chronic diseases should avoid the following: Coffee; fine Chinese tea and other herb teas; beers adulterated with medicinal vegetable substances not suitable for the state of the patient; so-called fine liqueurs prepared with medicinal spices; all kinds of punch; spiced chocolate; many kinds of colognes and perfumes; strongly scented flowers in the room; medicinally compounded tooth powders and tooth spirits [mouthwashes]; perfumed sachets; highly seasoned foods and sauces; spiced cakes and frozen goods [ices and ice creams] prepared with medicinal matters (e.g. coffee, vanilla, etc.); raw medicinal herbs on soups; vegetable dishes with herbs, roots or sprouting stalks (such as asparagus with long green tips); hop sprouts and all vegetables possessing medicinal powers (celery, parsley, sorrel, tarragon, all kinds of onions, etc.); old cheeses and meats which are putrid; foods which have medicinal side effects (e.g., the meat and fat of pigs, ducks and geese; all-too-young veal; sour foods; all kinds of salads).

All of these are to be removed from chronically ill patients, who should also avoid: every excess, even that of sugar and salt; alcoholic drinks not diluted with water; heated rooms; woolen clothing next to the skin; a sedentary lifestyle in closed quarters or, more often, only passive movement (through riding, driving, swinging); excessive breast-feeding; long afternoon naps lying down (in bed); reading in a horizontal position; keeping late hours; uncleanliness; unnatural voluptuousness; enervation from reading lubricious material; onanism, incomplete coition or abstinence from coition (either from superstition or to prevent the engenderment of children [pregnancy] in marriage; objects of anger, grief or vexation; passionate play; mental or bodily overexertion, especially immediately after a meal; dwelling in marshy regions and stuffy rooms; penury, etc.

All these things must be avoided as much as possible or removed if the cure is not to be hindered or even made impossible. Some of my imitators, by forbidding far more, rather indifferent things, seem to make the diet of the patient unnecessarily difficult, which is not to be sanctioned.

stacles to cure plus the addition of their necessary opposites here and there [i.e., where appropriate]:

1. innocent mental and emotional diversion;
2. active movement in the fresh air in almost all kinds of weather (daily walks, light manual labor);
3. appropriate, nutritious, non-medicinal foods and drinks, etc.

innocent diversions, exercise in the fresh air and a good diet, in addition to removing obstacles to cure.

§262

On the other hand, in febrile diseases (except in cases of mental confusion), since the subtle, unerring, internal sense of the here very lively, instinctual sustentive drive of life decides so distinctly and definitely, the physician simply needs to advise the patient's relations and attendants to put no obstacle in the way of this voice of nature, be it by the denial of enjoyments that the patient urgently demands or by detrimental proposals and persuasions.

The best regimen for acute illness involves satisfying the patient's cravings, within moderate bounds, along with avoidance of mental exertion and emotional shocks.

§263

1. The cravings of the acutely ill patient with regard to edible delectables and drinks is, for the most part, for things that give palliative relief. These are not, however, actually of a medicinal nature and they are only appropriate for the current need. The slight obstacles which this gratification, *held within moderate bounds,* could perhaps put in the way of the thorough removal of the disease[263] are amply made up for — indeed out-weighed — by the power of the homeopathically fitting medicine and the life principle unleashed by it, and by the refreshment afforded the patient through the gratification of his craving.
2. In like manner, in acute diseases, the temperature of the room and the warmth or coolness of the bed coverings must be arranged entirely according to the wishes of the patient.
3. All mental exertion is to be kept distant from the patient.
4. All emotional shocks are also to be kept distant from the patient.

263 Such desires are, in fact, rare. For example, in cases of purely inflammatory diseases where aconite is so indispensable, but whose action would be lifted [cancelled] by partaking of vegetable acids, the patient almost always craves only pure cold water.

Acutely ill patients rarely crave things that obstruct cure.

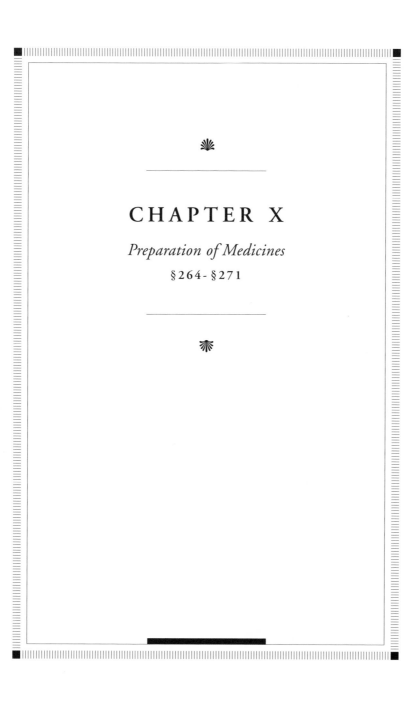

CHAPTER X

Preparation of Medicines

§264- §271

PREPARATION AND ADMINISTRATION OF MEDICINES
BY THE PHYSICIAN

§264

Physicians must be certain of the quality of their medicines.

The true medical-art practitioner must have the *most genuine, full-strength medicines* on hand in order to be able to rely on their curative power; he *himself* must know them according to their genuineness.

§265

Physicians should prepare their own medicines and personally give them to their patients.

It is a matter of conscience for the medical-art practitioner to be certain that each patient takes the right medicine every time. Therefore, the practitioner should give the patient the correctly selected medicine *from his own hands*, and he should also prepare the medicine himself.

PREPARATION OF SUBSTANCES FOR MEDICINAL USE

§266

The substances of the animal and vegetable kingdoms are the most medicinal when they are in their raw state.[266]

Processes that destroy or dissipate the medicinal power of animal and plant substances

266 All animal and plant substances have more or less medicinal power and can alter a person's condition, each in its own manner. The plants and animals used for food by the most enlightened peoples have these advantages: They have a larger concentration of nutrients, and the medicinal power of their raw states (already not very violent) is decreased by culinary and domestic preparation. Processes that partly destroy and dissipate the medicinal part of substances include:
1. Pressing out the detrimental juice, as with the cassava root of South America.
2. Fermentation of the flour in dough for making bread, of sauerkraut prepared without vinegar, and of brine-cured pickles.
3. Smoking of foods.
4. Heating of foods by boiling, stewing, toasting, roasting, baking or, for potatoes, by steaming.
5. By the addition of salt (pickling) and vinegar (sauces, salads), the animal and plant substances indeed lose much of their malignity, but

§267

The most complete and certain way to secure the powers of in-digenous [local] plants, and plants that can be obtained fresh, is as follows:

1. Press out the juice and mix it, *without delay*, with an equal amount of wine spirit [alcohol] strong enough for a sponge to burn in it.
2. Let this mixture stand for 24 hours in a stoppered glass bottle.
3. Decant the clear liquid from the fibrous and albuminous matter that has settled and store the liquid for medicinal use.[267a]

Preparation of medicinal liquid from fresh plants

they receive other disadvantages from these additions. However, the most medicinally powerful plants do lose their medicinal power, in part or entirely, by such treatments.

6. By complete dessication, all roots of the iris-species, horseradish, arum and peony lose almost all of their medicinal power.
7. Through the heat used in ordinary extract preparation, the juice of plants with the most violent medicinal action becomes a pitch-like mass which is quite inert.
8. By long exposure to the air, the pressed out juice of the deadliest plants becomes quite powerless. At moderate air temperatures, it soon ferments by itself, like wine, and thereby loses much of its medicinal power. It proceeds directly to another stage of fermentation, like vinegar, and then putrefies, thereby losing all of its peculiar medicinal power. If the starchy sediment [the fecula] it deposits is collected and washed, it is then completely harmless, like any other starch.
9. Even by the transudation that takes place when a quantity of green plants are piled on top of one another, the largest part of their medicinal power is lost.

267a Bucholz (*Taschenb. f. Scheidek. u. Apoth. a. d. J.*, Weimar, 1815, vols. I, VI) assures his readers (and his reviewer in the *Leipziger Literaturzeitung* [Leipzig Literary Newspaper], 1816, no. 82, does not contradict him) that we have the Russian campaign of 1812 to thank for this excellent mode of preparing medicines, from whence it came to Germany in 1813. Following the noble custom of many Germans to deny the merits of their compatriots, he conceals the fact that this invention and the directions that he quotes, *in my own words*, are from the *Organon of the Rational Medical Art*, first edition (§230 and footnote) which was published in 1810, two years before the Russian campaign. Some people would rather

Preparation of medicines using alcohol

4. Keep the preparation in a well-stoppered bottle, sealed with wax
 to prevent evaporation.
5. Store it away from sunlight.

The alcohol immediately stops all fermentation of the plant juice
and makes subsequent fermentation impossible. The whole medi-
cinal power of the plant juice is thus conserved *forever* (complete
and unspoiled) in well-stoppered and sealed bottles, stored away
from sunlight.[267b]

§268

Use of dry powders in
the preparation of
medicines

Medicines can be made from properly prepared, dry plant powders;
however, the rational medical-art practitioner will never accept on
trust and belief the powdered form of the exotic plants, barks, seeds
and roots that cannot be obtained in their fresh state. Rather, he
will convince himself of their genuineness beforehand, while they

267a *continued*

pretend that an invention came from the wilds of Asia than give a Ger-
man just credit for it. What times! What customs!

Alcohol has certainly been mixed with plant juices before (for ex-
ample, to preserve them for some time before making extracts of them)
but never with the intent to administer them in this form.

Preparation of medicinal
liquid or powder from
fresh plants: Exceptions to
the standard procedure

267b Equal parts of alcohol and freshly pressed juice are usually the most
appropriate proportion for depositing the fibrous and albuminous mat-
ter, however there are exceptions:

1. A double proportion of wine spirit [i.e., twice as much alcohol as
 plant juice] is needed for plants that contain a lot of tough mucilage
 (e.g., symphytum officinale, viola tricolor, etc.) or a lot of albuminous
 matter (e.g., aethusa cynapium, solanum nigrum, etc.).
2. Plants with very little juice (e.g., oleander, buxus, taxus, sabina,
 ledum, etc.) must first be pounded up alone into a moist, fine pulp
 and then stirred together with a double portion of alcohol, so that the
 plant juice and alcohol combine. Then the juice can be extracted by
 being pressed out. These plants can also be dried and then brought to
 the one-millionth powder-trituration with milk sugar (if one applies
 proper force with the mortar and pestle). After dissolving a grain of
 this, one can make further liquid dynamizations (see §271).

are still in their raw unpowdered state, before he makes the least medicinal use of them.[268]

POTENTIZATION OF SUBSTANCES

§269

For its own special purpose, the homeopathic medical art develops to a formerly unheard of degree the internal, spirit-like medicinal powers of crude substances. It does so by means of a procedure which belongs exclusively to it (and which was untried before my time) whereby these substances become altogether more than

268 Properly prepared dry powders can be kept *forever* in well-stoppered and sealed bottles, maintaining all their original medicinal power *without spoiling and becoming moldy*. However, one has to take a precaution that was hitherto almost unknown to pharmacists, who were unable to store powders without their spoiling, even when they were made from well-dried animal and plant substances and preserved in well-stoppered bottles.

Whole, raw plant substances, even when they are thoroughly dried, still contain a certain amount of moisture as an indispensable condition of the cohesiveness of their fabric. This is not enough moisture to allow spoilage when the substance is in its whole state, but it is far too much for a finely powdered state. Therefore, animal and plant substances that are fully dried in their whole state yield a somewhat moist powder when fully pulverized. This powder cannot be preserved in stoppered bottles without quickly becoming spoiled and moldy unless it is freed from this superfluous moisture. Further drying of the fine powder is best done as follows:

1. Spread the powder out on a flat, tin plate with a high rim.
2. Float the plate in a pot of boiling water.
3. Dry it, stirring the powder, until its particles no longer stick together in clumps but easily separate, like fine dry sand, and turn into dust.
4. Store powders in well-stoppered and sealed bottles that are airtight.
5. Keep the bottles away from sunlight and daylight (in covered cannisters, chests, boxes). All animal and plant substances gradually lose their medicinal power (even when they are whole and far more so when they are powdered) if they are not stored in airtight containers away from sunlight and daylight.

Preparation of dry medicinal powders

ever — indeed, immeasurably — penetratingly effective and helpful, *even those substances which, in their crude state do not manifest the least medicinal power* in the human body.[269a]

This remarkable alteration in the properties of natural bodies is achieved through mechanical action on their smallest particles by trituration and succussion *while these particles are separated from one another by means of an intervening, indifferent substance that is either dry or liquid.* This procedure develops the latent *dynamic* (*fn* 11) powers of the substance which were previously unnoticeable, as if slumbering.[269b] The dynamic powers of these substances

Law of medicinal powers

269a Long before I devised this procedure, it was known through experience, that several alterations in natural substances could be brought about *by friction* (e.g., warmth, heat, fire, development of odor in odorless bodies, magnetization of steel, etc.). However, all of these properties engendered by friction relate only to what is physical and lifeless, whereas there is a natural law according to which the physiological and pathogenic powers that are in the raw material of the medications (indeed even in natural substances never yet proven to be medicinal) — powers that alter the living organism's condition — are engendered by means of friction [in trituration] and succussion, under the condition that the natural substance is triturated and succussed with certain proportions of a nonmedicinal (indifferent) intervening medium. This wonderful law, which is physical but more especially physiological and pathogenic, was not discovered before my time. No wonder then, that the natural scientists and physicians of our day *(this law being unknown to them)* did not, until now, believe in the magical curative power of medications prepared (dynamized) according to homeopathic theory and employed in such small doses!

Dynamization of substances through rubbing and succussing

269b For example, there is no mistaking that a trace of latent magnetic power slumbers in the interior of the iron bar and the steel rod. There is no mistaking this because both of them, if they are stood upright after their forging, repel with their lower end a magnetic needle's north pole and attract its south pole, while the upper end of the iron bar or steel rod proves to be a south pole. But this is only a *latent* power; not even the finest iron filings can be magnetically attracted or held by either end of such a rod. Only when we *dynamize* this steel rod by strongly rubbing it *in one direction* with a blunt file does it become a true, active powerful

mainly have an influence on the life principle, on the condition of animal life.[269c] Therefore, this process is called *dynamization* or *potentization* (development of medicinal power). Its products are called dynamizations or potencies of different degrees.[269d]

§270

In order to best produce this development of power, a small quantity of the substance to be dynamized (about one grain) is first

Trituration of crude substances

magnet, capable of attracting iron and steel to itself and even of imparting magnetic power to another steel rod by mere contact (and even when the other steel rod is held at some distance). The more the steel rod has been rubbed, the greater its magnetic power.

Likewise, rubbing a medicinal substance and succussing its solution *(dynamization, potentization)* develops the medicinal powers lying hidden in the medicinal substance and discloses these powers more and more. The dynamization spiritizes the material substance, if one may use that expression.

269c The only thing that is heightened and more strongly developed is the power of these natural bodies to bring forth alterations *in the condition* of animals and humans when the natural bodies, in this improved state, are brought quite near to the living, sensitive fibers or touch the same (upon ingestion or olfaction). This is just like the magnet that only engenders magnetic power in a steel needle (especially in one whose pole is near to it or touching it) without altering the steel itself, which remains unchanged in the rest of its chemical and physical properties [*fn* 11]. And just as magnets do not bring about alterations in other metals, such as brass, dynamized medicines do not exert any action upon lifeless things.

The dynamization of medicinal substances only heightens their power to alter the condition of living humans and animals, nothing else.

269d Daily we hear homeopathic medicinal potencies referred to as *mere dilutions* when they are, in fact, the opposite. There is a true opening up of the natural substances produced by trituration and succussion, bringing to the revelatory light of day the specific medicinal powers that lie hidden in their inner wesen. The non-medicinal dilution medium merely helps as a supervening *accessory condition*. For example, the simple dilution of a grain of salt in a large amount of water results in just plain water; the grain of salt disappears and never becomes the *medicinal salt* [natrum muriaticum] that our well-prepared dynamizations have heightened to such admirable strength.

Potentized medicines are not mere dilutions. The dynamization process reveals a substance's hidden medicinal power. The substance's dilution in a non-medicinal medium is just one part of the process.

raised to the one-millionth powder-attenuation by means of a three-hour trituration process. Three one-hour triturations are done, each using 100 grains of milk sugar as explained in the footnote below.[270a]

Further potentization by dilution and succussion

The medicinal substance is then further potentized by means of dilution and succussion.

How to triturate a substance

270a Trituration to the one-hundredth powder-attenuation:

1. Obtain milk sugar of that especially pure kind that is crystallized on threads and comes to us in the form of round bars.
2. Put one third of 100 grains of powdered milk sugar in a glazed porcelain mortar, the bottom of which has been roughened by rubbing it with fine, moist sand.
3. Put 1 grain of the powdered medicinal substance to be triturated (or 1 drop of mercury, petroleum, etc.) on *top* of the powdered milk sugar.
4. Mix the medicine and the powder with a porcelain spatula for a moment.
5. Triturate the mixture rather strongly for 6 to 7 minutes, using a porcelain pestle that has been rubbed dull.
6. For 3 to 4 minutes, thoroughly scrape the mass from the bottom of the mortar and from the pestle, to make it homogeneous.
7. Continue the trituration (as described in step 5) for another 6 to 7 minutes.
8. Scrape the mass (as described in step 6) for another 3 to 4 minutes.
9. Add the second third of the milk sugar.
10. Repeat steps 4–8.
11. Add the last third of the milk sugar.
12. Repeat steps 4–8.
13. Put the powder in a well-corked vial that protects it from sunlight and daylight.
14. Label the vial with the name of the substance and the number 1/100 [to indicate the one hundredth attenuation, or first centesimal trituration, 1C].

Trituration to the one ten-thousandth powder-attenuation:

1. Mix 1 grain of the 1/100 powder with 1/3 of 100 grains of powdered milk sugar.
2. Follow steps 4–13 above.
3. Label the vial with the name of the substance and the number 1/10,000 [to indicate the one ten-thousandth attenuation, or second centesimal trituration, 2C].

Preparation of medicine to the first degree of potency [LM 1]:

1. Dissolve 1 grain of the triturated powder [i.e., the substance triturated to the one-millionth attenuation] in 500 drops of a mixture that is 1 part brandywine [90° grain alcohol] and 4 parts distilled water. The reason for using this 500:1 dilution ratio is explained in the footnote [270f] below.
2. Place *a single drop* of this mixture in a vial.
3. Add 100 drops of good wine spirit [95° grain alcohol] to the vial.[270b]
4. Give the tightly corked vial 100 strong succussions with the hand against a hard but elastic body.[270c] This is the first degree of dynamization.

Trituration to the one millionth powder-attenuation:

1. Mix 1 grain of the 1/10,000 powder with one third of 100 grains of powdered milk sugar.
2. Follow steps 4–13 above.
3. Label it with the name of the substance and the number 1/1,000,000 [to indicate the one millionth attenuation, or third centesimal trituration, 3 C]. Each grain of this powder contains one millionth of a grain of the original substance.

Each of these three trituration procedures takes *one hour* (six times 6–7 minutes for trituration plus six times 3–4 minutes for scraping). After the first hour of trituration, each grain of the preparation contains 1/100 of the medicinal substance used; after the second hour, 1/10,000 and after the third hour, 1/1,000,000. These are the three degrees of dry powder trituration which, if well executed, make a good beginning towards developing the power (dynamization) of the medicinal substance.

The mortar, pestle and spatula must be thoroughly cleaned before being used to prepare another medicine. Clean them as follows: | Cleaning trituration utensils

1. Wash them thoroughly in warm water.
2. Dry them thoroughly.
3. Place them in boiling water for 1/2 hour.
4. As an extra precaution, these utensils may be placed on top of glowing coals.

270b The size of the vial used for potentizing should be such that it is two-thirds full with this liquid. | Size of vial for potentizing substances

270c Such as a leather-bound book.

5. Thoroughly moisten[270d] fine sugar globules[270e] with this liquid.
6. Rapidly spread the sugar globules on blotting paper to dry.
7. Store the globules in a tightly stoppered little vial with the sign of the first degree of potency (I).
8. Protect the bottle from heat and daylight.

Preparation of medicine to the second degree of potency [LM 2]:
1. Take 1 globule of the medicine potentized to the first degree [LM 1] and put it in a new vial (with a drop of water in order to dissolve it).[270f]

Treatment of sugar globules with potentized medicinal alcohol

270d To moisten the globules with the medicinal alcohol:
1. Place the globules in a small cylindrical vessel made of glass, porcelain or silver and shaped like a thimble, with a fine opening in the bottom.
2. Moisten them with some of the dynamized medicinal alcohol.
3. Stir the globules.
4. Invert the vessel and tap out the globules onto a sheet of blotting paper in order to rapidly dry them.

Manufacture of sugar globules

270e The sugar globules should be made from starch flour and cane sugar by a confectioner under one's own supervision. First, the tiny globules are placed in a sieve to separate them from the fine dust-like particles. Then they are put through a strainer with holes through which only those weighing 1 grain per 100 can pass. This is the most useful size for the requirements of the homeopathic physician.

Centesimal and fifty-millesimal potency medicines: their relative medicinal power and gentleness of action

270f In earlier instructions, I specified that a whole drop of a liquid in a given potency be added to 100 drops of wine spirit for higher potentization. But meticulous experiments have convinced me that this proportion of the dilution medium to the medicine being dynamized (100:1) is much too narrowly limited to develop the powers of the medicinal substance properly and to a high degree, by means of a large number of succussions, unless one uses great force. Whereas if a single globule (100 of which weigh a grain) is used instead of a whole drop of liquid, and this is dynamized with 100 drops of wine spirit, then the ratio of dilutant to medicine becomes 50,000:1, indeed higher than that, because 500 of such globules cannot completely absorb 1 drop. In this much higher ratio of the dilution medium to the medicine, *many* succussions of the vial filled to two-thirds with wine spirit can bring about a far greater development of power.

With a ratio of the dilution medium to the medicine as low as 100:1, very many impacts by means of a powerful machine, as it were, are forced

2. Follow steps 3-8 above, labeling the bottle with the sign of the second degree of potency (II).

Preparation of medicine to the thirthieth degree of potency [LM 30]:

Continue the above procedure until the dissolved globule of the 29th degree of potency has formed a spiritized medicinal fluid with 100 drops of wine spirit, by means of 100 succussions, whereby globules that are moistened with this and dried are labeled XXX, the 30th degree of dynamization.

Only when crude medicinal substances are processed in this way, does one obtain preparations that have attained their full capability to aptly touch the suffering parts in the sick organism. In this way, by means of a similar artificial disease-affection, the feeling of the natural disease is withdrawn from the life principle which is present in these suffering parts. By means of this mechanical processing (provided it is properly executed, as specified above) a given medicinal substance which, in its crude state, is only matter (in some cases, unmedicinal matter) is subtilized and transformed by these higher and higher dynamizations to become a spirit-like medicinal power.[270g] This medicinal power *in itself* no longer falls within our senses. The medicated globule becomes the *carrier* of this invisible

in. As a result, medicines arise that, especially in the higher degrees of dynamization, almost instantaneously but with stormy — indeed dangerous — intensity, impinge on patients (especially delicate ones) without bringing about an enduring, gentle counter-action of the life-principle.

On the other hand, my new method engenders a medicine of the highest development of power and the gentlest action which, if well chosen, curatively touches all sick points.

Using these far more perfect [i.e., greatly perfected] dynamized medicinal preparations, one can, in acute fevers, repeat the small doses of the lowest degrees of dynamization even at short intervals and even with medicines of long-lasting action, such as belladonna.

Use of fifty-millesimal potencies in acute diseases

In chronic diseases, one can best proceed by beginning treatment with the lowest degrees of dynamization and, when necessary, continuing to the higher degrees which, although they become ever more powerful, always act only gently.

Use of fifty-millesimal potencies in chronic diseases

270g This assertion will not appear improbable if one considers that with this method of dynamization [of fifty-millesimal potencies] — which I

The attenuation of matter in potentized medicines

power and, in this capacity, it documents the salutariness of that power in the sick body. The medicated globule carries this invisible power even when it is used dry, but far more so when it is dissolved in water [§272].

PREPARATION OF POTENTIZED MEDICINES
DIRECTLY FROM FRESH PLANTS

§271

If the physician prepares his homeopathic medicines himself, as he should always do to rescue humanity from diseases,[271] he may use the fresh plant itself since only a little of the crude material is

270g *continued*

have found after many laborious tests and counter-tests to be the most powerful and, at the same time, the mildest in action (i.e., the most perfected) — the material part of the medicine is attenuated about 50,000 times and yet it is incredibly increased in power. If we multiply by 50,000 at each progressive dynamization [following initial trituration which achieves a dilution ratio of 1,000,000 to 1] the material substance is already reduced to 125,000,000,000,000,000,000 at the third potency $[1,000,000 \times 50,000 \times 50,000 \times 50,000 = 125 \times 10^{18}]$. This is the dilution after triturating the substance to the one-millionth attenuation and then dynamizing it to the third potency [LM 3]. The thirtieth dynamization, prepared progressively in this way, gives a fraction of material substance almost impossible to express in numbers. It becomes exceedingly probable that the matter, by means of such dynamizations (developments of its true, inner medicinal wesen) finally dissolves entirely into its individual spirit-like wesen. Therefore, in its crude state, it could be considered as actually consisting only of this undeveloped spirit-like wesen.*

* Several lines of text in §270, plus all but the first few lines of *fn* 270g appear in the original text in Dr. Richard Haehl's handwriting, not Hahnemann's. See Comments on the Text, pp. 278-279.

Government role in the preparation of medicines

271 Physicians should prepare their own medicines until that day when the government (having attained insight as to the indispensability of perfectly prepared homeopathic medicines) has them manufactured by a capable, impartial person so that they may be given, free of charge, to

required. This method can be used if the physician does not need the expressed juice [§267] for some other curative purpose.

1. Mix a couple of grains of the plant in a mortar with one third of 100 grains of milk sugar.

2. Bring the mixture to the one millionth trituration in three distinct steps (§270).

The substance can then be further potentized by means of succussion. This procedure is also to be observed with the remaining medicinal substances of either a dry or oily nature [*fn* 267b].

homeopathic physicians of the land who are versed in cure, who have been trained in homeopathic hospitals, proven in both theory and practice, and thus certified. In this way, the physician will not only be assured of the intrinsic superior quality of these divine curative implements, he will also be able to give them free to his patients, rich and poor.

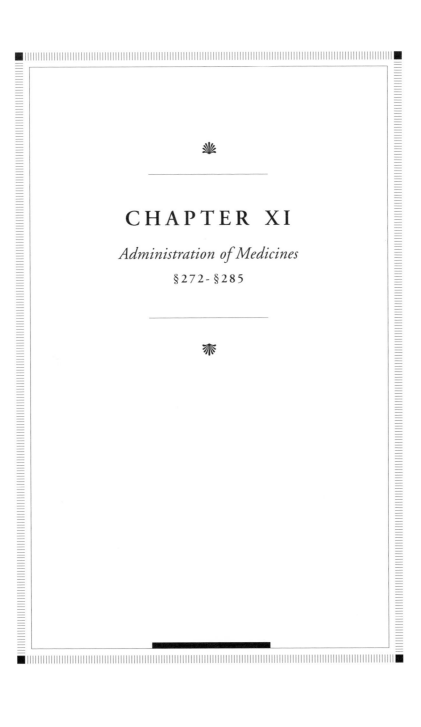

CHAPTER XI

Administration of Medicines

§272- §285

ADMINISTRATION OF SINGLE, SIMPLE MEDICINES

§272

One globule [of fifty-millesimal potency medicine, prepared as described in §270-§271],[272] when it is placed dry upon the tongue, is one of the smallest doses for a moderate case of recently arisen disease. Administered in this way, only a few nerves are touched by the medicine. On the other hand, a similar globule crushed in with some milk sugar, dissolved in a good amount of water (§247) and well succussed before each ingestion, furnishes a far stronger medicine for many days' use. Every dose, no matter how small, contacts many nerves all at once.

§273

In no case of cure is it necessary to employ more than a *single simple* medicinal substance at one time with a patient. *For this reason alone, it is inadmissible to do so.* It is inconceivable that there could be the slightest doubt about whether it is more in accordance with nature and more reasonable to prescribe only a *single, simple,*[273]

272 These globules retain their medicinal value for *many* years if protected from sunlight and heat.

273 The following may be accepted by homeopathic physicians as *simple* medicinal substances and used with patients:

1. Neutral [i.e., non-acidic] and middle [i.e., low acidity] salts which are compounded from two substances that are opposed to one another and combine through chemical relationship in unchangeable proportions.

2. Sulphuretted metals that have originated in the womb of the earth, as well as those that are artificially compounded combinations of sulphur with alkaline salts and earths, and that are always in constant proportions (e.g., natrum sulphuricum and calcarea sulphurica).

3. Those kinds of ethers formed by the linking of wine spirit [alcohol] and acids through distillation.

4. Phosphorus.

On the contrary, extracts of the so-called alkaloids of plants (e.g., quinine, strychnine and morphine) are subject to great diversity in their preparation, in which acids are used to extract the alkaloid [from the

well-known medicinal substance at one time in a disease or a mixture of several different ones. In homeopathy — the only true and simple, the only natural medical art — it is absolutely prohibited to administer to the patient, *at one time,* two different medicinal substances.

§274

The true medical-art practitioner already finds in quite simple medicines, employed singly and unmixed, all that he could wish for: artificial disease potences which are able to completely over-tune natural diseases by homeopathic power, to extinguish them for the feeling of the life principle and to permanently cure them. Therefore, it will never occur to the true medical-art practitioner to administer more than one simple medicinal substance at one time as a remedy, in accordance with the wise saying that it is wrong to use complex means where simple ones will suffice.

> Do not use complex means when simple ones will suffice.

Reasons for giving only one simple medicine at a time are:

1. Simple single medicines have been *fully proven* with respect to their pure characteristic actions in the unclouded healthy human state, but it is still impossible to predict *how* two or more medicinal substances might hinder or alter each other's actions upon the human body.

> The actions of two or more medicines given together have not been determined.

2. If it is homeopathically selected, a simple medicinal substance, whose symptom complex is exactly known, helps completely, and by itself alone, in diseases. But even in the worst case — where the medicinal substance could not be entirely and appropriately selected in accordance with symptom similarity, and therefore does not help — it is nevertheless useful in furthering our knowledge of remedies. As a result of the new ailments aroused by the medicinal substance in such a case, those symptoms are confirmed which this substance had already shown in provings on

> When a simple medicine is inappropriately administered to a patient, at least clinical data about its symptoms can be obtained.

whole plant]. Therefore, these cannot be accepted by the homeopathic physician as simple, unvarying medicines, especially since he possesses in the plants themselves as they are naturally constituted (e.g., cinchona, nux vomica, opium) everything he needs from them for cure. Moreover, the alkaloids are not the only medicinal constituents of plants.

the healthy human body. No such knowledge can be gained when compound means are used.[274]

RELATIONSHIP BETWEEN THE SIZE OF DOSE, THE HOMEOPATHICITY OF A MEDICINE AND THE RISK OR BENEFIT TO THE PATIENT

§275

The most appropriate medicine for a given case of disease is the one which is the most homeopathically selected and which is administered in the correct dose.

The appropriateness of a medicine for a given case of disease does not rest on its apt homeopathic selection alone, but also on the necessary, correct size (or smallness) of its dose. A medicine given in an *all-too-strong dose* for a given case of disease, even if the medicine is completely homeopathic to the case and in itself of a beneficial nature, will still damage the patient as a result of its size and the too-strong impression it makes on the life force and (due to its similar homeopathic action) on precisely those parts of the organism that are already the most sensitive and the most attacked by the natural disease.

§276

A too-strong dose of a homeopathic medicine does more injury than the same dose of an unhomeopathic medicine.

For this reason, a medicine that is homeopathically appropriate to a given case of disease, but that is given in too large a dose, does much more damage than an equally large dose of a medicine that is allopathic to the disease. In strong doses, the more homeopathic the medicine is to the disease state, and the higher its potency,[276a] the more damage it will do — much more than an equally large dose

Homeopathic medicines should not be used in combination with other kinds of medicine.

274 When the rational physician has carefully considered a case and given internally the apt, homeopathically selected medicine, he will leave to the irrational allopathic routine the practice of giving an additional herbal infusion of other medicinal substances, applying a poultice or a fomentation made from various herbs, inserting a medicated clyster or rubbing in this or that ointment.

Why some homeopaths praise the use of larger doses

276a The recent praise by some homeopaths for the larger doses is due to one of the following reasons:

1. they continue to use low potentizations of the administered medicine, dynamized in the hitherto manner (as perhaps I myself did 25 years ago for want of better knowledge),

of medicine that is unhomeopathic, bearing no relation to the disease state (i.e., that is allopathic to the disease state).

As a rule, all-too-large doses of an apt, homeopathically selected medicine give rise to great misfortune, especially if these too-large doses are frequently repeated. Not seldom, they endanger the patient's life or make his disease almost incurable. Too-large doses certainly do extinguish the natural disease for the feeling of the life principle — the patient suffers no more from the original disease from the moment the all-too-strong dose of the homeopathic medicine acts upon him — but the patient is then more strongly sick from the quite similar, only far more violent medicinal disease which is very difficult to expunge.[276b]

Frequently repeated, too-strong doses of a homeopathic medicine can endanger the patient's life or make his disease almost incurable.

2. the medicines they used were imperfectly prepared by the manufacturer, or

3. the medicines they used were not homeopathically selected.*

* In other words, homeopaths who have praised the larger doses do so for one of two reasons:

1. The potencies they are using are so low that they require larger doses to have an effect. This follows Hahnemann's point in §276 that the higher the potency, the smaller the dose that is needed to alter health (and the more harm that is done by a too-large dose).

2. The medicines they are using are not homeopathic enough to the disease state to work in small doses. This follows Hahnemann's point in §276 that the more homeopathic a medicine is, the smaller the dose that is needed to alter health (and the more harm that is done by a too-large dose).

A medicine that is poorly manufactured may fall into either of these two categories. For a brief history of Hahnemann's progressive development and use of different doses and potencies, see "Lecture XIV: Homeopathic Posology" in R.E. Dudgeon's *Lectures on the Theory and Practice of Homeopathy.*

276b [Examples of damage done by homeopathic medicines used in large and frequent doses:]

1. In this way, almost incurable mercurial wasting sicknesses arise from the persistent use of aggressive allopathic mercurial means, prescribed in large doses against syphilis. Yet in a few days, one or several doses of a mild but effective mercurial means would certainly thoroughly cure the whole venereal disease, along with the chancre, provided the chancre had not been dispelled by external measures (as always happens with allopathy).

Mercury, when prescribed in large doses for syphilis, engenders mercurial wasting sicknesses.

§277

The more homeopathic a remedy is to the disease, the more curative it will be when given in appropriately small doses which act gently.

For the same reason [§275], since a well-dynamized medicine whose dose is properly small becomes all the more curative and helpful — almost to the point of wonder — the more homeopathically it was searched out, it follows that a medicine whose apt selection has been homeopathically hit upon must also be all-the-more curative the more its dose descends to the appropriate degree of smallness for gentle aid.

HOW TO CHOOSE THE BEST SIZE OF DOSE

§278

The only guides for determining the most appropriate dose in each case are pure experiment, accurate experience and careful observation of each individual patient.

The question arises: what is the most appropriate degree of smallness for certain as well as gentle help? How small would the dose of each single, homeopathically selected medicine have to be for the best cure in each individual case of disease? It is easy to realize that no theoretical conjecture can solve the problem of determining, for each medicine in particular, what dose will suffice for homeopathic curative purposes, yet still be so minute that the gentlest and most rapid cure will be attained. Speculating intellect and subtle sophis-

276b *continued*

Quinine, when prescribed in large doses for intermittent fevers, engenders quinine wasting sicknesses.

2. Likewise, allopaths have given large, daily doses of cinchona and quinine for intermittent fevers where cinchona was correctly homeopathically indicated and where one very small dose of highly potentized cinchona would have unfailingly helped (i.e., in cases of intermittent swamp fever, with those patients who are not suffering from manifest psora [§242]). The allopath thereby engenders a chronic quinine wasting sickness, while psora is developed at the same time. If this does not gradually kill the patient (by corruption of internal organs important for life, especially the spleen and the liver) it at least makes him suffer in a sad state of health for years on end.

It is hard to conceive of a homeopathic antidote against this sort of malady, engendered by the excessive use of large doses of homeopathic medicines.

try give no information about it. It is also impossible to record all conceivable cases in a table in advance. Only pure experiment, careful observation of the excitability of each patient, and correct experience can determine the best dose *in each particular case.*

It would be foolish to disregard what pure experience teaches us about the smallness of the dose necessary for homeopathic cures and to advance the large doses of inappropriate *(allopathic)* medicines of the old practice. These allopathic medicines do not homeopathically touch the sick side of the organism; they only attack the parts of the organism not assailed by the disease.

§279

This pure experience now shows UNIVERSALLY that:

1. if considerable corruption of an important [vital] organ does not obviously lie at the base of the disease (even if the disease is chronic and complicated), and
2. if, during treatment, all other foreign medicinal impingements on the patient have been withheld,

then *the dose of a homeopathically chosen, highly potentized remedy for the beginning of treatment of an important (especially chronic) disease, as a rule, can never be prepared so small that it would not*

1. *be still stronger than the natural disease,*
2. *be able, at least in part, to over-tune the natural disease, and*
3. *even be able to extinguish a part of the natural disease in the feeling of the life principle, thus producing a beginning of the cure.*

As a rule, even the smallest homeopathic doses will be strong enough to begin a cure, except in cases in which vital organs are already seriously damaged, or in which other medicinal substances interfere with treatment.

TREATMENT WITH FIFTY-MILLESIMAL POTENCIES

§280

One should continue giving *gradually heightened* [more highly potentized] doses of the persistently serviceable medicine that engenders no new troublesome symptoms until the patient *with general improvement of condition* begins to sense anew, in a moderate degree, one or more of his old, original ailments. This renewal of old ailments indicates that:

Give gradually heightened doses of the most serviceable medicine which produces no new troublesome symptoms until the patient, with

general improvement, begins to suffer a homeopathic aggravation.

1. the patient is near cure due to the moderate doses that have, each time, been gradually heightened by means of succussion (§247),
2. namely, the life principle almost no longer needs to be affected by the similar medicinal disease in order to lose the feeling for the natural disease (§148),
3. the life principle, now freer from the natural disease, is beginning to suffer somewhat from the homeopathic medicinal disease, which is otherwise called a *homeopathic aggravation.*

§281

Discontinuing treatment with fifty-millesimal potency medicines

To be sure of this, leave the patient without medicine for eight, ten or fifteen days, giving only milk sugar [as a placebo] instead.

If the few last ailments were merely due to the medicine, which imitated the former original disease symptoms, then these ailments will pass away within a few days or hours and, if (with continued good living habits) nothing more of the original disease shows itself in these medicine-free days, then the disease is probably cured.

If, on the other hand, traces of the former disease symptoms still show themselves in the last days, then these are remnants of the original disease that are not entirely extinguished. These remnants should be treated anew, in the indicated way, with higher degrees of dynamization of the medicine.

Patient sensitivity affects the rate of advance to higher potencies.

Naturally, for the cure to ensue again, the first smallest doses must also be gradually heightened [increased in potency], however they should be heightened far less and more slowly with patients in whom one perceives a considerable excitability than with the more unreceptive patients, with whom one can raise the dose more rapidly. There are patients whose uncommon excitability is one thousand times greater than that of the most unreceptive ones.

§282

Homeopathic aggravation produced by the first LM doses indicates that these doses were too large.

If the first doses of a treatment, especially of a case of chronic disease, already bring forth a so-called *homeopathic aggravation* (i.e., a noticeable heightening of the original disease symptoms that were investigated at first) despite each repeated dose being somewhat

modified (more highly dynamized) by succussion prior to ingestion (§247), then it is a sure sign that these doses were all-too-large.[282]

282 There is a notable exception to the rule of beginning the homeopathic treatment of chronic diseases with the smallest possible doses and only very gradually increasing them. This exception applies to the three great miasms while they are still blooming on the skin; that is, the recently erupted *itch diathesis*, the undisturbed residual *chancre* (on the genitalia, the labia, the lips of the mouth, etc.) and *figwarts*. These blooming miasms not only tolerate but they require immediately, at the beginning, large doses of their specific remedy. They require their specific remedy in higher and higher degrees of dynamization ingested daily, or perhaps even several times a day. In treating these diseases in this way, one need not fear (as one must with diseases that are hidden in the interior) that ⸢he all-too-large dose, while extinguishing the disease, could engender (due to its being too large) the beginning of a medicinal disease, and with continued use, a chronic medicinal disease. In these cases where the blossoms of the three miasms are lying there openly, one can visibly perceive, in the daily progress towards cure, how much of the feeling of these diseases has been daily withdrawn from the life principle by the large dose. None of these three miasmatic diseases can go over into cure without the disappearance of their primary symptom; therefore the disappearance of these symptoms indicates to the physician that no more medicine is needed.

Since, in general, diseases are only dynamic infringements upon the life principle, with nothing material lying at their base, no *materia peccans* (a fable under which the old school in its delusion has been operating for millennia, to the ruin of its patients), there is then, in these disease cases, nothing material to take away, rub away, burn away, cut away or tie off without making the patient endlessly sicker and more incurable for the rest of his life than he was with the untouched blossom of these three great miasms (see *The Chronic Diseases*, vol. I).

What is essential about these outer signs of the internal virulent miasms is the dynamic enmity perpetrated upon the life principle. It is only possible to extinguish these miasms by impinging on the life principle with a homeopathic medicine that affects it in a similar way but more strongly. The feeling of the inner and outer spirit-like disease enemy is thus withdrawn in such a manner that it exists no more for the

Correct use of large doses of homeopathic medicine, in fifty-millesimal potencies, for the treatment of syphilis, sycosis and psora when their primary symptoms are still present

Removal of the primary symptoms of syphilis, sycosis and psora makes patients endlessly sicker.

Miasms can only be extinguished with stronger homeopathic medicines.

§283

Start with small doses
so that no harm will be
done if the medicine
given proves to be an
unfitting one.

In order to proceed entirely in accordance with nature, the true medical-art practitioner will prescribe his homeopathic medicine, best selected in all respects, in such a small dose that if, upon occasion, he should be misled through human weakness into employing a more unfitting medicine, the disadvantage of its make-up (unsuitable as it is to the disease) would be so small that it could be rapidly extinguished and made good by the life's own power and by the immediate opposition (§249) — likewise in the smallest dose — of a now more fittingly selected remedy, selected according to similarity of action.

ALTERNATIVE METHODS FOR ADMINISTERING MEDICINES

§284

Medicines may be
administered by olfaction,

Besides the tongue, the mouth,[284] and the stomach (which are the places most commonly affected by the ingestion of medicine),

282 *continued*

life principle, for the organism. The patient is thereby freed from the malady; he is released, cured.

Experience teaches that the itch diathesis, together with its eruption, and the inner venereal [syphilitic] miasm with its chancre, can and must be cured only by means of the specific medicine, taken internally. Figwarts, however, when they have remained untreated for a long time, must be treated with the external application of their specific medicine at the same time as it is used internally, in order to effect a complete cure [§285].

Administration of
medicines through
breast milk

284 The power of medicines passed on to the nursing infant through the milk of the mother or wet nurse is admirably helpful. Every childhood disease yields to the homeopathic medicine that is correctly chosen for the child and given in very moderate doses to the woman nursing him. In this manner, diseases are eradicated in these new earth citizens far more easily and surely than could ever happen at a later time. Psora is usually communicated through breast milk to most nursing infants, if they do not already possess it by inheritance from the mother. Therefore, nursing infants can be antipsorically protected in the same way — by means of medicinal milk.

medicines may be administered through the nose and respiratory organs which, by means of olfaction and inhalation through the mouth, are especially receptive to the impingement of medicines in liquid form. All the rest of the skin of our body (clothed with its epidermis) is also fit for the impinging action of medicinal solutions, especially when the medicinal solution is rubbed in at the same time that it is ingested.

inhalation and through the skin.

§285

Thus, the cure of very old diseases can be furthered by the physician rubbing (on the back, arms, upper and lower legs) the same medicine which is being taken internally and proves itself to be salutary to the patient when taken internally. Any parts subject to pain, cramps or skin eruption should be avoided [§194].[285]

Correct external application of the homeopathic medicine which is being given internally with success

285 The fact that medicines can be administered through the skin explains those rare miracle cures where chronically crippled patients (whose skin was nevertheless *whole and unblemished*) were rapidly and permanently cured after a few mineral baths. By chance, the medicinal constituents of the baths were homeopathically appropriate to the old malady. On the other hand, mineral baths have *very often* done great damage by expelling patients' skin rashes. After a brief period of well-being, the life principle usually allows the inner uncured malady to erupt elsewhere, upon another body site that is far more important for life and well-being.

Danger of mineral baths

For example, any of the following may arise: paralysis of the optic nerve and amaurosis, a clouding of the crystalline lens of the eye [cataracts], deafness, insanity, suffocating asthma, or a stroke that puts an end to the sufferings of the deceived patient.

It is a cardinal principle of the homeopathic medical-art practitioner (which distingushes him from every so-called physician of all the older schools) that he never employ any medication whose morbid impingements upon the healthy human being have not been carefully proven and thus become known to him (§20-§21). To prescribe for a patient a means which is unknown as to its positive actions on the human condition, upon mere conjecture about its possible salutariness in some similar case or because someone says, "This means has helped in such and such a disease," is an unscrupulous, dangerous venture which the homeopath who loves mankind will leave to the unfeeling allopath. For this reason, a genuine physician and practitioner of our art will *never* send his patients to

285 *continued*

any of the countless mineral baths because almost all of them are
unknown as to their exact positive action on the healthy human condi-
tion. Misused mineral baths are to be counted among the most violent
and dangerous of medicinal means. Out of a thousand patients blindly
sent to the most famous of such baths by the ignorant physicians who
have not been able to cure them with allopathic treatment, one or two
come back accidentally cured (though often *only apparently* cured) and
praise the miracle to the skies, while many hundreds quietly slink away
more or less aggravated. Some of them stay behind, readying themselves
for their eternal resting place, a fact attested to by the well-filled grave-
yards that surround the most famous baths.†

† For this reason, a true medical-art practitioner — who never practices
without correct principles, who never unconscionably gambles with
the life of the patient entrusted to him (as in a game of chance where
the odds against winning are five hundred or a thousand to one, and
losing means aggravation or death) — never endangers his patients'
lives by sending them off to take their chances at a mineral bath, as
allopaths often do with decorum, in order to free themselves of
patients that they or others have ruined.

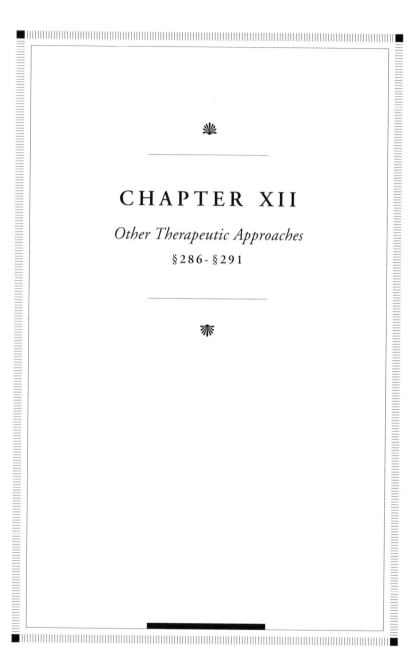

CHAPTER XII

Other Therapeutic Approaches

§286- §291

THE DYNAMIC POWER OF MAGNETS, ELECTRICITY
AND GALVANISM

§286

Magnets, electricity and galvanism have curative powers, but only the mineral magnets have been sufficiently proven as to their homeopathic usefulness.

The dynamic powers of mineral magnets, electricity and galvanism act as powerfully and as homeopathically on our life principle as do actual so-called medicines that lift diseases by means of oral ingestion, through the skin, or by olfaction. They thereby enable the cure of diseases, especially those of sensibility and irritability, of abnormal feeling, and involuntary muscle movements. However, the sure manner of employing electricity and galvanism (as well as the use of the so-called electro-magnetic machine) still lies too much in the dark to make homeopathic use of them. So far, both electricity and galvanism have been used only for palliation, doing great damage to patients. Up until now, their positive pure actions on the healthy human body have been but little proven.

§287

Homeopathic use of magnets

One can more surely avail oneself of the curative powers of a powerful magnet. The positive actions of its north and south poles are presented in the *Materia Medica Pura*. Although both poles are equally powerful, they stand in opposition to one another in the manner of their action. Doses may be moderated by the amount of time one or the other pole is applied (according to whether more of the symptoms of the north or the south pole are indicated). A plate of polished zinc can be used as an antidote for an all-too-violent action.

MESMERISM

§288

Positive mesmerism

I find it necessary to make mention here of so-called *animal magnetism* or *mesmerism* (so named in gratitude to Mesmer, its first founder) which differs in nature from all other medicines. This curative power (often foolishly denied or reviled for an entire cen-

tury) is a wonderful, priceless gift of God, granted to humanity. The life force of a healthy mesmerist, gifted with this power, dynamically streams into another human being by means of touch or even without it — indeed even at some distance. It does so through the powerful will of a well-intentioned individual. The mesmerist's life force dynamically streams into another human being just as one of the poles of a powerful magnet dynamically streams into a rod of raw steel. This curative power works in a different way in that in part, it replaces the life force lacking here and there in the patient's organism and in part, it drains off, decreases and more equally distributes the life force that has accumulated all-too-much in other places, thereby arousing and maintaining unnamable nervous sufferings. In general, it extinguishes the morbid mistunement of the patient's life principle, replacing it with the mesmerist's normal tunement which is powerfully impinging upon the patient. It does so, for example, in cases of old ulcers, amaurosis, paralysis of individual limbs, etc.

Many a rapid apparent cure in all ages can be attributed to the animal magnetizers gifted with great nature-power. The action of communicated human power upon the whole organism by means of the most powerful, good-natured will of a man whose life force is in full bloom[288] has been most brilliantly shown in the revival of some persons who remained in apparent death for a long time — a kind of wakening from death of which history gives us several undeniable examples. If the mesmerizing person of either sex is capable at the same time of good-natured enthusiasm (or perhaps even a degenerated form of it, such as bigotry, fanaticism, mysticism or obsessive philanthropy) then he is all the more in a position, with

288 Especially one of those men (of whom there are few in humanity) who, along with great good nature and full-blown bodily powers, *possesses very little or even no sexual drive*. Consequently, all the subtle life spirits that would otherwise be employed in the preparation of semen are available in quantity, ready to be communicated to others through touch and a powerful exertion of will. Some mesmerists with such curative power, whom I got to know, possessed *all* of these particular attributes.

Attributes of mesmerists with great curative power

this philanthropic, self-sacrificing action, not only to direct the power of his prevailing good nature exclusively upon the object requiring his help but also, as it were, to concentrate it there, thus occasionally working wonders.

§289

All of the above-mentioned modes of practicing mesmerism are based on a dynamic influx into the sufferer of more or less life force, and are therefore called positive mesmerism.[289a]

Negative mesmerism

Negative mesmerism deserves such a name because it has the opposite effect. The passes that are needed to waken people out of a somnabulistic sleep belong to this category, as well as all the manual executions covered under the names *calming* and *ventilating*. With undebilitated persons, this *discharge* of the life force which has excessively accumulated in a single part is most surely and simply produced, through negative mesmerism, by means of a very rapid movement of the flat out-stretched right hand, held parallel to and about an inch from the body, going from the top of the head down over the tips of the toes.[289b] The more rapidly this pass is executed, the stronger the discharge it produces. For example, in one

Misuse of positive mesmerism

289a When I speak of the decided and sure curative power of positive mesmerists, I certainly do not mean that most deplorable exaggeration of it (called somnambulism or clairvoyance) in which repeated passes are made for half an hour or even a whole hour at a time, day after day, on patients with a weak nervous system in order to induce that monstrous alteration in the tunement of the entire human wesen. This is a highly unnatural and dangerous state in which the person is transported from the world of the senses and appears to belong more to the spirit world. It has been used in vain attempts to cure chronic diseases.

Use of silk in mesmerism

289b It is an already-known rule that a person that is to be mesmerized, either positively or negatively, must not wear silk on any part of the body. It is less well known, however, that the mesmerist can communicate his life force to the patient in fuller measure if he stands on silk instead of standing on the bare floor.

case of apparent death, a woman who was previously healthy,[289c] received a violent emotional shock which suppressed her menstruation just prior to its onset. This probably resulted in an accumulation of energy in the precordial region. This was discharged and the entire organism was restored to *homeostasis* by a rapid negative pass, and she was revived. With such treatment, revival usually ensues immediately.[289d] In cases of very irritable persons, a gentle, less rapid negative pass occasionally relieves the excessive restlessness and anxious insomnia that sometimes stems from an all-too-powerfully given positive pass, etc.

§290

Mesmeric action is involved when a robust, good-natured person gives a massage to someone who was chronically ill and has been cured but is still in the process of slow recovery, and is still suffering from emaciation, weak digestion and lack of sleep. The massage therapist separately lays hold of the muscles of the limbs, chest and back, moderately pressing and, as it were, kneading the muscles, whereby the life principle is stimulated in its counter-action to restore the tone of the muscles and their blood and lymph vessels. Of course, the mesmeric impinging action is the main thing in this procedure, which should not be used to excess with patients who still suffer from emotional irritability.

Mesmerism in massage

289c Thus, a negative pass, especially a very rapid one, is extremely detrimental to a chronically weak person with low vitality.

Risk of negative mesmerism

289d A robust ten year-old country lad, due to a minor indisposition, was treated one morning by a so-called strokestress who repeatedly passed both tips of her thumbs very powerfully from the pit of his stomach out under his ribs, and he fell at once, deathly pale, into such an unconsciousness and immobility that, with all due exertion, one could not awaken him and he was almost taken for dead. I then had his older brother give him as rapid a negative pass as possible from the top of his head down over his feet, and he immediately regained consciousness and became lively and well.

Example of immediate recovery with negative mesmerism

BATHS OF PURE WATER

§291

Baths of pure water have been found useful both as palliatives and as homeopathically serviceable auxiliary means in the restoration of health. They have uses both in acute maladies and during the convalescence of patients recently cured of a chronic disease. In cases of convalescence, the state of the patient, as well as the temperature, duration, and frequency of the baths, must be taken into account. However, even when they are properly used, baths are not actually medicinal in themselves, since they only bring forth physically beneficial alterations in the sick body.

Warm baths Lukewarm baths, of from 31° to 34°C [88° to 93°F], serve to awaken the slumbering irritability of the fibers in cases of apparent death (from freezing, drowning, asphyxiation) where the feeling of the fibers has been benumbed. While these baths are only palliative, they often prove themselves to be sufficiently effective, especially if at the same time, coffee is given and the patient is rubbed by hand.

Warm baths can provide homeopathic assistance in cases where the irritability is very unevenly distributed and has accumulated far too much in some organs, as is the case with some hysterical cramps and infantile convulsions.

Cold baths Cold baths have proven to be a homeopathic aid and also a restorative palliative in the convalescence of patients who have been medicinally restored from a chronic disease. *Momentary* immersion in cold baths, of 7° to 13°C [45° to 55°F], has been found to be a homeopathic aid for a patient's lack of vital heat. Later in convalescence, momentary, frequently repeated immersions in cold baths have proven to be a restorative palliative for the tone of slack fibers. When the restoration of slack fibers is the intent, cold baths are to be taken for more than a moment, even for several minutes, and at increasingly cold temperatures. While this is a palliative, it only acts physically and therefore it is not connected with the disadvantage of an opposite reaction, which takes place (and is to be feared) with dynamic medicinal palliatives.

SYNOPSIS

The Synopsis originally appeared as the Table of Contents of Hahnemann's sixth edition of the *Organon*. For most paragraphs, the Synopsis summarizes the main text using the language that appears in the text. In a few instances, Hahnemann uses terms or gives descriptions in the Synopsis that do not appear in the main text. Most notably, he describes psora as the mother of all real chronic diseases, except the syphilitic and sycotic ones (§80–§81); he specifies the duration of homeopathic aggravations (§161); and he clarifies the meaning of §142 regarding the study of medicinal actions using sick people. In addition, he uses the terms 'disease-wesen' (*fn* 6), 'action-expression' (§57), 'homeostasis' (§66), and 'sensorium' (*fn* 69a).

I. PRINCIPLES OF CURE

§1-§2 The only calling of the physician is to cure rapidly, gently and permanently.

 fn 1 The physician's calling is not the forging of theoretical systems and attempts at explanation.

§3-§4 He must search out that which is to be cured in diseases and know what is curative in the different medicines in order to be able to suit the latter to the former, as well as to understand how to maintain the health of humanity.

§5 Attention to the occasions, fundamental causes and other circumstances as aids to cure.

§6 For the physician, the disease consists solely of the totality of its symptoms.

 fn 6 Regarding the old school's impossible speculation about the disease-wesen *(prima causa).*

§7 Paying attention to the circumstances discussed in §5, the physician needs only to take away the totality of the symptoms in order to cure the disease.

 fn 7a The obvious occasioning and maintaining cause of the disease is to be cleared away.

 fn 7b The reprehensibility of the symptomatic, palliative treatment mode, directed at a single symptom.

§8 Once all symptoms are expunged, the disease is always cured in its interior as well.

 fn 8 The old school injudiciously denies this.

§9 During health, a spirit-like power/force/energy (autocracy, life force) enlivens the organism and keeps it in harmonious order.

§10 Without this enlivening, spirit-like power, the organism is dead.

§11 During disease, initially only the life force is morbidly mistuned and expresses its suffering (the internal alteration) through abnormalities in the feelings and functions of the organism.

fn 11 Explanation of the word *dynamic.*

§12 When the symptom complex disappears, by means of curing, the suffering of the life force, that is, the entire inner and outer disease state, is also lifted.

 fn 12 It is not necessary for cure to be aware of how the life force brings the symptoms to pass.

§13 To assume that non-surgical disease is an inherent, separate thing housed in a person is an absurdity that has made allopathy so ruinous.

§14 All that is curably diseased makes itself known [discernible] to the physician through disease symptoms.

§15 The suffering of the sick life energy and the disease symptoms that are engendered thereby are an indivisible whole. They are one and the same.

§16 Our spirit-like life force can fall ill only through spirit-like influences of morbific malignities; and it can only be restored to health again through the spirit-like (dynamic) impingement of medicines.

§17 The medical-art practitioner simply has to take away the complex of disease signs to lift the total disease.

 fn 17a-b Explanatory examples.

§18 The totality of the symptoms is the only indicator, the only reference, to the remedy to be chosen.

§19 The alteration of condition in diseases (the disease symptoms) cannot be cured by medicines unless the medicines likewise have the power to bring to pass condition-alterations in humans.

§20 This condition-altering power of medicines can be perceived solely by means of their impingement upon *healthy* human beings.

§21 The disease symptoms that medicines engender in healthy human beings are the only thing from which we learn to discern the disease-curing power of those medicines.

§22 If experience shows that diseases would be most certainly and per-
 manently cured through medicines that reveal *similar* symptoms to a
 disease, then medicines of similar symptoms are to be taken for cure.
 If, however, experience shows that diseases would be most certainly
 and permanently cured through *opposite* medicinal symptoms, then
 medicines of opposite symptoms are to be chosen for cure.

 fn 22 The use of medicines whose symptoms have no actual
 (pathic) relation to the disease symptoms, but attack the
 body differently, characterizes the reprehensible *allopathic*
 method of treatment.

§23 Persistent disease symptoms are not cured by opposite medicinal
 symptoms *(antipathic treatment)*.

§24-§25 Only the *homeopathic* curative method, by means of medicines with
 similar symptoms, shows itself to be thoroughly helpful in experience.

§26 This rests on the following curative natural law: In a living human
 being, a weaker dynamic affection is permanently extinguished by a
 very similar, stronger one that only differs as to mode.

 fn 26 This happens with physical affections as well as with moral
 maladies.

§27 The curative capacity of medicines thus rests on their symptom-
 similarity to the disease.

§28-§29 Attempt at an explanation of this natural law of cure.

§30-§33 The human body is far more inclined to let itself be altered in its
 tuning by medicinal energies than by natural disease.

§34-§35 The correctness of the homeopathic curative law shows itself in the
 lack of success of every unhomeopathic treatment of an older mal-
 ady. It also proves itself in the fact that when two natural diseases,
 meeting in the human body, prove to be dissimilar to one another,
 they do not lift and do not cure each other.

§36 I. If the older disease dwelling in the body is equally strong or
 stronger than a new, dissimilar disease, then the older disease keeps
 the new one away from a person.

§37 So also in unhomeopathic treatments that are not violent, the chronic diseases remain as they were.

§38 II. A stronger new disease that befalls an already diseased individual only suppresses the old dissimilar disease dwelling in the body for as long as the new disease lasts, but the new disease never lifts the old one.

§39 In the same way, strong treatments with allopathic medicines (i.e., medicines which can arouse none of the similar symptoms to the disease) cure no chronic disease. Rather, they suppress the chronic disease for only as long as the attack with violent medicines lasts. Thereafter the chronic disease comes forth again, just as bad or worse.

§40 III. Or the new disease, after long impingement on the body, joins the old one that is dissimilar to it and there arises a double (complicated) disease. Neither of these dissimilars lifts the other.

§41 While it is not a rare occurrence for two dissimilar natural diseases to meet in the same organism, this happens far more frequently in the ordinary treatment procedure [when an artificial disease meets a dissimilar natural one]. In this case, a natural disease (one that is consequently not curable by a second dissimilar disease) associates itself with an artificial disease that has been engendered by employed medicines that are as violent as they are unsuitable (allopathic), whereby the patient becomes far more diseased, indeed doubly diseased.

§42 Due to their dissimilarity to one another, each of the diseases that form the complicated disease takes up its proper place [the place belonging to it] in the organism.

§43-§44 It is entirely different with the accession of a stronger disease to an old one that is *similar* to it. In this case, the old disease is lifted and cured by the stronger one.

§45 Explanation of this phenomenon.

§46 Examples of chronic diseases that have been cured by the accidental accession of another similar, stronger disease.

§47-§49 Even among diseases meeting together in the course of nature, only a disease that consists of similar symptoms can lift and cure the other one. Dissimilar diseases can never do this. This is instruction for the physician regarding the manner of medicines with which he can cure with certainty, namely, solely with homeopathic ones.

§50 Nature has only a few diseases with which to send homeopathic aid to other diseases and these, its help-means, are combined with many inconveniences.

§51 On the other hand, the physician has countless curative potences with great advantages over these [natural diseases].

§52 There are only two main modes of treatment, the homeopathic and the allopathic. These are direct opposites; they can not approach one another, nor ever unite.

§53 The homeopathic mode of treatment rests on an infallible natural law and proves itself to be the only excellent one.

§54 The allopathic mode of treatment appeared in many very different sequential systems, all of which called themselves rational medical art. This mode of treatment only saw disease matter (which they wanted to classify) in diseases, and they made pharmacological texts [teachings about medicines] out of presumptions.

 fn 54c Compound prescriptions.

§55-§56 The allopathic physicians have, in their detrimental mode of treatment, nothing in which patients can maintain a modicum of trust other than the palliatives.

 fn 56 Isopathy.

§57 In the antipathic (enantiopathic) or palliative way of treatment, a medicine of opposed action-expression *(contraria contrariis)* is prescribed against a single symptom of the disease. Examples.

§58 This antipathic procedure is faulty not only because it is directed only at a single disease symptom, but also because, in persistent ailments, after short apparent relief, true aggravation results.

 fn 58 Writings that testify to this.

VI. THE CHRONIC MIASMS

COMMENTS
ON THE
TEXT

THE SIXTH EDITION OF THE ORGANON

The original sixth edition manuscript of the *Organon* (which is currently held in the rare book collection of the University of California at San Francisco) consists of a copy of the fifth edition, bound with a sheet of paper between each page of text, upon which Hahnemann made handwritten changes to the fifth edition. This interfoliated volume includes a synopsis which served as the table of contents, a preface, an introduction, and 291 numbered paragraphs of text.

FIRST TRANSLATIONS OF THE SIXTH EDITION

The sixth edition of the *Organon* was completed in 1842, but it was not published until 1921. After Hahnemann's death in 1843, the manuscript was held by his wife Melanie Hahnemann, who stated that she was acting on Hahnemann's instructions in not publishing it immediately. At Melanie Hahnemann's death, the document passed to the Boenninghausen family. It was not until 1920 that members of the Boenninghausen family, financially ruined by World War I, agreed to sell the document to Dr. William Boericke of San Francisco, who had been making efforts to obtain the document for over twenty years. Dr. Richard Haehl acted as intermediary in the sale and kept the document for several months before delivering it to Boericke. During that time, Haehl prepared the manuscript for publication in Germany, where it was published in 1921. Dr. Boericke then prepared the first English translation of the sixth edition, which was published in 1922. Boericke produced his translation of the sixth edition by taking R.E. Dudgeon's translation of the fifth edition, making the deletions noted by Hahnemann and translating his additions. The new material translated by Boericke represents approximately 15% of the complete sixth edition text. In other words, about 85% of what is commonly known as the Boericke translation of the *Organon*, was translated by R.E. Dudgeon.

UNAUTHORIZED CHANGES TO THE TEXT

There have been numerous additions made to Hahnemann's original sixth edition manuscript in handwritings other than his own. A

list of the changes made to the original manuscript has been compiled by Dr. Josef M. Schmidt, and appears in an appendix to the *Organon der Heilkunst* which he edited (Heidelberg: Karl F. Haug, 1992). Most alterations to the text are minor, involving grammatical changes, or the addition of a word or two for purposes of clarification. There are, however, five passages which go beyond a few words and which are worth noting here.

Of the five passages, one was written in an unidentified hand and four were written by Richard Haehl, who also made many of the minor changes, probably while preparing the sixth edition manuscript for its original German publication. Three of the five passages have been deleted from the main text of this adaptation and appear below. The passages in §270 and *fn* 270g have been included in the main text. While the sources of the additions made by Haehl and others are not known, they may well have been taken from other writings of Hahnemann, or they may be interpretations of Hahnemann's teaching, made by the writer. The editorial decision to include certain passages and exclude others was made based on indications in the original manuscript and the content of each passage in question.

In §265, Hahnemann states, "It is a matter of conscience for the medical-art practitioner to be certain that each patient takes the right medicine every time. Therefore, the medical-art practitioner should give the patient the correctly selected medicine *from his own hands,* and he should also prepare the medicine himself." The following sentence, written in an unindentified handwriting, was added as a footnote:

> Since discovering this important fundamental principle of my teaching, I have endured much persecution in upholding it.

This is certainly a true statement. Various biographies describe Hahnemann's conflicts with the medical community, and especially with the guild of apothecaries (the drug industry of his day) who took him to court, and succeeded in having his medical license revoked, for advocating that physicians prepare and dispense their own medicines. While Hahnemann spoke and wrote about this elsewhere, he apparently did not choose to include a comment

Footnote to §265: Opposition to Hahnemann's recommendation that physicians prepare their own medicines

about it in the *Organon*. This passage has therefore been deleted from the main text.

Note to *fn* 270f:
Treatment of old,
troublesome local
maladies

In *fn* 270f, Hahnemann discusses the relative advantages in using fifty-millesimal potency medicines in the treatment of acute and chronic diseases. He ends the footnote by stating, "In chronic diseases, one can best proceed by beginning treatment with the lowest degrees of dynamization and, when necessary, continuing to the higher degrees which, although they become ever more powerful, always act only gently." To this, Haehl appended the following note:

> Only in the very rare cases where an old, troublesome local malady continues in spite of almost full restoration of health with good life force, is it not only allowable but *unavoidably* necessary to administer in ascending doses the medicine proven to be homeopathically helpful, however, potentized up to a very high degree by means of many hand succussions, whereupon such a local malady disappears very soon, in an often wonderful way.

While the above paragraph is interesting, and may well have been taken from Hahnemann's notes, Hahnemann did not include this here, and it is a jarring addition to *fn* 270. It has therefore been deleted from the main text. Hahnemann discusses the treatment of so-called local maladies in §185-§203, and he discussses the treatment of the primary symptoms of chronic miasms in *fn* 282, including the complete cure of inveterate figwarts (which he also mentions in §205).

The middle section of §270 has been replaced by the following passage in Haehl's handwriting:

> (provided it is properly executed, as specified above) a given medicinal substance which, in its crude state, is only matter (in some cases, unmedicinal matter) is subtilized and transformed by these higher and higher dynamizations to become a spirit-like medicinal power.[270g] This medicinal power *in itself* no longer falls within our senses.

The beginning and the end of the paragraph are torn and indicate damage. It is possible, even likely, that Haehl found the section to be all but illegible, and therefore replaced it. Whether or not he recopied Hahnemann's original text, or replaced it with something

different, is not known; however, what is written in Haehl's handwriting is consistent with the rest of the footnote, and it is consistent with Hahnemann's writing on the subject elsewhere. Therefore, it has been included in the main text.

Footnote 270g discusses the attenuation of material substance in fifty-millesimal potency medicines. The footnote begins as follows:

fn 270g:
The attenuation of matter in potentized medicines

This assertion will not appear improbable if one considers that with this method of dynamization [of fifty-millesimal potencies]—which I have found after many laborious tests and counter-tests to be the most powerful and, at the same time, the mildest in action (i.e., the most perfected)—the material part of the medicine is attenuated about 50,000 times and yet it is incredibly increased in power.

The footnote begins in Hahnemann's handwriting, which stops in the middle of the word 'powerful' in the first sentence. The word is completed in Haehl's handwriting which then continues to the end of the footnote. There is visible damage to Hahnemann's original handwritten footnote. This may explain why the footnote is completed in Haehl's handwriting. Since the footnote consists mostly of a mathematical explanation of potentized medicines, and since it would be clearly incomplete without the addition in Haehl's handwriting, the full footnote has been included in the main text.

In *fn* 284, Hahnemann discusses the administration of medicines to infants through breast milk. To this, Dr. Haehl has appended the following:

Continuation of fn 284:
Treatment of psora in pregnancy

However, the care of mothers in their first pregnancy is indispensable. This should be done by means of a gentle antipsoric treatment, especially with sulphur in the new [fifty-millesimal] dynamizations described in this edition (§270). This will eradicate the psora in the mother and in the fruit of her womb. Psora (which is the engenderer of most chronic diseases) has already been imparted to mothers through inheritance and it is almost always present in them. By treating mothers in this way, their progeny may be protected against psora in advance. This is so true that the children of pregnant women who are so treated come into the world far healthier and more robust — to every-

one's amazement. This is another confirmation of the great truth of my psora theory.

This note follows Hahnemann's handwritten footnote at a point in the text where there is no indication of damage and no indication that Hahnemann had written anything further. Therefore, it has been excluded from the main text. Hahnemann discusses the subject of antipsoric treatment during pregnancy in *The Chronic Diseases* (pp. 138-139).

GLOSSARY

Words that have been included in this glossary are those about which a reader might have questions. Only definitions that apply to the word's usage in the *Organon of the Medical Art* are given. The foreign words listed are those from which the English words have always or almost always been translated; rare exceptions to the general translation pattern of a word may not be listed. A foreign word's language or etymology is given in square brackets; where it is of interest, the word's most literal meaning is also given. Where no language is indicated, the word is German. Several definitions reflect Steven Decker's understanding of the *Organon* and the German language of Hahnemann's time; these are indicated by SRD. Examples of a word's usage are noted in parentheses.

a priori: *a priori* [LATIN *a*, from + *priori*, former], *apriorische* [GER-MAN]. **1.** Prior to, or independent of, experience, in contrast to *a posteriori,* which refers to that which is based upon experience. **2.** Made before or without examination; not supported by factual study. (p. 11, §110)

ab usu in morbis [LATIN]. Regarding its use in diseases. This phrase appeared as the title of statements regarding the use of particular medicines, meaning 'indications for use.' (p. 43)

abolish, get rid of: *abschaffen.* See **remove.**

abstract: *abziehen* [GERMAN], *abstrahieren* [from LATIN *abstrahere,* to draw away]. To separate in mental conception; to consider apart from the material embodiment, or from the particular instances. To summarize, epitomize. In §102, Hahnemann uses the German and Latin words synonymously (i.e., the word of Latin origin appears in parentheses following the German word) to describe the process of taking the case of an epidemic disease and forming the genus epidemicus.

accession: *hinzu kommend* [hereto coming]. An increase by means of something added. (§46)

accessory, attendant, side: *neben* [beside]. Subordinate or supplementary. (§7, §163)

acridity: *Schärfe* [sharpness]. Acrid matter, i.e., matter that is sharp or biting to the taste or smell, bitterly pungent and irritating to the eyes and nose. (p. 4)

action: *Wirkung* [working]. The state or process of acting or working upon something. (*fn* 11)

activity, function: *Thätigkeit.* See **function.**

acute: *acut* [sharp, from LATIN *acus,* needle]. Extremely sharp or severe; intense. An acute disease is one that has a rapid onset and a short course, resolving itself either by death or spontaneous recovery. (§72-§73)

acute miasm: *acutes Miasm.* An acute infectious disease which is invariable as to its wesen, and which is relatively fixed in its forms or patterns of disease manifestation. Disease symptoms manifest within a few days of the organism's being infected, during which time the internal disease develops completely. The course of the disease is lim-

ited, ending in either death or recovery within a few weeks. A listing of the specific acute miasms discussed by Hahnemann appears in the Index under 'Acute miasms.' (§73) See also **miasm**.

adjuvantia [LATIN]. Things that help; supporters. (p. 44)

aequalia aequalibus [LATIN]. Equal things for (or by means of) equal things. (p. 54)

affection: *Affection* [from LATIN *affectare*, to do to, influence; also, to attack with a disease]. A mental or bodily abnormality whose origin is in a disturbing influence on the mind, and which is brought forth by an inimical potence, such as a natural disease potence or a medicinal one. The term 'affection' refers to a very generic disturbance (as opposed to the terms 'disease,' 'malady' and 'wasting sickness' which are more specific). (§26, §29)

afflict: *behaften*. To distress with bodily or mental suffering. (§38, §50)

affliction: *Leiden* [sufferings]. A condition of pain, suffering, or distress. (p. 34)

after-action: *Nachwirkung* [after-working]. The counter-action of the life force. (§59) See **counter-action**.

agent: *Agens*. An entity by means of which something is done or caused. Hahnemann uses the term 'agent' interchangeably with 'potence' and 'wesen.' (§148)

aggravation, worsening: *Verschlimmerung*. An increase in the severity of symptoms; a worsening in the condition of a sick individual. **Homeopathic aggravation.** A very similar medicinal disease that displaces the patient's original disease. While it appears to the patient to be a worsening of pre-existing symptoms, it is actually the initial action of the homeopathic medicine whose symptoms are somewhat stronger than those of the natural disease. In other words, the patient with a homeopathic aggravation is experiencing stronger medicinal symptoms, not his original disease symptoms. (§157-§161) **Aggravation involving new sympton.** A medicinal disease produced by a medicine that is not completely homeopathic to the patient's disease. As with the homeopathic aggravation, an aggravation involving new symptoms is the initial action of the medicine, however the new symptoms brought forth by the not-completely-homeopathic medicine pertain not only to the medicine, but also to

the patient's natural disease; they are symptoms of the natural disease that were rarely or never felt by the patient until the medicine was given. (§156, §163, §180)

ague, cold fever: *kaltes Fieber* [cold fever]. An intermittent fever attended by alternating periods of chills, fever and sweating. The term 'ague' is used chiefly in reference to the fevers associated with malaria. (*fn* 235a)

aid, help, auxiliary: *Hülfs-*. See **help.**

ailment: *Beschwerden* [heaviness]. A symptom or collection of symptoms that causes noticeable discomfort. (*fn* 60, §70)

albuminous matter: *Eiweißstoff* [protein stuff]. Matter comprised of certain water-soluble proteins which can be coagulated by heat and which are found in egg white, blood serum, milk, and many other animal and plant juices and tissues. (§267)

alcohol: *Weingeist, Branntwein.* Hahnemann refers to two grades of alcohol in his directions for the preparation of medicines in §270, *Branntwein* [brandywine] and *guter Weingeist* [good wine spirit or rectified wine spirit]. In this text, *Branntwein* is specified as 90° grain alcohol (which is a liquid that contains 90% by weight of ethyl alcohol). *Guter Weingeist* is specified as 95° grain alcohol (which is a liquid containing 95% by weight of ethyl alcohol). References to *Weingeist* are translated as 'wine spirit' or 'alcohol.' In §248, Hahnemann refers to dilute alcohol, commonly defined as a liquid containing between 41 and 42% by weight of ethyl alcohol.

alkali: *Alkali* [from ARABIC *al-qaliy,* ashes of salt wort], *Laugensalz* [GERMAN]. A strong base, especially the metallic hydroxides. Alkalies combine with acids to form salts, combine with fatty acids to form soap, neutralize acids, and turn litmus paper blue. (*fn* 67, *fn* 69, *fn* 273)

alkaloid: *Alkaloid* [alkali + GREEK *eidos,* form, shape]. One of a group of organic alkaline substances obtained from plants. They usually have a very bitter taste and a powerful action on the animal system. While some are liquid, most alkaloids are solid. They are usually water-insoluble, yet alcohol-soluble. The first alkaloid to be discovered was morphine in 1817. The names of organic alkaloids are regularly formed in *-ine,* as nicotine, strychnine, quinine, aconitine, theine. (*fn* 273)

alive to: *inne werden* [inward becoming]. To become inwardly conscious of. To come alive to something involves vital realization and conscious participation. (§61) See also **participation.**

allopathic: *allöopathisch* [from GREEK *allos,* other, different + *pathos,* disease, suffering]. Pertaining to the treatment of disease with medicines and other treatments which produce symptoms that are different from symptoms of the disease. The symptoms produced by the medicine have no manifest pathic relation to the symptoms of the disease. (§54, §55)

allopathy: *Allöopathie.* The school of medicine, also referred to by Hahnemann as the old school, whose modes of medical treatment are, with few exceptions, either allopathic or antipathic. In the Introduction, Hahnemann presents a history of allopathy. (pp. 3, 9) See also **contraria contrariis curentur.**

alterantia [LATIN]. Alteratives; treatments or medications intended to alter the patient's condition. (p. 40)

amaurosis: *Amaurose* [from GREEK *amauros,* dark]. Partial or total blindness involving disease of the optic nerve, usually without external change in the eye. (§288)

ambergris: *Ambra.* A waxy, grayish substance formed in the intestines of sperm whales and found floating at sea or washed ashore. It is variegated like marble, remarkably light, rugged on its surface, and when heated it has a fragrant odor. Also called ambergis. (p. 40)

ambient. That supersensible sphere within the general environment which pertains to a particular individual and which holds the factors to which one is particularly resonant (i.e., the factors which impinge upon or affect a particular individual and not another). The ambient comprises the circumstances, events and conditions which inform the whole situation of a particular individual, for example it is connected to one's receptivity to certain diseases and not others. Hahnemann was aware of the intimate relation between the human organism and its ambient; this is reflected in his recommendations that the medical-art practitioner record and carefully consider both a person's symptoms and circumstances in order to obtain the image of a person's disease (§7, §18, §24). The human wesen, or dynamis, forms a unity with the human organism and its ambient, permeating both spheres. The term 'ambient' is used in

the Glossary to define terms; it is not used in the *Organon*. [Resource: SRD] See also wesen.

amelioration: *Besserung* [bettering]. A lessening of the severity of symptoms; an improvement in the condition of a sick individual. (§253-§255)

amenorrhea: *Amenorrhöe* [from GREEK *a*, not + *men*, month + *rhoia*, flow]. The absence of, or abnormal cessation (suppression) of, menses. (§80)

amplification: *Lautwerdung* [loud-becoming]. An increase in magnitude or loudness. (§157)

analogue: *Analogon*. 1. Something that bears an analogy to something else. 2. An organ or structure that is similar in function to one in another kind of organism but is of dissimilar evolutionary origin. (§145, §168)

aneurysm: *Pulsader-Geschwulst* [pulse artery-swelling]. Localized abnormal dilation of a blood vessel, usually an artery, due to a weakness of the wall of the vessel. (p. 17)

anlage: *Anlage* [on-layment]. 1. Arrangement; layout. 2. Foundation; basis. 3. The rudimentary basis of an organ or organism. (§78)

annihilate: *vernichten*. See remove.

antipathic: *antipathisch* [from GREEK *anti*, against + *pathos*, disease, suffering]. Opposed to. Antipathic medicines initially produce symptoms which are opposite to those to be cured, while homeopathic medicines produce symptoms which are very similar to the totality of disease symptoms. In §23, Hahnemann equates the terms 'antipathic,' 'enantiopathic' and 'palliative.' Throughout the *Organon*, he uses the terms 'antipathic' and 'palliative' interchangeably. (§55-§60)

antiphlogistic: *antiphlogistisch* [from GREEK *anti*, against + *phlogistos*, on fire]. Preventing or relieving inflammation. (p. 46)

antipsoric: *antipsorisch*. Pertaining to the group of homeopathic medicines identified by Hahnemann as effective in curing the psoric miasm and diseases arising from it. These are distinguished from the apsoric medicines, also referred to by Hahnemann as the general class of medicines. (§103, §195)

antisyphilitic: *antisyphilitisch.* Pertaining to that group of homeo-
pathic medicines identified by Hahnemann as effective in curing
syphilis and the syphilitic miasm. (§222)

aperient: *öffnend* [opening]. Pertaining to those medicines intended to
promote circulation of body fluids by removing obstructions. An
aperient [a 'gently opening means'] usually refers specifically to a
medicine intended to gently stimulate evacuation of the bowel; a
laxative. (p. 22)

aphrodisiac: *aphrodisiaca* [from GREEK *aphrodisia*, sexual pleasures,
from Aphrodite]. Aphrodisiac; a food, medication or treatment
intended to increase sexual desire. (p. 40)

apoplexy: *Apoplexie* [from GREEK *apoplessein*, to cripple by a stroke]. A
sudden hemorrhage into any organ or tissue (identified by the organ
involved, as in abdominal, or pulmonary apoplexy). Cerebral
apoplexy (currently referred to as cerebrovascular accident or stroke)
involves a sudden effusion of blood or serum in the brain. (*fn* 205a)

apparatus: *Apparat* [from LATIN *parare*, to prepare, equip]. A critical
apparatus is a collection of referenced information. In §172, the
term is used to refer to the materica medica.

apprehend: *auffassen.* 1. To grasp mentally. 2. To become conscious of,
as through the emotions or senses. (§82)

**appropriate, apt, belonging to, commensurate, fitting, pertinent,
proper, suitable, well-aimed.** Hahnemann uses various similar
words to describe appropriateness or suitability. These have been
translated according to contextual nuances. Words used in the
Organon include: *Angemessen* [measured to]. Suitable, appropriate,
befitting, proportionate, properly proportioned. Translated as
'appropriate' (§40), 'commensurate' (*fn* 74a), 'suitable' (§30, §70).
Geeignet [owned]. Appropriate to a purpose or an occasion; suit-
able. Translated as 'appropriate' (§7, §40), 'fit' (p. 49), 'suitable'
(*fn* 40a). *Gehörig* [belonging to]. 1. Proper; characterized by appro-
priateness or suitability. 2. Characteristically belonging to the being
or thing in question. Translated as 'appropriate' (§42), 'belonging to'
(§173), 'due' (§66), 'pertinent' (§89), 'proper' (§40), 'suitable' (§68).
Passend [fitting]. Appropriate, suited, well fitting. Translated as 'fit-

ting' (*fn* 73b). *Treffend* [hittingly]. Apt; well-aimed; exactly suitable. Of the various words used to describe the suitability or appropriateness of a medicine for a disease, 'apt' and 'most apt' are among the strongest, often describing the exactly fitting medicine, the simillimum. *Treffend* is almost always translated as 'apt' (§106, §120); in one instance (§104), it is translated as 'well-aimed.'

approximate: *nahe kommen* [to come near]. To come close to; be nearly the same as. (§136)

apsoric: *apsorisch.* Not pertaining to psora. Hahnemann differentiates between the apsoric medicines (also referred to as the general class of medicines) and the anti-miasmatic or antipsoric medicines. (§222)

apt, well-aimed: *treffend.* See **appropriate.**

arouse, stimulate: *erregen.* To rouse or to stimulate to action or to physiological readiness for activity; to stir to action that which is at rest. (p. 39, §74)

art: *Kunst.* Hahnemann writes about disease and cure in artistic as well as in scientific terms. In fact, his artistic language is central to his treatise on the medical art. The language of the various arts of music, painting, sculpture, architecture and poetry is exhibited thoughout the *Organon.* Hahnemann presents a full musical analogy in his use of the *stimm* words, here translated as tunement. Painting is evoked in his use of the term *Bild* (meaning picture, image) and his description of the physician sketching the image of the disease (§192). The word 'gestalt' figures prominently in sculpture; Hahnemann uses it to describe the totality of symptoms in a case of disease (§6). 'Anlage' (meaning make-up, layout, or structure) is an architectural term; Hahnemann uses it in reference to one's bodily constitution (§78). Hahnemann alludes to the art of verbal expression in several ways: He uses the word *Aeusserungen* (which literally means utterances) to refer to the manifestations of disease (§11). He refers to the disease 'expressing itself' though symptoms (§12), to the 'pure language of nature' (§144), to the physician's 'articulation' of the disease case (§192) and to the 'voice of nature' (§262).

The quintessential feature of art resides in the creation of a symbol which presents a whole truth, and in the appreciation of that symbol on the part of the beholder. However, the medical-art

practitioner's function is the reverse of that of the creative artist in that the patient creates the symbol (the disease) which must then be understood and appreciated by the physician (semiotics). In a case of disease, the symbol produced by the patient represents, not some absolute whole truth, but rather the truth of his ignorance or his separation from the truth. In other words, whereas the creative artist starts from a truth and reproduces it, the patient proceeds from a fundamental error and reproduces that in his consequent symptoms. It is the office of the medical-art practitioner to be in connection with the whole truth and also able to experience the state of the patient in order to successfully treat the patient's disease. [Resource: SRD] See also **knowledge, participation.**

articulate: *erörtern.* To express in coherent verbal form; give words to; fit together into a coherent whole. (§192)

artlessness: *Unkunst* [non-art]. That which lacks art, knowledge or skill. (§149)

asthenia: *Asthenie* [from GREEK *astheneia,* without strength]. Loss or lack of bodily strength; weakness; debility. (p. 44)

asthma: *Asthma* [from GREEK *asthma,* panting]. A condition involving paroxysmal constriction of the bronchial airways with consequent difficulty in breathing accompanied by periodic wheezing and coughing. (§80)

attendant, accessory, side: *neben.* See **accessory.**

attribute, property: *Eigenschaft.* See **property.**

aude sapere [LATIN]. Dare to know. The phrase was probaby first used by the Roman lyric poet, Horace. It was later used by the German philosopher, Immanuel Kant, summarizing the philosophy of the Enlightenment. Its suggested meaning is 'dare to know for yourself.'

autocracy: *Autocratie* [GREEK, self-governance]. 1. Self-sustained or independent power. 2. Supreme, uncontrolled, unlimited authority or right of governing in a single person. Hahnemann uses the Greek term *Autocratie* to clarify and help define the terms 'life force' and 'dynamis' (§9), and 'energy activity of the living organism' (§156).

autonomic: *selbstthätig* [self-acting]. 1. Occurring involuntarily; automatic, such as an autonomic reflex. 2. Resulting from internal stimuli; spontaneous. (§11)

auxiliary, helping, aid: *Hülfs-*. See **help**.

aware, to be: *wissen*. To have cognition about, such as knowledge gained from books, lectures or scientific study, as opposed to knowledge gained from participative experience *(kennen, erkennen)*. (§3, §4, §59) See **knowledge**.

back-action: *Rückwirkung*. The counter-action of the life force. (p. 13) See **counter-action**.

befallment: *Zufall* [from the verb *zufallen*, to fall to]. That which falls to a person; a phenomenon, symptom or occurrence, including one that may appear to be an accident or coincidence. Befallments include those symptoms which are felt over a period of time or occur periodically, as well as those incidents or accidents that may occur only once but which are quite significant (e.g., a stroke, an injury, etc.). Any symptom can be described as a befallment, but not all befallments are symptoms. In other words, befallments include both symptoms and other occurrences and phenomena of importance in a case of disease. (§86, §133)

behold: *durchschauen*. To view something deeply and attentively, receiving an impression of that thing. Beholding suggests the capacity to see into the core of something. It involves imagination which bridges the gap between having information about something and having deep personal knowledge of it, between *wissen* and *kennen*. This is differentiated from *einsehen* [in-seeing, seeing insightfully] in that *einsehen* is more cognitive, more sentient as opposed to *durchschauen* which is more aesthetic. (§54, §104)

belonging to: *gehörig*. See **appropriate**.

bias: *Befangenheit* [caughtness]. Having a preference or an inclination that inhibits one's impartial judgment; the state of being caught or enmeshed in such partiality. In §83, Hahnemann refers to freedom from bias (*Unbefangenheit*) as the first requirement of a case-taker. In *fn* 73a, he uses the verb *befangen* to refer to physicians who are caught in their prejudices.

bilious: *gallicht*. 1. Pertaining to bile. 2. Afflicted with symptoms of a disordered condition of the liver which is marked by an excess of bile. (*fn* 73a)

blindness: *Blindheit* [blindness], *schwarzer Staar* [black stare]. Sightlessness. (§46, §80)

bloodletting: *Aderlaß.* The removal of blood, usually from a vein, as a therapeutic measure. The two primary means of bloodletting used by physicians of Hahnemann's time were cutting the vein to let blood out (venesection) and leeches to suck the blood. (*fn* 60)

bodily, corporeal, somatic: *Körper-, körperlich* [from LATIN *corpus,* body]. Pertaining to the body (the entire material structure of an organism) as opposed to the mind and spirit. (§59, §216) See also **organism.**

bodily fluids, juices: *Säfte* [juices]. Natural body fluids or secretions of fluid such as blood, semen, or saliva. Hahnemann refers to the loss of *Kräfte und Säfte,* forces and juices, or vitality and bodily fluids — the one dynamic, the other material — in describing the adverse effects of allopathic treatments. (p. 2, *fn* 22, *fn* 74a)

body: *Körper, Leib.* In most instances, 'body' is translated from *Körper,* referring to the entire corporeal structure of an organism (§88, §111). 'Body' is translated from *Leib* in the terms 'body constitution' (*Leibes-Beschaffenheit,* §5), and 'body and soul' (*Leib und Seele,* §6, §214). *Leib,* which has various meanings, is also translated as 'trunk' (*fn* 235) and 'abdomen' (*fn* 88).

bone-softening: *Knochen-Erweichung.* A term used in pathology texts of the old school of medicine in reference to rachitis, or rickets. (§80)

bring forth, generate: *vorbringen.* To give rise to; produce. (§108, §114)

bubo: *Beule* [bulge]. A tumor or abscess with inflammation occurring in certain glandular parts of the body, as in the groin or armpit. An inguinal bubo is in the region of the groin. (§204)

buffy coat: *Speckhaut* [fat skin]. In Hahnemann's time, the buffy coat was defined as "a grayish crust or buff, varying in thickness, observed on blood drawn from a vein during the existence of violent inflammation, pregnancy, etc. It is particularly manifest in pleurisy. It is consequent to an increase in fibrin in the blood, and the blood takes longer to coagulate, allowing the red blood cells to settle to the bottom." Hahnemann refers to the buffy coat as "the coagulable lymph in the blood." This is different from the current definition of the term. (p. 15)

business, pursuit: *Geschäft.* The occupation or work in which a person is engaged. While 'business' has been used in some contexts to

translate *Geschäft* (§105, §146, §186) it is a somewhat inadequate word in that *Geschäft* includes as one of its meanings that type of work involving beneficial acts performed for others (conveyed, in English, by certain uses of the word 'office'). When Hahnemann discusses the various points of business of the genuine medical-art practitioner, he is referring both to one's work and to one's office. *Geschäft* is also translated as 'pursuit' (§76).

C potency medicines. See **centesimal potencies.**

cachectic: *kachektisch* [from GREEK *kakhexia*, bad condition of the body]. Suffering from a cachexia, a condition in which the system of nutrition is damaged in connection with a chronic disease, resulting in weight loss, wasting of muscle, loss of appetite, and general debility. (p. 41)

calamity: *Unheil.* An event that brings terrible loss, lasting distress, or severe affliction. Hahnemann calls the allopathic system of medicine a 'calamitous art' (*Unheilkunst,* §13).

cancer: *Krebs* [crab]. A generalized disease condition characterized by the growth of malignant tumors in various locations in the body. These tumours are characterized by an uncontrolled growth of cells derived from normal tissue which are then able to kill the host organism by spread of cells from the site of origin to distant sites, or by local spread. (§80)

cantharide: *Cantharide* [from LATIN *Cantharis*]. Medicinal substance made from dried insects of the species *Cantharis vesicatoria* or Spanish fly. Formerly used internally as a diuretic and as a stimulant to the genito-urinary organs, and used externally as a counter-irritant or vesicant [blistering agent]. Also formerly considered an aphrodisiac, when taken internally. Cantharis is currently used, in potentized form, in homeopathic medical practice. (p. 18, §59)

cardialgia: *Cardialgie* [from GREEK, *kardialgia*, heart pain]. Localized pain in the region of the heart. (§174)

caries: *Knochenfraß.* A gradual decay and disintegration of bony tissue or a tooth. (§80)

cataract: *grauer Staar* [grey stare]. An opacity of the lens of the eye, of its capsule, or of both, which results in more or less impairment of sight. (§80)

catarrh: *Stockschnupfen* [impacted cold]. An acute or chronic condition, characterized by inflammation of mucous membranes, especially of the nose and throat, with increased secretion from the affected tissue. (§59)

causa morbi [LATIN]. Cause of disease. (p. 16)

causa occasionalis [LATIN]. Occasioning cause. (§7) See **occasion.**

cause: *Ursache.* The producer of an effect, result, or consequence. Hahnemann uses several terms to refer to different types of causal relationship, including: *verursachen* [to cause], *vorbringen* [to bring forth], *erzeugen* [to engender], *bewirken* [to produce], *veranlassen* [to occasion] and *schaffen* [to create]. In general, Hahnemann reserves the term 'cause' for discussions of the fundamental cause of disease (i.e., chronic miasms). A notable exception is his one reference to occasioning causes of disease (§7) which he generally refers to as occasions of disease.

caustics: *Beitzen* [etchings]. Substances which, when applied to living tissue, act like fire, burning and corroding the part and dissolving its texture. (*fn* 54c)

cauterization: *Brennen* [burning]. The process of burning or searing with a hot iron. (*fn* 54c)

centesimal potency medicines, C potencies. Potentized medicines prepared using a dilution ratio of 100 parts of dilutant to 1 part of medicinal substance. (*fn* 270f) See also **fifty-millesimal potencies.**

chancre: *Schanker.* A dull red, hard, insensitive lesion that is the first manifestation of syphilis. (§80)

characteristic: *charakteristisch* [from Middle English *carecter*, distinctive mark, imprint on the soul; from GREEK *kharassein*, to inscribe, from *kharax*, pointed stick]. Pertaining to a feature that helps to distinguish a disease state; distinctive. Hahnemann states that strange, rare and peculiar symptoms are characteristic, whereas common or general symptoms are not. (§153, §198) See also **strange, rare and peculiar.**

chief, principal: *Haupt-.* First, highest, or foremost in importance, rank, worth, or degree. (§82, §212)

chilliness: *Frostigkeit.* 1. Being cool or cold enough to cause shivering. 2. Having a sensation of cold that may or may not involve a lowering of one's body temperature. (§59) See also **cold.**

cholera, Asiatic: *ostindische Cholera*. An acute infectious disease which is currently characterized by profuse watery diarrhea, vomiting, muscle cramps, severe dehydration, and depletion of electrolytes. In Hahnemann's time, cholera was a very rapid and fatal disease. People would be suddenly struck down by the disease and unless they were treated successfully within a very short time (10–15 minutes) they would rapidly decline and die within a few hours. The disease was characterized by a sudden attack of weakness that was so profound that someone who was afflicted would suddenly be unable talk or stand upright. The eyes would sink in, the face, hands and body would turn bluish and icy cold, and the face would have an expression of hopelessness and anxiety, revealing a fear of suffocation. There was typically a burning in the stomach and cramps in the muscles, but no vomiting or diarrhea. Those that survived this first stage would progress to a second stage characterized by profuse watery diarrhea, vomiting, muscle cramps, severe dehydration and depletions of salts in the blood. It is this later stage which is more familiar to us in modern times. Asiatic cholera was identified by Hahnemann as an acute miasm. (§73) See also Hahnemann's article, "Cause and Prevention of the Asiatic Cholera," translated in *The Lesser Writings*.

chronic: *chronisch* [from GREEK *chronos*, time]. Lasting for a long period of time. Chronic diseases are those which (each in its own way) dynamically mistune the living organism with small, often unnoticed beginnings. Unaided, the life force is unable to extinguish the disease and allows it to spread, mistuning the life force to a greater and greater extent until finally the organism is destroyed. Hahnemann differentiates between protracted, long-standing diseases (which include, but are not limited to, the chronic diseases) and truly chronic diseases. True chronic diseases either stem from chronic miasms or are caused by allopathic treatments. (§72-§82)

chronic miasm: *chronisches Miasm*. A natural chronic disease which is invariable as to its wesen, and which is a collective disease with a large totality of symptoms (§103). Chronic miasms are the fundamental causes of an extremely wide variety of disease manifesta-

tions. In the *Organon of the Medical Art* and *The Chronic Diseases*, Hahnemann discusses three chronic miasms: psora, sycosis and syphilis. Chronic miasmatic diseases never pass away by themselves. They can never be extinguished, or even diminished, by the strength of even the most robust constitution, nor can they be overcome by even the most wholesome diet or regimen. They increase and worsen from year to year until the end of life, unless they are cured by homeopathic medicines which are specific to them. (§78) See also **miasm.**

cinchona: *Chinarinde* [China bark]. Dried bark of the tree cinchona, also referred to as China bark or Peruvian bark. Cinchona was used in large doses by the old school of medicine to treat intermittent fevers, as was quinine, an alkaloid derived from cinchona. Cinchona (known as *cinchona officinalis*) was the first homeopathic medicine to be proven by Hahnemann. (§234)

cinnabar: *Zinnober.* A heavy reddish mercuric sulfide, HgS, that is the principal ore of mercury. (p. 17)

circumspection: *Umsicht* [around-sight]. Heedfulness of circumstances and potential consequences; caution, prudence. (§246)

clyster: *Klystier* [from GREEK *klyster,* syringe]. A medicine injected into the rectum to empty or cleanse the bowels, to afford nutrition, etc.; an injection, enema; sometimes a suppository. (*fn* 274)

codex: *Codex.* A manuscript volume, especially of a classic work. The codex was the earliest form of a book, following the use of scrolls and wax tablets. (§143)

cogitate, reflect: *nachdenken* [*nach,* after + *denken,* to think]. To think profoundly. Cogitation involves thoughtful consideration, reflection, rumination and meditation. (§61, §189, §205)

cold: *kalt.* Having a temperature lower than normal body temperature; feeling no warmth; uncomfortably chilled. 'Cold' (*kält*) involves a lowering of one's body temperature, while 'chilly' (*frostig*) refers to the sensation of being cold. (§65)

cold ailment: *Erkältungs-Beschwerden.* An ailment arising from exposure to cold or to a draft. (p. 53)

cold fever, ague: *kaltes Fieber.* See **ague.**

cold-blooded: *kaltblütig.* Without feeling or emotion. (§228)

collective disease: *Collectivkrankheit.* A disease, such as an epidemic, in which many people have the same disease, stemming from the same contagion. (§101)

colliquative: *colliquativ* [from LATIN *con,* together + *liquare,* to melt]. Pertaining to the excessive discharge of a body fluid, as a colliquative perspiration. (p. 35)

commensurate: *angemessen.* See **appropriate.**

complex: *Inbegriff.* See **symptom complex.**

compound prescriptions: *gemischte Recepte, zusammengesetzte Recepte.* Polypharmaceutic preparations; medicinal preparations containing more than one medicinal substance. (p. 44, *fn* 25, *fn* 54c)

conceptive: *empfänglich* [*em,* in + *fänglich,* catch-ative]. **1.** Receptive; capable of receiving or taking in. **2.** Pertaining to, or capable of, conception. Throughout the *Organon,* Hahnemann uses reproductive language to describe the disease process. For example in §64, he states that disease is engendered [procreated] when a disease potence impinges upon the life force, which initially acts receptively or conceptively. *Empfängniß* (*fn* 181) is the German word for reproductive conception. [Resource: SRD]

condition: *Befinden.* The condition of a human being is comprised of one's feelings, functions and sensations (§19, §31). Hahnemann uses the term 'human condition' to refer to the condition of a given individual, not the condition of humanity in general. The disease condition is characterized by morbid feelings, malfunctions and adverse sensations (§11, §189) in contrast to the disease state which is characterized by false or 'superstitious' beliefs and fancies (*fn* 17a) and which is primarily manifested in one's behavior. See also **state.**

condition-state: *Befindenszustand.* In uniting the terms condition (*Befinden*) and state (*Zustand*), Hahnemann is referring to that aspect of the human being that comprises both the condition and the state. He is also indicating that one's condition and one's state are two integral parts of a larger whole; they form a functional polarity whose common functioning principle is the being of the organism. (§37, §194) See also **functional polarity.**

confabulation: *Erdichtung.* Replacement of fact with fantasy unconsciously in the memory. (*fn* 74a)

confortantia [LATIN, to strengthen]. Comfortants; medications and other treatments intended to comfort (i.e., soothe and strengthen). (p. 39)

constant: *stetig.* 1. Continually occurring; persistent. 2. Unchanging in nature, value, or extent; invariable. (§197, §198)

constitution: *Beschaffenheit* [GERMAN, makeup], *Constitution* [from LATIN *constituere*, to set up]. 1. The composition or makeup of a thing. 2. The makeup of a person, in body and/or soul. Uses of 'constitution' in the *Organon* include: *Leibes-Beschaffenheit* (body constitution, §5), *Leibes- und Seelenbeschaffenheit* (body and soul constitution, §136), *Körper-Constitution* (bodily constitution, §81), *Körperbeschaffenheit* (bodily constitution, §102, §117, §138). In different contexts, *Beschaffenheit* is also translated as 'quality' or 'makeup.' *Einrichtung* [GERMAN, inner direction] may be translated as 'constitution,' 'organization,' or 'arrangement' (p. 28, p. 36). See also **quality.**

consumption: *Schwindsucht* [shrinking sickness]. A wasting condition involving gradual decay or diminution of the body, which precedes death in the greater part of chronic diseases. This condition is particularly evident in pulmonary tuberculosis (or phthisis pulmonalis) which has therefore taken the name pulmonic consumption. In this text, *Lungensucht* is translated as pulmonary tuberculosis; *Schwindsucht* is translated as consumption. (*fn* 81b) See also **tuberculosis.**

contagious, infectious: *contagiös* [from GREEK], *ansteckend.* [GERMAN]. In this translation, both 'contagion' and 'infection' refer to the dynamic transmission of disease. The term 'infection' is used when the transmission of disease also involves microbial matter (§33). The term 'contagion' is used when disease transmission may or may not involve microbes or definitely does not, such as the dynamic action of a disgusting sight upon one's imagination which results in nausea (*fn* 11). This distinction is made in the text by Hahnemann, but not through the use of two different words.

Hahnemann uses the Greek word *contagiös* and the German word *ansteckend* synonymously.

contingent: *etwanig.* 1. Conditional; dependent on certain conditions. 2. Possible; liable to occur but not with certainty. (§7)

contraria contrariis [LATIN]. Contrary things for (or by means of) contrary things. (§56)

contraria contrariis curentur [LATIN]. Let contrary things be cured by contrary things. *Contraria contrariis curentur* specifically refers to antipathic treatment. This is a fundamental principle of allopathy, the system of medicine (also referred to by Hahnemann as the old or the hitherto school of medicine) which has been the dominant medical system for centuries and continues to be so today. Its usual methods of treatment — antipathic, allopathic, and surgical — are based on the underlying principle that one or a number of the symptoms of a disease are the disease itself, to be countered by various means. This is in contrast to the homeopathic perspective which sees the totality of disease symptoms as evidence of the underlying disease which will necessarily be lifted and annihilated simulaneously with the cure of the entire disease. The disease symptoms, taken as a whole, serve as the treatment indicator and should almost never be treated by means which are either different from them (allopathic) or opposed to them (antipathic). Such treatment may result in suppression of the symptoms without a cure of the underlying disease; the disease will then return in the same or another form, aggravated and worsened. (p. 48)

convulsions: *Convulsionen.* Spasms of a general nature which are typically involuntary and relatively violent. (p. 33, §291) See also **spasms.**

corporeal, bodily, somatic: *Körper-, körperlich.* See **bodily.**

corrigens, corrigentia [LATIN]. Things that correct; improvers. (p. 44)

corruption: *Verderbniß.* The destruction or spoiling of anything, especially by disintegration or decomposition. (§216)

counter-action: *Gegenwirkung* [counter-working]. *Gegenwirkung* (counter-action), *Nachwirkung* (after-action) and *Rückwirkung* (back action) are used interchangeably by Hahnemann to describe the life force's automatic reaction to a medicinal substance's initial action. In other writings, this is referred to as the secondary action. In the Index, all references to after-action, back-action and counter-

action are included under the headings 'Counter-action' or 'Initial-and counter-actions.' In addition, specific use of the terms 'after-action' and 'back-action' are listed separately. (§63)

counter-irritant: *antagonistisches Reizmittel* [antagonistic irritant or stimulant]. An agent such as mustard plaster that is applied locally to produce an inflammatory reaction for the purpose of affecting some other part of the body, often adjacent to or under the surface which is being irritated. (p. 25)

counterproductive, inexpedient: *unzweckmässig, zweckwidrig.* See **inexpedient.**

cowpox: *Kuhpocken.* A mild, contagious skin disease of cattle, which is characterized by the eruption of a pustular rash. The British physician, Edward Jenner, found that smallpox could be prevented by inoculation with the substance from cowpox lesions. Cowpox is very similar to smallpox, differing primarily in that it has a more rapid course and is much gentler. (§38)

cramps: *Krämpfe.* Sudden, involuntary, spasmodic muscular contractions causing severe pain. Cramps and spasms are both local in their symptoms. Cramps are deeper and more painful than spasms. (*fn* 60) See also **spasms.**

create: *schaffen* [to shape]. To cause to exist; bring into being. (*fn* 6, *fn* 12)

crepuscular: *dunkel fortwährend* [dark continuing]. Resembling or likened to twilight; dim, indistinct. (§216)

critical: *bedenklich.* 1. Of or relating to a crisis. 2. Forming or having the nature of a turning point; crucial, decisive. 3. Indispensable; essential. 4. Fraught with danger or risk; perilous. The German and the English words share these different meanings. (pp. 3, 30; *fn* 148)

curative, healing, medical, therapeutic: *Heil-.* Remedial. Pertaining to the restoration of health or the intention to restore health. Many words used by Hahnemann are compound words that include *Heil-. Heil-* is translated as either 'medical,' 'curative,' 'healing,' or 'therapeutic' depending on context. See also **cure.**

cure, heal: *heilen.* To restore to health through curative means or through the natural process of healing. To make whole again. In this translation, 'to cure' (§1) refers to the restoration of health

brought about through the use of medicines or other treatments, while 'to heal' (§39) refers to the body's own process in recovering from an injury. Throughout the text of the *Organon*, Hahnemann distinguishes, in various ways, between healing and curing, however, the German language has only one word, *heilen*, which encompasses both meanings. General references to both healing and cure are translated with the words 'medical' and 'therapeutic.' [Resource: SRD]

cyanosis: *Blausucht* [blue sickness]. Slightly bluish, grayish, slatelike or dark purple discoloration of the skin due to the circulation of deoxygenated blood, stagnation of blood in a particular part, or the general lack of blood circulation. (§80)

damage: *Beschädigung*. Injury, harm. 'External damages' include but are not limited to physical injuries. (§186)

deafness: *Taubheit, Taubhörigkeit*. Partially or completely lacking in the sense of hearing. (§46, §80)

debilitate, weaken: *schwächen*. To sap the strength or energy of; enervate. (§74)

decillionfold dilution: *decillionfach Verdünnung*. A dilution of 1 part medicinal substance in $1x10^{60}$ parts non-medicinal liquid. This is the dilution ratio of a thirty-centesimal (30 C) potency medicine. (p. 15)

decoct: *kochen* [to cook]. To extract by boiling down, as contrasted with an infusion, in which the medicinal substance steeps in hot water. (p. 44)

deliberation: **Ueberlegung** [over-laying]. The action of deliberating, or weighing a thing in the mind; careful consideration with a view to decision. (p. 36, §34)

desquamation: *Abschuppung* [flaking off]. Shedding of the cells forming the epidermis of the skin and the surface layer of mucous and serous membranes. (§38)

destroy: *zerstören*. See **remove**.

detrimental, harmful: *schädlich*. Injurious, damaging. (§16, §59) The noun, *Schädlickeiten* [harmfulnesses] is translated as 'malignities.' (§33, §110)

deviating, divergent, diverging: *abweichend*. See **divergent**.

diathesis. See **itch diathesis**.

diet: *Diät.* 1. Course of life: way of living or thinking. 2. Customary course of living as to food. Hahnemann uses the term 'diet' to refer to food intake (§125) and also to regimen in other areas, such as 'mental and bodily diet' (§244) and 'diet for the soul' (§228). See also **regimen.**

digitalis purpurea [LATIN]. An extract prepared from the plant *digitalis purpurea*, or purple foxglove, which initially slows the heart rate and then acts as a cardiac stimulant. Digitalis was used antipathically, in large doses, by the old school of medicine. It is currently used, in potentized form, in homeopathic medical practice. (p. 42)

diminish, reduce: *verkleinern* [to make small]. To make smaller or less. 'Diminished doses' are doses made minute through potentization and through the use of smaller amounts. (§25)

Dioscorides [ca. 40-90 A.D]. Greek physician and pharmacologist whose work, *De Materia Medica*, was the foremost classical source of modern botanical terminology and the leading pharmacological text for sixteen centuries. (p. 18)

discern: *erkennen.* To have deep personal knowledge, such as that based on participative experience. (§3, §110) See **knowledge.**

disease: *Krankheit.* A solely dynamic mistuning of the life force, which is manifested in one's state (which is primarily exhibited in behavior), in one's condition (which comprises one's feelings, functions and sensations), and in one's appearance (which includes objective signs of disease); an alteration of the state and condition of healthy organisms which expresses itself through objective and subjective symptoms of disease. Becoming diseased is a dynamic process which manifests itself through adverse sensations and irregular functions in the organism, through signs and symptoms which are felt by the patient, perceived by those around patient, and observed by the physician.

Diseases can be classified according to duration (see **acute, chronic, protracted**) and categorized according to genesis (as iatrogenic, ideogenic, or pathogenic diseases). An iatrogenic disease is one which has been induced by a physician through his diagnosis, manner or treatment (see the Introduction). The ideogenic dis-

eases are those of the spirit and soul. They include diseases referred to by Hahnemann as the highest diseases (i.e., those which can be brought to pass through a mistunement of the life principle by means of the imagination, *fn* 17a), and they include diseases which are spun and maintained by the soul (§224-§266). The pathogenic diseases include those whose propagation involves infectious micro-organisms (e.g., the epidemic diseases) and also those brought about by toxic substances such as poisons. The pathogenic diseases, like all other forms of disease, are transmitted dynamically. Hahnemann refers to the involvement of infectious matter (i.e., micro-organisms) in the propagation of disease in *fn* 81b. He more fully discusses the role of micro-organisms in the transmission of disease in his article, "Cause and Prevention of the Asiatic Cholera" (translated in *The Lesser Writings*) in which he refers to the "excessively minute, invisible, living creatures, so inimical to human life." He describes Asiatic cholera as "composed of probably millions of those miasmatic animated beings," and he discusses the habituation of these micro-organisms to colder climates as follows: "When they are transferred to distant and even colder regions, they become habituated to these also, without any diminution either of their unhappy fertility or of their fatal destructiveness."

It is important to understand that Hahnemann's expressed views on the role of micro-organisms in the transmission of certain diseases in no way contradicts his very strong and clear statements that disease is transmitted in a purely dynamic way. Micro-organisms, like all living organisms, include a dynamic aspect without which they cannot exist; the material organism and its dynamic presence form a unity (§15). Therefore, where they are involved in the transmission of disease, micro-organisms act dynamically as well as having a material presence. Hahnemann clearly indicates that diseases (and also medicines) affect the conditon of the human organism only by acting dynamically upon the life force. The wesen of the disease dynamically interacts, impinges upon and alters the tunement of the dynamis (i.e., the human wesen). In other words, the wesen of the disease acts on a dynamic level instantaneously, in the wake of which there is a material manifestation of the disease,

which is associated with the reproduction and growth of micro-organisms. [Resource: SRD] See also **miasm**.

diseased, morbid: *krankhaft*. See **morbid**.

disease-making, morbific: *krankmachend*. See **morbific**.

dispatch: *beseitigen*. See **remove**.

dispel, expel: *austreiben, vertreiben*. See **remove**.

displace: *versetzen*. See **remove**.

disposed: *disponiert* [from LATIN *disponere*, to arrange]. Having a pre-disposition, tendency or susceptibility. In §31, Hahnemann uses the phrase *disponiert und aufgelegt*, two words (one with a Latin root, the other German) that mean disposed or inclined to. *Aufgelegt* literally means laid open to. This phrase is translated as 'disposed and laid open to.'

dissolvent: *auflösend*. Pertaining to medicines which were presumed by old school practitioners to dissolve disease matter. One of the basic concepts of medicine in Hahnemann's time (as in ours) is that most diseases involve a material contamination of the body (the *materia peccans*). Medicines were used that were thought to cause the disease matter to liquify and pass out of the body. These medicines were called 'dissolvents' for this presumed ability. In *fn* 20 of the Introduction, Hahnemann points out that the term itself reveals a material view of disease. (p. 22)

distinguished: *ausgezeichnet*. Distinct, characteristic. Hahnemann equates the German word *ausgezeichnet* (distinguished) with the word of Greek origin, *charakteristich* (characteristic). (*fn* 67)

divergent, diverging, deviating: *abweichend*. 1. Drawing apart from a common point; diverging. 2. Differing from another. (*fn* 119b, §136, §239)

dose: *Gabe* [GERMAN, a giving], *Dosis* [from GREEK, a giving]. That which is given or administered. Dose refers to the amount of a medicinal substance that is administered. This includes both the medicine's potency (higher potencies having less material and therefore being considered as smaller doses) and the number of globules given. 'Small dose' generally refers to a small quantity of a potentized substance; 'large dose' generally refers to a large quantity of a crude (i.e., unpotentized) substance. In some passages, Hahnemann

also refers to a large dose (or quantity) of a potentized medicine (*fn* 276a, *fn* 282). A 'too-strong dose' is one which is too large and therefore makes too-strong an impression on the life force (§275, §276). Hahnemann almost always uses the German word *Gabe*. In two instances — §276 (strong doses) and *fn* 282 of the Synopsis (all-too-large doses) — he uses *Dosis*. For a brief history of Hahnemann's development and use of different doses and potencies, see Dudgeon's *Lectures on the Theory and Practice of Homeopathy*, Chapter XIV, entitled "Homeopathic Posology."

dram: *Quentchen.* A unit of weight. A drachme was the principal silver coin of the ancient Greeks. One dram originally represented the approximate weight of one such coin. Different systems of measurement differ slightly in their definition of dram. In the U.S. and British systems, a fluid dram is equivalent to approximately one teaspoonful or 1/8 of a fluid ounce (28 millileters); a solid dram is equivalent to approximately 3.89 grams. (§248)

drive away: *verdrängen.* See **remove.**

dropsy: *Wassersucht* [water sickness]. A generalized condition of edema in which the body tissues contain an excessive amount of tissue fluid. Also known as anasarca. (§80)

duce natura [LATIN]. Guide according to nature. (p. 34)

dynamic: *dynamisch.* Of the nature of some immaterial, supersensible influence. Of or relating to energy, force or power. (*fn* 11)

dynamis: *Dynamis* [GREEK]. The human wesen. Hahnemann uses the term dynamis in reference to the life force or life principle. (§9, §12, §13) See also **life force, wesen.**

dynamization: *Dynamisation.* A multi-step process (involving dilution and succussion, or trituration) by which the inner medicinal power of a crude substance is released or increased. Synonym: potentization. (§269)

dyspnea: *Schwerathmigkeit* [heavy breathing]. Labored or difficult breathing, sometimes accompanied by pain. (§46)

earths: *Erden.* The oxides of certain metals which agree in having very little taste or smell, and in being uninflammable, for example, magnesia, alumina, zirconia, and the alkaline earths baryta, lime, and strontia. (*fn* 273)

embrocations: *Einreibungen* [in-rubbings]. Mixtures, usually of an oily nature, intended for external application; lotions or liniments. (p. 34)

emetic: *Brechmittel.* A medicine or other means that produces vomiting. (*fn* 11)

emotion, emotional mind: *Gemüt.* That faculty capable of taking in impressions and having responses to them. The emotional mind is an aesthetic faculty, as opposed to the *Geist*, which is a faculty of pure intelligence. The *Gemüt* is also the chief faculty of participative consciousness.

In the *Organon*, Hahnemann refers to various emotions of the *Gemüt*, which are typically exhibited through behavior. These include: dejection (p. 13); grief, fright and chagrin (p. 13); mourning, grief and bereavement (*fn* 26); a mild, gentle emotional mind which may turn to ingratitude, hard-heartedness, deliberate malice and the most degrading, the most revolting tempers of humanity (*fn* 210); emotional states which are quiet and calm, mild and phlegmatic, or which are glad, cheerful, and stubborn, or unchangeable and not inclined to fright or vexation (*fn* 213); emotional shocks (§263); and emotional irritability (§290).

Hahnemann makes several references to the role of the emotional mind in the production of somatic symptoms: In *fn* 8 of the Introduction (p. 13), he discusses the relationship between the - emotional mind and the body, indicating that emotional disturbances (i.e., disturbances of the *Gemüt*) can dynamically engender a somatic condition (i.e., a stomach vitiation). He also makes the connection between emotional mistunement and somatic symptoms in *fn* 232, in which he refers to "a somber, melancholic temper, an intolerable, hypochondriacal emotional-mistunement with disturbance of several vital functions (digestion, sleep, etc.)." His strongest statement of the production of somatic symptoms by a mistunement of the emotional mind is in §225 in which he states, "With but little infirmity, it develops outward from the emotional mind due to persistent worry, mortification, vexation, abuse, or repeated exposure to great fear or fright. While initially there is but little infirmity, in time emotional diseases of this kind often ruin the

somatic state of health to a high degree." In §88, 'emotional mood' is translated from *Gemüths-Stimmung*, literally 'tunement of the emotional mind.' [Resource: SRD] See also **participation, soul, spirit.**

enantiopathic: *enantiopathisch* [from GREEK *enantios*, opposite + *pathos*, disease, suffering]. The treatment of one disease by using another disease that produces changes or symptoms antagonistic to it. (§23, §56) See also **antipathic.**

endemic: *endemisch* [from GREEK *en*, in + *demos*, people]. Pertaining to a disease that occurs continuously in a particular population or geographical area. Some diseases which, at times, are epidemic over wide districts, have a restricted area where they are endemic and from which they spread. For example, cholera, the plague and malaria are endemic in certain areas. (§244)

enduring, permanent: *dauerhaft*. See **permanent.**

energic: *energisch*. Having or exhibiting energy. (p. 32)

energy: *Energie* [from GREEK, *energos*, active], *Kraft* [GERMAN, energy, force, power]. 1. Power actively and efficiently displayed or exerted. 2. Power not necessarily manifested in action. Hahnemann uses *Energie* only once in the *Organon* (§63). *Kraft* (*fn* 11) is translated as 'energy,' 'force' or 'power,' depending on context; however, it should be understood to include the meanings of all three English words. See also **life force.**

engender: *erzeugen*. To generate, beget, procreate. Hahnemann uses *erzeugen*, with its procreative meaning, to describe the process of contracting a disease and the process of homeopathic cure. The reproductive homology is clearest in §64, where he states that disease is engendered [procreated] when a disease potence impinges upon the life force, which initially acts receptively or conceptively.

enliven: *beleben* [*be*, be + *leben*, live]. To give life to. (§9, §10)

entire, whole: *ganz*. Having no part which is excluded or left out. (§12)

enucleate: *ausschälen*. To remove an entire mass or part without rupture, especially pertaining to a tumor. (*fn* 205)

epidemic: *Epidemie* [from GREEK *epi*, upon + *demos*, people], *Seuche* [GERMAN, contagion]. An outbreak of infectious disease affecting a large number of people in a particular area at one time. Hahnemann

uses both the Greek and the German terms to describe infectious epidemic diseases. (*fn* 33, §100)

epilepsy: *Fallsucht* [falling sickness]. A chronic disease characterized by sudden, brief attacks of altered consciousness, motor activity or sensory phenomena. Convulsive seizures are the most common form of attacks. (§80)

eradicate: *austilgen, vertilgen.* See **remove**.

errhine: *Schleim erregende Niesemittel* [mucous-arousing sneezing means]. A means that promotes or induces nasal discharge. (§59)

error: *Fehler.* 1. An act, an assertion, or a belief that unintentionally deviates from what is correct, right, or true. 2. A deviation or straying from an accepted code of behavior. (§260)

erysipelas: *Rothlauf.* A febrile disease, accompanied by diffused inflammation of the skin, producing a deep red color. In *The Chronic Diseases* (p. 10) Hahnemann indicates that, for centuries during the Middle Ages, erysipelas (also known as St. Anthony's fire) was one of psora's primary forms of manifestation. (§194)

esse [LATIN, to be]. Being. *Esse* is used to define 'wesen'; it is not used in the *Organon*.

essentially: *wesentlich.* Constituting or being part of the essence of something; inherent. The root of *wesentlich* is wesen. (§201, §255) See **wesen**.

established practice, last: *Leisten.* See **last**.

ether: *Aether* [from GREEK *aither*, air]. A very light, volatile and inflammable fluid, produced by the distillation of alcohol or rectified wine spirit (95% grain alcohol) with an acid. Ethers are lighter than alcohol, of a strong, sweet smell, susceptible of great expansion, and of a pungent taste. They are so volatile that when shaken, they dissipate in an instant. (*fn* 273)

examine: *untersuchen* [*unter,* under + *suchen,* search]. To observe carefully or critically; to study or analyze. (§83)

exceptional, particular, peculiar: *sonderlich.* See **strange, rare and peculiar**.

excitability: *Erregbarkeit* [arousability]. Ability to respond to stimuli. (§278)

excitantia [LATIN]. Excitants; stimulants. (p. 39)

excite: *aufregen* [up-rouse]. 1. To rouse to activity. 2. To produce increased activity or response. (p. 39)

exotic: *ausländisch*. Located away from one's native country; foreign. (§123, §268)

expectoration: *Brust-Auswurf* [chest out-throw]. Matter coughed up from the chest and lungs. (p. 18)

expel, dispel: *austreiben, vertreiben*. See **remove**.

experience: *Erfahrung, Erlebniss*. Participation in events or activities that results in the acquisition of knowledge. Hahnemann refers to pure experience [*reine Erfahrung*] as the sole and infallible oracle of the medical art (§25). Pure experience is participative experience with complete freedom from bias and prejudice; it involves the highest level of functioning of the *Geist* and the *Gemüt* (i.e., the rational-intellectual and the aesthetic faculties). Pure experience is the basis of *kennen* and *erkennen* (knowledge and discernment) and is a fundamental requirement of the homeopathic medical art, coming into play both in the investigation of medicines (provings) and in the investigation of diseases (case-taking). Hahnemann describes the medical art as both the most noble and the most difficult of the arts partly because it has to do with attaining and maintaining that purity of experience which is required in self-provings and in the participative relationship between the physician and the patient. This requires a high degree of health on the part of the medical-art practitioner. (Hahnemann almost always uses the term *Erfahrung;* he uses *Erlebniss* only once, in *fn* 33.) [Resource: SRD] See also **art, participation**.

experiment, proving, test: *Versuch*. A test made under controlled conditions in order to demonstrate a known truth, examine the validity of a hypothesis, or determine the efficacy of something previously untried. In general, *Versuch* is translated as 'experiment' or 'test.' It is translated as 'proving' when it refers to a medicinal experiment conducted upon a healthy individual. (§23, §52, §122) See also **proving**.

export, convey outward: *ausführen*. See **remove**.

expression, manifestation: *Aeußerung*. See **manifestation**.

expulse: *ausstossen*. See **remove**.

expunge: *tilgen*. See **remove**.

expurgate: *auspurgiren*. See **remove**.

extinguish: *auslöschen*. See **remove**.

extirpate: *ausrotten*. See **remove**.

extraneous, foreign: *fremdartig*. See **foreign**.

exutorium: *Exutorium* [from LATIN *exsudare*, to sweat out]. A medicine or treatment which causes fluids to ooze through the skin, such as an irritating substance applied to the skin. (p. 33)

fathom, investigate: *erforschen*. See **investigate**.

fear: *Furcht*. Feeling of agitation and anxiety caused by the perception or the belief that danger is present or imminent. (§225)

feelings: *Gefühle*. 1. Psychic states of consciousness involving emotions, sentiments, or desires, such as a feeling of happiness or excitement. 2. Bodily sensations, such as a feeling of warmth. The term *Gefühle* can refer to either emotions or sensations, but its primary designation is in the psychic realm. Hahnemann indicates that one's condition is comprised of feelings, functions and sensations. (§9, §11)

fiber: *Faser*. 1. Any of the filaments constituting the extracellular matrix of connective tissue; tissue. 2. Any of various elongated cells or threadlike structures, especially a muscle fiber or a nerve fiber. (*fn* 269c, §288, §291)

fifty-millesimal potency medicines, LM potencies. Potentized medicines prepared using a dilution ratio of 50,000 parts of dilutant to 1 part medicinal substance (see §270 for preparation instructions). Fifty-millesimal potencies were the last potencies to be developed and used by Hahnemann (1837-1843). He outlines the method of preparation and guidelines for use for the first time in the sixth edition of *The Organon*, in which he states that fifty-millesimal potencies work faster and are gentler in their action than the centesimal (C) potencies, prepared with a dilution ratio of 100:1. 'LM' is something of a misnomer for fifty-millesimal potencies since 'LM' actually designates the number 950 ('L' indicating 50, subtracted from 'M' indicating 1000). The actual Roman numeral designation of 50,000 can be written either as IↃↃↃ or as \overline{L}. Fifty-millesimal potencies are also known as Q (quinquagenimillesimal) potencies. Hahnemann does not give a name to fifty-millesimal potencies, referring to them simply as his new method of dynamization. (§246-§248)

figwarts: *Feigwarzen.* Genital warts or wart-like growths that look like a cauliflower. According to Hahnemann, figwarts (a symptom of gonorrhea) are the primary means by which the sycotic miasm reveals itself. (§41, §80) See also **sycosis.**

fine, subtle: *fein.* 1. Very small in size, weight or thickness (p. 5, §13, §128, *fn* 268). 2. Able to make fine distinctions which are difficult to detect or analyze, not immediately obvious, abstruse (p. 8).

fine-feeling: *feinfühlig.* Delicate; marked by sensitivity of discrimination, the ability to make or detect effects of great subtlety or precision; responsive to very small changes. (§130, §156)

fistula: *Fisteln* [from LATIN *fistula,* pipe]. An abnormal tubelike passage from a normal cavity or tube to a free surface or other cavity. It may be due to congenital incomplete closure of parts, or it may result from abscesses, injuries, or inflammatory processes. (p. 17)

fitting: *passend.* See **appropriate.**

fontanel: *fontanel* [from FRENCH *fontanelle,* little fountain]. A point on the body (typically a hollow between two muscles) considered an appropriate place for the application of a seton or cautery, hence the word's use in reference to setons and other means of producing issues (i.e., suppurating sores maintained by a foreign body in the tissue, such as a seton). (§39)

force, power, energy: *Kraft.* *Kraft* spans the meanings of force, power and energy. *Kräfte* (plural) is translated either as forces (p. 31), powers (§3) or vitality (§148).

foreign, extraneous: *fremdartig.* 1. Of external origin; introduced or added from without. 2. Foreign to the object in which it is contained. 3. Heterogeneous; allopathic. (§39, §69, §156, *fn* 259)

frenzy, raving: *Raserei.* 1. A state of violent mental agitation or wild excitement. 2. Temporary madness or delirium. (*fn* 232)

fright: *Schreck.* Sudden, intense fear, as of something immediately threatening; alarm. (§221, §225)

function, activity: *Thätigkeit.* *Thätigkeit* can mean either 'function' (§9) or 'activity' (§10) and has been translated according to context. 'Function' refers to the special kind of activity proper to anything; the mode of action with which it fulfills its purpose (e.g., sleep, digestion, respiration, sexual function, etc.). 'Activity' refers to

action in general. A person's condition is comprised of feelings, functions and sensations.

functional polarity. A unity in antithesis; an identity through opposition. A functional polarity consists of two functions which are polar opposites, but which together entail a larger, more inclusive function, referred to as their common functioning principle.

The following are four examples of functional polarities discussed by Hahnemann: *a.* the human wesen and the human spirit whose common functioning principle is human being, *b.* the condition and the state of an organism whose common functioning principle is the being of the organism, and which Hahnemann refers to as the condition-state, *c.* the sustentive power of life and the generative power of life whose common functioning principle is life force, and *d.* intellectual knowledge (*wissen*) and knowledge based on participative experience (*kennen, erkennen*) whose common functioning principle is knowledge.

Hahnemann's mode of thought and writing is neither linear nor abstract, but rather functional. Hahnemann's functional way of viewing his subject is so complete and consistent that for every functional concept presented to the reader, there is almost always, somewhere in the *Organon*, the presentation of its functional compliment. Functional polarities are more fully explicated in the writings of Samuel Taylor Coleridge, Johann Goethe and Wilhelm Reich. The term 'functional polarity' is used in the Glossary to define terms; it is not used by Hahnemann. [Resource: SRD]

fundamental: *Grund-* [ground]. Of or relating to the foundation or base. 'Fundamentally,' 'based upon,' 'grounded in' and 'thorough' are derived from the same root, *Grund.* (p. 11, §28, §56)

fundamental cause of disease: *Grundursache* [ground cause]. The deepest underlying cause of a disease, which may be inherited or acquired through infection. (§5)

fungus hematode: *Blutschwamm* [blood sponge]. A type of bleeding tumor or growth on the body which appears as a spongy mass of granular tissue. It grows unevenly, with loss of normal architecture, so that it looks like a fungus growth; however, no fungus is involved. These tumors may be malignant and aggressive. (§80)

fusion: *Zusammenschmelzung* [*Zusammen,* together + *schmelzung,* melting]. The merging of different elements into a union; a melding. (*fn* 40a)

galvanism: *Galvanism* [from Luigi Galvani, Italian physiologist, 1737-1798]. Therapeutic use of a direct current of electricity. (§59)

Geist. See **spirit.**

Gemüt. See **emotions, emotional mind.**

generate, bring forth: *vorbringen.* See **bring forth.**

generative power: *Erzeugungskraft.* Capacity to engender. The life force, in conjunction with an external potence (either disease or medicinal), has the power to engender disease. Hahnemann refers both to the generative power of the life force and the generative power of medicines. He refers to the life force as the engenderer of disease in the Introduction (p. 37) and as the engenderer of symptoms in *fn* 22. He refers to the disease-engendering power of medicines in §21. [Resource: SRD] See also **engender, sustentive power of life.**

genesis: *Genesis* [GREEK birth, beginning]. The coming into being of something; the origin. (p. 43)

genus epidemicus [LATIN]. The wesen of an epidemic disease, expressed in the collective symptom complex of all those taken ill with the same epidemic disease. When an epidemic of infectious disease occurs, no one patient will show the full array of symptoms characteristic of that particular epidemic. However, by combining the symptoms of a number of patients and analyzing them together as a group, it is possible to find one or two remedies that will be helpful for all the patients affected (at least all those not already suffering from developed psora). This group of symptoms describes the 'genus epidemicus' (i.e., the genius or the wesen of the epidemic disease). While Hahnemann does not use the term, he discusses what is now referred to as the 'genus epidemicus' in §101, §102 and §241.

gestalt: *Gestalt.* A configuration or pattern of elements so unified as a whole that its properties cannot be derived from a simple summation of its parts. (§6, §92)

globule: *Kügelchen* [little globe]. A pellet made of powdered milk sugar, used in the preparation of homeopathic medicines. (*fn* 248, *fn* 270d)

gout: *Gicht.* A disturbance of uric-acid metabolism occurring predominantly in males, usually manifesting first as a painful inflammation of the fibrous and ligamatous parts of small joints, especially of the big toe. It then appears in other smaller joints (e.g., in the feet and the hands) eventually attacking larger joints. Gout has a number of other symptoms, especially of the digestive system. The arthritic attacks are associated with elevated levels of uric acid in the blood and the deposition of urate crystals around the joints. The condition can become chronic and result in deformity. (§80)

govern: *walten.* 1. To control the actions or behavior of. 2. To exercise a deciding or determining influence upon. (§9, §50, §148, §189)

grain: *Gran.* A grain in the modern British and American systems of measurement is equivalent to approximately 0.065 grams. A grain in the Nurembourg system of measurement (purportedly used by Hahnemann) is equivalent to approximately 0.062 grams. (§270 and footnotes)

habitual: *gewöhlichen.* Of the nature of a habit; usual. (§195)

harmful, detrimental: *schädlich.* See **detrimental.**

heal, cure: *heilen.* See **cure.**

healing, curative, medical, therapeutic: *Heil-.* See **curative.**

health: *Gesundheit* [soundness]. Soundness; freedom from disease or abnormality; a condition of optimal well-being or functioning. Hahnemann uses two words to refer to health: *Gesundheit,* translated as health (§12) and *Wohlseyn,* translated as well-being (§120). *Gesundheit* refers more to objective indications of health while *Wohlseyn* is more subjective. The *Organon* presents three models of ideal health in terms of the three spheres of feeling, thinking and willing. The patient in perfect health is a depiction of healthy feeling (i.e., the focus is upon healthy feelings, functions and sensations, §9); the self-proving physician is a depiction of healthy thinking (§141); and the mesmerist who possesses great good nature and a powerful will is a depiction of the healthy will (§288). [Resource: SRD]

help, aid, auxiliary: *Hülfs-* [help]. 1. Giving assistance or support; helping, as helpful means (p. 36). 2. Acting as a subsidiary; supplementary, as auxiliary sciences (p. 9).

heroic: *heroisch.* Unusually powerful. (§74, §121)

herpes: *Flechte.* An eruption of vesicles in small distinct clusters, accompanied with itching or tingling, including shingles (herpes zoster), ringworm, etc. This term was applied to several cutaneous eruptions, from their tendency to spread or creep from one part of the skin to another. (§46)

heterogenic: *heterogen* [from GREEK *heteros*, other + *genos*, type, kind]. Of unlike natures; composed of unlike substances; heterogeneous. Opposite of homogeneous. (p. 25, *fn* 22)

heteropathic: *heteropathisch* [from GREEK *heteros*, other + *pathos*, disease, suffering]. Treatment of disease by administration of medicines that produce symptoms in healthy individuals which differ from those of the disease being treated; allopathic. (§52)

Hippocrates [ca. 460–375 B.C.]. Greek physician referred to as the father of medicine because he was the first person in the Western medical tradition to record his medical experiences for future reference. (p. 8)

hit upon: *treffen.* To encounter; to light upon. (§192, p. 270)

homeopathic aggravation: *homöopathische Verschlimmerung.* See **aggravation.**

homeopathy: *Homöopathie* [from GREEK *homoios*, like + *pathos*, disease, suffering]. The medical art and science, developed by Samuel Hahnemann, which is based upon the cure of the totality of symptoms in a disease by means of medicines and treatments capable of producing symptoms in healthy individuals which are similar to those of the disease itself. In §24, Hahnemann states that, in homeopathy, a medicine is sought for the totality of symptoms of the disease case, with regard for the originating cause and for the accessory circumstances, which (among all medicines whose condition-altering abilities are known from having been tested in healthy individuals) has the power and the tendency to engender the artificial disease state most similar to that of the case of disease in question.

homeostasis: *Gleichgewicht* [equal weight]. The ability or tendency of an organism or a cell to maintain internal equilibrium by adjusting its physiological processes. (§289)

homogenic: *homogen* [from GREEK *homoios,* like + *genos,* type, kind]. Of the same kind, nature or character; congruous; homogeneous. Opposite of heterogenic. (p. 11)

human: *Mensch-, menschlich.* Of, or relating to, human beings. 'Human beings,' 'humanity,' 'individuals' and 'people' are various translations of *Menschen.* 'Persons' is translated from *Personen.* (§32)

human condition: *Menschenbefinden.* See **condition.**

hyperphysical: *hyperphysisch.* Beyond or outside the realm of the physical. (*fn* 31)

hypochondria: *Hypochondrie.* A condition marked by various psychological and somatic symptoms, so named because hypochondriacs typically have an uneasy sensation in the hypochondrium (especially in the area of the spleen). Hypochondria is characterized by extreme increase in sensibility, palpitations, illusions of the senses, panic attacks, disordered digestions, and a succession of morbid feelings which appear to stimulate various symptoms of disease. Hypochondriacs experience exaggerated uneasiness of various kinds, especially with regard to their health. (*fn* 81b, *fn* 232)

hypochondrium: *Hypochondern* [from GREEK *hypo,* less than, below + *chondros,* cartilage]. That part of the abdomen just below the lower ribs, on each side of the epigastrium. (p. 41)

hysteria: *Hysterie* [from GREEK *hustera,* womb]. 1. An affection characterized by both psychological and somatic symptoms, so named because it was believed to have its seat in the uterus. Hysteria is seen more frequently in women, but also in men. It generally occurs in paroxysms, principally characterized by alternate fits of laughing and crying with a sensation as if a ball were ascending from the hypogastrium towards the stomach, chest and neck, producing a sense of strangulation. Violent attacks can be accompanied by loss of consciousness and convulsions. (*fn* 81b)

idem [LATIN]. The same. (p. 52)

idiosyncrasies: *Idiosyncrasien* [from GREEK *idios,* personal, private + *sunkrasis,* comixture, temperament]. Cases involving an individual with a physiological or temperamental peculiarity; individuals who have an uncommon, morbid reaction to a particular substance. (§117)

ill-being: *Uebelseyn.* A state of being diseased. Opposite of well-being. (§48)

illness: *Erkrankung* [becoming ill]. Disease, poor health. (p. 8, §117)

image: *Bild.* Picture; accurate representation. (§7, §102)

imbecility: *Blödsinn.* Moderate to severe mental retardation describing a mental age of from three to seven years. Generally involves the capacity for some degree of communication and performance of simple tasks under supervision. The term belongs to a classification system no longer in use. (§80)

imperforate anus: *verwachsener After* [grown-together anus]. An anus that is closed, without an opening. (*fn* 7a)

impinge: *einwirken* [in-work]. Work into; encroach upon; make inroads into. In this text, 'to impinge upon' [from LATIN *impingere*, to fix, drive in] means to have initial superficial contact with something, followed by a thrusting, driving or penetration into it. *Einwirkung* is translated both as 'impingement' and as 'impinging action.' (§16, §66, §108)

impotence: *Impotenz.* Want of vigor with an inability to engage in sexual intercourse, often due to an inability to achieve or sustain an erection. (§80)

impression: *Eindruck.* An effect produced by an external force or influence upon the mind; a dynamic action or effect produced by an external potence upon the life force. In §64, Hahnemann states that in a proving, "during the initial action of artificial disease potences (medicines) upon our healthy body, our life force appears to comport itself only conceptively (receptively, passively as it were) and appears as if it were forced to allow the impressions of the artificial potence impinging from without to occur in itself, thereby modifying its condition." In §275, he refers to the impression that too-strong doses of homeopathic medicine make upon the life force.

 Eindruck has an aesthetic connotation which is conveyed in the expressions 'first impression' and 'artistic impression.' Specifically, impressions are made upon the life force organized in the emotional mind (the *Gemüt*), which is the aesthetic faculty.

 In discussing the earliest indications of a patient's amelioration or aggravation, Hahnemann gives examples of mental and emotional

alterations which are easily seen if one observes with exact attentiveness, but which cannot be easily described in words. In §253, he states, "When there is an ever-so-slight beginning of improvement, the patient will demonstrate a greater degree of comfort, increasing composure, freedom of spirit, increased courage — a kind of returning naturalness. When there is an ever-so-slight beginning of aggravation, the patient will demonstrate the opposite of this, exhibiting a more self-conscious, more helpless state of emotional mind, of the spirit, of the whole behavior and of all attitudes, positions and performances — a state which draws more pity to itself." These are all descriptions of changes in a patient's state which make an aesthetic impression upon the observer.

The observer's life force responds to impressions with responsions (i.e., dynamic, aesthetic responses involving the *Gemüt*). In the above example of aggravation, the observer's responsion is pity. Impressions and responsions are two aspects of participative experience which is the basis of all living knowledge (*kennen* and *erkennen*). [Resource: SRD] See also **knowledge, observe, partipation.**

improper: *ungehörig* [not belonging to]. Not suited to circumstances or needs; unsuitable. (§54)

indicator: *Hinweisung* [GERMAN], *Indication* [from LATIN *indicare*, to show, from *index*, forefinger, indicator]. That which serves as a reference, guide or pointer in choosing a remedy. In the Introduction (pp. 11, 22), Hahnemann discusses the old school's causal indicators, which were believed to point to both the cause of the disease and its treatment. What the old school physicians perceived to be the general character of the disease was deemed to be the causal indicator (e.g., cramp, debilitation, lack or excess of particular gases in the bodily fluids, etc.). Their accessory indicators were believed to provide further guidance in the choice of treatment. In §18, Hahnemann states that the only real cure-indicator is the complex of all the symptoms and circumstances perceived in each individual case of disease. Hahnemann uses the German and the Latin terms synonymously.

indifferent: *gleichgültig.* Of the same nature throughout; undifferentiated. (*fn* 69a)

indisposition: *Uebelbefinden* [malady-condition]. An indefinable and fairly superficial sense of ill-being. (§148)

individuals: *Menschen. See* **human.**

induce: *bestimmen.* To bring about or stimulate the occurrence of. (§74)

indwelling: *inwohnend.* Inhabiting or residing within as a spirit, force or principle. (§9, §21, §39, §117)

inexpedient, counterproductive: *unzweckmässig* [not according to purpose], *zweckwidrig* [contrary to purpose]. Inadvisable; inappropriate to a purpose. (§39, §72, §76).

infarct: *Infarct* [from LATIN *infarcire,* to cram or stuff in]. An obstruction occurring in any of a number of locations in the body. Hemorrhagic infarcts are obstructions of local blood supply, as by a thrombus or an embolus, resulting in necrosis in nearby tissue. Intestinal infarcts are obstructions of the intestines from the accumulation of feces. (p. 11)

infectious, contagious: *ansteckend, contagiös.* See **contagious.**

infertility: *Unfruchtbarkeit* [unfruitfulness]. The persistent inability to conceive a child. (§80)

influence: *Einfluß* [*ein,* in + *fluß,* flow, flux]. 1. Power to produce an effect on someone or something by imperceptible or intangible means. 2. Power to affect the nature, development, or condition of someone or something. (§11)

inimical: *feindlich.* Injurious or harmful in effect; adverse; hostile. (§11, §31)

initial action: *Erstwirkung* [first working]. An individual's first alteration in health, brought about by the impinging action upon the life force of an external potence, such as a medicinal or disease potence. While the initial action is primarily due to the impinging potence, it also partly belongs to the life force and is, in fact, a product of the impinging potence and the life force. In other writings, this is referred to as the primary action. (§59, §63-§66)

injury: *Verletzung.* Damage or harm done to or suffered by someone or something. (§187)

insanity: *Wahnsinn.* A severe mental or emotional disorder, such as a psychosis; a condition in which false conception or judgment, a

defective power of the will, or an uncontrollable violence of the emotions or instincts has been produced by disease. (§216)

in-see, realize: *einsehen.* See **realize**.

insensible: *unempfindlich.* Lacking sensibility. (§57, §69) See **sensibility**.

instinctual: *instinktartig.* Pertaining to, involved with, or depending upon instinct, an innate capability not involving intellect. (p. 70, §148)

insufferable: *unleidlich.* Difficult or impossible to endure; intolerable. (§96, *fn* 96)

intellect: *Verstand.* In the German language, a distinction is made between intellect (*Verstand,* §126) and reason or rational thought (*Vernunft,* §229). The intellect is that faculty concerned with analysis and discrimination while reason is concerned with the synthesis of ideas, the combination of thesis and antithesis whereby a new and higher level of truth is revealed.

intermittent, reciprocal: *wechsel.* See **reciprocal**.

invasive: *eingreifend* [ingripping]. Tending to invade, intrude or encroach upon. (§207)

inverted: *umgekehrt* [turned around]. Reversed; back to front, consequently contrary to reason and common sense. (§56)

investigate, fathom: *erforschen.* To make a detailed inquiry or systematic examination in order to penetrate the meaning or nature of something. (§71)

irritable, stimulable: *reizbar* [GERMAN], *irritabel* [from LATIN]. **1.** Capable, on a sensorial level, of responding to stimuli, as compared to sensibility which involves conscious response to stimuli in addition to sensorial response. All living tissue is irritable to a certain degree in that it can feel and respond to a stimulus (§113, §291). **2.** Abnormally sensitive, either sensorially or emotionally (§290).

irritant: *Reiz.* Any agent which induces or gives rise to irritation or pain, heat and tension. Irritants may act dynamically (Hahnemann defines diseases as mistuning irritants, §70), mechanically (as with a puncture or scarification), chemically (as with alkalies and acids) or in a specific manner (as with cantharides). (p. 26)

irritation: *Reiz, Gereiztheit.* A condition of excessive irritability of a bodily organ or part produced by an irritant. The tissues are over-

stimulated, resulting in a breakdown of orderly functioning and inflammation. (§30, *fn* 74a)

isopathy: *Isopathie* [from GREEK *isos,* equal + *pathos,* disease, suffering]. A method of treating a disease using a producer or product of the disease (e.g., the use of a medicine made from a particular poison to treat a person who has ingested that poison, or the use of a medicine made from poison ivy to treat a case of poison ivy).

Isopathy was promulgated by several physicians who were contemporaries of Hahnemann, including Magister Wilhelm Lux, a German veterinary surgeon to whom Hahnemann refers in *fn* 36 of the Introduction (pp. 52-54). The mode of treatment advocated by Lux and others represents a clear deviation from Hahnemann's teachings in two major ways: *a.* the effects of the isopathic medicines were not known in that they were not proven on healthy individuals to determine the full set of medicinal symptoms they were capable of producing, and *b.* no careful consideration was given to the individuality of the patient's case; medicines were simply prescribed based on the presumed identical nature of the medicine and the disease. Hahnemann points out, however, that in making a potentized medicine from any substance, the nature of the substance is necessarily changed. Hahnemann had already established this with medicines such as Lycopodium (made from spores of club moss), Aurum metallicum (made from gold) and Natrum muriaticum (made from table salt); these substances were not effective as medicines until they were transformed by the processes of trituration, dilution and succussion. In the same way, a substance involved in the reproduction or transmission of a disease is changed by the process of potentization which develops its inherent medicinal powers. Therefore, a potentized medicine made from such a substance (e.g., Psorinum, Tuberculinum, or a remedy made from HIV-infected blood) is no longer identical to the unpotentized substance. If the medicine is curative in a particular case of disease, it is because it is homeopathic, not isopathic, to the disease. Hahnemann refers favorably to the term 'isopathy' as used by the author of *The Isopathy of Contagions* (p. 54).

itch diathesis: *Krätze* [scratch]. A psoric disease which infects the entire individual and is characterized by itching and scabby or scaly eruptions. Hahnemann identified the itch diathesis as the primary manifestation of psora. The manifold secondary manifestations of psora may or may not include skin symptoms. In Hahnemann's time, the itch diathesis was sometimes referred to as scabies; however, the definition for scabies at that time was very different from its current definition; it covered many other affections besides the one now known as scabies (i.e., the highly communicable skin disease caused by the arachnid *sarcoptes scabiei*, the itch mite, which is transmitted by direct contact with infected persons). 'Diathesis' is defined as a permanent (hereditary or acquired) condition of the body which renders it liable to certain special diseases or affections; therefore, 'itch diathesis' aptly fits Hahnemann's description of *Krätze*. (§38-§40)

jaundice: *Gelbsucht* [yellow sickness]. A diseased condition whose principle symptom is yellowness of the skin and eyes, with white feces and highly colored urine. (§80)

juices, bodily fluids: *Säfte*. See **bodily fluids.**

kidney stone: *Nierenstein*. Calculus or crystalline mass present in the pelvis of the kidney, varying in size from a small granular mass to one which is one inch or more in diameter. (§80)

kind, manner, mode: *Art*. See **mode.**

know: *kennen*. To have knowledge based on participative experience as opposed to knowledge gained from books, lectures or study. (§3) See **knowledge.**

knowledge. Hahnemann uses various terms to refer to different modes of knowledge: **To be aware:** *wissen* [to wit]. To have intellectual awareness, discursive cognition, such as that knowledge gained from books, lectures or scientific study. *Wissen* has both a cognitive and a perceptive component; it involves the senses and the brain (as spectators rather than as participators). Specifically, *wissen* refers to cognition based upon perception. The German word for science is *Wissenschaft*. (§3, §4, §99) **To know:** *kennen* [to ken]. To have deep personal knowledge, such as that based on life experience, specifically that part of life experience that cannot be conveyed to another

person through teaching or demonstration. For example, the difference between *wissen* and *kennen* is the difference between knowing about water from reading about it and studying it scientifically versus knowing from having dived into lakes, waded in streams and walked in the rain. *Kennen* has an aesthetic component which is absent in *wissen*. Through direct experience, one receives an impression about something and has a reponse to it. The differentiation between these two basic kinds of knowing (*wissen* and *kennen*) is found in the Latin languages as well; for example, in the words *savoir* and *connaitre* in French; *saber* and *connocer* in Spanish — the former referring to knowledge of facts and acquaintance with ideas; the latter referring to experiential or participative knowledge of a person, thing or situation. (§3, §4, §52) **To discern:** *erkennen.* The terms *kennen* and *erkennen* both refer to personal knowledge gained from participative experience. *Erkennen* is the higher of the two, referring to a level of knowledge that is raised out of the feeling, aesthetic realm into that of pure thought. It is the purest, deepest, most complete form of knowledge. This is the basis, for example, of artistic knowledge. Hahnemann uses *erkennen* to describe the knowledge gained by doing provings of medicines on oneself. (§3, §6, §11) [Resource: SRD] See also **participation**.

kyphosis: *Kyphosis* [GREEK, humpback]. Exaggeration or angulation of the normal posterior curve of the thoracic spine. Gives rise to the condition commonly known as hunchback or Pott's curvature. (§80)

lachrymal: *Thränen-* [tears]. Pertaining to the tears. (p. 17)

languor: *Trägheit* [inertia]. Lack of physical or mental energy; listlessness. (§97)

lassitude: *Mattigkeit* [dullness]. Lusterlessness; a state or feeling of weariness, diminished energy or listlessness. (§153)

lasting: *bleibend* [remaining]. Enduring; permanent. (*fn* 69a, §198)

learn, experience: *erfahren.* To gain knowledge through experience. (§108)

lege artis [LATIN]. Read with cunning or skill [a command]. (p. 47)

leukophlegmasia: *Leucophlegmasia* [from GREEK *leukos,* white + *phlegm,* phlegm]. A disease, defined in old medical terms as a drop-

sical condition denoted by a pale, tumid and flabby condition of the body; a kind of dropsy in which white phlegm rises throughout the body, making the flesh spongy. Alternately defined as a condition of inflammation and hardness of the tissues, not due to dropsy. (p. 16)

leukorrhea: *Leucorrhöe* [from GREEK *leukos*, white + *rhoia*, flow]. Mucous discharge from the cervical canal or vagina, which usually is white or yellow. (*fn* 81b)

life energy: *Lebens-Energie.* See **life force**.

life force: *Lebenskraft* [*Lebens*, life + *kraft*, force, power, energy]. That force/power/energy which enlivens the material organism. In health, the spirit-like life force that enlivens the material organism as dynamis, governs without restriction and keeps all parts of the organism in admirable, harmonious, vital operation, as regards both feelings and functions, so that our indwelling, rational spirit can freely avail itself of this living, healthy instrument for the higher purposes of our existence (§9). The diseased life force imparts to the organism the adverse sensations and irregular functions that we call disease (§11). The life force and the material organism are an indivisible whole; they are one and the same, although in thought, we split this unity into two concepts in order to conceptualize it more easily (§15). The life force is the human wesen or an aspect of it (see **wesen**), which is one of two supersensible presences of the human being, the other being the human spirit (which is not a wesen).

Throughout the *Organon*, Hahnemann uses several terms in reference to the life force. These include: 'dynamis' (*Dynamis*, §9), 'life energy' (*Lebens-Energie*, §72), 'life force' (*Lebenskraft*, §10), and 'life principle' (*Lebensprincip*, §11). In certain contexts (primarily in the Introduction) Hahnemann also uses the terms 'nature' (p. 25) and 'the life' (p. 22, §283) to refer specifically to the life force. In the fifth edition of the *Organon,* Hahnemann used the terms 'life force,' 'dynamis' and 'nature.' In the changes and additions made for the sixth edition, he added the terms 'life principle,' and 'life energy.' In almost all additions to the sixth edition, Hahnemann preferred to use the term 'life principle.'

Hahnemann uses other terms in connection with the life force. These include 'the sustentive power of life' (*Lebens-Erhaltungskraft,*

§63), 'the sustentive drive of life' (*Lebens-Erhaltungstrieb*, §262), 'nature-power' (*Natur-Kraft*, p. 32, §288) and 'the energy activity of the organism' (§156).

In the Index, references to the life force, by any name, are detailed under 'life force/energy/power.' In addition, references to the life force by a name other than *Lebenskraft* are listed separately (under 'Dynamis,' 'Life energy,' 'Life principle,' 'Nature,' 'Nature-power,' 'Sustentive drive of life,' and 'Sustentive power of life').

life principle: *Lebensprincip.* See **life force.**

lifestyle: *Lebensweise.* See **regimen.**

lift: *heben, aufheben.* See **remove.**

living habits: *Lebensordnung.* See **regimen.**

LM. See **fifty-millesimal potencies.**

local: *örtlich* [GERMAN], *local* [from LATIN *locus*, place]. A local malady (*Local-Uebel*) is one whose chief symptom is external and limited to one part of the body. Truly local diseases are those which do not involve the whole organism, such as trivial injuries. Most so-called local diseases are not local; they are one-sided diseases with a principal symptom which is external (§185-188). *Local* and *örtlich* are synonymous. Hahnemann uses both words in the following statement (§186): "These maladies were considered to be merely local (*örtlich*) and therefore they were called local maladies (*Local-Uebel*)."

long-lasting, protracted: *langwierig, langdauernd.* See **protracted.**

lubricious: *schlüpfrig* [slippery]. **1.** Having a slippery or smooth quality. **2.** Shifty or tricky. **3.** Lewd; wanton. **4.** Sexually stimulating; salacious. (*fn* 260)

lysis: *Lysis* [GREEK, dissolution]. The gradual decline of a fever or disease. Opposite of crisis. (p. 26)

maggots: *Madenwürmer.* See **worms.**

maintain: *unterhalten* [under-hold, hold up from below]. **1.** To keep in an existing state; preserve or sustain. **2.** To keep up or carry on; continue. (§4, §94)

maintaining cause: *unterhaltende Ursache.* A maintaining cause of disease is a factor which is responsible for the continuation of the disease, acting as an obstacle to cure. Examples given by Hahnemann include external factors (e.g., a foreign body in the eye, a too-tight

bandage, poisons that have been swallowed) as well as physiological ones (e.g., imperforate anus, bladder stones). Circumstances which act as maintaining causes include such things as bad living conditions and stressful relationships. (§7, *fn* 7a)

makeup, quality: *Beschaffenheit.* See **quality.**

malady: *Uebel.* [Illness, evil]. *Uebel* is one of several words used by Hahnemann to refer to disease. Because *Uebel* has two meanings — 'disease' and 'evil' — it has been translated with the term 'malady' which has the Latin root *mal,* meaning bad (as in malicious, malignant). (§136, §148)

malignities: *Schädlickeiten* [harmfulnesses, from *schaden,* to harm, to damage]. Noxious or harmful factors; noxae. (*fn* 22)

mania: *Manie* [from GREEK *mania,* madness]. Mental derangement characterized by great excitement, extravagant delusions and hallucinations and, in its acute stage, great violence. (§38, §213)

manifestation, expression: *Aeußerung* [utterance]. The act of giving voice to. Hahnemann's use of the term *Aeußerung* conveys his point that the life force expresses or gives voice to its internal disease by means of signs and symptoms, disease manifestations. (§12, §20)

manifold: *vielfältig, mannigfach.* 1. Many and varied; of many kinds. 2. Having many features or forms. (§62, *fn* 232)

manner, mode, kind: *Art.* See **mode.**

materia medica: *Materia medica* [LATIN]. A pharmacological text; a reference book containing a list of medicines and their uses. (§110)

materia peccans [LATIN, offending matter]. Noxious matter believed by the old school of medicine to be the cause of disease. (*fn* 13)

material, matter, substance: *Materie, Materiell, Stoff, Substanz.* Something that occupies space and can be perceived by one or more of the senses. Depending on context, *Materie* and *Materiell* have been translated as 'matter' or 'material;' *Stoff* has been translated as 'matter' or 'substance,' and *Substanz* has been translated as 'substance.' (*fn* 11, §70, §148)

matter, material, substance: *Materie, Materiell, Stoff, Substanz.* See **material.**

means: *Mittel.* 1. A medicine or other treatment or regimen intended to cure a disease. 2. Any treatment intended to remedy a situation.

Hahnemann makes reference to many kinds of means (e.g., helping means, pain means, emetic means, allopathic means). *Heilmittel* (literally, cure-means) is translated as either 'remedy' or 'curative means.' (§55)

measles: *Masern.* An acute, contagious disease, usually occurring in childhood and characterized by the eruption of red spots on the skin, a fever, and catarrhal symptoms. Also known as rubeola. Hahnemann identified measles as an acute miasm. (§73)

medical, curative, healing, therapeutic: *Heil-.* See **curative.**

medical art: *Heilkunst* [*Heil,* to heal or to cure + *Kunst,* art]. The art of the cure and prevention of disease, by means of medicines and other therapeutic treatments, regimen, and the removal of obstacles to cure. (§25, *fn* 60) See also **art.**

medical-art practitioner: *Heilkünstler.* Medical artist. Hahnemann uses the term *Heilkünstler* (§3) to distinguish true practitioners of the medical art from ordinary adherents of the old school of medicine. He uses the term physician (*Arzt,* §5) to refer to medical practitioners in general. See also **art.**

medication: *Arzneimittel* [medicinal means]. A medicine; a medicament. (*fn* 269a)

medicine: *Arznei.* Any substance that possesses the power to alter a person's state of health. Remedies are those medicines which are curative. (§19)

melancholia: *Melancholie* [from GREEK *melankholia,* sadness]. A variety of mental alienation, characterized by excessive gloom, mistrust and depression, sometimes focused upon one subject or train of ideas, or upon a few subjects. (§216, §224)

melicera: *Honig-Geschwulst* [honey tumor]. Cyst containing matter of honeylike consistency. (p. 17)

mental: *Geistes-.* Where *Geist* appears alone, it is translated as 'spirit'; however, for ease of reading, expressions linking *Geist* and *Gemüt* (such as those discussed below) have been translated with 'mental' and 'emotional.' **Mental and emotional disease:** *Geistes- und Gemüths-Krankheit.* Mental and emotional diseases can be either ideogenic (originating in the spirit) or miasmatic, first manifesting in the body and then becoming one-sided diseases of the mind or emo-

tions. Hahnemann refers to both 'mental *and* emotional disease' (§218) and 'mental *or* emotional disease' (§224). **Mental and emotional organs:** *Geistes- und Gemuths-Organe.* In §215 and §216, Hahnemann refers to the mental and emotional organs, which he describes as almost spiritual (i.e., supersensible). This is a reference to organs which appertain to the spirit (*Geist*) and the emotional mind (*Gemüt*); it does not mean that the *Geist* and the *Gemüt* are organs. **Mental or emotional state:** *Geistes- oder Gemüths-Zustand.* State of the spirit or the emotional mind. (§88) See also **spirit, emotion.**

mercurialia [LATIN]. Mercurials; medicines made from mercury, which is a silvery-white poisonous metallic element, also called quicksilver. (p. 40)

mesmerism: *Mesmerism.* A therapy developed by the German physician, F. Anton Mesmer (1734-1815). Mesmer sought to treat disease through animal magnetism, a method of transferring vitality from one person to another. A variety of methods were developed, chief of which involved using the hands to stroke down a person's body without touching it. These were called 'magnetic passes' and from this comes the rubric in homeopathic medical repertories, 'desires to be magnetized,' describing those people who found this pleasurable or relieving of their discomfort, and who wanted the procedure to be frequently performed. Mesmer postulated that vitality could be accumulated in certain materials such as water, iron or silk and from these 'charged' materials the accumulated vitality could be used by people deficient in life force. Eventually Mesmer conceived of this energy as something universal which came from outside the earth (as from the planets) and which was a universal matrix supplying energy to all living beings. Despite numerous reports of cure, Mesmer's findings were rejected by scientists of his time, and he was considered to be a fraud. With the later development of hypnotism, Mesmer's therapeutic approach (which involved trance states) was further trivialized in that it was suggested and assumed that the therapeutic effects achieved with mesmerism were no more than a form of suggestion or hypnotism. (§288-§289)

metaschematism: *Metaschematism* [from GREEK *metaschematismus*, to change the form of]. A change of the form of a disease, as when expectoration of blood follows the suppression of menses. (p. 18)

metastases: *Metastasen* [from GREEK *meta*, after, beyond, over + *stasis*, stand]. Change in location of the manifestations of a disease; transfer of disease manifestations from one organ or part to another not directly connected. Hahnemann discusses metastases which are induced by allopathic medicines and also those which are induced by the diseased life force in an attempt to preserve more vital organs. (*fn* 201)

meteoric: *meteorish* [from GREEK *meteorizein*, to raise up]. Of or relating to the earth's atmosphere or the heavens. (§73)

miasm: *Miasm* [from GREEK *miasma*, taint, stain, pollution]. An acute or chronic disease which is infectious and which is invariable as to its wesen. In other words, the disease's essential *esse* (the dynamic, self-subsisting presence which is the disease) is invariable. Miasms are collective diseases in that everyone who manifests the disease (in whatever form) has the same disease. This is also true of the uniquely-occurring epidemic diseases (e.g., the various epidemic outbreaks of different kinds of influenza); everyone in a given epidemic outbreak suffers from the one and the same disease, even if their symptoms differ. The difference between the uniquely-occurring epidemic diseases and the miasms is that the wesen of each separate uniquely-occurring epidemic disease is different from every other one that occurred previous to it; no two such epidemics are exactly alike. The wesen of a miasm, on the other hand, always remains the same. This is true both of the acute miasms (e.g., the measles) whose disease manifestations are limited and fairly invariable, and the chronic miasms (e.g., psora) whose disease manifestations are numerous and vary greatly; all miasms, no matter how variable or how fixed their disease manifestations, always remain the same as to their wesen.

Hahnemann compares the acute miasms with the uniquely-occurring epidemic diseases in §100, in which he states that "each reigning epidemic is in many regards a phenomenon of a particular kind that is found, by exact investigation, to deviate greatly from all former epidemics (which have been falsely labeled with certain

names). This is true of all contagious diseases except those that stem from an invariable infectious tinder, such as smallpox, measles, etc." In other words, uniquely-occurring epidemic diseases are acute collective diseases which reign for a greater or lesser period of time, but when a given collective outbreak has completely died out, it does not recur. Acute miasms, on the other hand, are epidemic diseases which do recur in completely separate outbreaks.

Hahnemann compares the chronic miasms with the uniquely-occurring collective diseases in §103, in which he states, "Just like the mostly acute epidemics, the chronic wasting sicknesses remain the same as to their wesen. Just as I did with the epidemics, I had to investigate the chronic wasting sicknesses (namely and principally psora) much more exactly than ever before. I had to do this because of the extent of the symptoms in these chronic diseases and also because one patient carries only a part of the symptoms in himself, while a second or third patient, etc. suffers from some other befallments which likewise, as it were, are only a part torn off from the totality of the symptoms that make up the entire extent of the one and the same disease. Therefore, the complex of all the symptoms belonging to such a miasmatic wasting sickness (in particular, psora) can only be ascertained from *very many* such individual chronic patients." In other words, the chronic miasms are also collective diseases, however, they are a kind of pandemic of the largest magnitude; they have spread worldwide and have continued in the population for many centuries instead of being limited to particular outbreaks.

While the wesen of a chronic miasm remains invariable, the forms in which the disease manifests are numerous; manifestations of psora are innumerable. In *The Chronic Diseases* (p. 8), Hahnemann states, "Thousands of tedious ailments of humanity are the true descendents of many-formed psora alone; they are merely descendents of one and the same vast original malady." In §81, Hahnemann remarks that it is "understandable how psora could now unfold itself in so many countless disease forms in all the human race since this age-old infectious tinder has gone, little by little, through many millions of human organisms over the course of hundreds of generations, thus attaining an incredible proliferation." This suggests

some kind of pleomorphic mutation (i.e., the disease has various characteristic embodiments over time) but the disease wesen remains the same. In *The Chronic Diseases* (pp. 10-12) Hahnemann indicates that some such mutation has taken place with regard to the manifestation of psora. He indicates that psora began primarily as an itching eruption of the skin; it then manifested primarily as leprosy which was a further development of this skin condition, and was still characterized by a violent itch; it later (with suppression) became less a skin condition and more an internal itch diathesis with secondary manifestations of great variety.

All miasms, whether acute or chronic, can be described in terms of four stages of development (*The Chronic Diseases*, pp. 39, 97). Hahnemann describes these stages as follows:

Infection — Infection happens dynamically and in a moment. In the first moment of infection, the miasmatic disease no longer remains local. The nerve which was first affected by the miasm has already communicated it in an invisible, dynamic manner to the nerves of the rest of the body.

Development of the infection — The living organism has at once, all unperceived, been so penetrated by this specific excitation that it is compelled to appropriate this miasm gradually to itself until the whole being is permeated with the miasm. The tinder of infection develops and becomes a general disease of the entire organism over the course of several days.

Appearance of the primary symptom — The primary local symptom breaks forth only after the complete internal development of the disease in the whole person, at which point the diseased life force endeavors to alleviate and soothe the internal malady through the establishment of a suitable local symptom. The primary symptom serves to divert and palliate the internal disease, delaying the outbreak of secondary ailments. As the internal disease increases, so must the corresponding primary symptom, in order to keep the internal malady latent.

Appearance of secondary symptoms — Expulsion of the primary symptom, by any means, will result in the development of secondary symptoms by the life force. For example, suppression of the

psoric itch eruption may result in any of a wide variety of secondary disease manifestations (discussed by Hahnemann in §80 and more fully enumerated in *The Chronic Diseases*).

The acute and chronic miasms differ in that acute miasmatic diseases finish relatively quickly, but once a person has been infected with a chronic miasm, the disease continues unless it is cured with homeopathic medicines specific to it. Also, a chronic miasm can be inherited from a person who has been infected, as well as from a person who has inherited the disease. In this way, the chronic miasm may continue for generations. See also **acute miasm, chronic miasm, disease.**

migraine: *Migräne* [from GREEK *hemikrania,* half skull]. Headaches affecting one half of the head, also known as hemicrania. (§80)

miliary fever: *Purpurfriesel.* See **purpura miliaris.**

minister naturae [LATIN]. Helper of nature. (p. 33)

mistunement: *Verstimmung.* See **tunement.**

mode, manner, kind: *Art.* A manner, way, or method of doing something; the way in which a thing is done or happens. In *fn* 26, Hahnemann gives examples of things which are similar in their manifestations and actions but which have different modes. Index listings under 'Mode' only include Hahnemann's use of the term; more complete listings appear under the names of the various modes, e.g., homeopathic, allopathic, etc.

mold, established practice: *Leisten* [last, such as a shoemaker uses to make a particular size of shoe]. A fixed or restrictive pattern or form. (*fn* 60, *fn* 73a, *fn* 81b)

mood, tunement, pitch: *Stimmung.* See **tunement.**

moral: *moralisch* [from LATIN *moralis,* custom]. Of or pertaining to certain beliefs and customs, especially those concerning the distinction between right and wrong, good and evil, in relation to the actions, volitions or character of responsible beings. In *fn* 17a, Hahnemann refers to artificial deception and persuasion as moral remedies. These are remedies that directly address a person's beliefs. In *fn* 26, Hahnemann makes a distinction between moral maladies and physical affections, moral maladies being those that arise from a person's false beliefs. Hahnemann also connects 'moral' with false

beliefs in §224, where he refers to perverted morality, along with faulty upbringing, bad habits, neglect of the spirit, superstitions and ignorance as sources of that kind of mental illness which is spun and maintained by the soul. When Hahnemann refers to moral diseases, he often uses the word *Uebel* (translated here as malady) which means both evil and disease.

morbid, diseased: *krankhaft* [sickly]. Pertaining to disease; pathological. (§8, §11, §31)

morbific: *krankmachend* [sick-making]. Disease producing. (§11)

mortification: *Kränkung.* A feeling of wounded pride, shame or humiliation. (§225)

moxa: *Moxa* [JAPANESE]. Mugwort (artemesia), a soft combustible substance which is burned on or above the skin. Moxa continues to be used in Oriental medicine. An extremely small amount may be burned on the skin or on the tops of acupuncture needles for the purpose of stimulating, or increasing the stimulation to, a particular acupuncture point. Old school physicians used moxa in much larger amounts, burned directly on the skin, as a cautery or counter-irritant. (p. 26)

mucilage: *Schleim* [mucous]. The gummy part of plant sap. (*fn* 267b)

narcotic: *narcotisch* [from GREEK *narkotikos,* benumbing]. Pertaining to medicinal substances whose initial action is sedative and pain-reducing. (§113-§114)

nature: *Natur* [from LATIN *natura,* to be born]. 1. The material world and its phenomena (§39). 2. The forces and processes that produce and control all the phenomena of the material world, as in the laws of nature (§34). 3. The fundamental character or disposition of someone or something (§41). 4. The life force. In the Introduction, Hahnemann uses the terms 'nature,' 'crude nature' and 'nature-power' to refer specifically to the life force (pp. 25, 32). See also **life force.**

neoplasm: *Afterorganisation.* A new and abnormal formation of tissue, such as a tumor or growth which may be either benign or malignant. (§80)

nerve fever: *Nervenfieber.* A typhus fever. (p. 41) See **typhus.**

nervina [LATIN]. Medicines which act on the nervous system, and which were used by the old school of medicine to treat conditions attributed to the nerves. (p. 39)

neutralize: *indifferenzieren, neutralisiren.* 1. To render ineffective; to counteract the effect of (p. 26, §69). 2. *Chemistry:* To cause (an acid or a base) to undergo neutralization, rendering it neither acidic nor alkaline (*fn* 69a).

noble: *edel.* A noble organ is an important or vital organ. (§216)

non plus ultra [LATIN, no more beyond]. The ultimate; representing or exhibiting the greatest possible development or sophistication.

nosologist: *Nosologe* [from GREEK *nosos*, disease + *logos*, word, reason]. A practitioner of the science of description or classification of diseases. (p. 20)

observe: *beobachten.* 1. To take notice of something or someone, both scientifically and aesthetically (§83). 2. To act in conformity with, as observing a code of conduct (§228). Observation involves both perception and participation, both seeing and beholding. For example, a case-taker uses the senses to observe a patient — looking, listening, smelling, etc. and also receives an impression of the patient and has a reponse to that impression. The case-taker's impression and responsion are a part of the observation of the patient. [Resource: SRD] See also **impression, participation.**

obstacle to cure: *Hinderniss der Heilung.* Something that stands in the way or hinders progress towards cure, that is, towards the total annihilation of disease. (§260)

obstacle to recovery: *Hinderniss der Genesung.* Something that hinders the process of recovery from a disease or an injury. (§3)

occasion: *Veranlassung* [on-letting]. Something that brings on or occasions a condition or event. Other writers and translators have referred to this as the exciting cause of disease; however, the German word *Veranlassung* indicates neither excitation nor cause. The term refers to situations, not to agency. Hahnemann reserves the term 'cause' (*Ursache*) primarily for the fundamental cause of disease and for diseases caused by prolonged, violent allopathic treatments. Only once in the *Organon* (§7) does Hahnemann refer to the occa-

sioning cause (*veranlassende Ursache, causa occasionalis*). In all other instances, he refers simply to the occasion of disease. (§5)

odd: *eigenheitlich.* See **strange, rare and peculiar.**

olfaction: *Riechen* [to smell]. A method of administering homeopathic remedies by sniffing or inhalation through the nose. (§284)

onanism: *Onanism* [after Onan, son of Judah (Genesis 38:9), who spilled his semen on the ground]. 1. Masturbation. 2. Coitus interruptus. (*fn* 93, *fn* 260)

one-sided disease: *einseitige Krankeit.* A disease in which only one or two main symptoms stand out so that the other symptoms of the disease are almost completely obscured; the disease is focused in certain main symptoms while the other symptoms are not perceptible. Hahnemann indicates that true cases of one-sided disease are rare. (§173, §210, §216)

opium: *Mohnsaft* [poppy juice]. A bitter, yellowish-brown, strongly addictive narcotic drug prepared from the dried juice of unripe pods of the opium poppy. Morphine, codeine and papaverine are alkaloids of opium. (§57)

organic: *organisch.* Of or relating to the organism. (§201)

organism: *Organism.* An organized or organic system; a whole which consists of dependent and interdependent parts. The human organism is more than just the body; it is a living presence with properties (e.g., a material body), accomplishments (e.g., fending off malignities) and developmental capacity (e.g., the ability to become more seasoned through provings). The human organism houses the mental, emotional and bodily faculties. (§9, §11, §26) [Resource: SRD]

Organon: *Organon* [GREEK, instrument, bodily organ]. An instrument of thought or knowledge, especially a set of principles for use in scientific or philosophical investigation. (Aristotle entitled his collection of writings on logic *The Organon;* Francis Bacon entitled his work *The New Organon.*)

origin, source: *Ursprungs.* See **source.**

originating cause: *Entstehungs-Ursache* [arising cause]. That factor which is responsible for and productive of the origin and rise of something, its birth, genesis, emergence, generation, development, or formation. (p. 10, §24)

over-tune: *überstimmen.* See **tunement.**

palliative: *palliativ* [from LATIN *palliare*, to cloak or conceal]. Pertaining to medicines and other treatments which give superficial relief, temporarily alleviating symptoms without curing. Hahnemann equates the terms 'antipathic,' 'enantiopathic' and 'palliative' (§23). Throughout the *Organon,* he uses the terms 'antipathic' and 'palliative' interchangeably. (§56, §69, *fn* 67)

palsy, paralysis: *Lähmung* [laming]. Temporary or permanent loss of sensation, or loss of ability to move or to control movement. (§80, *fn* 81b)

paroxysm: *Paroxismus* [from GREEK *paroxunein,* to stimulate, irritate].
1. A sudden, periodic attack or recurrence of symptoms of a disease.
2. A sudden spasm or convulsion of any kind. (§115, §235, *fn* 235)

part, as in **partly** or **in part:** *theils.* Hahnemann uses this grammatical form to divide something into categories. These categories are usually exclusive of one another, but they are not necessarily exhaustive. For example, in §72 Hahnemann states that human diseases are in part acute and in part chronic; here, he does not discuss those protracted diseases which are not chronic. In §31, he refers to inimical potences as "partly psychical and partly physical," by which he means that a given potence has both a psychical and a physical component.

participation: *Theilnahme* [partaking]. The partaking of the substance, quality or nature of someone or something. One of the fullest forms of participation (also referred to as participation mystique) involves imaginative identification with people and things outside oneself, a merging of one's consciousness with that of another person, with a group or with the external world. This type of participation is characterized by the primary involvement of the life force. Hahnemann's references to 'pure experience' (§23, §25) and to 'the living holistic participation of the life principle' (§189) involve a level of participation akin to that of participation mystique.

For example, it is through participating observation that the medical-art practitioner takes the complete case, including not only the perceptible signs of disease but also the imperceptible (but discernable) state of the patient which is to some degree, but not entirely, exhibited in behavior. The medical-art practitioner takes

the case using both the sentient faculty (which includes the brain and the senses) and the aesthetic faculty (the *Gemüt*). In participating through one's life force, one receives an impression and has a responsion (i.e., a dynamic, aesthetic response to an impression). It is the life force organized in the *Gemüt* that takes this impression from an external potence and then has a responsion. When a genuine medical-art practitioner, who is free of bias, is taking a case, the practitioner's impressions and responsions are pure. They are in the realm of objective, not subjective, emotion.

Hahnemann gives two examples of such objective emotion. In §253, he states, "When there is an ever-so-slight beginning of aggravation, the patient will demonstrate the opposite of this, exhibiting a more self-conscious, more helpless state of emotional mind, of the spirit, of the whole behavior and of all attitudes, positions and actions — a state which draws more pity to itself." In §210, Hahnemann states, "One often encounters patients with the most painful, protracted diseases who have a mild, gentle emotional mind such that the medical-art practitioner feels impelled to bestow attention and sympathy upon them." In the first case, pity is the objective emotion, the responsion that the medical-art practitioner will have. In the second case, the medical-art practitioner feels objective sympathy.

Pure experience, involving participation while being free of bias, is the basis of *kennen* and *erkennen* (experiential knowledge and discernment). It is a key requirement in the practice of the medical-art practitioner which makes the difference between the mere science of medicine (based on *wissen*, intellectual awareness) and the medical art. [Resource: SRD] See also **art, experience, impression, knowledge.**

particular, peculiar, exceptional: *sonderlich.* See **strange, rare and peculiar.**

passion: *Leidenschaft.* 1. Any kind of feeling by which the mind is powerfully affected or moved; a vehement, commanding, or overpowering feeling, such as ambition, avarice, desire, sexual affection, hope, fear, love, hatred, joy, grief, anger, revenge. 2. An affection of the mind. 3. Activities or occupations in which one is dominated by powerful feelings. (§126, §156)

pathic: *pathisch* [from GREEK *pathos*, disease, suffering]. Pertaining to disease. (*fn* 22)

pathogenic: *pathogenisch* [from GREEK *pathos*, disease, suffering + *gennan*, to produce]. Productive of disease. (*fn* 269a)

peculiar: *eigenthümlich, sonderlich.* In certain contexts, 'peculiar' is translated from *eigenthümlich;* in others, it is translated from *sonderlich.* See **strange, rare and peculiar.**

penury: *karges Darben* [scanty want]. Extreme want or poverty; destitution. (*fn* 260)

people: *Menschen.* See **human.**

perceive: *wahrnehmen* [true-taking]. To become aware of directly through any of the senses. (§6, §20, §141)

permanent, enduring: *dauerhaft* [durative]. Durative; existing or continuing for a long time so as to seem fixed or established. (§2, §23, §27, §91)

persistent: *anhaltend.* Refusing to give up or let go; persevering obstinately. (§23, §59, §86)

persons: *Personen.* Living human beings. Hahnemann usually uses the word *Mensch-* to refer to human beings. In a few instances he uses *Personen.* 'Human beings,' 'humanity,' 'individuals' and 'people' are various translations of *Menschen;* 'persons' is the translation used for *Personen.* (§107)

pertinent: *gehörig.* See **appropriate.**

phlegmatic: *phlegmatisch* [from GREEK *phlegma*, human phlegm]. Sluggish, dull, heavy, not easily excited into action or passion; as a phlegmatic temper or temperament. (*fn* 213) See also **temper.**

physical: *physisch* [from GREEK *phusikos*, of nature]. 1. Of or according to the laws of nature, as the force of gravity is a physical fact. 2. Of, or produced by the forces of physics. 'Physical' does not mean 'material.' In the Introduction (p. 52), Hahnemann differentiates between the purely physical powers and the dynamic ones. He states that the purely physical powers (i.e., temperature, weight) are of a different nature than the dynamic medicinal ones in their impinging actions on the living organism. In §31, Hahnemann indicates that inimical potences (i.e., disease malignities) are partly psychical and partly physical. By this he means that a given inimical potence

has both a psychical and a physical aspect. Both aspects are non-material and supersensible; the physical aspect operates according to the laws of physics, while the psychical aspect is in the realm of the spirit, the soul and the emotional mind. See also **psychical**.

physician: *Arzt.* Medical doctor. See also **medical-art practitioner**.

physiological: *physiologisch.* Of or relating to physiology; pertaining to the bodily functioning of the organism. (*fn* 269a)

pitch, mood, tunement: *Stimmung.* See **tunement**.

placebo: *etwas Unarzneiliches* [something unmedicinal]. An inactive substance which is *a.* given to satisfy a patient's demand for medicine, or *b.* used in controlled studies of medicines, whereby the medicine being tested is given to one group, placebo is given to another group, and the results obtained from the two groups are compared. Hahnemann only refers to the use of placebo with patients. (§91, *fn* 96, §281)

plague, levantine: *levantisch Pest.* Bubonic plague, an infectious epidemic disease characterized by fever, swelling of the lymph glands, a rapid course and a high mortality. In the Middle Ages, it was known as the black death, which ravaged Europe several times. It periodically invaded Europe from the East and swept westward, hence Hahnemann's reference to it as the levantine plague. Hahnemann identified the levantine plague as an acute miasm. (§36, §73)

plaster: *Pflaster.* A moist, warm, pasty mass folded inside a thin cloth and laid on the skin; a poultice. Primarily used by the old school to draw out infectious matter or to act as a counter-irritant. (*fn* 60)

play: *Spiel.* Amusement; recreation. Passionate play involves occupation for one's amusement in which one is dominated by powerful emotions. (*fn* 260)

plethora: *Plethora.* An excess of blood in the circulatory system or in one organ or area of the body. (*fn* 74a)

pleuralgia: *Seitenstiche* [side stitches]. Intercostal neuralgia; pain in the side. (p. 25)

ponder: *erwägen* [weigh]. To reflect or consider with thoroughness and care. (§94)

potence, potency: *Potenz* [from LATIN *potentia*, power]. A supersensible entity possessed of and capable of exerting power. Hahnemann

uses the terms 'potence,' 'wesen' and 'agent' interchangeably. A potence can be healthful or harmful, natural or artificial. In §31, Hahnemann refers to inimical potences as partly psychical and partly physical, by which he means that a given inimical potence has both a psychical and a physical aspect. *Potenz* is translated as potency when it refers to the result of the potentization of a medicine, as in degree of potency (*Potenz-Grad*, §246).

potentization: *Potenzirung* [from LATIN *potentia*, power]. A multi-step process (involving dilution and succussion, or trituration) by which the inner medicinal power of a crude substance is released or increased. Synonym: dynamization. (§269)

power, force, energy: *Kraft*. *Kraft* includes the meanings of force, power and energy. In most instances, 'power' is translated from *Kraft*. In the following instances, power is translated from *Macht*, meaning power or might: 'privilege and power' (p. 3), 'physician's power' (p. 16), 'power of the external world' (*fn* 10), 'power and action' (*fn* 11), 'in our power' (§30), and 'power of natural bodies' (*fn* 269c).

powers, forces, vitality: *Kräfte*. *Kräfte* is the plural of *Kraft* (which is translated as force, power or energy). Depending on context, *Kräfte* is translated as powers (§110, §135), forces (p. 31), or vitality (§149). It is translated as vitality where it refers to the bodily forces, as in *Kräfte und Säfte*.

practitioner: *Practiker*. One who practices a profession or occupation. Where 'practitioner' appears alone, it is translated from *Practiker* (*fn* 25). Medical-art practitioner is a translation of *Heilkünstler*. See **medical-art practitioner.**

precordial region: *Präcordien*. Area on the center and towards the left side of the chest, lying in front of the heart. (§289)

preponderant: *überwiegend* [outweighing]. Having superior weight, force, importance, or influence. (*fn* 33)

presuppose: *voraussetzen*. To believe or suppose in advance. (*fn* 228)

prevailing: *gegenwärtig* [present], *vorwaltend* [fore-governing], *vorherrschend* [fore-ruling]. 1. Of or pertaining to something which is superior in any contest, which rules or is most influential. 2. Pre-

dominent in extent or amount; most widely occurring or accepted; generally current. (§46, §59, §217, §288)

prima causa morbi [LATIN]. First (primary) cause of disease. (p. 10)

primary action: *Primärwirkung.* Initial action. Hahnemann uses the term *Erstwirkung* (initial action or first action) throughout the *Organon.* The term *Primärwirkung* (primary action) appears once (p. 27).

principal, chief: *Haupt-.* See **chief.**

proactive: *vorwirkend* [fore-working]. Acting before, as opposed to reacting. (§61)

produce: *bewirken* [to be-work]. To effectuate, bring about. (*fn* 40a) The noun form, *Wirkung,* is translated as 'action.'

prompt: *hervorlocken* [lure forth]. To move to act; spur; incite. (§181)

proper: *gehörig.* See **appropriate.**

property, attribute: *Eigenschaft.* A quality or characteristic inherent in or ascribed to someone or something. *Eigenschaft* is translated as 'property' where it refers to a thing (*fn* 269c) and as 'attribute' where it refers to a person (*fn* 288).

protracted, long lasting: *langwierig, langdauernd.* Of long duration; dragged out over a long period of time. All chronic diseases are protracted but not all protracted diseases are chronic. (§5, §59, §77)

proving: *probieren* [to prove], *Versuch* [test]. A controlled experiment in which a medicine is administered to a healthy individual to ascertain what changes (signs, symptoms, behavior) the medicine produces on the body and the mind. The term 'proving,' as used by Hahnemann, refers to one trial with a single individual. Many such provings are required to fully test the powers of a medicinal substance. *Probiren* is consistently translated as 'to prove.' *Versuch* is translated as 'test,' 'experiment' or 'proving,' depending on context. (§105-§145)

proximate cause: *nächste Ursache* [next cause]. An event or condition that immediately precedes a disease and to which the disease is typically attributed. (*fn* 1)

prussic acid: *Blausäure.* A rapidly acting poison that occurs naturally in plants and is obtained synthetically by several methods. It acts by

preventing cellular respiration. Also known as hydrocyanic acid or hydrogen cyanide. (§74)

pseudo-assuagement: *Schein-Beschwichtigung.* False, sham or mock appeasement. Appearing to make something (e.g., a disease or symptom) less intense or severe without actually doing so. (§69)

psora: *Psora* [from HEBREW *tsorat*, a groove, fault; a pollution; a stigma; often applied to leprous manifestations and to the great plagues]. One of the three chronic miasms described by Hahnemann, who considered it the root of most chronic diseases. Psora is a collective disease; its entire and complete image can only be obtained by gathering together the symptoms of a very large number of patients, who appear to be suffering from many, essentially different chronic maladies, but who are actually suffering from different manifestations of the same disease, psora. In *The Chronic Diseases* (pp. 42-43), Hahnemann states that at least seven-eighths of all natural chronic diseases (i.e., those not caused by allopathic treatment) have psora as their only source, while the remaining natural chronic diseases spring from syphilis or sycosis, or from a complication of the two or, rarely, three miasms. According to Hahnemann, psora first reveals itself with the itch diathesis, a condition involving voluptuous itch and skin eruptions. (§80-82) See also **antipsoric, itch diathesis, miasm.**

psychical: *psychisch* [from GREEK *psukho*, soul, life]. **1.** That which involves the interaction of the spirit (*Geist*), the soul (*Seele*) and the emotional mind (*Gemüt*), having components of thinking, feeling and willing (§73). **2.** That which affects an individual's thinking, feeling and willing. [Resource: SRD] (§31) See also **physical.**

psychotherapeutic means: *psychische Heilmittel* [psychic curative means]. Treatment of mental and emotional disorders through the use of psychological techniques. (§226)

purgative: *purgirend* [from LATIN *purgare*, to cleanse]. An agent which stimulates a bowel movement. (§39)

purge away: *abführen.* See **remove.**

purpura miliaris: *Purpurfriesel* [purple fever]. Hahnemann describes purpura miliaris fever, also known as roodvonk or red miliary fever, as coming from Belgium in 1801 and frequently being mistaken by phyicians for scarlet fever. Hahnemann refers to scarlet fever as the

true, smooth erysipelous scarlet fever of [i.e., described by] Syndenham, in order to differentiate it from purpura miliaris fever. (*fn* 38h, *fn* 73b)

pursuit, business: *Geschäft.* See **business.**

quality, make-up: *Beschaffenheit* [makeup]. **1.** A quality of someone or something is an inherent or distinguishing trait, especially one serving to define or describe its possessor. **2.** The make-up of something is the way in which it is composed or arranged: its constitution, composition or construction (§283). *Beschaffenheit* can mean either of these and is translated according to context. *Beschaffenheit* is also translated in certain contexts as 'constitution' and as 'nature' (§139). See also **constitution.**

quinsy: *Bräune* [brown]. **1.** Inflammatory sore throat. **2.** Acute inflammation of the tonsils and the surrounding tissue, often leading to the formation of an abscess. (*fn* 81b)

rachitis: *Rhachitis* [from GREEK *rhachis*, the spinal column + *itis*, inflammation]. **1.** Inflammation of the spine. **2.** A term often used by physicians in the eighteenth and nineteenth centuries to refer to rickets, a deficiency condition in children which involves inadequate deposition of lime salts in developing cartilage and newly formed bone, resulting in abnormalities in the shape and structure of bones. Rickets is currently understood to result from a deficiency of vitamin D, which is integral to the proper calcification of bones as they develop. (§36, §80)

rage: *Wuth.* **1.** Violent, explosive anger (*fn* 220). **2.** A current, eagerly adopted fashion; a fad or craze (p. 16).

raving, frenzy: *Raserei.* See **frenzy.**

realize: *einsehen* [in, *ein* + see, *sehen*]. To see into the true nature of something and comprehend it completely. Clearly realizable or in-seeable principles (§2) are principles that are so lucid that it is easy to grasp their full nature. Nothing is obscure or incomprehensibly complex.

reason: *Vernunft.* The capacity for logical, rational thought; in particular, the synthesis of ideas, the combination of thesis and antithesis whereby a new and higher level of truth is revealed. (§229) See also **intellect.**

receptive: *receptiv* [from LATIN *re*, again + *cipere*, take]. Having the quality of, or capacity for, receiving or taking in. Hahnemann uses the Latin word *receptiv* and the German word *emfänglich* (both meaning receptive) synonymously. *Emfänglich* has the additional undertone of 'conceptive' (the noun form, *Empfängniß*, means reproductive conception). In this text, *receptiv* is translated as receptive and *emfänglich* (used once, in §64) is translated as conceptive. Interestingly, Hahnemann uses these terms to describe a person's openness to disease, as opposed to *anfällig* [attackable], the commonly used German term for 'susceptible.' See also **conceptive**.

reciprocal, intermittent: *wechsel* [interchange]. The interchange of states or actions. Hahnemann uses the term *wechsel* in reference to diseases, actions, and states. In this translation, diseases are referred to as 'intermittent,' actions are referred to as 'reciprocal,' and states are referred to as either 'reciprocal' or 'intermittent,' depending on the context. Intermittent diseases [*Wechselkrankheiten*] are those in which two or more reciprocal states alternate and which may include periods of apparent well-being (§231). Reciprocal actions [*Wechselwirkungen*] refer to the initial actions of certain medicines in which particular symptoms alternate with other symptoms (§115).

reduce, diminish: *verkleinern*. See **diminish**.

reflect, cogitate: *nachdenken*. See **cogitate**.

regimen: *Lebensart* [living mode]. The regulation of such matters as have an influence on the preservation or restoration of health; a particular course of diet, exercise, or mode of living, prescribed or adopted for this end. Hahnemann places great importance on lifestyle and regimen in disease prevention and as an adjunct to the cure of diseases. He uses several terms to refer to the general subject of regimen, including: 'regimen' [*Lebensart*], 'living habits' [*Lebensordnung*], 'lifestyle' [*Lebensweise*], and 'diet' [*Diät*] which includes diet of food and drink and also mental diet and diet for the soul. All references, by whatever name, are indexed under 'Regimen/diet/lifestyle.' (§78, §150, §252)

reign: *herrschen*. 1. To be predominant or prevalent. 2. To have widespread influence. (*fn* 22, §36, §54, §100)

relations: *Angehörigen* [belongers to]. Friends, relatives, or those about one. The medical-art practitioner is instructed to obtain informa-

tion about a case of disease not only from the patient but also from the patient's relations. (§84, §93)

remedy, curative means: *Heilmittel* [*Heil,* healing, cure + *mittel,* means]. **1.** A means for the cure of a disease or other disorder of body, mind or spirit; any medicine or treatment which promotes restoration to health. **2.** A means of counteracting or removing inimical influences of any kind. (§3, §7, §70)

remove. Hahnemann uses several words to indicate removal or annihilation of disease. These include: **Abolish, get rid of:** *abschaffen.* To do away with completely (§228, §252). **Annihilate:** *vernichten.* **1.** To destroy completely; to reduce to nonexistence. **2.** To nullify or to render void. (§2, §17) **Destroy:** *zerstören.* To do away with; to put an end to (p. 17, *fn* 266). **Dispatch:** *beseitigen.* To finish off (p. 21, §73). **Displace:** *versetzen.* **1.** To take the place of; supplant. **2.** To transfer, shift. (§31, 34) **Drive away:** *verdrängen.* To push, propel or thrust away; repulse (§68). **Eradicate:** *austilgen, vertilgen.* To get rid of completely; eliminate (*fn* 67, §50, §69). **Expel, dispel:** *austreiben, vertreiben.* To force or drive outward (p. 33, *fn* 7a, §51, *fn* 276b). **Export, convey outward:** *ausführen.* To send or transport outward (pp. 21, 23). **Expulse:** *ausstossen.* To drive or thrust out; to expel forcefully (p. 19). **Expunge:** *tilgen.* To eliminate completely, erase (§8, §39). **Expurgate:** *auspurgiren.* To remove objectionable material from; to purge. (p. 14). **Extinguish:** *auslöschen.* **1.** To put out; quench. **2.** To put an end to; destroy. (§26, §29) **Extirpate:** *ausrotten.* **1.** To root out; pull up by the roots. **2.** To destroy totally; obliterate. (§51, §200) **Lift:** *heben, aufheben.* **1.** To raise. **2.** To bring an end to; bring about a surcease. **3.** To cancel. (§2, §17) **Purge away:** *abführen.* To remove, as if by cleansing (p. 22). **Remove:** *entfernen.* **1.** To take away; withdraw. **2.** To do away with; eliminate. (§4, §72) **Take away:** *hinwegnehmen.* To remove (*fn* 17a). **Vanquish:** *besiegen.* To conquer; to defeat in battle (*fn* 29). **Wipe away:** *verwischen.* To completely remove by, or as if by, rubbing; destroy completely (§150).

repellentia [LATIN]. Repellents; things that repel or drive something back. (p. 17)

repercutientia [LATIN]. Things that make something rebound or reflect. (p. 35)

representative: *stellvertretend.* Acting or serving in place of something else; vicarious. (§201, §204)

responsion. A dynamic, conscious and aesthetic response to an impression, which involves the *Gemüt* (i.e., the emotional mind) as contrasted with other kinds of reactions or responses, such as an automatic reaction or a purely sensorial, autonomic response. The term 'responsion' is used in the Glossary to define terms; it is not used in the text of the *Organon.* [Resource: SRD]

revolutionary: *revolutionär* [from LATIN *revolvere,* to turn over]. Characterized by or resulting in a sudden, momentous change. (p. 29)

revulsive means: *revellirendes Mittel* [from LATIN *revellere,* to tear back]. A treatment or medicine used by the old school to produce a counter-irritation in the body. (p. 38)

rickets. See **rachitis.**

rheumatism: *Rheumatism* [from GREEK *rheuma,* discharge + *ismos,* condition]. Any of several pathological conditions involving the muscles, tendons, joints, bones, or nerves, characterized by inflammation, soreness and stiffness. (*fn* 81b)

roborantia [LATIN, to strengthen]. Roborants; medications or other treatments intended to restore or increase strength or vigor; strengtheners. (p. 39)

roodvonk: *Roodvonk.* See **purpura miliaris.**

saltpeter: *Salpeter.* In the nineteenth century, saltpeter was defined as a neutral salt formed by nitric acid in combination with potash, naturally occurring in the East Indies, in Spain, near Naples and in other places. Saltpeter was also found on walls sheltered from the rain, and it was extracted by lixiviation from the earth under cellars, stables and barns. Currently, both potassium nitrate and sodium nitrate are alternately known as saltpeter. Its uses include the pickling of meat and the manufacture of pyrotechnics, explosives, matches, rocket propellants, and fertilizers. (p. 35)

salutary: *heilsam.* Conducive or favorable to health; wholesome. (§191, *fn* 253, §285)

scald-head: *Kopfgrinde.* Popular term for porrigo, a condition characterized by scaly eruptions of the hairy scalp, unaccompanied by

fever. The eruptions are of many clinical descriptions, from pimples to ringworm. Also known as scalled head. (§46)

scarlet fever: *Scharlachfieber.* An acute contagious disease occurring predominantly among children and characterized by a scarlet skin eruption and high fever. Scarlet fever became increasingly common during the early part of the nineteenth century. By the latter half of the century, it was the most common cause of death in children over the age of one year. By 1900, the mortality was decreasing and it virtually ceased by 1965. Hahnemann refers to scarlet fever as "Sydenham's true, smooth erysipelous scarlet fever" in order to differentiate it from purpura miliaris fever which Hahnemann states arrived from Belgium in 1801 and was confused by physicians with scarlet fever. In his introduction to Belladonna, in *Materia Medica Pura*, Hahnemann describes the prophylactic power of belladonna "given in the smallest dose every six or seven days" against scarlet fever, which he identifies as an acute miasm. (*fn* 33, *fn* 73b)

scirrhous tumor: *skirrhöse Geschwulst.* A hard, dense, cancerous growth, usually arising from connective tissue. (p. 17)

scoliosis: *Skoliosis* [GREEK, crookedness]. Lateral curvature of the spine. Scoliosis typically consists of two curves in the spine: the original abnormal curve and a compensatory curve in the opposite direction. (§80)

scrofula: *Skrophel* [from LATIN *scrofula*, breeding sow]. A chronic wasting disease which has a disturbance of nutrition at its base. It is characterized by disturbances of the skin, mucous membranes, joints, bones, sensory organs, and especially of the lymphatic glands. It can manifest either as an accumulation of fatty deposits in certain parts of the body (known as torpid scrofula) or as a deficiency in fat, related to too-rapid growth (known as erethetic scrofula).

Someone with torpid scrofula typically develops an unusually large head, coarse features (e.g., a thick, swollen nose and upper lip, broad cheek bones, large belly), swollen glands in the area of the neck, and soft flabby muscles. (Modern readers will recognize this syndrome as similar to marasmus due to nutritional deficiency; however, it is considered to be distinct from marasmus. Scrofula may occur with or without marasmus as a concomitant.)

Someone with erethetic scrofula typically has unusually white

skin (very thin and transparent, through which blood vessels can be seen) which becomes easily reddened, unusually red lips, soft hair, and a bluish color to the sclera (the white part of the eye). Such individuals tend to be listless, with a dreamy, lazy look. The muscles are thin and flabby; the bones lack density, giving the body an excessively light feel; the teeth have a bluish look and are long, narrow and glistening.

In both forms of scrofula, there are skin eruptions which are usually seated on the face and scalp. Typically, these eruptions are moist and look like eczema or ringworm. There can also be a condition of the mucous membranes characterized by irritation and eruptions near the junction of the mucous membrane and the skin (e.g., near the eyes, ears, or nose at the upper lip). Discharge from the membrane flows onto the surrounding skin, causing the characteristic irritation. These catarrhs (which may be bronchial, intestinal, urinary, or of the sexual organs) are generally obstinate (i.e., recurrent and persistent). The joints may be affected with non-inflammatory fluid accumulation (white swellings) or with suppurative processes involving the ends of the bones. In some, there are caries of the bone ends and destruction of the connective tissue around the joints, which results in specific pathologies (e.g., coxitis, gonarthracace, etc.). The bones themselves may also be inflammed and develop caries or even necrosis. If the eyes are affected, inflammation of the conjunctiva or the cornea will eventually leave spots or scarring on the tissues involved. If the nose is affected, there will be obstinate coryza (a 'cold' or upper respiratory infection). If the ears are affected, inflammation can be severe, sometimes leading to destruction of the underlying bone.

The most affected tissues are the lymphatic glands. Everywhere that the skin, mucous membranes or other tissues are affected, there will be inflammation and swelling of the associated regional lymphatic vessels and glands. This spreads to associated tissues in the form of suppuration or abscesses. The process is slow, extremely persistent and leaves ugly scars. The cervical glands are the most affected, especially those behind the ears and under the lower jaw, sometimes extending as low as the shoulders. In some cases, the primary focus is in the bronchial or mesenteric glands. It sometimes

happens that the glands can swell without inflammation in any sur-
rounding tissue. Where purulent material forms, it is a thick, hard,
cheesy mass which becomes chalky and hard, leaving deformities
under the skin.

Scrofula may be inherited (usually from parents suffering from
tuberculosis, cancer or advanced syphilis, or as a result of inbreed-
ing) or it may be acquired as a result of several inimical influences,
such as poor diet and other inadequate living conditions, including
lack of exercise and fresh air. (§80)

search out, single out: *aussuchen.* To make a thorough examination of;
look over carefully in order to find something; explore. (§103, §105)

self-bracing: *sich ermannend* [*sich*, self + *ermannend*, to man]. Sum-
moning up resolution for a task; pulling one's self together for an
effort. (p. 26)

self-engenderer: *Selbsterzeugerin.* Hahnemann refers to medicines as
self-engenderers of symptoms (§181) because, unlike diseases, medi-
cines do not depend on any particular receptivity of the life force to
have an effect upon it. As Hahnemann states in §32, all medicines
work unconditionally, that is, "every true medicine works at *all*
times, under *all* circumstances, on *every* living human being, and
arouses in him its peculiar symptoms." Hahnemann makes the same
point in stating that a medicine is capable, *of itself,* of engendering
or arousing certain symptoms (p. 49, §70, §213). See also **engender.**

self-preservation: *Selbsterhaltung* [*Selbst*, self + *er*, up + *haltung*, hold-
ing]. **1.** Protection of oneself from harm or destruction. **2.** The
instinct for individual preservation; the innate desire to stay alive.
See also **sustentive power of life.**

semiotics: *Semiotik* [from GREEK *sema,* sign]. **1.** Branch of medicine
concerned with signs and symptoms. **2.** The scientific study of
symptoms as a whole or in one particular case; symptomatology.
Semiotics includes the study of symbols as well as symptoms. (p. 10)

sensation, sensibility: *Empfindung, Sensibilität.* See **sensibility.**

sensibility, sensation: *Empfindung* [GERMAN], *Sensibilität* [from LATIN
sensus, sense]. Sensation is somatic feeling (e.g., pain, itching). Sen-
sibility is the ability to feel or perceive which includes not only sen-
sation, but also mental or emotional responsiveness, an aesthetic

receptiveness to impression. *Empfindung* can mean either 'sensation' or 'sensibility' and has been translated according to context (§11, *fn* 67). *Sensibilität* has been translated as 'sensibility.' (§113, §139) See also **feelings.**

sensible: *sinnlich.* **1.** Perceptible by the senses. **2.** Having the faculty of sensation; able to feel or perceive (p. 37). **3.** Feeling or perceiving something and becoming conscious or cognizant of it (§133). **4.** Acting with or exhibiting good sense: a sensible person (*fn* 210).

sensitivity: *Empfindlichkeit.* Ability to feel or transmit a sensation. Sensitivity refers to neural awareness, the capacity to register stimuli. (§113)

sensorium: *Sensorium* [LATIN, organ of sensation]. The entire sensory system of the body. (*fn* 69a, p. 269)

seton: *Haarseile* [*Haar,* hair + *seile,* rope]. A long twist of horse-hairs, or a long strip of twisted silk or linen thread, drawn through the skin by a large needle and left to act as a counter-irritant and to allow fluids to drain away from an area. Typically, a fresh part of the thread is drawn through the wound each day. (*fn* 54c)

si modo essent [LATIN]. Provided it exists. (p. 19)

sick: *krank.* Diseased. *Krank* is translated as 'sick' or 'diseased.' *Siechthum* is translated as 'wasting sickness.' (§1) See also **wasting sickness.**

side, accessory: *Neben.* See **Accessory.**

sign: *Zeichen.* While the term 'sign' currently refers to any objective evidence or manifestation of disease, Hahnemann uses the term interchangeably with 'symptom.' Both terms refer to either subjective or objective indications of disease. References to both signs and symptoms are listed in the Index under 'Symptoms.' (§104, §154, §217) See also **symptom.**

similar: *ähnlich.* Alike but not identical. (§24)

similia similibus [LATIN]. Similar things for (or by means of) similar things. The use of similars to cure disease is one of the central tenets of homeopathic medicine. (p. 58)

similia similibus curentur [LATIN]. Let similars be cured by similars. *Similia similibus curentur* is the law of similars upon which the homeopathic medical art is based. (p. 48)

simillimo [LATIN]. That to which the simillimum is similar (i.e., the disease). (*fn* 56)

simillimum: *Simillimum* [LATIN, most like]. That medicinal potence capable of producing a set of symptoms which are the most similar to those in the case of disease to be cured. Hahnemann uses the term *simillimum* only once in the *Organon* (*fn* 56). He generally refers, instead, to the 'most apt,' the 'most fitting' or the 'most suitable' homeopathic remedy, or he refers to the 'specificum' (§147) or the 'specific remedy' for a given case of disease. One of his strongest references to the simillimum is in §154 in which he refers to "the most fitting, homeopathic, specific remedy for *this* disease state." See the Index listings 'Simillimum,' 'Homeopathic remedy, most apt' and 'Specific medicines.'

single out, search out: *aussuchen.* See **search out.**

smallpox: *Menschenpocke* [*Menschen*, human + *pocke* pustules]. An acute, highly infectious, often fatal disease characterized by high fever and aches with subsequent widespread eruption of pimples that blister, produce pus, and form pockmarks. Smallpox was identified by Hahnemann as an acute miasm. (§46)

somatic, bodily, corporeal: *Körper-, körperlich.* See **bodily.**

somnambulism: *Somnambulism* [sleep walking]. The fact or habit of walking about and performing other actions while asleep. (*fn* 289a)

soul: *Seele.* Intermediary between the spirit (*Geist*) and the emotional mind (*Gemüt*). In *fn* 224, Hahnemann indicates that the soul has feelings and volition. He states, "It appears as if the soul of the patient feels, with exasperation and sadness, the truth of these rational expostulations and acts directly upon the body as if it wanted to restore the harmony that has been lost...." In §229, he refers to the "indignant soul languishing in the fetters of a sick body." In §225-§227, Hahnemann discusses diseases which are spun and maintained by the soul. In §228, he discusses a diet for the soul, involving the psychologically fitting approach to be taken towards a patient with a mental or emotional disease.

source: *Quelle* [well], *Ursprung* [arch-spring]. The point at which something springs into being or from which it is derived or obtained; origin. *Ursprung* is translated as either 'source' or 'origin;'

Quelle is translated as 'source.' In Hahnemann's usage, there is no apparent difference in their meaning. (p. 10, §102)

spasms: *Zuckungen.* Involuntary and, in severe cases, painful contractions of a muscle or of a hollow organ with a muscular wall. Cramps are painful spasms. Convulsions are spasms of a general nature. Colic is a spasmodic condition involving the stomach, bowels or other abdominal organs. (*fn* 232)

special: *sonder, speciell.* See **strange, rare and peculiar.**

specific remedy: *specifisches Heilmittel.* The most fitting remedy for a particular disease state or condition, also referred to by Hahnemann as the specificum. (§82, §143)

specificum: *Spezifikum* [from LATIN *specificum,* that which is specific]. The most fitting, homeopathic remedy for a particular disease state or condition; the simillimum. (§147)

speed: *glücken* [succeed]. To help to succeed or prosper; to aid, as in "God speed." (§109)

spirit: *Geist.* The faculty of pure intelligence in the human being, which is manifested through the operations of intellect (p. 37) and reason (§9). That aspect of the human being that dwells in the organism and is associated with the higher functioning of the mind. The human spirit (*Menschen-Geist*) is one of two supersensible presences that permeate the organism, the other being the human wesen (*Menschenwesen*) or dynamis. The human spirit and the human wesen form a functional polarity whose common functioning principle is human being (see **functional polarity**). Hahnemann connects the human spirit with intelligence and the human wesen with instinct. Hahnemann also refers to 'the higher human spirit' (p. 37) which is the noetic faculty for higher ideas, that is, it is the highest level of pure intelligence. [Resource: SRD] See also **mental, wesen.**

spiritized, spiritual: *geistig.* See **spiritual.**

spirit-like: *geistartig.* Closely resembling or possessing certain characteristics of the spirit, such as the traits of being invisible, supersensible, immaterial. (§9) See **spirit.**

spiritual, spiritized: *geistig.* 1. Of, relating to, consisting of, or having the nature of spirit. 2. Neither tangible nor material; supersensible. (p. 12, *fn* 6, §270)

sporadic: *sporadisch* [from GREEK *spora*, a scattering, sowing]. Occurring at the same time in widely scattered localities. Hahnemann attributes acute sporadic diseases to meteoric and telluric influences and malignities to which only a few people are receptive. (§73)

spurge laurel: *Seidelbast.* A low-growing, evergreen Eurasian plant *(Daphne laureola)*, used by old school physicians as an exutorium. (p. 33)

spy out: *auspähen.* To investigate intensively. (*fn* 81b, §100)

stamp: *geartet.* Fashioned, natured, constituted. Patients of an opposing stamp are literally 'oppositely fashioned' or of an opposing nature. (§97)

state: *Zustand.* A mode of being. A person's state refers particularly to the state of the *Geist* and *Gemüt* (i.e., the spirit and the emotional mind). An individual's state is not directly perceptible but reveals itself through behavior, through changes in one's condition (i.e., feelings, functions and sensations), and through one's circumstances. A person's state is also directly discernible to the astute, participative observer. A healthy state involves knowledge of the truth of things. A diseased state is characterized by ignorance, which includes false beliefs (supersititions) and fancies connected with compelling deceptions. (§17, §224) [Resource: SRD] See also **condition, impression, participation.**

status morbi [LATIN]. State of the disease. (§183)

steatoma: *Speck-Geschwulst* [fat tumor]. An encysted tumor whose contents are similar to fat. (p. 17)

sternutatory means: *Schleim erregende Niesemittel* [mucous arousing sneezing means]. A medicine or treatment that provokes sneezing. (§59)

stimulate, arouse: *erregen.* See **arouse.**

strange, rare and peculiar. Hahnemann uses various terms to describe symptoms which are characteristic of a disease, in that they are strange, rare or peculiar. **Exceptional, particular, peculiar:** *sonderlich.* Out of the ordinary course, unusual; deviating widely from the norm. Translated as 'exceptional' (§153, §165), 'particular' (§145, §164) or 'most peculiar' *(sonderlichst,* §95, §235), depending on context. **Odd:** *eigenheitlich* [ownness]. Peculiar; a characteristic pro-

perty with less ownership suggested than with *eigenthümlich* (§153).

Peculiar: *eigenartig* [own-like], *eigenthümlich* [own-dom]. Distinct from all others; belonging distinctively or primarily to one person, group, or kind; special, unique, characteristic. Peculiar is translated from *eigenthümlich* throughout the text (§102, §215) except in §73, §74, §80, *fn* 80,and *fn* 235a where it is translated from *eigenartig*. **Special:** *sonder, speciell.* **1.** Surpassing what is common or usual; exceptional. **2.** Distinct among others of a kind. 'Special' is almost always translated from *sonder*. In one instance, it is translated from *speciell* (p. 19). **Striking:** *auffallend* [falling up, therefore it strikes you]. Conspicuous (§152, §153). **Uncommon:** *ungemein*. Not common; rare (§165). **Unusual:** *ungewöhnlich*. Not usual or ordinary (§84, §153). See also **characteristic.**

striking: *auffallend.* See **strange, rare and peculiar.**

stroke: *Schlagfluß* [hit-flux]. An apoplectic seizure; a sudden effusion of blood or serum in the brain, typically resulting in a loss of muscular control, diminution or loss of sensation or consciousness, dizziness, slurred speech, or other symptoms that vary with the extent and severity of the damage to the brain. Also known as cerebral accident, or cerebrovascular accident. (*fn* 81b, *fn* 285)

substance, material, matter: *Materie, Materiell, Stoff, Substanz.* See **material.**

subtle, fine: *fein.* **1.** So slight as to be difficult to detect or analyze (§13, §221). **2.** Able to make fine distinctions (§130, §141). In the Preface (p. 5), Hahnemann describes subtle doses as those doses that are so small that they exactly suffice to lift the natural malady without causing pain or debilitation.

succussion: *Schütteln.* Vigorous shaking with impact. Part of a multi-step process for potentizing substances to bring out their medicinal powers. Hahnemann recommended that substances be succussed by holding a vial of the properly diluted substance in the hand and striking a hard but elastic body such as a leather-bound book, using an up and down motion of the forearm. (§269-§271)

suitable: *angemessen, geeignet, gehörig.* See **appropriate.**

sulphuretted metals: *geschwefelt Metalle.* Metals that are combined or impregnated with sulphur. (*fn* 273)

supersensible: *übersinnlich* [beyond the senses]. Above and beyond perception by the senses. (§6, *fn* 11)

supervening: *hinzutretend* [stepping up to]. **1.** Coming directly or shortly after something else, either as a consequence of it or in contrast with it; following closely upon some other occurrence or condition. **2.** Occurring as something additional or secondary. (§38, *fn* 269d)

suppression: *Unterdrückung* [under-pressing]. Forcible concealment, masking, or forcing under. The suppression of symptoms refers to the concealment of perceptible manifestations of a disease condition without the cure of the disease. (p. 38, §200)

suppuration: *Vereiterung.* The process of pus formation, specifically as the outcome of a condition of inflammation which starts with slight chills and involves an alteration of the pain in the involved part from a lancinating pain to a heavy one (i.e., with a sense of weight in the part). (§80, *fn* 256)

suspend: *suspendiren* [from LATIN], *aufschieben* [GERMAN]. To cease for a period; hold in abeyance. The Latin and the German terms are synonymous. (§38, §44)

sustain: *erhalten* [*er,* up + *halten,* to hold]. **1.** To keep in existence; maintain. **2.** To supply with necessities or nourishment; provide for. (§4, §72)

sustentive drive of life: *Lebens-Erhaltungstrieb.* That drive of the life force which sustains; its drive for self-preservation. See also **life force.** (§262)

sustentive power of life: *Lebens-Erhaltungskraft.* That power of the life force which sustains, as contrasted with that power of the life force which engenders (its generative power). In disease, the life force brings both its generative and sustentive powers to bear in engendering and sustaining the disease (§63, *fn* 205a). It makes and maintains symptoms in a diseased effort to preserve life (pp. 28, 35). In health, the sustentive power of the life force is involved in maintaining the organism in admirable, harmonious, vital operation (§9); its generative power is involved in conception and pregnancy, as well as other creative endeavors. [Resource: SRD] See also **life force.**

sycosis: *Sykosis* [from GREEK *sukosis,* ulcer resembling a fig]. The sycotic miasm is one of three chronic miasms described by Hahnemann.

According to Hahnemann, its development follows infection with gonorhhea. Gonorrheal figwarts are its primary symptom, removal of which will result in the development of secondary symptoms of the sycotic miasm. (§79)

symptom: *Symptom.* Any indication of disease in the patient. (§6) Symptoms may be either subjective or objective. Hahnemann uses the terms 'symptom' and 'sign' interchangeably in his reference to the three major modalities of disease manifestation: *a.* behavior (i.e., attitudes, positions and performances indicating the mental and emotional state, §253), *b.* indications of conditon (i.e., abnormalities in feelings, functions and sensations, §11, §19), and *c.* appearance (i.e., objective signs, both those that are readily observable and those that involve tests or the use of diagnostic instruments). Symptoms may be experienced by the patient or by observers of the patient, either through the sense organs or the faculties of participation (i.e., the *Geist* and the *Gemüt*). [Resource: SRD] See also **signs, participation.**

symptom complex: *Symptomen-Inbegriff* [*Symptomen,* symptoms + *Inbegriff,* (quint)essential inclusive concept]. That group of characteristic symptoms of a disease which represents the essence (wesen) of the disease. Hahnemann uses two terms to refer to the symptomatology (the combined symptoms) of a medicine or a case of disease: *Symptomen-Inbegriff* (the symptom complex, §16, §100) and *Gesammtheit der Symptome* (the totality of symptoms, §7, §24). The term 'totality of symptoms' refers to the sum total of disease symptoms; the term 'symptom-complex' contains a limiting reference to the essence of the disease as revealed by its characteristic symptoms. While the two terms seem to be used fairly interchangeably (§18), there is a distinction between them. Hahnemann, who was fluent in several languages, often used terms in such a way as to remind the reader that a word that represents a thing is not the thing itself. By describing the symptom totality with two different terms, Hahnemann provides the reader with a fuller, more dynamic and more holographic definition. [Resource: SRD]

symptomatic treatment: *symptomatische Curart.* Treatment of a single symptom of a disease as opposed treatment of the disease based upon the totality of symptoms. (*fn* 7b, §58)

syphilis: *Syphilis.* A chronic, infectious, venereal disease. Today, syphilis is described as occurring in three stages. The primary lesion, which is usually on the genitals, appears two to four weeks after infection, starting as a small red papule and changing to a small ulcer and then to a hard chancre. The lymph nodes typically enlarge two weeks after the appearance of the primary lesion. The secondary stage commences about six weeks after the first appearance of the primary lesion. This stage is characterized by lesions of the skin and mucous membranes, which vary greatly in appearance (contributing to syphilis being called 'the great imitator'). Enlargement and induration of regional lymph nodes occurs. Other common symptoms of the second stage include headache, fever and a general malaise. While these are common symptoms, they do not appear in all cases. The tertiary stage of syphilis may include serious cardiovascular problems, central nervous system problems and various types of psychosis. Today, the great variety of symptoms of syphilis makes diagnosis much more difficult than in the past.

Syphilis was first introduced in Europe at the end of the fifteenth century; at that time, it manifested with severe, rapidly developing symptoms. In contrast to the disease's relatively slow progress today, syphilis in sixteenth century Europe turned a healthy person into a leprous-looking mass in a few weeks, typically ending in death within a year. Syphilis was introduced in Europe by the crew that sailed with Christopher Columbus, who were infected while in the West Indies, where the disease was considered to be endemic and manifested in a fairly mild form. In Europe during the 1500's, syphilis (referred to then as the pox or the French disease) typically started as an ulcer on the mouth or genitals, followed by rashes, joint pains and gummy tumors all over the body which grew to the size of eggs or even the size of loaves of bread. In some cases, the lips, nose, throat and tonsils were eaten away. "We saw joints denuded of their flesh and bones, growing squalid, the face eaten away gape with hideous opening, the lips and throat giving forth but feeble sounds," reported Girolamo Fracastoro, author of the poem about a shepherd named Syphilis, after which the disease was later named.

Hahnemann identified syphilis as a chronic miasm whose primary symptom is the syphilitic chancre, and which is the source of many other chronic ailments. He describes syphilis as being the most easily cured of the chronic miasms as long as it is not complicated with psora and its primary symptom has not been removed by local treatments. (§79)

take away: *hinwegnehmen.* See **remove.**

tapeworm: *Bandwurm.* See **worms.**

telluric: *tellurisch* [from LATIN *tellus,* earth]. Of or related to the earth or the soil. (§73)

temper: *Laune.* Temperament. An aspect of one's nature which is distinct from the disposition and the constitution. In medieval physiology, it was held that each of the four temperaments or tempers (i.e., sanguine, phlegmatic, choleric and melancholic) corresponded to one of the four cardinal humours, or bodily fluids (i.e., the blood, the phlegm, the choler, and the melancholy, which was also known as black choler). This concept of one's psychological constitution being related to one's bodily constitution is still present in the term 'temper.' (*fn* 88, *fn* 210)

test, experiment, proving: *Versuch.* See **experiment.**

therapeutic, curative, healing, medical: *Heil-.* See **curative.**

therapy: *Therapie.* A treatment of disease, injury or disability. (p. 19)

thorough: *gründlich* [from *gründ,* ground]. 1. Exhaustively complete. 2. Carried out through the whole of something. (*fn* 6, §25) See also **fundamental.**

tinder: *Zunder.* Inflammatory matter; readily combustible material, such as dry twigs used to kindle fires. Hahnemann refers to chronic miasms as the infectious tinder (i.e., the kindlers) of almost all natural chronic diseases. (pp. 29, 94, §81)

tinea: *Tinea* [LATIN, worm]. Any fungus skin disease occurring on various parts of the body, the name indicating the part affected. *Tinea capitis* occurs on the head. Commonly called ringworm. (§38)

tolle causam [LATIN]. Remove the cause. (p. 9)

tone down, tune down: *herabstimmen.* See **tunement.**

tonica [LATIN]. Tonics; medications or other treatments intended to restore or increase body tone. (p. 39)

totality of symptoms: *Gesammtheit der Symptome.* All the signs and symptoms of a disease (either a natural one or an artificial medicinal one); the entire, outwardly reflected picture of a disease. (§7) See also **symptom complex.**

trace out: *auszeichnen* [*aus,* out + *zeichnen,* draw]. To mark out; to diagram or trace out from an original. (§209)

transudation: *Schwitzen* [sweat]. The passage of fluid through the tissue of any organ, which may collect in small drops on the opposite surface, or evaporate from it. (*fn* 266)

treatment: *Cur* [from LATIN *cura,* medical treatment], *Behandlung* [GERMAN, handling, management]. **1.** The act, manner, or method of handling or dealing with someone or something. **2.** Administration or application of medicines or other means to a patient or for a disease or an injury; medical management. Both *Cur* (§37) and *Behandlung* (§35) are translated as 'treatment.' In a few instances, *Behandlung* is translated as management (p. 58).

trituration: *Reiben* [rubbing]. **1.** The act of rubbing, grinding, or pounding into fine particles or a powder. **2.** A dry method of potentizing medicinal substances whereby the substance is finely ground in a mortar with a certain proportion of milk sugar, thereby progressively attenuating it. The potentization of medicinal substances is also accomplished by means of dilution and succussion, which Hahnemann describes as a kind of trituration (*The Chronic Diseases,* p. xix) since it, too, involves a form of rubbing and dilution in a non-medicinal medium. (§269-§270)

troublesome, wearisome: *beschwerlich.* See **wearisome.**

tuberculosis, pulmonary: *Lungensucht* [lung sickness]. An infectious disease of human beings and animals characterized by the formation of tubercles on the lungs and other tissues of the body, often developing long after the initial infection. (A tubercle is a painless and slow-growing nodule or swelling, especially a soft, pliable mass containing a substance, composed mainly of lymphocytes and epithelioid cells, which is much like pus in appearance and consistency.) In this text, *Lungensucht* is translated as pulmonary tuberculosis; *Schwindsucht* is translated as consumption. (§38) See also **consumption.**

tune differently, alter the tuning of: *umstimmen.* See **tunement.**

tune down, tone down: *herabstimmen.* See **tunement.**

tunement: *Stimmung* [from *stimmen,* tune; *Stimme,* voice; *Stimmung,* mood]. Tuning, mood, pitch. The 'tunement' of the organism or the life force refers to its relative health or derangement (*fn* 31, §34). By using a musical term, Hahnemann suggests that the organism, along with its enlivening life force, has a vibration and an aesthetic capacity which is altered and deranged by disease. Related terms used by Hahnemann include: **Mistunement:** *Verstimmung* [*Ver,* mis + *Stimmung,* tunement]. A state of being out of tune (§11, §16). **Over-tune:** *überstimmen* [*über,* over + *stimmen,* tune]. 1. To impose a different tunement upon. 2. To overpower, as with a louder voice or a stronger tunement or vibration. Hahnemann uses the term 'over-tune' in discussing the process of cure by which a medicinal potence over-tunes the mistuned life force (§68). **Tune differently, alter the tuning of:** *umstimmen* [*um,* in another way + *stimmen,* tune]. To tune to a different frequency, vibration or state (§21). **Tone down, tune down:** *herabstimmen* [down tune]. Lower the tuning, pitch, frequency or vibration of (*fn* 60).

typhus: *Typhus* [from GREEK *typhos,* fever]. Any of a group of acute infectious diseases which are characterized by great prostration, severe headache, generalized rash, and sustained high fever usually lasting two to three weeks. Particularly characteristic is a small, weak, unequal pulse. Epidemic typhus is prevalent in crowded, unsanitary conditions. Dungeon (or gaol) fever, ship fever, hospital fever, camp fever, nerve fever, and classic typhus are various names that were given to outbreaks of typhus. (*fn* 81b)

typus [LATIN, type]. 1. Type of disease. 2. Term used to refer to the periodicity of intermittent fevers. (p. 41, §234)

unadulterated: *ungekünstelt.* Unartificial, unrefined, unalloyed. (§123)

uncommon: *ungemein.* See **strange, rare and peculiar.**

understanding appreciation: *Verständniss.* Awareness which involves delicate perception, especially of aesthetic qualities or values. (*fn* 141, §224)

unusual: *ungewöhnlich.* See **strange, rare and peculiar.**

unvarying, invariable: *gleichbleibend* [same-remaining]. Fixed; unchanging. An unvarying disease is one which, over time, does not alter in its wesen. Hahnemann primarily describes the miasms as unvarying diseases. (p. 50, §46, *fn* 81b) See also **miasm.**

uphold: *aufrecht erhalten* [upright to maintain]. To support; to prevent from falling or sinking. (§74)

vaccination, inoculation: *Einimpfung.* Inoculation with a vaccine in order to protect against a particular disease. A vaccine is made either with a weakened or altered form of the live germ associated with a particular disease (which is intended to reproduce in the body, resulting in a mild form of the natural disease), or it is made with a killed form of the germ, and given in a much larger dose. Both approaches are intended to stimulate the body's immunity against the disease. (§38)

valerian: *Baldrian.* A plant of the genus *Valeriana,* native to Eurasia and widely cultivated for its small, fragrant flowers and for use as a medicine. (p. 41)

vanquish: *besiegen.* See **remove.**

venereal disease: *venerische Krankheit.* A disease which is acquired primarily through sexual intercourse. Hahnemann uses the term in reference to syphilis and gonorrhea. (§40)

venesection: *Ader-Oeffnung* [vascular opening]. The opening of a vein to allow blood to flow out; a method of bloodletting. (p. 15)

vesicle: *Blüthchen* [little blossom]. **1.** A small sac or bladder containing fluid. **2.** A blister-like small elevation on the skin containing serous fluid. (§80)

vexation: *Verdruss, Aergerniß.* **1.** Feeling of distress, irritation, harassment. **2.** A tendency to become angry or irritable. (§77, §221, §225)

vigor: *Vollkräftigkeit* [full power]. Great energy, force or power. (§122)

virtual: *virtuell* [from LATIN *virtus,* virtue]. Of or pertaining to effective force or power. In *fn* 11 and §16, Hahnemann uses *virtuell* in discussing dynamic actions and tunement-altering medicinal energies.

virulent: *böse.* Extremely malignant or violent. (§39)

vital: *Leben-.* *Leben* is almost always translated as *life,* as in life force. Exceptions are: 'vital operation' (*Lebensgang,* life course or running-order, §9) and 'vital heat' (*Lebenswärme,* life warmth, §59).

vitality, forces, powers: *Kräfte.* **1.** That principle, energy or force which distinguishes living things from nonliving things. **2.** Vigor, energy. *Kräfte* is the plural of *Kraft* (translated as force, power or energy). Depending on context, *Kräfte* is translated as powers (§110, §135), forces (p. 31), or vitality (§149). It is translated as vitality when it refers to the bodily forces, as in the expression 'vitality and bodily fluids' *(Kräfte und Säfte).* See **bodily fluids.**

vitiation: *Verderbniss* [from LATIN *vitium*, fault]. Spoilage, corruption. (p. 13)

voltaic pile: *Voltaische Säule.* A source of electricity consisting of a number of alternating disks of two different metals (such as silver and zinc) separated by acid-moistened pads; a battery, consisting of two or more connected cells that produce a direct current by converting chemical energy to electrical energy. (p. 40)

voluptuous: *wohllüstig.* **1.** Suggesting ample, unrestrained pleasure to the senses. **2.** Devoted to or indulging in sensual pleasures. A 'voluptuous itch' (§80) has a background of sexual energy (which psoric itches do to a greater extent than other itches). 'Unnatural voluptuousness' *(fn 260)* is an addiction to sensual pleasure, or an over-indulgence in pleasure and luxury.

wasting sickness: *Siechthum.* A lingering, weakening, wasting disease. Hahnemann uses the word particularly in reference to miasmatic diseases and to protracted sicknesses that are the result of artless medical treatments. (§41, §149)

weaken, debilitate: *schwächen.* See **debilitate.**

wearisome, troublesome: *beschwerlich* [heavy]. Weighing one down; causing fatigue; tedious or tiresome *(fn 37)*

well-aimed, apt: *treffend.* See **appropriate.**

wesen: *Wesen* [pronounced vāʹzən]. 'Wesen' is a multi-faceted term which can mean any of the following: essence, substance, creature, living thing, nature, or entity. There is no single English word that adequately translates *Wesen.* In almost every instance in the *Organon,* Hahnemann uses the term to refer to that entity which is the essential unchanging *esse* of something: its being, its quintessence. A wesen is not an abstraction; it is a dynamic, self-subsisting presence

even though that presence is not material and has no mass. A wesen is also not a property; it permeates the whole of something and is indivisible from it. The romantic philosophers of the nineteenth century (such as Coleridge) used the word 'genius' in the same way that Hahnemann, Goethe and other German thinkers used the word 'wesen.' The word 'genius' also appears in the fifth edition of the *Organon* (§130) and in various books and articles on homeopathic medicine. The term is most frequently used in connection with the genius (i.e., the wesen) of a remedy.

Hahnemann indicates that the wesen of a disease (§7) impinges upon the wesen of the human being (§10), resulting in a particular set of symptoms. The wesen of a medicine (§20, §21) is introduced by the medical-art practitioner in order to retune the mistuned wesen of the patient, thereby restoring the patient to health. Hahnemann's use of the word 'wesen' in these various contexts makes it clear that the life force, diseases and medicines are all operating in the same dynamic dimension.

The life force or the life principle can be interpreted either as the wesen of the human being (i.e., as a self-subsisting entity) or as an aspect of the human wesen (i.e, as a property of the human wesen). A wesen cannot be a property of something because it is its *esse*, its being. While Hahnemann generally writes about the life force or the life principle as if it were an entity, he also makes certain specific references to its being variable in amount (which can be true of a property but not of an entity). These include: *a.* his reference in *fn* 60 to the reduction and exhaustion of the life force as a result of Broussais' system of bloodletting, warm baths and starvation diet, *b.* his reference in §288 to both the increase and the decrease of the life force as a result of mesmeric treatment, and *c.* his reference in the Introduction (p. 47) to the 'supply' of life principle. The most consistent interpretation of the *Organon* leads to the following conclusion: What Hahnemann calls the dynamis (§9, §12) is the human wesen, while the life force is its executive power.

A wesen always forms a unity with a particular body, but that body may or may not have a material presence, that is, it may

include a particular material body or it may not. All wesens phenomenalize themselves through a complete system of hierarchical functions (as in an organism). The wesen is the source of acts committed through the body with which it forms a unity.

The human wesen permeates and forms a unity with the entire body of a particular human being. This includes but is not limited to one's material body; it also includes one's larger supersensible sphere, referred to by some writers as one's ambient (see **ambient**). In other words, the human wesen permeates both the human organism and its ambient, both of which are manifestations of the wesen; the wesen forms a unity with and is a common substratum of both. Therefore, the human wesen's sphere of action includes the individual's organism as well as the circumstances, events and conditions which inform the whole situation of the individual.

Hahnemann refers to various wesens other than the human wesen. Each different medicine and disease is a wesen. A collective disease (such as an epidemic or a miasmatic disease) is one which manifests in many different people but whose wesen is the same in all cases. The disease wesen is the same even when it manifests with different symptoms in different cases. The body with which a collective disease wesen forms a unity is largely supersensible; only its manifestations are perceptible. Hahnemann also describes the allopathic medical system as a wesen (p. 8). The body with which it forms a unity is a body of thought, associated with certain organized activities in the world (which could also be thought of as a kind of supersensible corporate body). Its perceptible manifestations include practitioners with a particular medical orientation and particular forms of treatment which affect patients' symptoms in certain ways. [Resource: SRD]

whitlow: *Nagelgeschwür.* A suppurative inflammation at the end of a finger or toe. It may be deep seated, involving the bone and its periosteum, or superficial, affecting parts of the nail. Also called a felon or paronychia. (§189)

whole, entire: *ganz.* See **entire**.

whooping cough: *Keichhusten.* A highly contagious disease, particularly of children under the age of eight, characterized by a bronchitis

and a particular type of cough. The characteristic 'whoop' consists of a long, crowing inspiration because of the spasmodic closure of the glottis (the vocal cord part of the larynx) which is followed by several short expirations in quick succession, ending most frequently with vomiting of food and large masses of tough, gelatinous phlegm from the bronchi. The child feels the cough coming and dreads it, almost always grabbing hold of something for support during the paroxyms of coughing, which can be so intense as to interfere with breathing and the action of the heart. These can result in the face turning blue and the veins standing out prominently and, in severe cases, with bleeding from the mouth, the nose or even the ears. The usual course of disease is 18 weeks in length. Though the condition appears serious to those standing by, fatalities are infrequent except in infants and children of less than one year of age, who are the most seriously affected; their mortality rate can be from 4 to 25% depending on external circumstances. The disease is more severe in malnourished children subject to poor living conditions. Hahnemann identified whooping cough as an acute miasm. (§73)

wipe away: *verwischen.* See **remove.**

wont: *pflegen.* To be in the habit of doing something. Refers to the habitual or customary practice in a particular situation. (§98)

worms. Hahnemann mentions three types of worm in the *Organon.* **Maggot:** *Madenwurm.* The legless, soft-bodied, wormlike larva of any of the various flies of the order *Diptera.* While most types of maggot feed on decaying matter, some maggots, such as the large voracious maggots of many blowflies, feed on any animal matter including living tissues. Infestations of these maggots may be cutaneous, intestinal, atrial (within a cavity such as the mouth, nose, eye, sinus, vagina, urethra), via a wound or external. (p. 14) **Mawworm:** *Spulwurm.* Any of a variety of worms that infest the stomach and intestines, especially applied to the roundworm (*ascaris lumbricoides*) and the threadworm or pin worm (*enterobius vermicularis*). The *ascaris lubricoides* (round worm) resembles a large earth worm, measuring 17-23 cm. [6.7-9.1 in.] in length. After a com-

plicated life cycle in the body, the adult worm ends up in the intestines. A light infestation may cause no symptoms; a heavy infestation may lead to colic or even obstruction of the gut. The *enterobius vermicularis* (pin worm, thread worm) is the most common and least harmful of intestinal parasites. The worms look like little threads; the females average 8-13 mm. [0.3-0.5 in.] in length, the males average 2-5 mm. [0.1-0.2 in.]. They live in considerable numbers in the large intestine, particularly of children. (Some worms may also find their way into the genital organs and bladder in females.) Typically, the most serious symptom is irritation around the anus accompanied by intense itching, especially in the evening when the female emerges from the anus to lay eggs and then die. (p. 14) **Tapeworm:** *Bandwurm.* The *taenia*, which is flat and white (resembling tape) and up to 12 m. [40 ft.] in length, infests the alimentary canal of vertebrates. Different varieties of *taenia* range in the seriousness of symptoms produced, from no perceptible symptoms (e.g., by the *taenia saginata*) to the production of hydatid cysts in body tissues (e.g., by the *taenia solium*). Even a very small hydatid cyst in the brain may cause serious symptoms, similar to that of a tumor, while a hydatid cyst in the liver may grow to the size of a man's head before causing much trouble. (p. 23)

worsening, aggravation: *Verschlimmerung.* See **aggravation.**

yellow fever: *gelbes Fieber.* An infectious tropical disease transmitted primarily by mosquitoes of the genera *Aedes* (especially *A. aegypti*) and *Haemagogus.* The disease occurs in three stages. The first stage manifests as a very high fever, severe pains in the head, restlessness, deleriuim, fear of death, vomiting of bile, and other signs of severe inflammation. The second stage commences as apparent improvement but is soon followed by a variety of further symptoms, most prominent of which is vomiting and hemorrhage. Hemorrhage is from the stomach and intestines. Blood is vomited and the stools are black or bloody. There is bleeding under the skin, from the gums, nose, ears, eyes and other body parts and organs. The third stage is one of collapse with jaundice; slow oozing of blood from almost every orifice of the body; black vomit; bloody, black or to-

tally suppressed urine; apathy; deleriuim, etc. The disease lasts from
three to ten days and usually ends in death. Hahnemann identified
yellow fever as an acute miasm. (§73)

■ REFERENCES ■

Dudgeon, R.E. *Lectures on the Theory and Practice of Homeopathy.* New Delhi: B. Jain, 1990.

Hahnemann, Samuel. *The Chronic Diseases: Their Peculiar Nature and their Homeopathic Cure.* Translated by L.H. Tafel. New Delhi: B. Jain, 1992.

_____.*The Lesser Writings.* Translated by R.E. Dudgeon. New Delhi: B. Jain, 1990.

_____. *Materia Medica Pura.* Translated by R.E. Dudgeon. New Delhi: B. Jain, 1989.

_____.*Organon der Heilkunst, Sixth Edition.* Edited by Joseph M. Schmidt. Heidelberg: Karl F. Haug, 1992.

_____.*Organon of Medicine: The Art of Healing, Fifth Edition.* Translated by C. Wesselhoeft. New Delhi: B. Jain, 1988.

_____.*Organon of Medicine, Fifth and Sixth Edition.* Translated by R.E. Dudgeon and W. Boericke. Edited by K.N. Mathur. New Delhi: B. Jain, 1970.

_____.*Organon of Medicine, Sixth Edition.* Translated by J. Künzli, A. Naudé, and P. Pendleton. London: Victor Gollancz, Ltd, 1983.

Nikiforuk, A. *The Fourth Horseman: A Short History of Epidemics, Plagues, Famine and Other Scourges.* New York: M. Evans, 1991.

Raue, C.G. *Special Pathology and Diagnostics with Therapeutic Hints.* Philadelphia: F.E. Boericke, Hahnemann, 1885.